W9-CLA-297

PICTURE MACHINE: THE RISE OF AMERICAN NEWSPICTURES

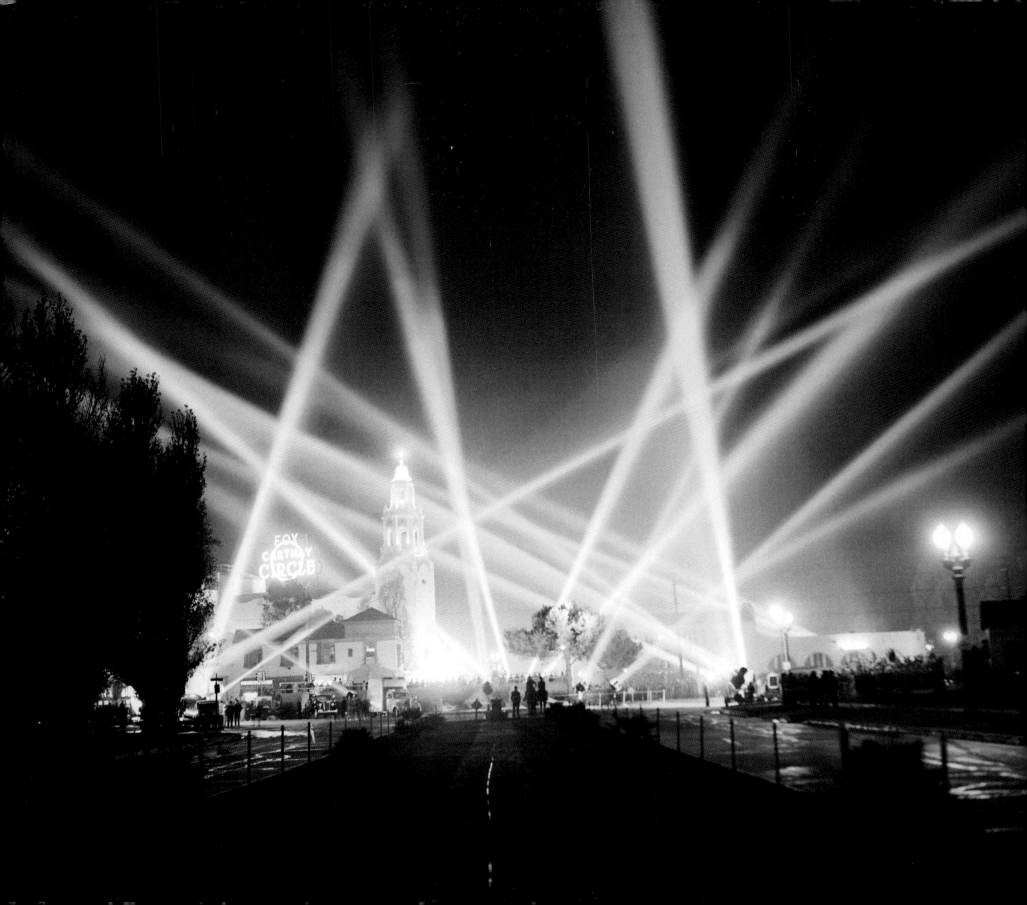

PICTURE MACHINE

THE RISE OF AMERICAN NEWSPICTURES

WILLIAM HANNIGAN AND KEN JOHNSTON

HARRY N. ABRAMS, INC., PUBLISHERS

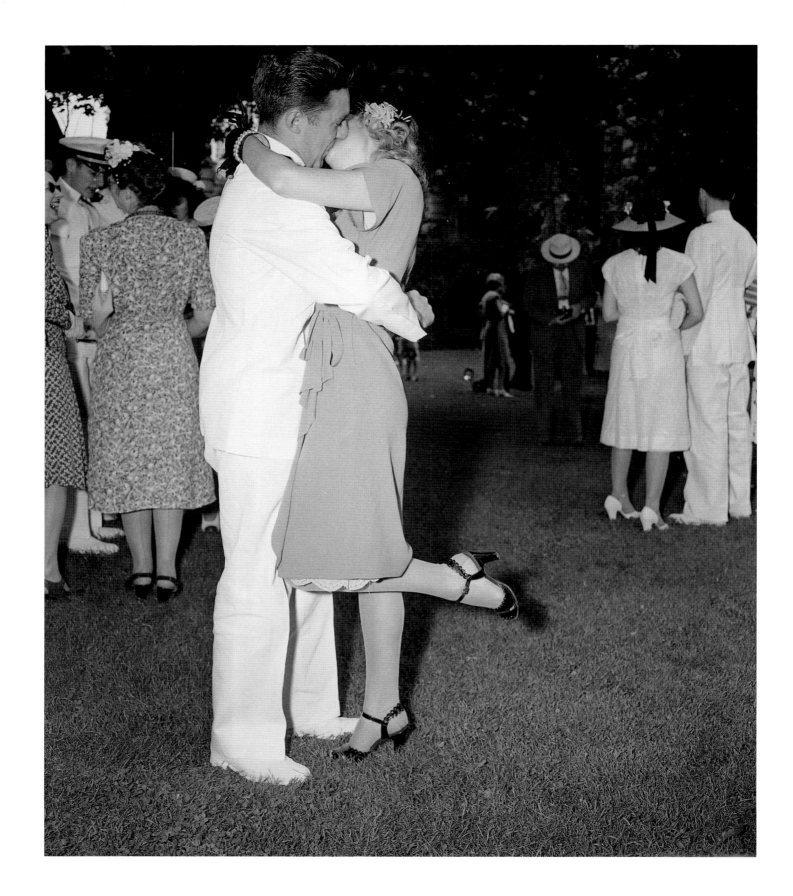

Couple kissing at commencement
ceremony, 1946 (see page 189).

CONTENTS

MAKING AMERICAN IMAGES..7

WILLIAM HANNIGAN

EYE NEWS: A SHORT HISTORY OF PICTURE NEWS

IN AMERICA ...12

KEN JOHNSTON

PLATES ..20

BIBLIOGRAPHY ..281

IMAGE REFERENCE NUMBERS ..282

INDEX ..284

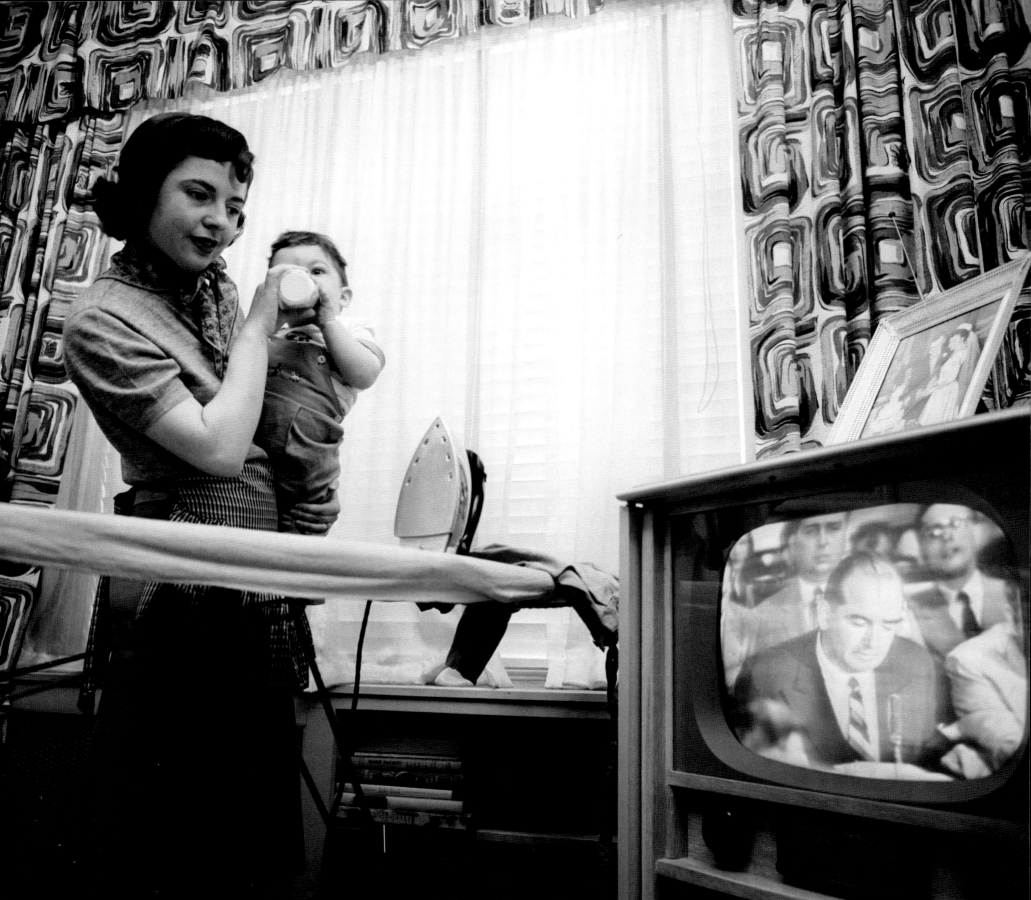

MAKING AMERICAN IMAGES

WILLIAM HANNIGAN

President Ronald Reagan being shot. A lone figure standing in protest against tanks rolling into Tiananmen Square. A firefighter cradling a young victim of the Oklahoma City bombing. Federal agents raiding a Miami home to claim Elian Gonzales. The terrorist attack on the World Trade Center. Live war via satellite phone. A constant feed of images made instantly accessible on the Internet and on television. The evolution of technology has enabled a culture that can be visually satisfied instantaneously. Within minutes of a news story breaking, we can log on or tune in and see images of a story as it unfolds. Even when that event is on another continent, in remote areas yet to be connected with electricity, we can experience and interpret an event with images almost immediately. Not only have recent innovations in technology made seeing pictures an expected part of our experiencing events, but they have also

eliminated all formerly accepted delays of that experience; no longer must we wait for the morning edition of the paper in order to see what has happened. An image of an event captured today can be instantly and simultaneously viewed by people around the globe.

This may appear to be another quantum leap facilitated by the information age, but it is actually the realization of a vision that is more than a century old, one shared by generations of newspapermen and –women and the ultimate goal of the news service—to be in all places at all times capturing the events of the world with the ability to distribute this information instantly and globally. And yet is this experience so different from what we have been used to? Do we not have iconographic images from earlier times, and do we not relate to a common shared experience through such pictures? Ruby shooting Oswald. Marilyn Monroe in her

white dress over the subway grate. The Iwo Jima flag raising. The Hindenburg explosion. Newspictures have provided this unifying experience for nearly a century—an experience that was introduced with the advent of the news agency and cemented within American culture with the arrival of the wirephoto. Today's technology—digital, the Internet—is the second great leap for newspictures. Wirephoto was the first.

At the midpoint of the nineteenth century, demand and technology led to revolutionary changes in the newspaper industry. Both readers and publishers of daily papers of varied circulation sizes across the country wanted more national and international news in a timely fashion. The answer to this demand was the technology of the wire, more accurately the telegraph. Words could now travel incredible distances at never-before-seen speeds, allowing newspapers to print coverage of events just hours after they occurred. However, the cost to meet this demand via the use of this technology was proving to be prohibitive for many newspapers as they tried to compete to meet the readers' new wants. Time on the major wires was limited, which left papers vying for access to send and receive news. In turn each was paying full rates—fees charged for transmission based

upon usage time—to the owners of the wires. There were also rumors circulating in the industry that the telegraph services were thinking of starting syndication systems for gathering and delivering news for sale—something they were already suspected of doing with the news gathered by independent papers and transmitted on their lines. In reaction to this, six New York–based newspapers would forever alter how news is gathered, edited, presented, and consumed in America. With a cooperative agreement, the *New York Herald*, the *Courier and Enquirer*, the *New York Journal of Commerce*, the *New York Tribune*, the *New York Sun*, and the *New York Express* established The Associated Press in 1848. By pooling and redirecting the resources each had previously dedicated to gather and distribute the news independently, these six papers could obtain broader coverage of global news events while significantly reducing costs within their own papers, as well as through new-found negotiating power in dealing with the companies that operated the wires. In short order it would also become apparent that a very profitable market existed if these papers were to syndicate this consolidated news coverage to a member subscriber base of other newspapers, essentially allowing other papers access to

the news transmissions for a subscription fee. As syndication became a reality readers in every region of the country were now able to access the same information simultaneously as this new business model and telegraph lines allowed smaller market papers to stay competitive.

Although there had been similar models that predated the founding of the AP, the AP would rise to near monopolistic dominance by the end of the nineteenth century. Publishing giants E. W. Scripps and William Randolph Hearst would both later form their own news services, United Press (1907) and International News Service (1909), respectively, to compete with the AP—a direct reaction to the AP's refusal to service their papers. There was more than enough room for competition. Advancements made in the production process—most significantly the invention of the Linotype machine and faster printing presses—as well as technological advancements, such as the expansion of telephone systems and the development of radio, transformed the world of news into a highly efficient and competitive place. Information was able to be transformed into type at incredible speed and the demand for it was there. The number of American newspaper titles had more than doubled between 1880 and 1900, from eight hundred and fifty to nearly two

thousand, and by 1925 daily American newspaper circulation was close to forty million. But nothing would do more to revolutionize the newspaper publishing world or drive competition than the arrival of the photograph.

The visual makeup of print media changed radically with the perfection of the halftone process at the end of the nineteenth century. Prior to the invention of halftone, or "dot," process, illustrated papers relied on different forms of etching or woodcuts, all very laborious processes, to reproduce images in print; many of these were interpreted from photographs but clearly lacked the detail of a photographic image. Although photography had been commonplace for more than half a century, it was not being used as a direct mechanism of communication or as a tool of journalism. With the arrival and eventual adoption of the halftone process, photographs began to appear regularly within newspapers. Now, at the same time the major news agencies were forming, photographs were being presented in newspapers as documentation—official records of an event. Photography was steadily emerging as a visual reinforcement to the written word. No longer would news agencies cover any major event without a photographer present—the newspicture had arrived.

At the beginning of the twentieth century, as more and more publishers moved to make photographs a regular feature of their papers, photography was already more than sixty years old, and the photographic image was an integrated component of American culture. Once newspaper readers had tasted the change their appetites were insatiable. In the summer of 1919 Joseph Medill Patterson, then co-publisher of the *Chicago Tribune* with his cousin Colonel Robert McCormick, launched

America's first tabloid in New York. He called it the *Illustrated Daily News*, (shortened soon after to the *Daily News*) "New York's Picture Paper," and within five years it had a circulation of over three quarters of a million readers. The bottom line—pictures sold papers, which sold ads. For business the benefits were obvious but the costs prohibitive. The costs associated with incorporating photographs into publication were significant. Changes to the printing presses along with incorporating photos into the daily production process—photographers, cameras, film and processing materials, darkroom staff, etc.—all added tremendous costs. To many smaller publishers the increased cost of photo production and publishing would be crippling, whereas in larger markets, where the potential was greater for increased readership and market share, increased ad sales and overall increased revenue, publishers were more ready to take on such risk. The news services, having already solved this problem for text, moved to take advantage of this challenge. Most papers were already subscribers to the text news services and so an easy and obvious solution was to incorporate pictures into this feed as well, although, unfortunately, no method of electronic dissemination existed and the pictures remained reliant on more primitive means of distribution. The first to do this was Hearst, forming International News Photos as a division of International News Service. Scripps followed in 1922 with United Features and a year later United Newspictures, to be followed by Acme Newspictures in 1924. AP News Photo Service arrived in 1928. One other significant player arrived as well that same year, Wide World Photos, launched by the *New York Times*. Still, by 1935, only three hundred of twenty-one hun-

dred American newspapers had photo departments (in-house photographers and production staff), most of which were a part of newspapers located within urban areas. Now, with the news services distributing photos, smaller papers had a solution to what was becoming a threatening competitive advantage. But still the playing field was not totally level. As the distribution of images, unlike text over the wire, was limited to its mode of transportation—ground, sea, or air—pictures took days or even weeks to arrive after a story first broke. In the often ferociously competitive news business timing is everything, old news does not sell papers, and to many publishers the increased costs of photo production just did not add up. As a result, readers of papers in many smaller cities were still not seeing photographs as news. It was not until the arrival of the Wirephoto that regular publication of newspictures became commonplace for many readers.

From as early as 1847, when F. C. Bakewell successfully transmitted a simple graph picture electronically using rotating cylinders, inventors have sought to find a successful method for sending pictures over the wires. In the early 1920s the American Telephone & Telegraph Company announced a commercial system to do just this, and set up sending-and-receiving stations in eight cities. This technology became known as telephoto. Although it was received initially with great enthusiasm, critical and practical tests proved the reproductions to be of poor quality and transmission times were over an hour, making it a less than viable option for most publications. Only in rare instances, when an image was of profound news value, would editors choose to print a telephoto image over one delivered by traditional means.

Essentially AT&T was confronted with a $2,800,000 failure and in June 1933 it was abandoned. But the dream of transmitting pictures by wire did not die with it, for near the end of that same year, Bell Laboratories announced the invention of an entirely new process, one that would prove to be both a critical as well as a commercial success. The Wirephoto machine would come to revolutionize photography, newspaper publishing, journalism, and the essence of how we communicate. For the first time pictures could accompany text, following it over the wire to the newspapers, allowing readers to view pictures simultaneously with the news.

The public response to this was to demand more. At the time of the Wirephoto's arrival, one in three people polled stated they did not believe what they read in the press. Unlike today when sophisticated readers demand, and journalists strive for, a certain level of objectivity, leading papers in the United States at the end of the nineteenth century often liberally embellished events to the point of sensationalist melodrama to sell newspapers. None more so than the papers of William Randolph Hearst and Joseph Pulitzer. In the wake of this "yellow journalism," the presence of the newspicture seemed to many a validation of what was appearing in print or as an even truer record of an event. The contemporary discourse questioning the photograph as "truth" had yet to develop and a naive trust in the photograph to tell the true story existed amongst many readers. Reactions within the media world to the rising prominence of pictures in newspapers covered the spectrum, from the passively dismissive to the morally opposed to those who would embrace it fully. Anthony North, writing in *New Outlook* in June 1934, warned against the encroachment

Example of an early wire transmitted photograph. Image shows Charles Lindbergh being greeted outside the American Embassy after his 1927 Transatlantic flight.

of the image and completely disconnects the photographer from the act of image creation in describing the arrival of the new wire technology:

Are we in danger of becoming a nation of news picture addicts? A new machine of the Machine Age, starting shortly to operate on 10,000 miles of telephone lines, will accentuate the movement of taking the eye off the printed word and placing it upon the news pictures. [The machine]... increases the chances of the odds-on favorite in the Orage Handicap: "Civilization is a race between education and destruction."

Within that same year, Malcolm Bingay, editor of the *Detroit Free Press*, speaking at the thirteenth annual convention of the American Society of Newspaper Editors, would react thus:

We are not only politically and economically [in a period of transition] but journalistically. The old forms are breaking up and new ideas are coming in, and the big thing, until television comes and blows us all out of the

water, is the development of that completely new technique of photography combined with newspaper stories. It is an idea, it is a theory. Nothing yet is factual. I haven't seen a newspaper in the United States, including my own, that has yet caught what is coming.

The fact of the matter was that not only was competition amongst papers and news agencies growing ever more fierce, but now the newspaper industry also had to compete with motion pictures, radio, and whispers of a new approaching technology — television. Pictures were driving paper sales, and once publishers realized that the financial return could outweigh the increased costs—increased circulation generally meant increased ad spending—there was no looking back. With images riding the wires simultaneously with text, thus being fully integrated in the reporting of the news, the economic reality for publishers became that in order to stay competitive they would have to embrace newspictures. This fiscal reality was coupled with the embracing of newspictures by the readers, described in an article on Wirephoto in *Fortune* in 1937, "What really caused the commotion was the dawning realization among publishers that pictures had become quite as important as news itself, and that journalistic necessity was rapidly requiring that pictures be fresh as the news, riding right behind it on the wires." In the thirties the number of pictures used in the metropolitan daily increased by about two-thirds, reaching thirty-eight percent of overall page space per issue in 1938. The newspicture and now the wirephoto were here to stay.

One person who saw this clearly and early was Kent Cooper, general manager of the Associated Press, and the single greatest proponent of wirephotos. Cooper had spent much of his career following the development of wire transmission technologies for telegraphing pictures. He also believed unwaveringly in the use of photography to tell the news and was the driving force behind AP launching its photo service in 1928. When AT&T announced their service in the early 1920s he was optimistic but ultimately disappointed as the service did not prove to be commercially viable. But with the arrival of the new Bell Laboratories system in 1933, Cooper finally had the answer he was searching for. In a bitter fight that nearly split the AP apart, Cooper was able to convince the membership to move forward with Wirephoto, an AP trademark that would eventually become the standard term for transmitted images, primarily by securing enough subscribers—publishers who signed on for the syndication service—to underwrite the estimated $1,000,000 annual costs, ushering in what he believe to be "the newest and biggest departure in newspaper work since words were first telegraphed." Indeed he was right, and this was certainly not lost on his competitors. Within a year of AP launching Wirephoto all the other major news agencies developed their own systems, Hearst's INP launched Soundphoto, the New York Times/Wide World Photo introduced Wired Photos and Scripps-Howard put forth Acme Telephoto. By the end of the 1930s hundreds of images were being transmitted to newspapers and in turn to readers across the country every day. Now, not only were readers viewing newspictures simultaneously with text, they were also viewing them simultaneously with the rest of the nation.

The public's appetite appeared insatiable. With all the major United States news services now providing images by wire transmission, nearly every American newspaper had access to newspictures as events unfolded. Publishers were no longer at the mercy of train schedules or weather conditions. Although the news agencies had been distributing pictures for more than a decade, newspaper publishers and their readers were still dependent on traditional means of transportation, as well as their proximity to an event, to determine when they would see photographic coverage. Now with images being transmitted to member papers throughout the country, readers everywhere were seeing the same images in their morning editions from coast to coast. The wirephoto brought about a common experience; it was now possible for a single image to define an event, to become the visual record, or indeed *the* record, of an event in the public's mind. Within the first year of competition amongst the "wires" an event would occur that illustrated this to everyone in journalism. On May 6, 1937, in Lakehurst, New Jersey, dozens of journalists, writers, newsreel cameramen, photographers, and radio announcers awaited the arrival of the dirigible *Hindenburg*, the world's largest airship ever built, at 804 feet long. As it neared the ground and crew members went out to secure the mooring cables the ship suddenly burst into flames. Seven million cubic feet of burning hydrogen consumed the ship in less than a minute and killed one third of the people on board. The photographers that were poised and ready for the landing now had in their filmholders some of the most sensational images ever created. As these images raced across the country and were set on the front page of nearly every paper in the land it would become clear to all that the photograph would be the true record of this event.

The photographer was now the chronicler of events, right alongside the journalist and in turn the photograph, or more accurately the newspicture, became an integral part of the documentation of the world's news. The buzz of a story on the street went from, "Did you read …?" (print), to "Did you hear …?" (radio), to "Did you see …?" (newspictures). The wirephoto enabled a shared experience across the nation and potentially across the globe. For the first time readers' reactions, interpretations and experiences of an event could be shared. The magnitude of this is hard for us to understand from where we sit today, so enmeshed are our daily lives with technology and the consumption of mass-distributed visual media, and so easy is it for us to reference shared images in our conversation. But in effect what the wire services did was create the potential for an event to be changed from a personal or regional experience to a national cultural experience. The image now operated as a link, unifying the American culture through this shared experience. One person's image or record of an event became the same as the next person's. For example, the national cultural reference to Ruby shooting Oswald is undoubtedly Bob Jackson's photograph. At the time of its distribution this image was how America witnessed and vicariously experienced the event, and now, for multiple generations it is a shared memory, a common experience. The wire services were in effect creating a national family album, a visual chronicling of events as interpreted by disparate individual photographers around the country.

In order to stay competitive each wire service had to provide its subscriber base with as near complete national and international coverage as possible. This led to each having a network of photographers feeding images into a few main bureaus in major urban centers from every state in the union. This feed, originally intended only to service the needs of this daily supply and demand, now exists as one consolidated archive. The images in this book are drawn from the archives of four major wire services, INP, ACME, UPI, and P&A, and together they create a daily record of the twentieth century American experience. An abundant visual record of a century exists; these newspictures are documentation of all the events deemed newsworthy of the past hundred years. And what we find in this record are not just the shared memories, the iconographic images, but an infinite number of photographs created by a multitude of independent witnesses and interpreters. We are left with a daily visual chronicle that has no clear agenda or singular vision, no common aesthetic, no single unifying element other the fact that these images were offered day after day as records of events, as documents, as news, as what Americans were experiencing. Taken at face value this is a record, a logbook of history.

Looking back now on this visual chronicle, however, we see something much more dynamic than a static log. As the century went on, photographers, publishers, and readers grew more visually sophisticated and so, too, did newspictures in their use. It is the central period of this evolution—from the implementation of photographic news coverage during the first world war through the period that saw the rise of the photojournalist as auteur in the 1960s—that is the focus of the images selected for this book. As newspictures and wire distribution grew into maturity in the 1930s, the photograph was becoming ubiquitous. From store window advertisements to the pages of *Vogue* and *Vanity Fair* to the recently launched *Life*, the photograph was rapidly

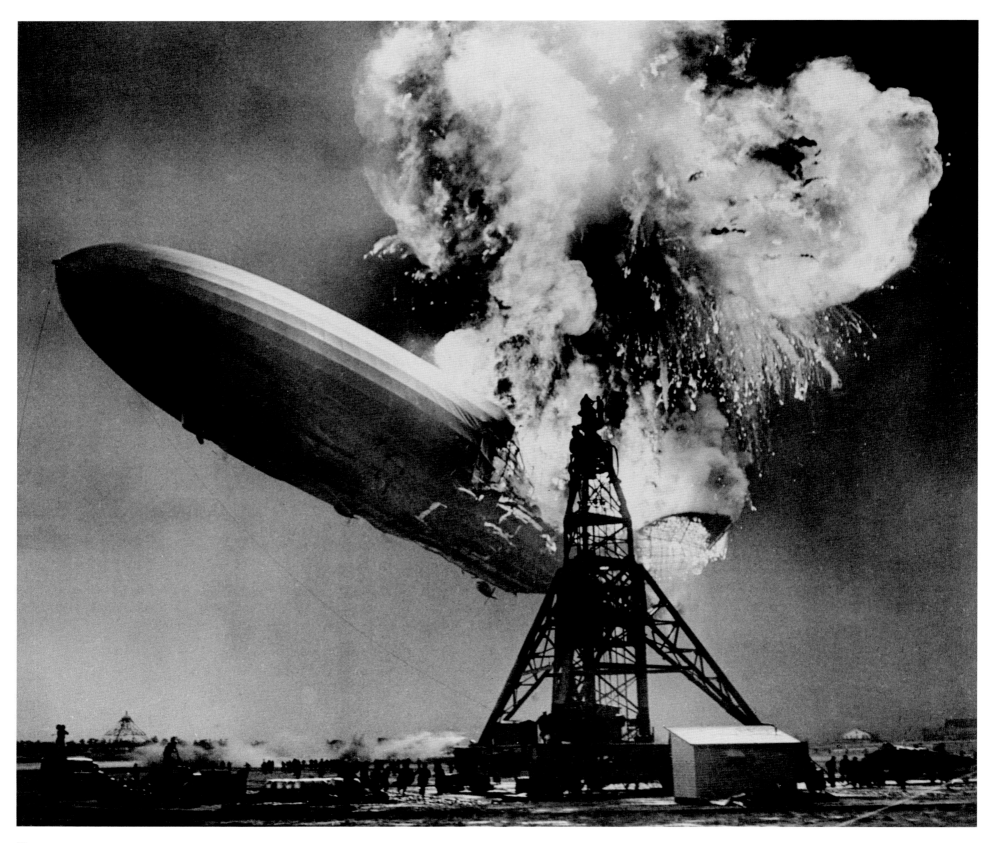

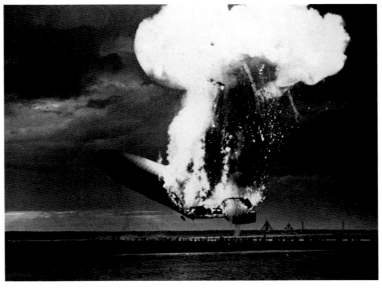

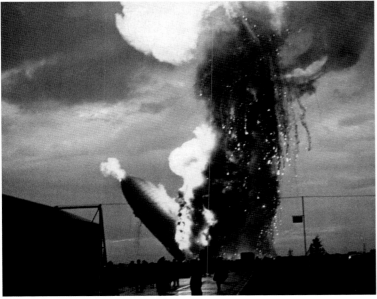

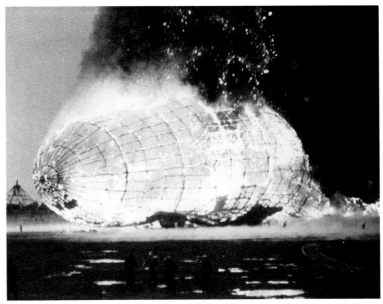

becoming a tool of communication. Technological changes at this same time, the introduction of lightweight handheld press cameras, particularly the Speed Graphic, which incorporated technical developments including a synchronized flash, liberated the photographer while highlighting the element of speed. It also helped to shape a new aesthetic, one capable of capturing action, and being overtly expressive.

We see in these images an evolution from simple static documentation to a much more refined use of the medium, a craft or even art form can come through in newspictures just as can sometimes be found within the words they accompany. This is an evolution that has had to continue its cycle with increasing rapidity in parallel with the evolution of technology and media to the present. Coupled with this, and much

more elusive, are the external factors that influenced their creation, use and survival. Use hinged on the decisions of editors—what stories actually get covered?; publishers—is his oldest friend running for governor?; advertisers—does the paper go soft on a strike story with its biggest advertiser?; bureau chiefs—which images or stories go out over the wire first?; publicists—no access to the star on set unless the photographers

shoot from fifteen feet. We are left to wonder whose agenda dictated this usage. As newspictures were influenced by such agendas, as they moved beyond supportive illustration for the text story, or simply grew to embody more of the photographer's subjective interpretation than objective record of an event, the interchange between reader/viewer and the news media, as well as our collective visual language, had to

change. No longer could the viewer be a passive or trusting consumer. Culturally we were forced to become sophisticated readers of images, challenging the origins, placement, and presentation of images as a part of the news. Now, as we look at these images we ask ourselves, is this a reflection of the American image or is it the construction of the American image? The truth lies somewhere in the middle.

EYE NEWS
THE STORY OF PICTURE
NEWS IN AMERICA

KEN JOHNSTON

This is a book of news service photographs culled from the United Press International photo archive, the news photo branch of the United Press International news service. The UPI photo archive is the largest, most intact collection of twentieth-century news service photography in the United States, greater in size and equal in breadth to the photo archive of the Associated Press, UPI's historical rival. There are images in the UPI photo archive dating from circa 1880 to 1990, the bulk of them from the 1920s through to the 1960s. Included in the archive are photographs from a variety of smaller news photo services that were all in one way or another ultimately combined to create UPI. These include Acme Newspictures, International News Photos, and Pacific and Atlantic (and these archives as well contain others, generating, as we'll see, an extended, scrubby, acronym-laden family tree). Overall, the UPI photo archive holds approximately eleven million images, the work of hundreds of anonymous photographers.

Edward Willis Scripps and William Randolph Hearst, two of the most significant men in American news history, were directly responsible for the creation of UPI, which was, and still is, a news service. News services occupy a middleman position between the broad, messy, news-making world and the producers of news, the news media (newspapers, television news, etc.). They provide news wholesale and generally don't deliver directly to consumers of news, the public. Like the news media, services gather, package, and distribute news information as stories, pictures, or raw data. Structured similarly to their major clients, the newspapers, services are made up with editors in charge determining which subjects to cover, reporters (called correspondents and scavengers in the nineteenth century) and photographers in the field following stories and leads, more editors and copy staff collecting, collating, and creating stories, and various other staff getting the news out to clients. The most common means of text news distribution by news services from the 1870s on were telegraph and telephone wires and, as a result, they earned the nickname "wire" services. Services generally come in two flavors; they are either organizations that sell news stories to whoever will buy, or cooperative structures that distribute news only among members. The first news services in the United States were in fact informal cooperatives known then as press associations, created among individual newspapers to increase profit and ultimately stifle competition.

News services in the United States grew out of an oxymoronic mix of competitive cooperation, at a time in the early nineteenth century when newspapers were being founded at an astounding rate as America grew. News of the nation and world at large was a prized commodity in towns isolated by distance and few roads, as the nation pressed westward and immigrant populations grew. At the time news services first appeared in the United States in the 1820s, news, like the mail, traveled by horse, boat, and carrier pigeon along slow circuits, the roads and waterways. Time was always a factor, as the fresher the news, the more papers would be sold. In cities with competing papers, the one with the speediest access to raw news got the scoops and beat the competition.

By the 1840s there were close to four hundred daily papers and upwards of three thousand weeklies in the U.S., outside of New York City. At this point, New York City was fast becoming the clearinghouse for American news distribution. News from abroad arrived with foreign ships in the New York harbor and city papers would each run a rowboat out to incoming vessels, hoping to beat the others back to publication. It was expensive and risky, and at best gained only a few hours' lead. In 1848 six of New York's morning papers informally founded the "Harbor News Association," to pool resources (and rowboats) to gather the news, believing that collectively they had a better chance to defeat the evening papers. The benefits of cooperation grew and soon the group was sharing the costs of getting news along the single, congested telegraph line between Washington, D.C., and New York City. The Harbor News Association would, after a few twists and turns, become the New York Associated Press in the 1860s. Other press associations were formed in Chicago, California, New England, and elsewhere. These swapped news with the New York association and other member groups. But New York still held a majority and controlled the network, indulging in the usual capitalist offences, monopolizing and denying service to competitors. If you weren't an AP member, you couldn't use the AP news, and getting it elsewhere was an expensive proposition, especially if you were in an isolated western city (and western at this point meant, say, Cincinnati). The AP by-laws also prohibited members from using competing services. Besides having the most extensive nationwide news network, the AP was in cahoots not only with the Western Union telegraph company controlling the wires, but also with all three major European news services, Reuters, Havas, and Wolff. By 1900, the AP had been squeezing news distribution in America for decades, and after years of working both with and around the major associations, Scripps and Hearst both determined to start their own separate and independent news services, which, over time, would produce and

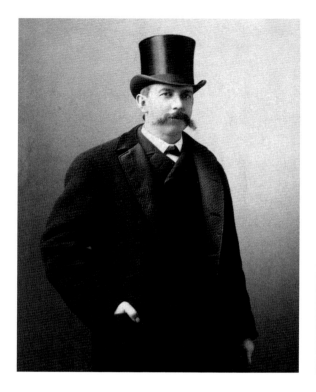

Edward Willis Scripps, c. 1900.
William Randolph Hearst, 1928.

accumulate the images represented in this book.

E.W. Scripps owned ten papers from Seattle to Chicago by 1900. Although he was offered a 25 percent share in the AP that same year, he declined, being just plain fed up. He described the news services at that time, including the AP, as being either moribund and/or corrupt, later saying that "competition had reduced the whole press association business to an absurdity." He believed that Americans would never get "correct" news via the AP, that the various capital and political agendas of the AP would not allow unfiltered, non-biased news to surface. Not that Scripps's intentions in starting his own services were completely altruistic. Joining the AP would have interfered with his ability to start up or purchase new papers, if they happened to be in towns with competing AP-member papers. The AP was also oriented toward servicing morning edition papers, which

meant Scripps's afternoon papers could only publish hours-old news. Personally, Scripps was a fairly conservative businessman and was most definitely a capitalist; his papers, however, were aimed at, and priced for, the working classes, whom he referred to as "the 95%." Politically, his papers presented an independent, sometimes liberal, pro-labor stance. In contrast, the member papers of the AP tended toward the conservative and, well, highbrow, and this certainly contributed to Scripps's decision to go it on his own. Scripps began his first small, regional news service for his own chain of papers in 1897, and by 1906, he owned three. In 1903, he founded the nonprofit Newspaper Enterprise Association, a "feature" service that distributed ready-made in-depth news stories as well as illustrations and comics, again, for his papers only. In 1907, he took over an ailing (and corrupt) New York news service, the Publisher's Press, renaming it the United Press Associations

in 1911. The UP, and at this point the Newspaper Enterprise Association as well, syndicated news stories, comics, and photographs to whoever would pay for the service—they were not cooperatives. The UP quickly became the number two service in the United States behind the AP, quietly turning a profit by its tenth year. By 1915 it was servicing six hundred twenty-five clients, the bulk of whom were small-to-middling local papers across America.

Meanwhile, Hearst was having his own troubles with the AP. Hearst had inherited his first paper, the *San Francisco Examiner*, in 1887 and purchased the *New York Morning Journal* in 1895. In 1897 the news service the *Journal* relied on (the original United Press news service, unrelated to Scripps's later outfit) went under due to scandal. Hearst applied to the AP as a replacement service, but was refused membership. He had been raiding the staff of Joseph Pulitzer's *New York World* and, as it turns out,

Pulitzer held a deciding vote at the AP as to who could and who could not join—and voted against Hearst. Hearst was left in the lurch. His solution was to quickly buy up another paper that did have an AP franchise. And yet even while he thus attained his membership in the AP, Hearst, like Scripps, wanted the freedom to purchase and start papers without restraint, and so he set up his own news syndication services for his papers, beginning around 1900. These he incorporated in 1909 as the International News Service. The INS, like Scripps's United Press, syndicated news stories on contract, not membership, and distributed news via the wire as well as mail.

Hearst's approach to the news business was more flamboyant and more geared toward the sensational than Scripps. His headlines were loud, stories often slanted. What he shared with Scripps was the orientation toward the wage-earning public. Because of this, both men's news services stressed the vernacular and were vital in developing the use of human-interest stories, one-on-one interviews, color sections, and illustrations into the everyday American news scene. Both Scripps and Hearst were on the same side of a significant struggle in the American news arena that would last from the 1850s until the 1930s, between those who promoted and purveyed images, and those who saw images as a lesser class of information than text. Promoters of text were generally the conservative, old-money papers, and services such as the AP, which saw illustration at best as frivolous, and, at worst, as a threat to the culture at large, dumbing down the audience. The picture people, including Hearst and Scripps, among others, were the upstarts and independents,

populist, younger, and vying for an audience. The novelty and power of photography insured that the upstarts and independents would exploit it.

The United Press and the International News Service held, respectively, the second and third positions behind the Associated Press for over forty years. In 1958 the UP successfully negotiated the purchase of the INS, and the two services combined to become United Press International. UPI began to falter financially soon thereafter and the Scripps organization eventually sold it in 1982 for one dollar. It has since changed hands a few times.

The news photo archive of UPI (the library of pictures, not the story service) was sold away from the overall UPI organization to the Bettmann Archive in 1990, which had managed it since 1985. The Bettmann Archive was not a news service. It was a historical picture archive founded in 1935 by Otto Bettmann, a German Jewish expatriate. Bettmann created what was probably the most well known, and possibly the first, commercial historical picture archive in the United States. Bettmann collected and sold images of the past, primarily to book publishers and advertising agencies. The Bettmann Archive was probably the best place for the UPI picture archive to be, as linking into the lucrative commercial market assured it would continue to be accessed. The Bettmann Archive was itself sold to Bill Gates's media corporation Corbis in 1995, as the then-owner of Bettmann, Herb Gstalder correctly surmised that Corbis, with its substantial research and development budget, would best be able to care for the archive long into the future.

Picture news in America did not begin with Scripps or Hearst. It had been a regular thing since the 1850s,

THE MURDERER'S ATTACK ON HIS MOTHER.

THE MURDER OF THE LITTLE BOYS.

THE MURDER OF THE SERVANT GIRL.

THE MURDERER AS HE WAS FOUND BY THE POLICE.

A page from Harper's Weekly, *November 6, 1858.*

in nationally distributed periodicals such as *Harper's Weekly* and another weekly, *Frank Leslie's Illustrated Newspaper.* Both these papers prominently—they averaged a 50/50 ratio of images to text per issue—featured line engravings of contemporary subjects along with editorial cartoons, written news, and fiction. By today's standards *Harper's* was more a magazine than a newspaper, covering subjects of national interest, including the American West, technical marvels, natural disasters, and portraits of significant folk. *Leslie's* was the more newspaperlike of the two, emphasizing spot and breaking news stories, such as the murder of a New York dentist for which *Leslie's* sent a sketch artist to make on-the-scene drawings. In mid-nineteenth-century America, regular access to images as ready conveyors of information, particularly news stories, was a relatively novel thing and the illustrated papers found a ready market. Best-selling issues could reach a circulation of two hundred thousand or so, which was very high for the time. As their popularity grew, regional illustrated newspapers such as the *Southern Illustrated News* appeared in larger cities where the circulation base was big enough to support the printing costs. In 1873 the first illustrated *daily* paper, *The Daily Graphic*, appeared in New York. That same year historian Frederick Hudson described the spread and effect of the illustrated papers: "Every newspaper stand is covered with them. Every railroad train is filled with them. They are 'object-teaching' to the multitude. They make the battlefields, the coronations, the corruptions of politicians, the balls, the racecourse, the yacht race, the naval and military heroes . . . familiar to everyone. They are, in brief, the art gallery of the world." What the illustrated papers ultimately did was establish images as a regular, viable, and popular part of the American news scene.

Photography had always played a supporting role in the nineteenth-century illustrated papers, as the technology to reproduce photographs in print did not exist for the first forty years the illustrated papers were around. Woodcut engravings of the type used by the illustrateds were etched by hand, and could not reproduce the continuous sweep of gray tones of a black-and-white photograph. Although many inventions appeared from 1852 on, it wouldn't be until 1890, with the introduction of the halftone printing process, that regular, high-speed, mechanical copying of photographs onto newsprint was possible. Prior to this the only way for the illustrated papers to exploit the marvel of photography was as a reference for engravings. They often ran composite images created from multiple sources including pencil sketches, written descriptions, and photographs. Occasionally single images based solely on a significant photo, like those taken by Matthew Brady during the Civil War, were run. It's interesting to wonder, though, how they would have used photographs if they had had the ability to print them directly early on, for the illustrateds had a particular way of presenting pictorial news that photography didn't necessarily fit in with.

Engravings of news subjects that ran in the illustrated papers were essentially artistic endeavors and they generally followed the pictorial and stylistic modes of the day, drawing on the compositional conventions of academic painting. Depiction of dramatic news subjects mimicked melodrama, utilizing expressions and poses from the theater (and dime novels) to depict emotion. Engravings relied on pictorial conventions to recast news as narrative, supporting the written text it accompanied. In this regard, there was some question as to the applicability of photography to news coverage. Compared to engravings, the "all-seeing eye" of the camera produced seemingly raw, wide-open views of the world, an evidently unfiltered reality that was certainly not narrative. Photographers, like the sketch artists mentioned above, followed pictorial convention, but in the news world their products were still not seen as authored, hand-fashioned, or artistic in the way engravings were. Photography was thought to depict the world, news and otherwise, objectively.

The older, engraving-saturated illustrated papers described above were all defunct by 1895. By then there were more papers—there were close to two thousand daily papers in the United States by 1900, compared to eight hundred fifty in 1880—and more were able to print illustrations, including photos. By 1897 major papers like the *New York Times* and the *New York Tribune* were producing illustrated supplements weekly (in both cases, they were photographic supplements). Because these papers had large circulations, they were able to afford not only the machinery, but also the staff of technicians needed to prep the pictures for print. Illustration was no longer an exclusive domain, and it is this factor that probably wiped out the old illustrateds. And yet this is not to imply that all papers were embracing illustration. For the majority of papers it was still not economically feasible to print pictures. Text still reigned supreme at many news organizations, where illustrations were at best a necessary evil used as decoration or a play to increase circulation, not to convey news. This attitude lasted, at least in some places, for quite a while—in 1947 Basil L. Walters, the executive editor of the Knight newspaper chain, described how even then, "in the majority of [news] offices, pictures are handled as nuisance jobs."

Although photographs began showing up regularly in papers in the 1890s, there remained technical and financial limits on both what they could cover and how they could be used. Slow-speed film and mechanical shutters required a lot of light for exposure and necessitated that subjects move very little to prevent motion blur. Subjects had to be shot in daylight or by harsh flash powder that created so much smoke photographers were often banned from using it indoors. Flash bulbs didn't come along until the 1920s, eliminating the smoke problem. Negatives were for the most part fragile and heavy glass plates—the standard until the late 1920s. Cameras were bulky as well, and focus had to be guessed or directly measured until single lens reflex cameras, which allowed photographers to adjust focus on the camera's focal plane, began appearing around 1900. The first

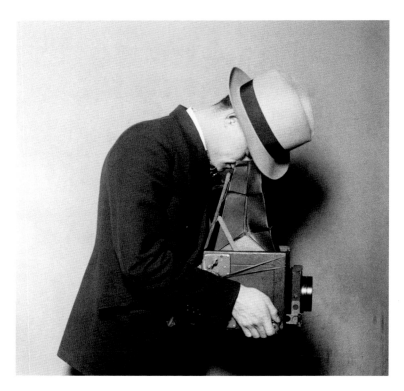

A Pacific & Atlantic news photographer, c. 1930.

model designed specifically for news photographers, the Speed Graphic, came out in 1912. The halftone printing process, revolutionary as it was in that it allowed photographs to be printed relatively cheaply and speedily, was still fairly crude and photographic details didn't always come through in print. Newspaper reproductions of photographs were murky (described as "muddy blotches" by one newspaper man), and required an "artist's" touch-up. It was also expensive to run photographs. An editor at the *Chicago Inter-Ocean* got himself fired for publishing a full-page spread of photographs in 1907, because of how much it cost. Still, photographs were popular and their use increased over the decades.

Certain basic elements of news photography as we know it today were invented in the period from circa 1890 to 1925. It's during this time that news photography gained definition as a form of news content with its own manners and means.

Faster, lighter cameras and high-speed film determined photographic practice and news photography came to be about being in the right place at the right time, about access and immediacy. Photography began to represent the point of view of the bystander or the eyewitness. Sketched and written news could be based on eyewitness accounts, but could never represent details or action or emotion as directly as a photograph. Photographers had to be present. Fittingly, in later years, UPI's slogan was "A UPI Man is Always at the Scene."

The news photographer's role was pretty well defined by the 'teens. Francis A. Collins, in his 1916 book *The Camera Man*, described the situation: "Let an accident occur in the most remote part of the city, at any hour of the day or night, and the news photographer will be on the scene as soon as the ambulance. He is among the first to respond to any fire. At any public function, in or out of doors, the

click of a battery of cameras is a familiar, perhaps an irritating, sound. In the offices of the newspapers, and the news photographers, scores of alert camera men are held in readiness to start anywhere on a moment's notice." It was about action, about getting in and getting the shot, capturing the thing. But there was an unstated question around exactly who or what was doing the "capturing." Photographers for the most part were looked on as technicians, skilled or otherwise, that only manned the machines, the cameras and enlargers, which actually "described" the scene. In short, photographers weren't seen to be making journalism, just gathering facts; not interpreting news subjects, only reining them in. Even the picture-friendly papers and services like those owned by Scripps and Hearst didn't credit photographers. The strongest evidence of this is the fact that the vast majority of American newspaper and news service photography shot prior the 1960s is anonymous. Of all the images in this book, only eight are credited. In this regard, photographers were like the other now unknown mid-to-low-level workers in the news chain, the story and picture editors, caption-writers, copy boys, darkroom workers, and library staff.

Even if their product wasn't credited, the exploits of photographers often were. There was a certain level of daredevil prestige along with novelty associated with the job from the early years. As publicity, papers would play up the lengths their photographers might go to get a shot (see page 40), and in these instances the capturing of the news was the news. But save for the occasional risk, the job was mostly routine, a lot of waiting around for Presidents or paddy wagons with only the occasional

intense moment. The responsibilities of the news photographer's job were well defined by the 1920s. A 1931 article in the magazine *Photo Era* provides a sort of job description: "Newsphotography may not be a job the shrinking-violet type of man would find congenial, perhaps; but a newsphotographer does not always have to resort to sly tactics to get newsy pictures. Nor, indeed, is it always necessary for them to invade forbidden precincts for picture subjects." There wasn't much money in it, either. As late as 1947, photographers earned only three dollars per shot, and that was only for those that ran.

If the photographers were the cowboys, the editors ran the ranch. The editor controlled which, of all the shots turned in by a photographer, actually got used, as well as determined what was covered in the first place. The editor's job framed that of the photographer, by directing and selecting. Likewise, the caption writer provided context for the photographs, explaining in all-powerful words what an image depicted and why it might be news. Caption writing, as practiced by the services covered in this book, had a style of its own and we have included the original captions, where extant, with the images. They tended to be far from dry, written with plenty of color and flurry, in the parlance of the day. In this they were like the stories the services released, particularly the Hearst organization, tending toward the sensational.

The news services officially moved into the picture business between 1910 and 1928, although many had actually distributed images prior to then. Hearst was the first to formally step in. The International News Photo division of his International News Service officially began in 1910 along with a newsreel film branch. Scripps's Newspaper Enterprise

Association, which had distributed photographs as early as 1903, of the Wright Brothers' first powered aicraft in air, founded Acme Newspictures in 1923 in partnership with the United Press. Hearst and Scripps weren't the only ones doing it: the *New York Times* created its Wide World Photo service in 1919. The AP started its News Photo Service last, in 1928. Yet another, the Pacific and Atlantic News Service, was started as a joint venture between the *Chicago Tribune* and the *New York Daily News*, in 1925.

Why did the news photo services appear when they did? First off, the number of papers with the ability to print pictures was large enough to warrant the risk. Also, newspapers were being threatened (or, at least they thought they were) by radio news, as it placed news stories directly into a reader's home much faster than a paper ever could. Radio, however, could not run pictures, so the papers began exploiting this difference any way they could in an attempt to save their share of the news market. As a result, the services were working furiously to accommodate the papers with pictures.

There was also the sudden success of the tabloid papers in the 1920s, in particular the *New York Daily News*. Begun in 1919, it seriously upped the ante for the use of pictures by newspapers. Started by the owners of the *Chicago Tribune*, the *Daily News* was heavy with photographs, candid, scandalous, and otherwise (an oft-cited example is the shot of Ruth Snyder strapped in the electric chair that ran on the front page in 1928). The *Daily News* proved to be very, very popular. Its success demonstrated that using pictures on a daily basis could be profitable, and the demand for pictures grew. On a side note, Hearst started his own tabloid to compete directly with the *Daily News*, the *New York Daily Mirror*, in 1924.

International News Photos logo, c. 1945.
United Press International Newspictures logo, c. 1965.
Acme Newspictures logo, c. 1940.

Another influencing factor was speed. By the 1920s image distribution networks and times were improving. In 1910, it took three and a half days by train to get pictures from one coast to the other. By the 1920s airmail could get them there in twenty-four hours. But that still wasn't fast enough, as the written stories always hit first. What was desired was a method to send images by wire or radio, just as text had been sent since the 1850s.

By the 1920s it seemed that at long last a practical means of regularly transmitting images by wire had arrived. Scripps's Newspaper Enterprise Association attempted wire as well as wire*less* (radio) transmission of images as early as 1924, but it turned out to be unfeasible. Theirs was certainly not the first attempt. In fact, wire transmission of images had been desired since the very days the telegraph appeared. The first facsimile (as in "fax") machine, designed to electrically transmit copies of documents, was patented in 1843, but a working model was apparently never built. A later design was demonstrated in

1851 at the World's Fair in London. Invented by Frederick Bakewell, it utilized rotating cylinders on both the transmitting and receiving ends, just like those used in the 1930s and beyond, into the 1970s. A machine specifically designed to transmit line drawings was unveiled in 1898, and was used to transmit illustrations of the Philippine-American War between the *New York Herald* and the *Chicago Times-Herald* in 1899. The first machine designed specifically for the transmission of photographs, invented in Germany by Arthur Korn, was demonstrated in 1904. By 1922, he was able to send an image from Rome to Berlin and from there on to Maine, in forty minutes. But the practical implementation of wirephoto, as it came to be known, wouldn't happen until 1935. The basic technology was there, but the infrastructure was not.

In 1925, American Telephone and Telegraph wired photos of Calvin Coolidge's presidential inauguration along its system of phone lines. According to a 1934 article in *New Outlook* magazine, "The inventors and developers of the new gadget . . .

went to the trouble of 'shooing all the little birdies off the wires' in the national circuit that day. It is a fact that no operations of any kind were permitted on the lines of the coast-to-coast hook-up during the transmission of the pictures and that all engineering work straight across the country was suspended." The amount of effort it took to electronically convey a photo was extensive, not to mention expensive: there must have been a fair amount of dollars lost to the temporary suspension of all long-distance services across America for the time it took to transmit the Coolidge image. AT&T had used the inauguration transmission to herald their new Public Telegraph service. The service was ostensibly designed to allow businesses to fax documents, but there weren't many takers. And although the idea was sound, AT&T hadn't realized what it would actually take in terms of equipment and cost, and it would take ten more years of engineering and financial finagling before everything was in place.

Ironically, it was the stodgy, old, and, as one newspaper editor put it

in 1936, "the too serene and bland" AP that really got photo transmission by wire going, thanks mostly to a forward-thinking general manager named Kent Cooper, who had worked at the AP since 1927. He had spent many years trying to convince AP members to use images. In 1933, two years before the service was operational, AT&T shopped its revamped but still very expensive system to the various picture agencies. The AP was the only one to bite, but only after Cooper managed to convince AT&T to set qualifications for users of the pending wire service that only the AP had any hope of guaranteeing. Monopoly, again. Cooper was also able to get enough AP members on board to underwrite the five million dollar project. AP Wirephoto officially began service on January 1, 1935, exclusively for AP members only, and just twenty-four had signed on.

Prior to the unveiling of Wirephoto, the Scripps and Hearst organizations as well as the *New York Time's* Wide World service had all begun development of their own systems. Unlike Wirephoto, which required the

use of specially dedicated phone lines (costing $56 a mile annually) and expensive, massive machinery, the new systems used standard long-distance phone lines and were portable, allowing transmission from a standard telephone. These new systems were INP's Soundphoto, NEA-Acme's Telephoto, and Wide World's Wired Photo, all of which were on line by April 1936, scarcely a year after AP Wirephoto.

In July 1937 *Popular Photography* magazine ran an article called "The Inside Workings of a National News Photo Service," which gave an extremely detailed look into how these services functioned at a crucial point in their history, just after wire service came along. The article is specifically about Scripps's Acme Newspictures service, but the general information could apply to all the services, as they were all structured very much the same. The Acme general manager is quoted in the article as saying how news services are about "Speed, accuracy and preparedness," being modeled on the newspaper office and, "edited as a newspaper is. . . . But

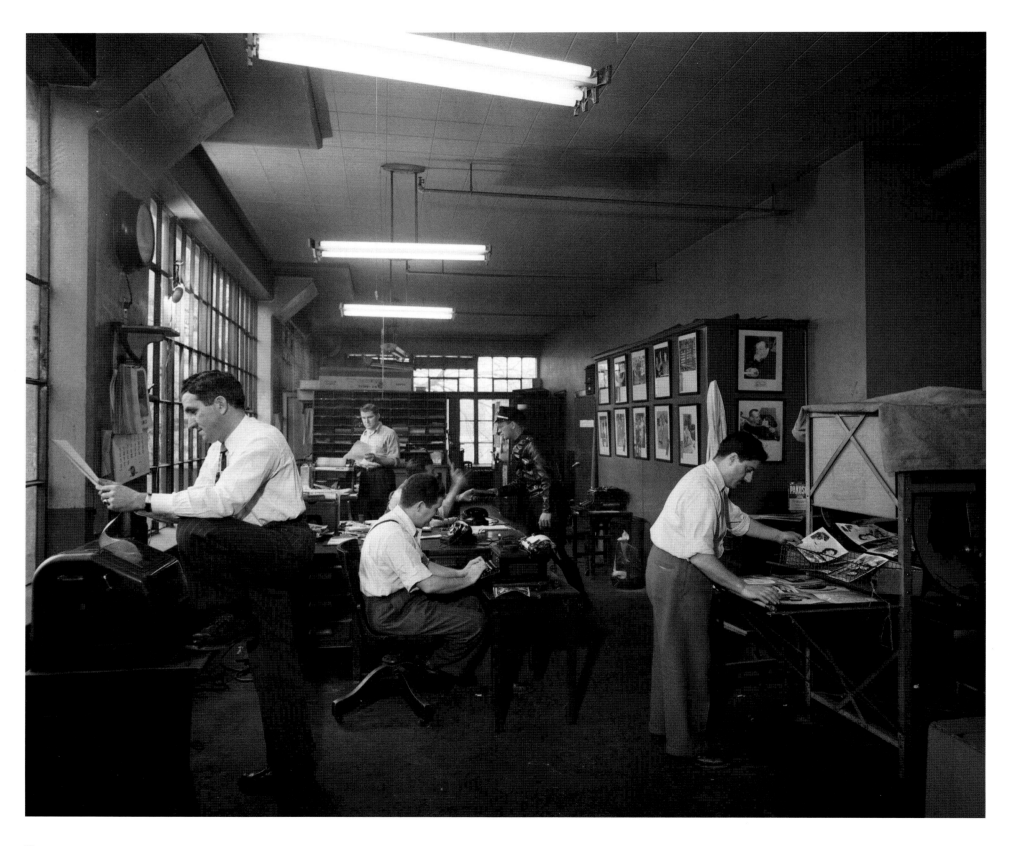

instead of using words, you use pictures." As at a newspaper, editors swept all available sources for potential stories, reading the papers, getting "hunches [and] hot tips" from the police and elsewhere. They also subscribed to the text newsfeed services like the UP to get stories. Once it was decided what should be covered, the agency sent word to any of its "thousands" of correspondents (i.e., photographers) around the world, ninety-eight of whom were in America. The New York office alone employed twelve staff photographers plus two "roving" freelancers. The editors, by the way, didn't choose every story, as photographers in the field often suggested stories to be shot. The agency received an average of four hundred photographs a day from around the world. "Backend" staff included caption writers, picture filers, and darkroom workers. The routine went something like this: editors would come up with a story to be covered and photographers would be sent to the scene. If and when the shots were had, the photographer would get them to the Acme office via foot, car, air express, radio, "fast ship," or even dirigible. Once in house, an image, if accepted by the editor, would be assigned a unique number and captioned. Darkroom staff would immediately create a print of the image for the wire transmitter, as well as multiple copies for non-wire clients and "the morgue," as the in-house picture files were called. Then, "each picture is card-indexed, listed and cross-indexed," facilitating the quick locating of a shot should it become news again. The photographic negative would be filed along with its caption in numerical order alongside other shots as they came in.

Only forty-eight papers received Acme's direct print service, which was exclusively for those that had their own photo departments. These would be the papers able to utilize wire pictures. The article goes on to describe the actual wire transmission machine in detail: "When pictures must be transmitted quickly . . . they are sent out by the Telephoto machine, termed the Record-o-phone, which is attached to telephone lines. An induction coil runs into the machine which is approximately six feet high, with a flat face, similar to a clock. . . . The photograph is placed on a sender which resembles a roller. By electrical adjustment, the sending apparatus is synchronized with the receiving machine. A dual wavy green line is apparent when the tone of both machines is properly set. And thus three minutes and twenty seconds after the picture is put on the roller, it is received in cities hundreds, or in some cases thousands, of miles away."

News photos hit it big in the 1930s. The news photo wire services were solidly in place by then, servicing clients with images at an astounding rate. By March 1936 AP Wirephoto was averaging sixty-five images transmitted every day. By 1937, Acme brought in around one hundred twenty-five images a day from various photographers around the world, and serviced close to eight hundred fifty papers. Tabloid papers like the *New York Daily News* were using two thousand five hundred images a month by the 1930s, according to its managing editor. It was obvious that images had established a place as viable and popular conveyers of news information, even though arguments questioning the values of images as news would continue for a few years more. The wire's role in all this was that it allowed images to travel at the speed of text, reaching news consumers at the same moment. Picture news had been around since the 1850s but was never as "fresh" as written news until the

1930s and the wire. The wire essentially eliminated the last technical barrier against images as news.

Drawing Numbers
in Nation's Draft Lottery

JUNE 20, 1917
PHOTOGRAPHER: UNKNOWN

The huge blackboard that told the story
set up in the room where the
lottery took place.

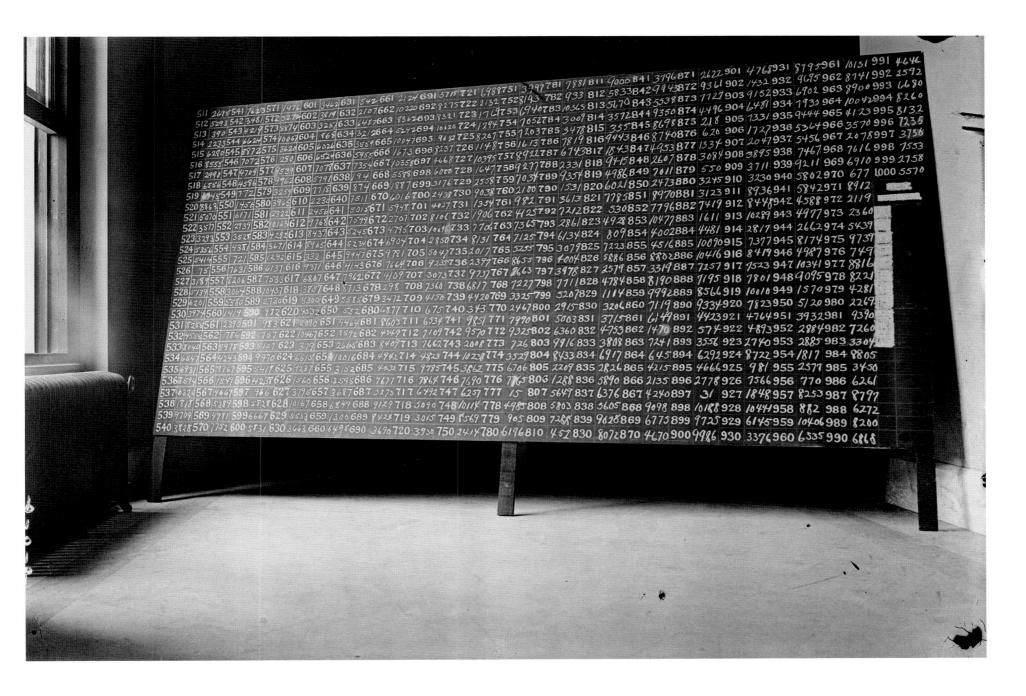

Third Game
World Series at Ebbets Field
Brooklyn Nationals-vs-Red Sox

OCTOBER 10, 1916
PHOTOGRAPHER: UNKNOWN
BROOKLYN, NEW YORK

Scene at Ebbets Field showing crowds on line
at 6:00 A.M. waiting for gates to open.

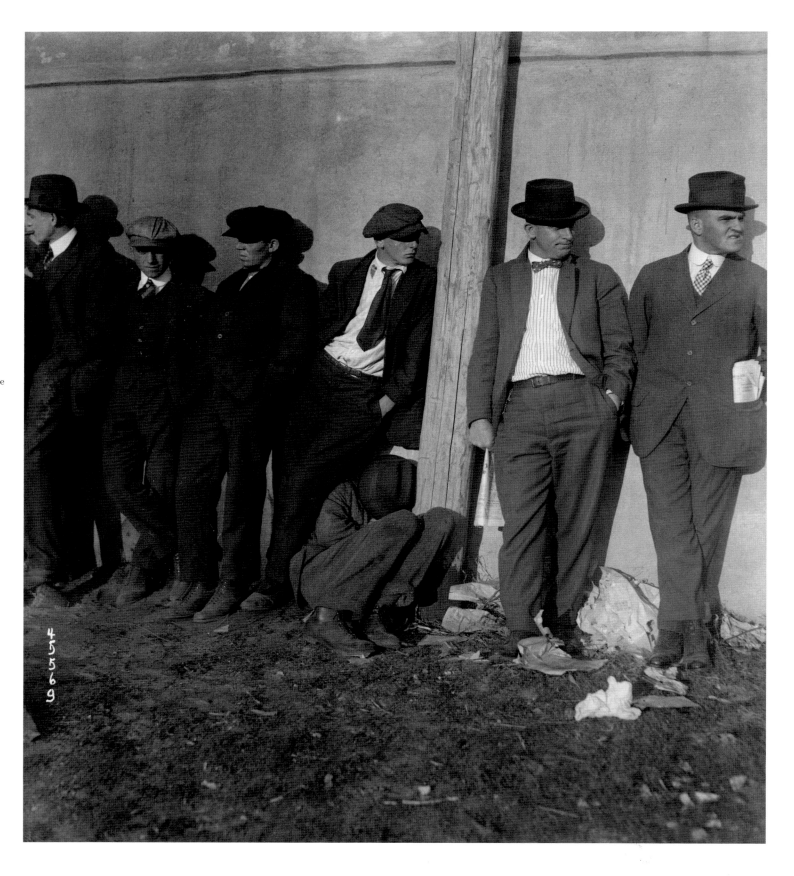

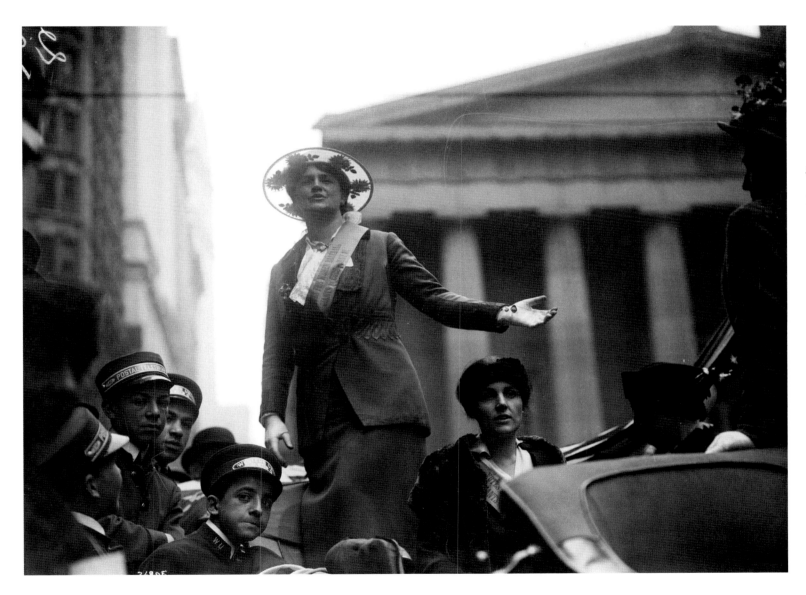

Suffragettes Invade Wall
and Broad Streets to Sell Tickets to
the Baseball Game that is to be
Played by the New York Giants and
Chicago Cubs at the Polo Grounds
on May 18 for the Benefit
of the Suffrage Cause

APRIL 28, 1915
PHOTOGRAPHER: UNKNOWN
NEW YORK, NEW YORK

Mrs. James Lees Laidlaw delivering
speech on cause.

Society Equestrians on the Bridal Path in Central Park

APRIL 1, 1915
PHOTOGRAPHER: UNKNOWN
NEW YORK, NEW YORK

Mrs. John Jacob Astor.

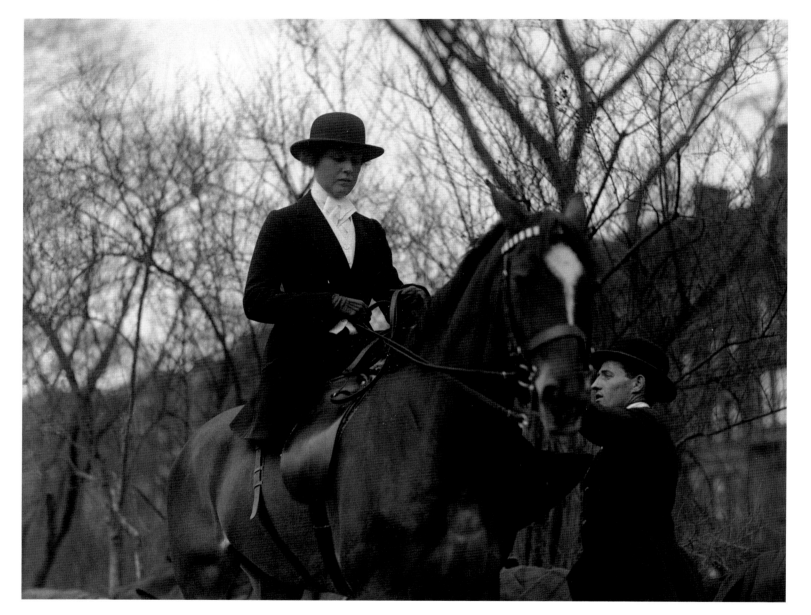

U.S. Marines Sail for Haiti

JULY 31, 1915
PHOTOGRAPHER: UNKNOWN
PHILADELPHIA, PENNSYLVANIA

Marines boarding the U.S.S. *Connecticut* at League Island Navy Yard, Philadelphia, when 500 marines sailed for Port-au-Prince, Haiti, to aid Admiral Caperton's men in disarming the unruly natives.

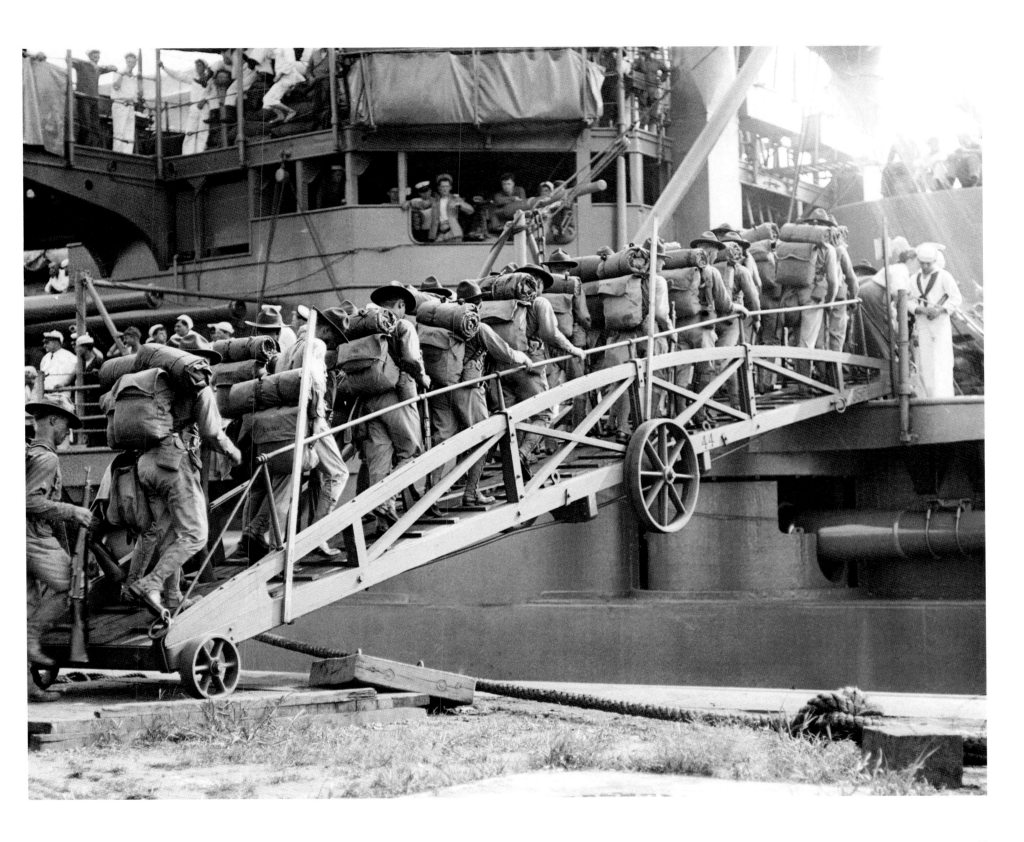

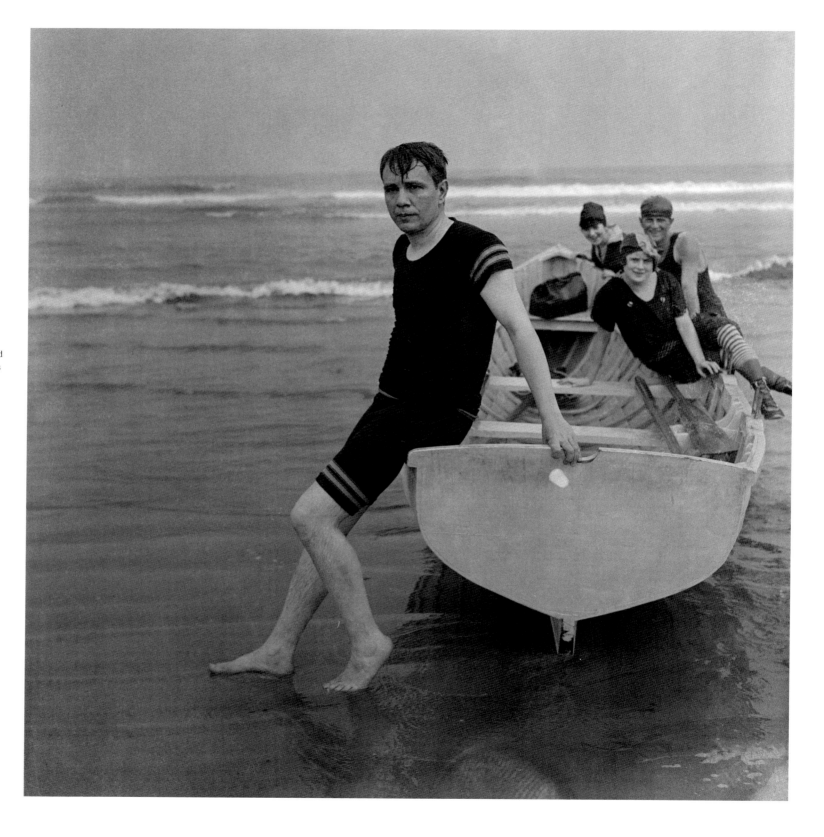

Thaw Frolics in the Ocean on His First Day of Freedom

JULY 17, 1915
PHOTOGRAPHER: UNKNOWN
ATLANTIC CITY, NEW JERSEY

This photograph of Harry K. Thaw was made at Atlantic City, the day after he had been declared sane by Justice Hendricks and a jury in the Supreme Court of New York. It shows the slayer of Stanford White enjoying his first day of freedom at Atlantic City, where he spent several hours on the beach and in the surf.

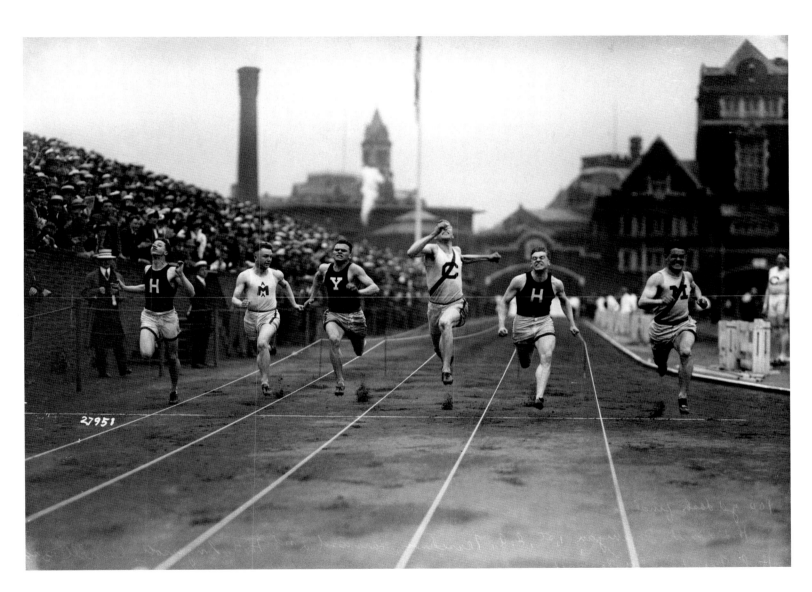

100 Yd. Dash Final

APRIL 29, 1915
PHOTOGRAPHER: UNKNOWN

H. L. Smith, Michigan, 1st; E. A. Teaschner,
Harvard, 2d; H. H. Ingersoll, Cornell,
3d; H. I. Treadway, Yale, 4th.

The Boston Braves in
Spring Training at Macon Georgia

MARCH 5, 1915
PHOTOGRAPHER: UNKNOWN
MACON, GEORGIA

Rabbit Maranville, shortstop.

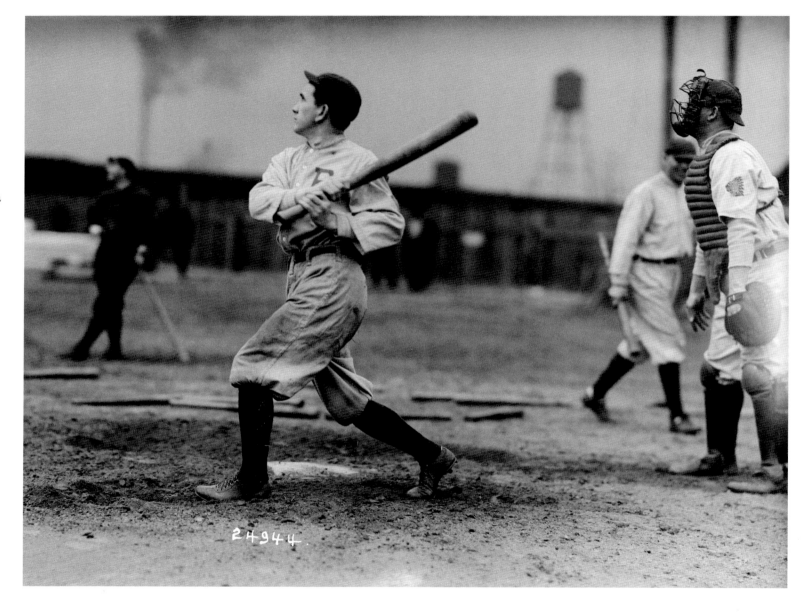

OCTOBER 30, 1914
PHOTOGRAPHER: UNKNOWN
NEW YORK, NEW YORK

Salvation Army lassies making up
bandages for the Red Cross Hospitals
in Europe. Photo made at New York
Salvation Army Headquarters.

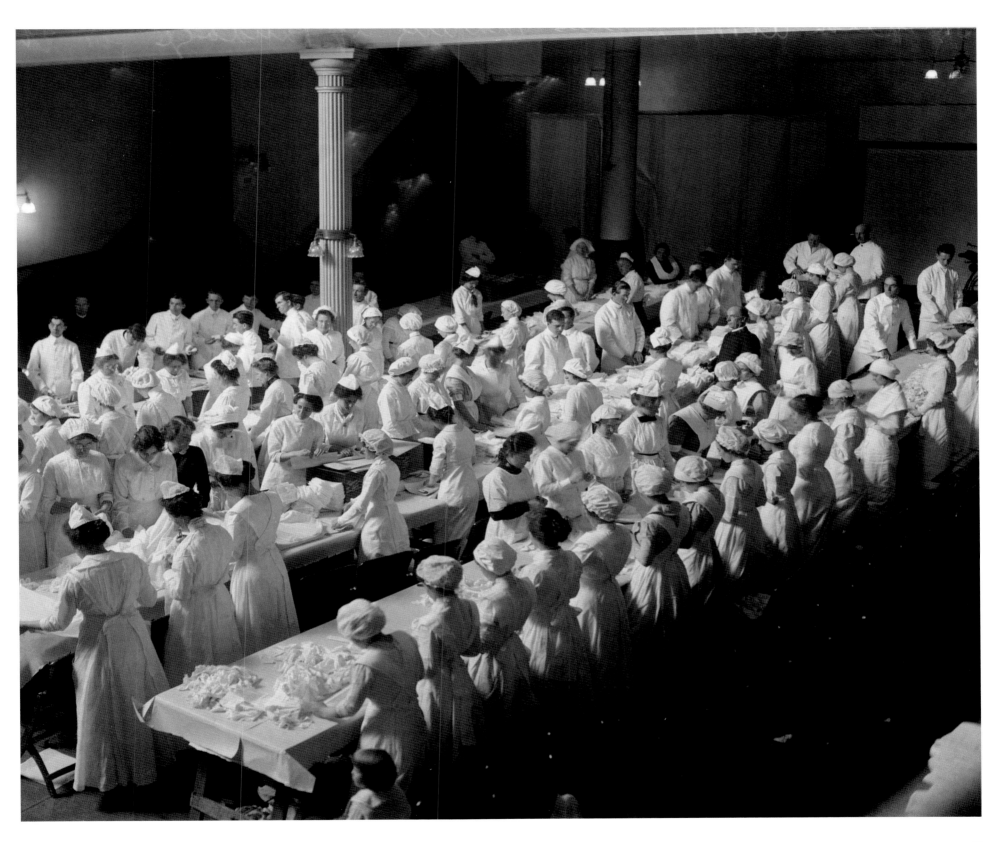

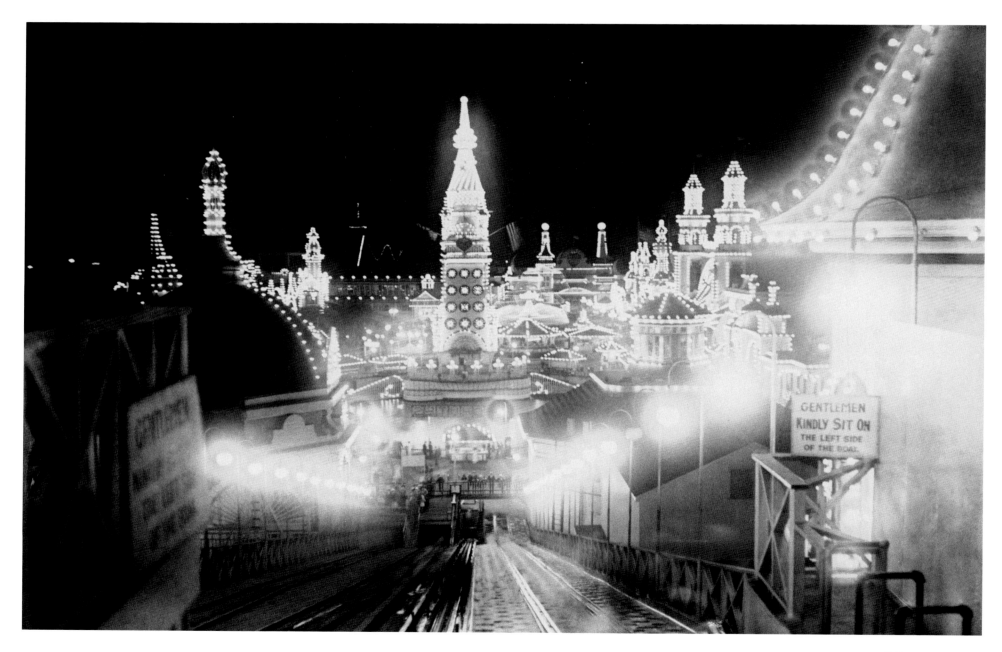

1918
PHOTOGRAPHER: UNKNOWN
CONEY ISLAND, NEW YORK

Coney Island illuminated.

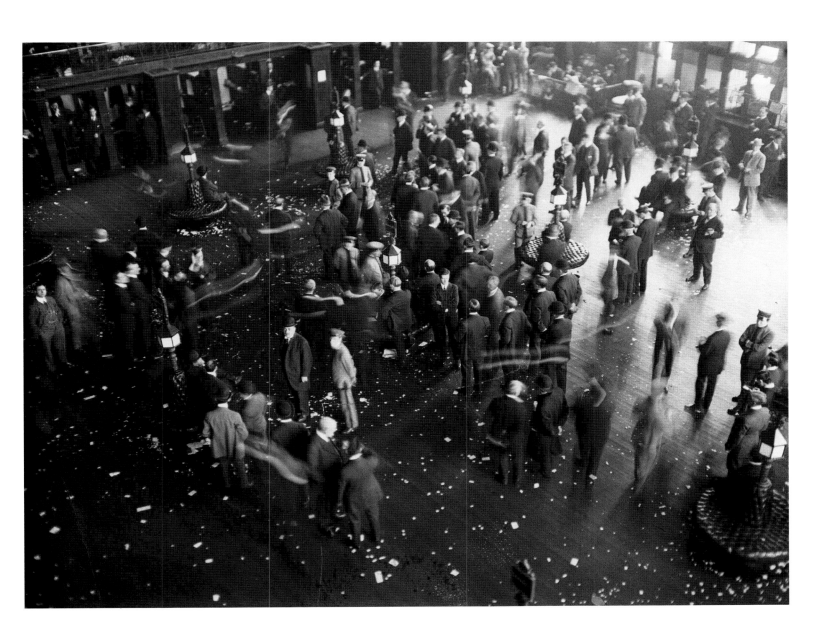

C. 1914
PHOTOGRAPHER: UNKNOWN

Workers on the floor
of an unidentified exchange.

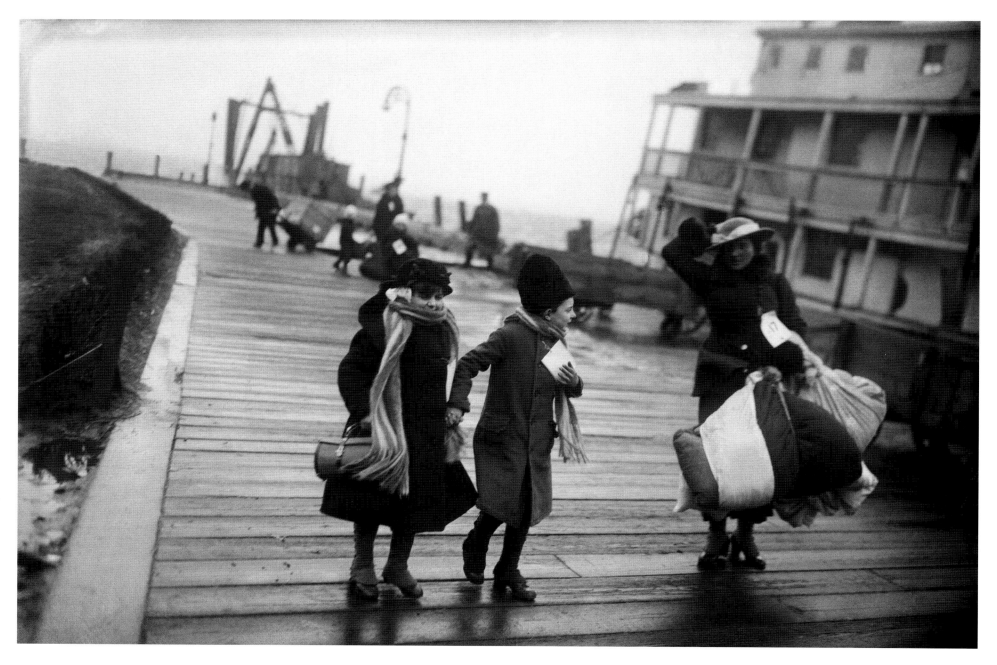

JANUARY 4, 1917
PHOTOGRAPHER: UNKNOWN
ELLIS ISLAND, NEW YORK

Belgian refugees at Ellis Island.

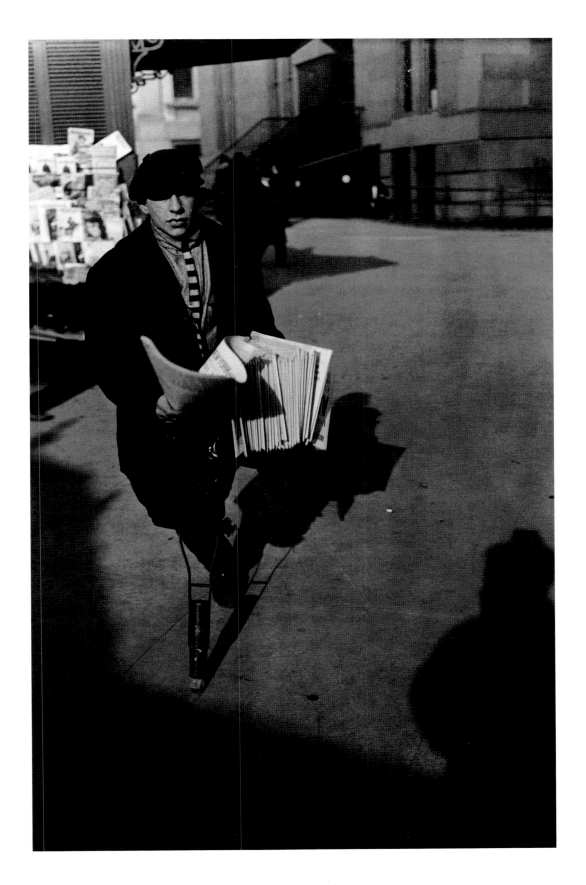

JANUARY 1, 1916
PHOTOGRAPHER: UNKNOWN
NEW YORK, NEW YORK

Newsboy with wooden leg running
to make sale.

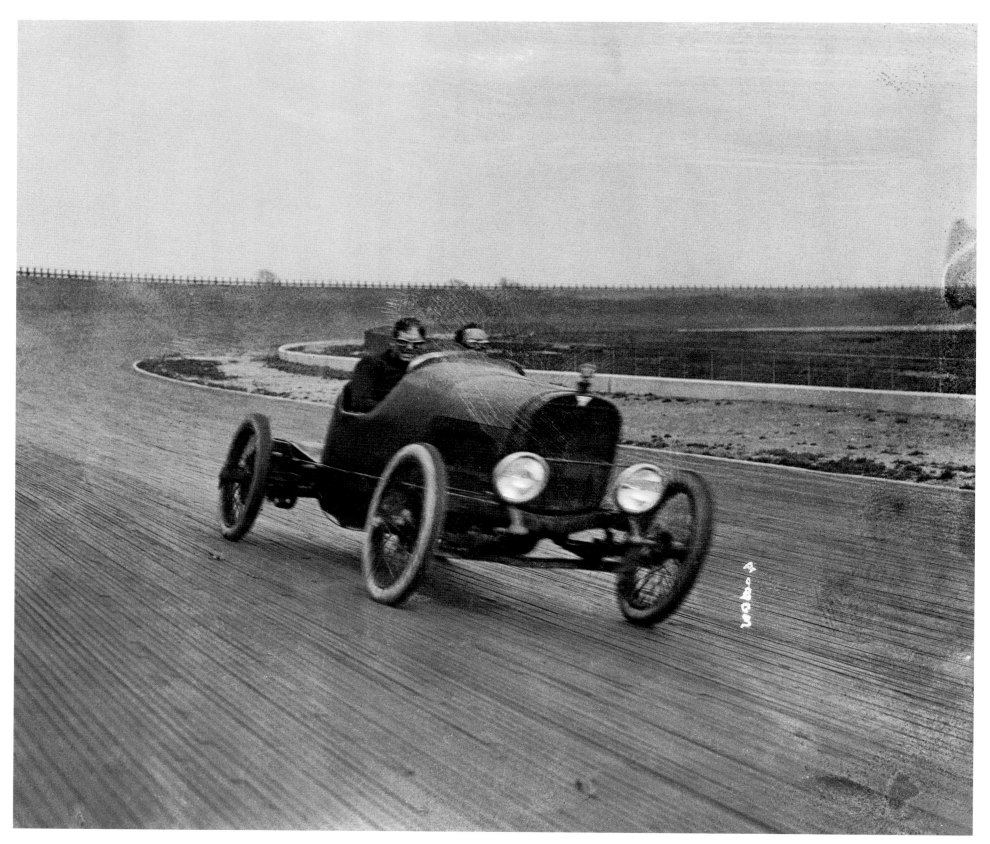

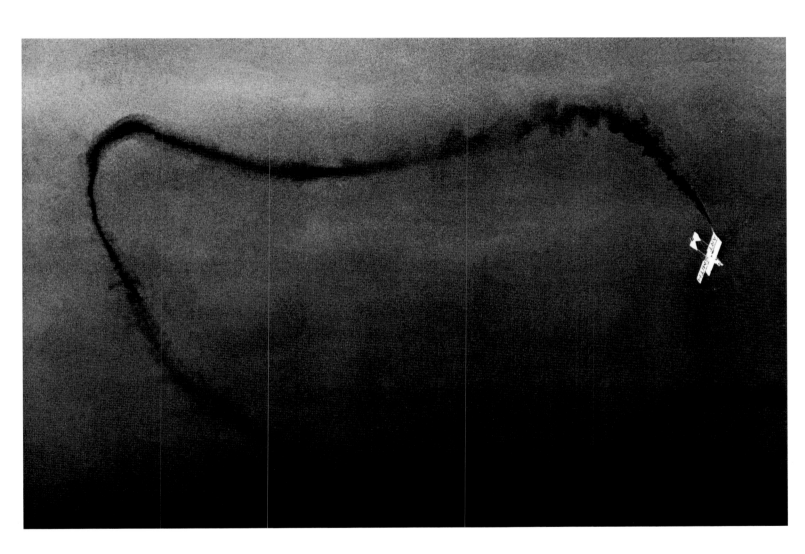

Art Smith in Death-Defying Flight

AUGUST 5, 1915
PHOTOGRAPHER: UNKNOWN
SAN FRANCISCO, CALIFORNIA

Remarkable flight of Art Smith, at
the Panama-Pacific Exposition at San
Francisco, where this daring young
aviator, in what he calls his "flight of aerial
insanity," is shown flying upside down.
The long queue of smoke from his cylin-
ders and some smoke pots carried on his
machine show trail followed by the
aviator during this remarkable exhibition.

MAY 2, 1916
PHOTOGRAPHER: UNKNOWN
BROOKLYN, NEW YORK

Ralph Mulford, in his Hudson "Super 6" pho-
tographed just as he broke the world's 24-hour
motor record by covering 1,819 miles.

1914
PHOTOGRAPHER: UNKNOWN
NEWPORT, RHODE ISLAND

Photo shows Mrs. Robert Goelet, Jr., having
stepped from a carriage, about to take the
leash of her small dog from the driver.

SEPTEMBER 3, 1918
PHOTOGRAPHER: UNKNOWN
NEW YORK, NEW YORK

Taking draft slackers into 69th Street Armory.

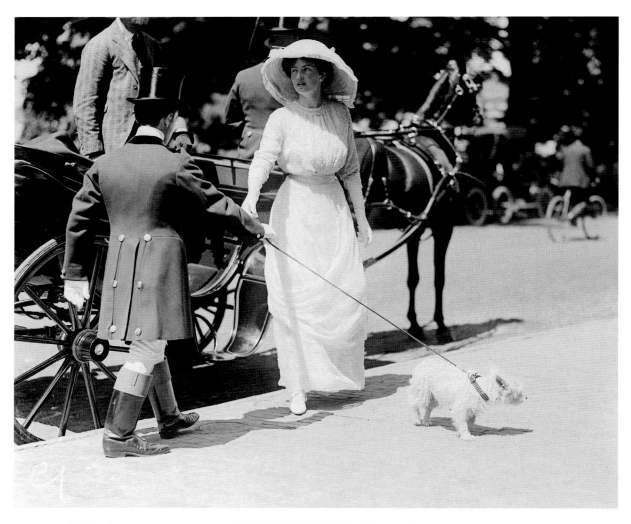

Nationwide War Being Waged Against Infantile Paralysis as Thousands of Children are Inflicted

JULY 1916
PHOTOGRAPHER: UNKNOWN
USA

This photograph shows a Mother carrying her infant stricken with the dread disease to an ambulance waiting to take it to a hospital.

DECEMBER 1, 1918
PHOTOGRAPHER: UNKNOWN
NEW YORK, NEW YORK

Troops returning on the *Lapland*.

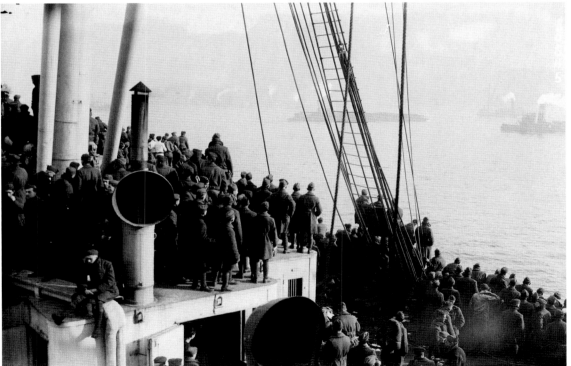

JULY 25, 1920
PHOTOGRAPHER: UNKNOWN
SAN FRANCISCO, CALIFORNIA

Japanese families, men, children, and picture brides aboard liner *Shinyu Maru* arrive in Frisco.

The Boston "Braves" at Boston

SEPTEMBER 14, 1914
PHOTOGRAPHER: UNKNOWN
BOSTON, MASSACHUSETTS

Larry Gilbert, outfield.

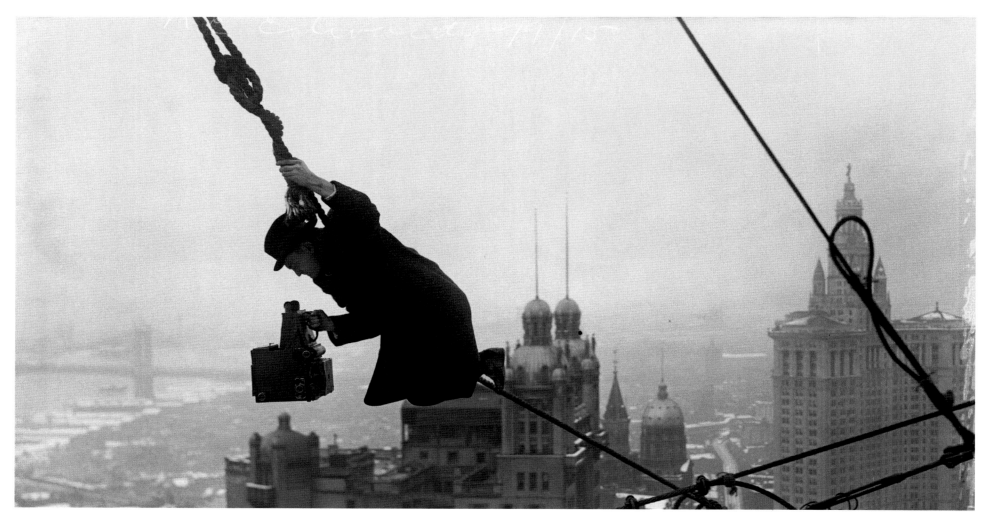

"Dare-Devil" Photography
Atop the New Western Union
Building, Fulton St., by Hearst-
Selig Photographers

MARCH 7, 1915
PHOTOGRAPHER: UNKNOWN
NEW YORK, NEW YORK

Photographer (N.E. Edwards) on rope.

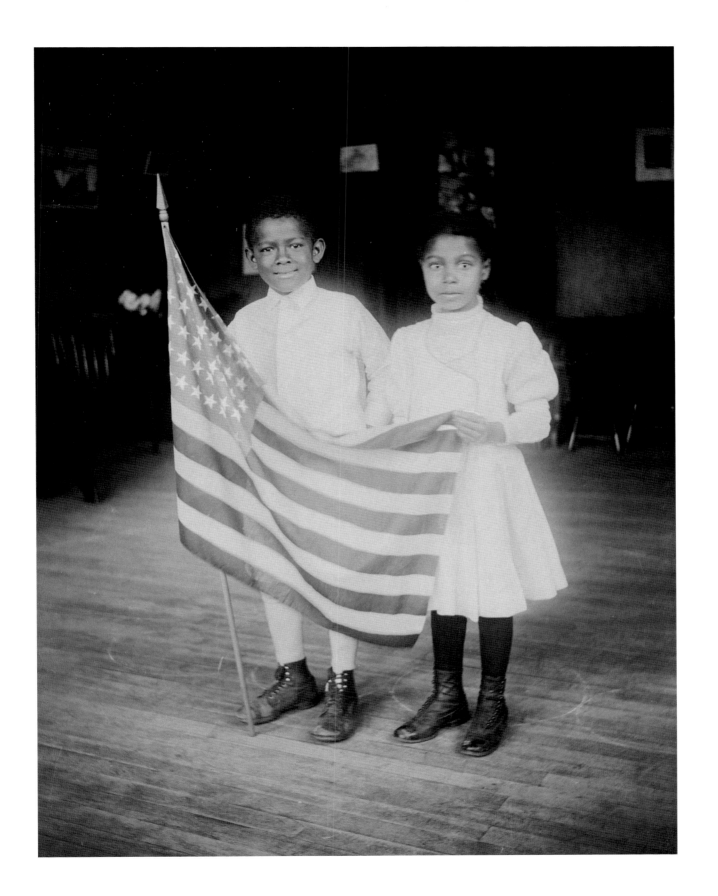

Calendar Subjects

AUGUST 11, 1915
PHOTOGRAPHER: UNKNOWN

My Flag.

41

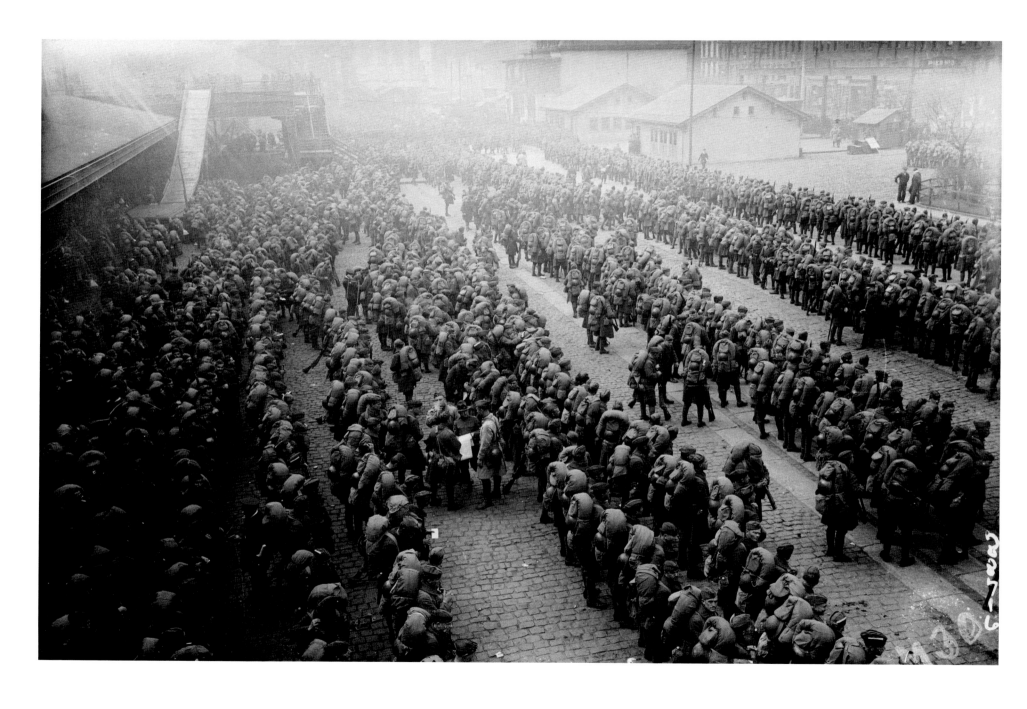

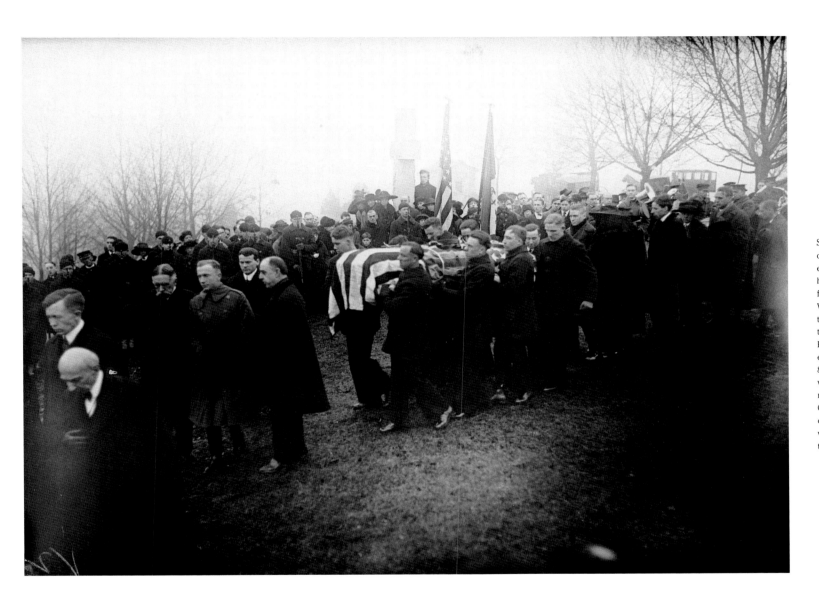

FEBRUARY 22, 1920
PHOTOGRAPHER: UNKNOWN
WASHINGTON, D.C.

Simplest services marked the obsequies of Rear Admiral Robert E. Peary, discoverer of the North Pole whose funeral was held yesterday, Washington's Birthday from the home at 1831 Wyoming Ave., Washington, D.C. The casket draped in the colors and bearing the small U.S. flag that Admiral Peary raised at the North Pole together with his sword, belt and epaulettes was borne from the house by 8 enlisted men of the Navy. The casket was placed on a black draped gun carriage and taken to Arlington National Cemetery near the Capitol. Three troops of cavalry and a battery of field artillery with massed military bands comprised the escort.

Arrival of the SS *America*

APRIL 28, 1919
PHOTOGRAPHER: UNKNOWN

The men of the 308th, the "Lost Battalion" Regiment and the 307th Regiment line up in the street after debarking.

Babe Ruth Undergoes
Operation on Arm

JANUARY 17, 1923
PHOTOGRAPHER: UNKNOWN
NEW YORK, NEW YORK

Babe Ruth, suffering from an ulcerated
arm, was at St. Vincent's hospital to
undergo a minor operation. The Babe's
southpaw is the one affected, and imme-
diately after the operation, Ruth seemed
to be in better condition. He suffered an
infection, just above the wrist of his left
hand, and was advised to have an opera-
tion performed to prevent a possible
spread of the infection. The Bambino
is shown here with his damaged wing
in a sling.

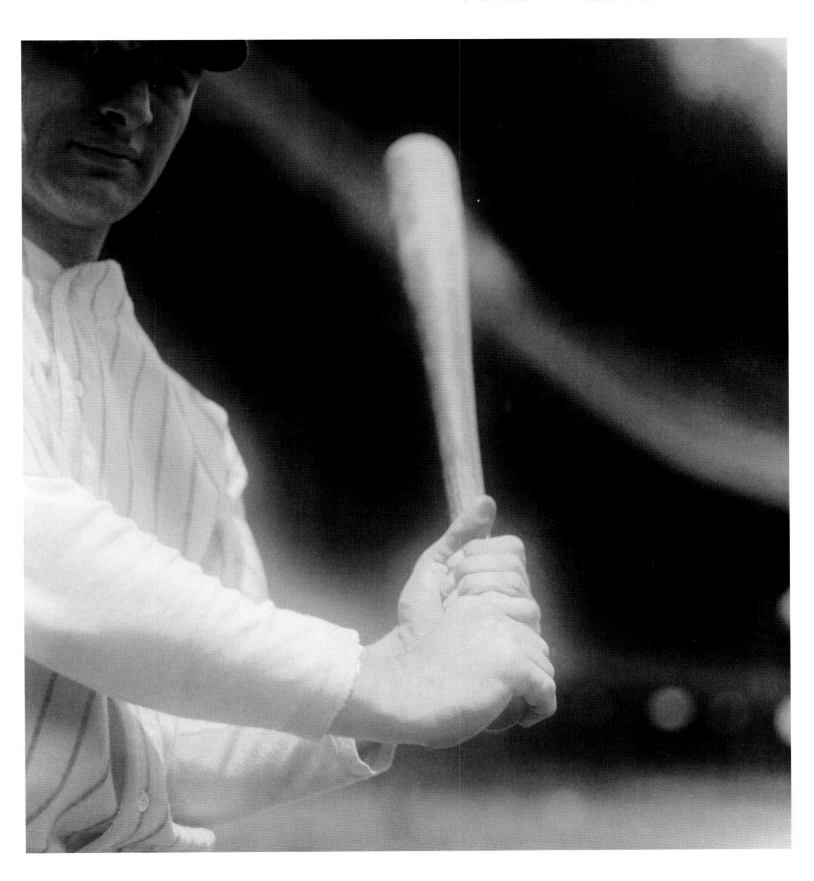

JULY 2, 1929
PHOTOGRAPHER: UNKNOWN

Lou Gehrig, whose 21 home runs make
him the leading home run hitter in the
American League, demonstrates his grip
on the bat as he steps up to the plate.
Gehrig is one of the few natural sluggers
in the big leagues.

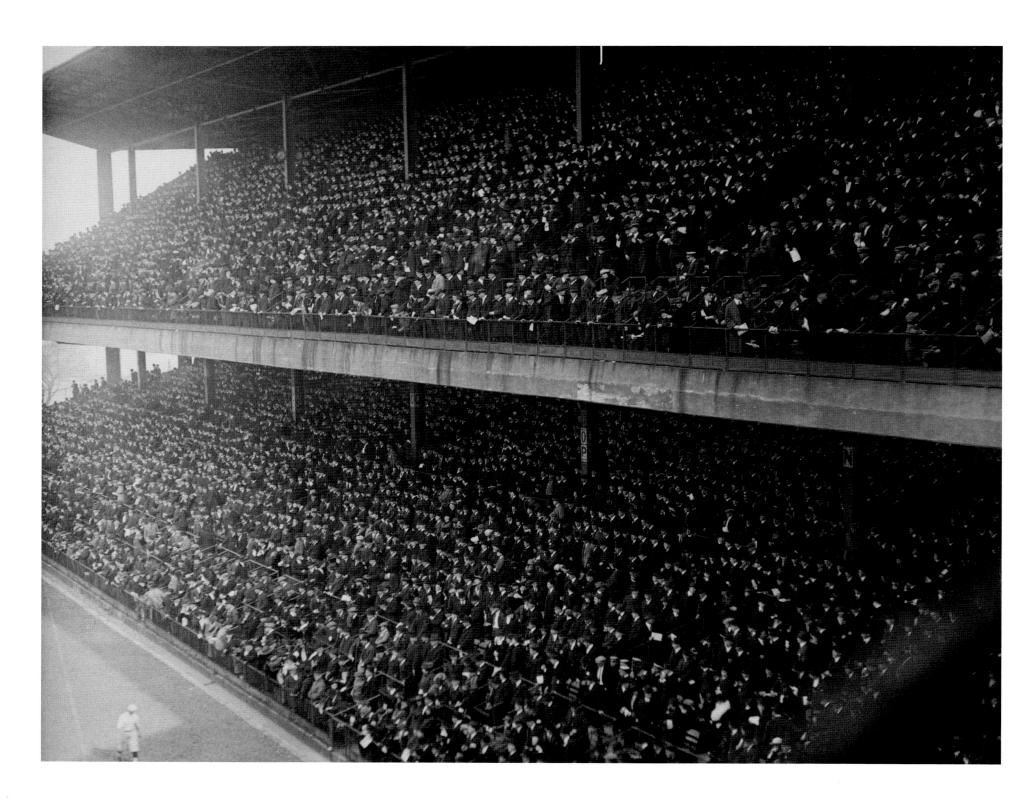

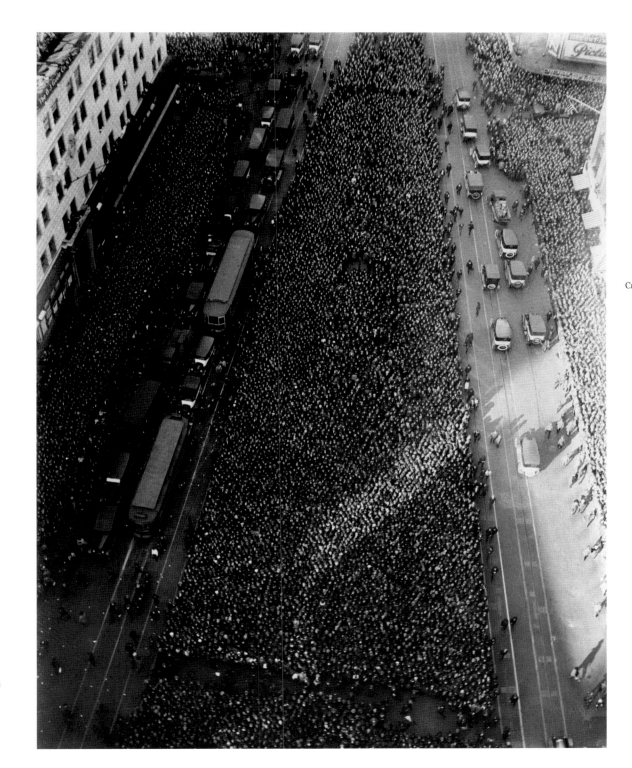

Crowds watching scoreboard at Times Square
during 1921 World Series.

Ebbets Field Crowd at Game

APRIL 18, 1920
PHOTOGRAPHER: UNKNOWN
BROOKLYN, NEW YORK

Brooklyn vs Braves.

This photo shows the Annapolis men
sitting wrapped in blankets on the sidelines
before their classmates.

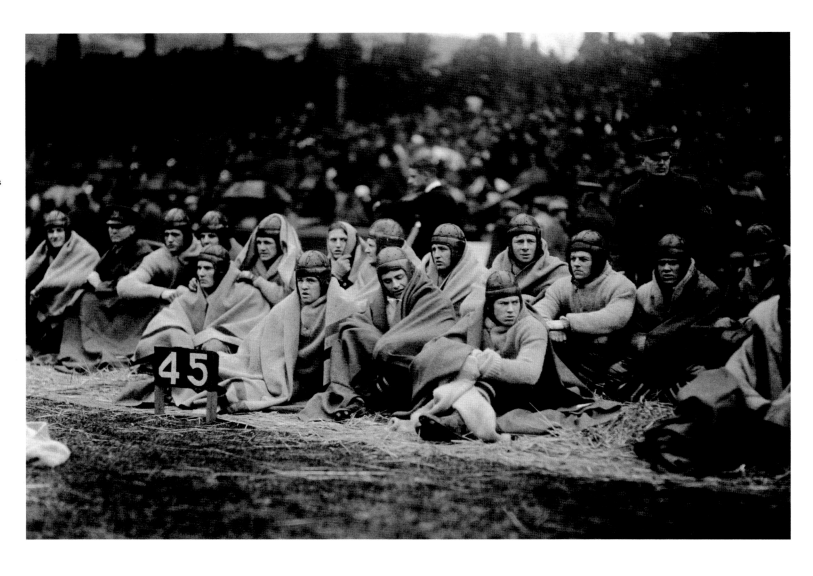

APRIL 4, 1905
PHOTOGRAPHER: UNKNOWN
PALM BEACH, FLORIDA

View of Palm Beach party at house of
Mr. and Mrs. Edward Hutton.

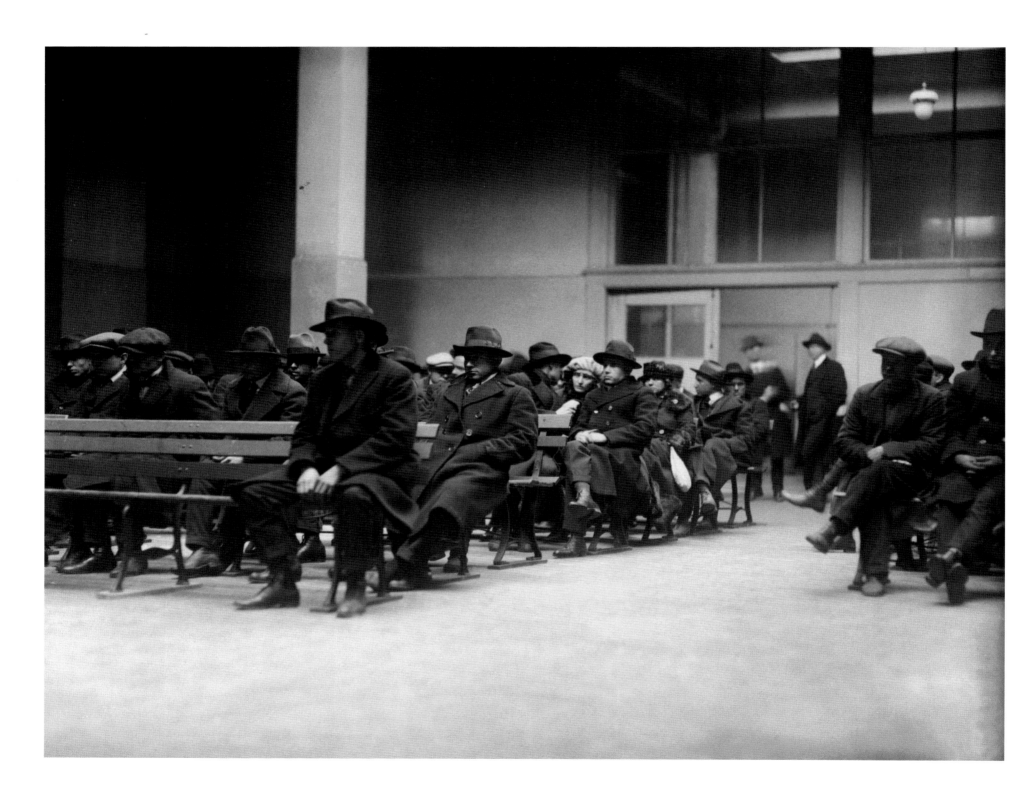

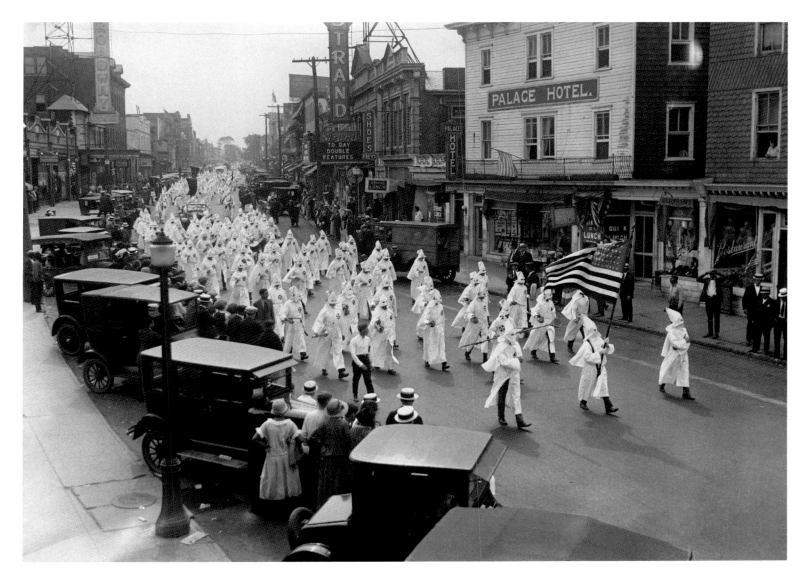

JULY 4, 1924
PHOTOGRAPHER: UNKNOWN
LONG BRANCH, NEW JERSEY

A general view of hooded Klansmen parading
through the streets of Long Branch.

JANUARY 2, 1920
PHOTOGRAPHER: UNKNOWN
NEW YORK, NEW YORK

Sitting in Ellis Island's large reception
room, suspected "reds and radicals" wait to
be sent to wards.

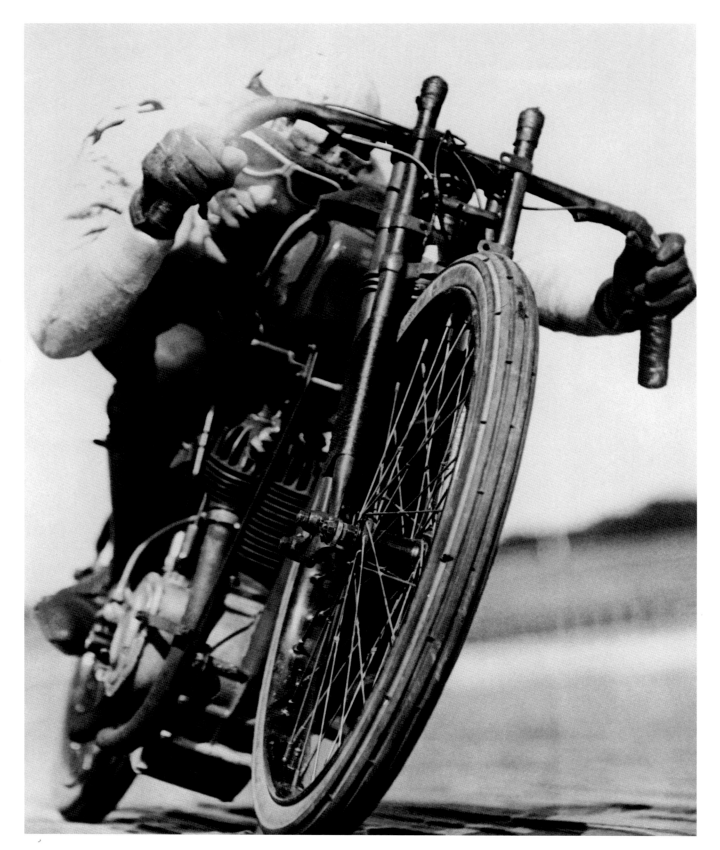

Enthusiasts from all parts of the country witnessed the annual speed race here. Some new speed records were made. Ralph Hepburn encircling the track at the limit of speed on his motorcycle.

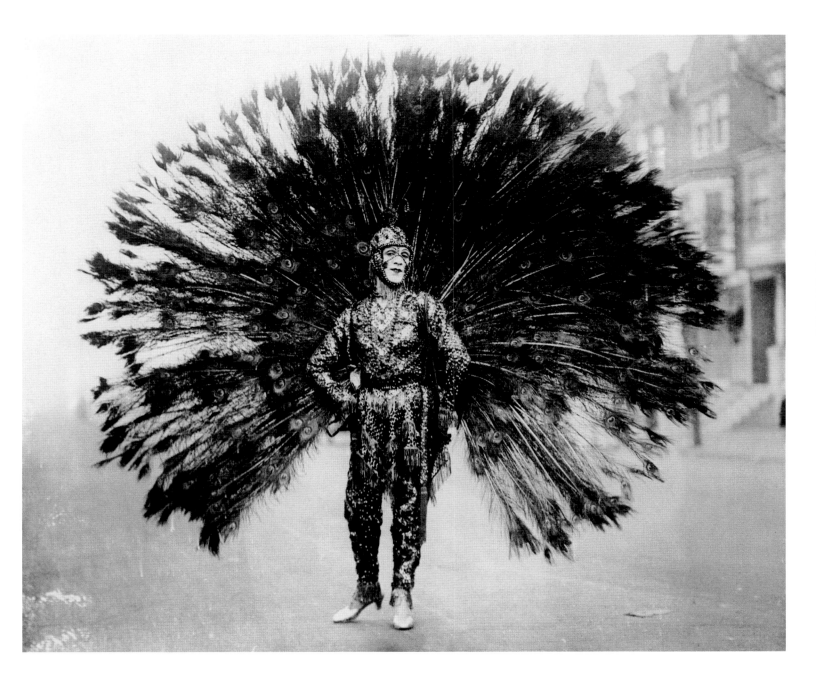

And Then How He Strutted

JANUARY 1, 1926
PHOTOGRAPHER: UNKNOWN
PHILADELPHIA, PENNSYLVANIA

Wearing this gorgeous peacock costume, Francis Patameda, of Philadelphia, was one of the striking figures in the annual Mummers Parade in Philadelphia on New Year's Day, and proved one of the prize winners. Oh boy, how he strutted down Broad Street!

Society at Palm Beach

FEBRUARY 1, 1924
PHOTOGRAPHER: UNKNOWN
PALM BEACH, FLORIDA

Irving Berlin, composer, on the beach.

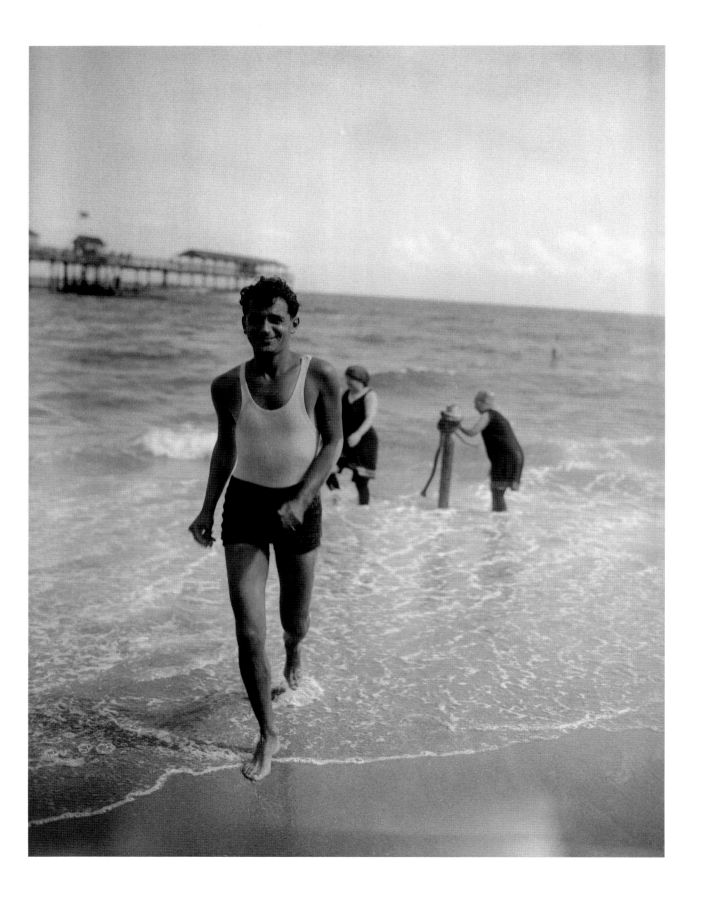

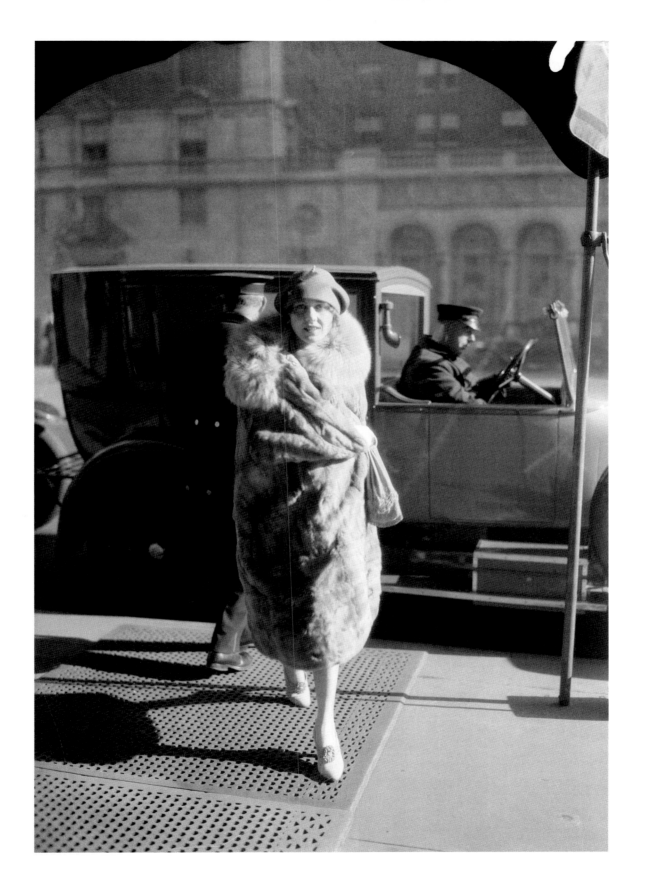

NOVEMBER 18, 1924
PHOTOGRAPHER: UNKNOWN
NEW YORK, NEW YORK

Mrs. Greg Brokaw (Clare Booth)
on Park Avenue.

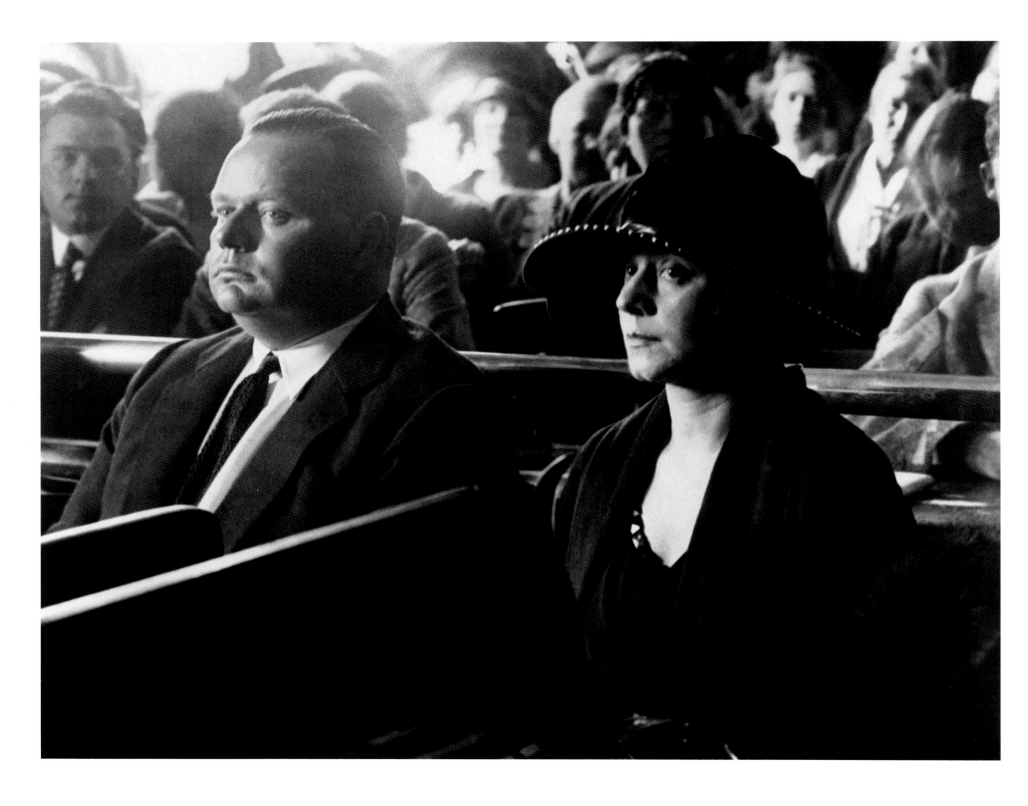

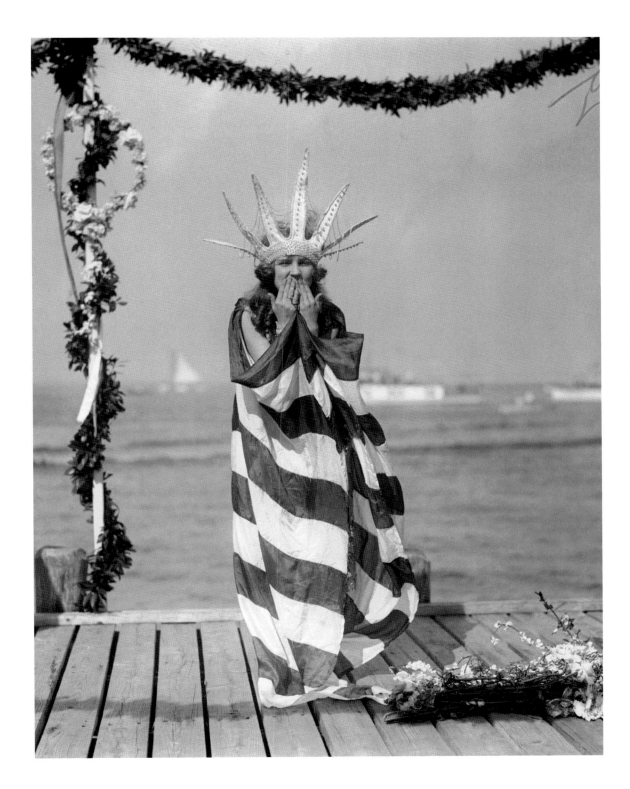

SEPTEMBER 7, 1922
PHOTOGRAPHER: UNKNOWN
ATLANTIC CITY, NEW JERSEY

Miss Margaret Gorman of Washington, D. C., who last year was crowned as "Miss America" Queen of Beauty, in her royal robes. She was pictured as she awaited the arrival of "King Neptune" on his royal barge, marking the opening of the great Pageant of Beauty.

SEPTEMBER 28, 1921
PHOTOGRAPHER: UNKNOWN
LOS ANGELES, CALIFORNIA

Roscoe "Fatty" Arbuckle and Rosene Arbuckle in court.

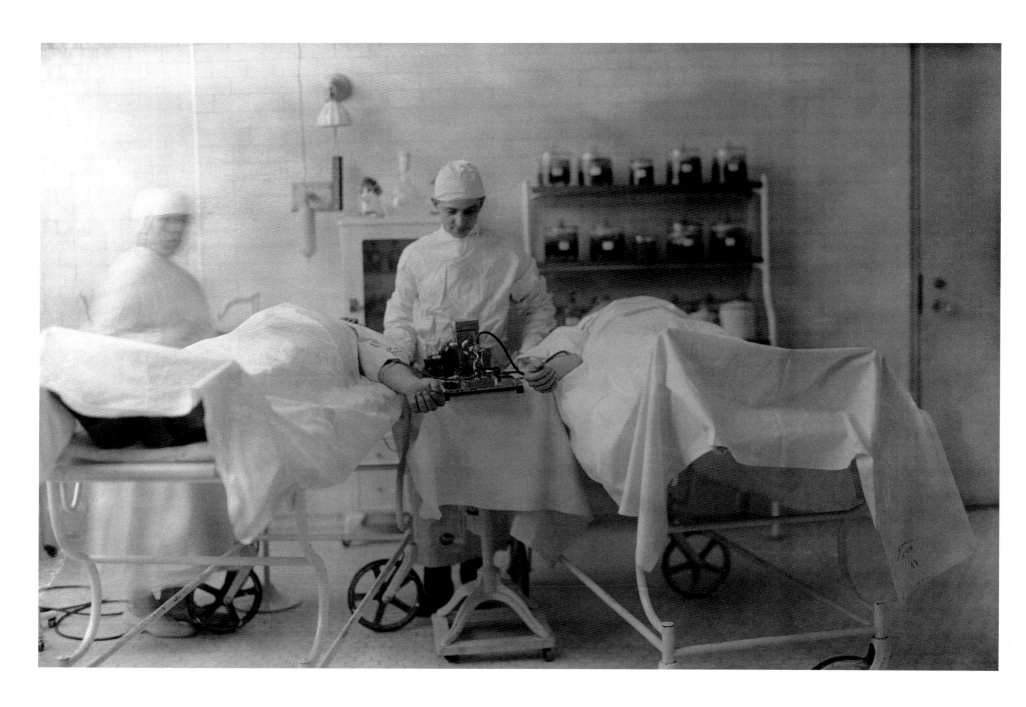

The Prince of Wales at the Polo Games

AUGUST 13, 1924
PHOTOGRAPHER: UNKNOWN
WESTBURY, LONG ISLAND

Action photos of the polo game.

NOVEMBER 3, 1925
PHOTOGRAPHER: UNKNOWN
BROOKLYN, NEW YORK

Greenpoint Hospital astounds
medical world with new method in
transfusion operations.

JANUARY 9, 1924
PHOTOGRAPHER: UNKNOWN
NEW YORK, NEW YORK

With all available deck space fitted up
with desks, cots and classrooms inside
for inclement weather, three ferry boats
are now in operation as schools for the
ever increasing number of school chil-
dren with tuberculosis. The boats, which
are under supervision of the Board of
Education, are also equipped with an
up-to-date kitchen and the children are
fed the noon meal. Photo shows school
children all bundled up in blankets
and Eskimo suits, on the cots taking
breathing exercises.

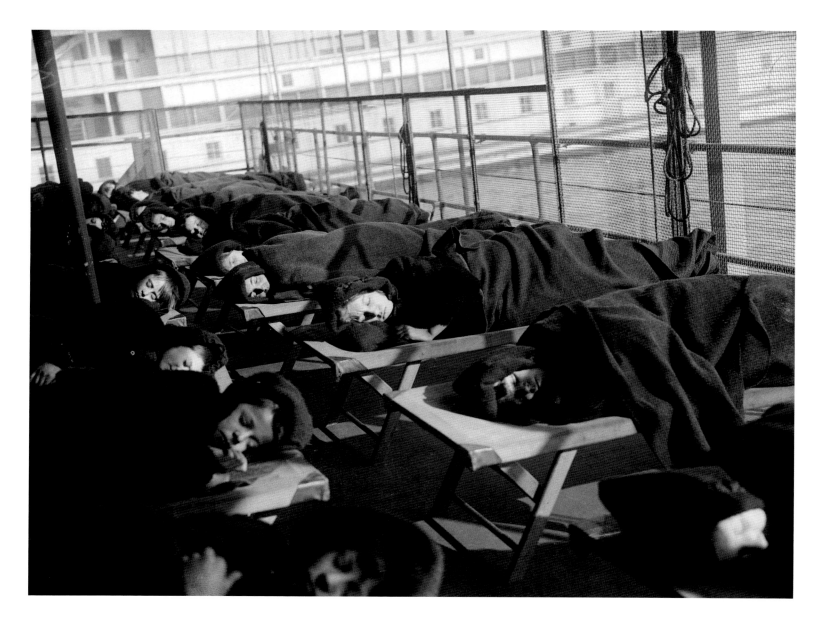

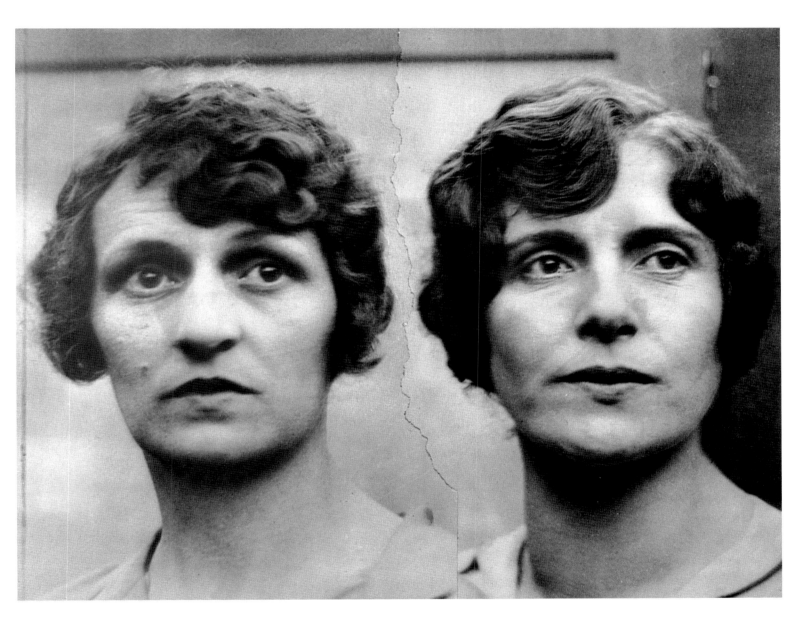

AUGUST 25, 1926
PHOTOGRAPHER: UNKNOWN
LOS ANGELES, CALIFORNIA

Photographs of Aimee Semple McPherson (right) and Mrs. Lorraine Wiseman, sister of "Miss X" and who says she was the one known as Mrs. McIntire at Carmel, California, and she took care of her there every day. Note the marked resemblance in pictures.

APRIL 1924
PHOTOGRAPHER: UNKNOWN
LOS ANGELES, CALIFORNIA

Here's a charming pose of Gilda Gray, America's queen of shimmy shakers, who is in California taking screen tests prior to her appearance on the silver screen. Gilda will very likely shimmy her way to triumph on the screen as she has up on the stage.

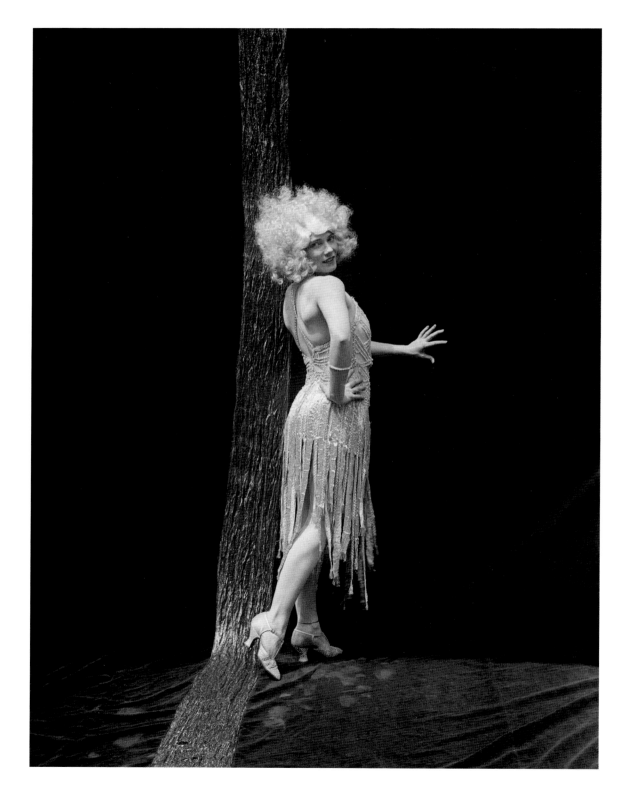

FEBRUARY 20, 1925
PHOTOGRAPHER: UNKNOWN
NEW YORK, NEW YORK

W. C. Fields with Ziegfeld Follies girls.

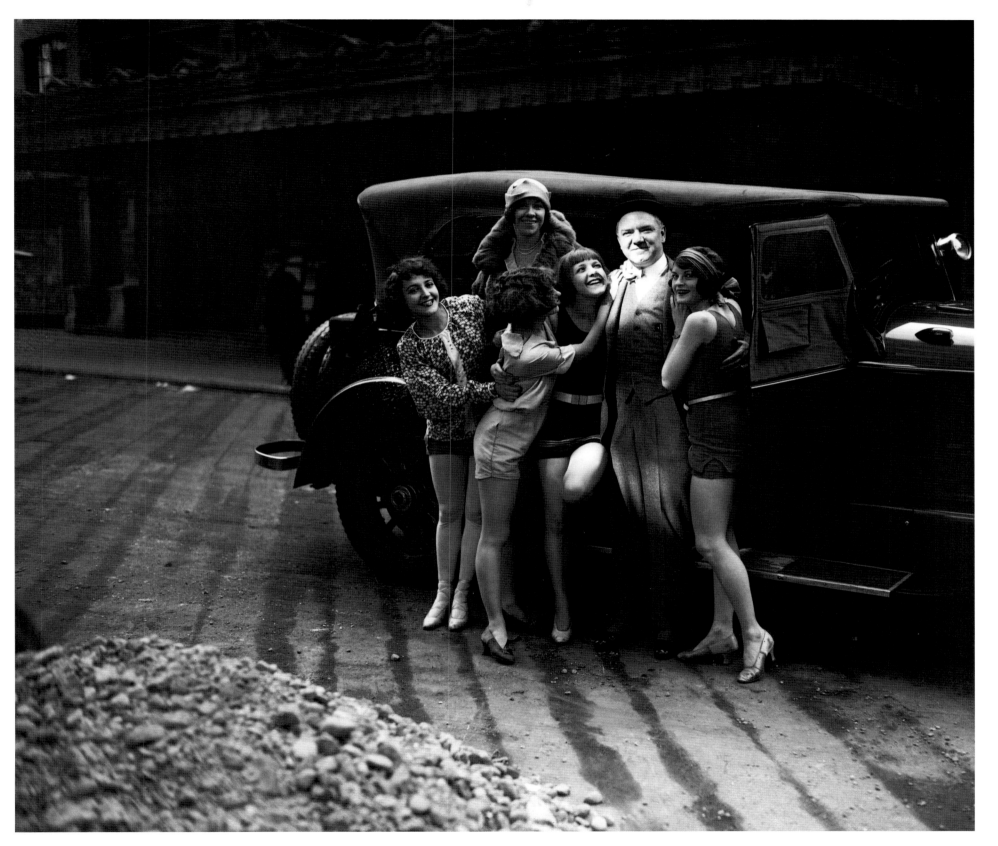

After about a 7-minute lapse, the jury returned a verdict of guilty against John T. Scopes, and he was fined $100. This photo shows Scopes (left) with Dudley Field Malone listening to the jury's verdict: "We find the defendant guilty as charged in the indictment."

The Close of the Scopes Trial

John T. Scopes as he stood before the judge's stand and was sentenced.

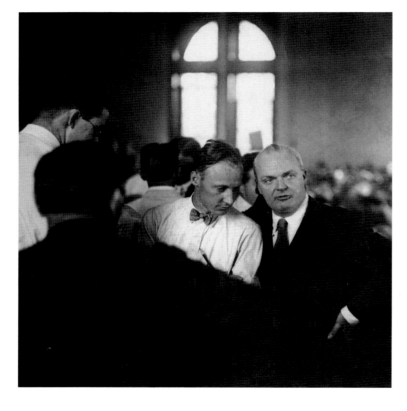

Sportsman Park
St Louis vs Yankees World Series

Lou Gehrig crosses plate on double play.
2nd run don't count.

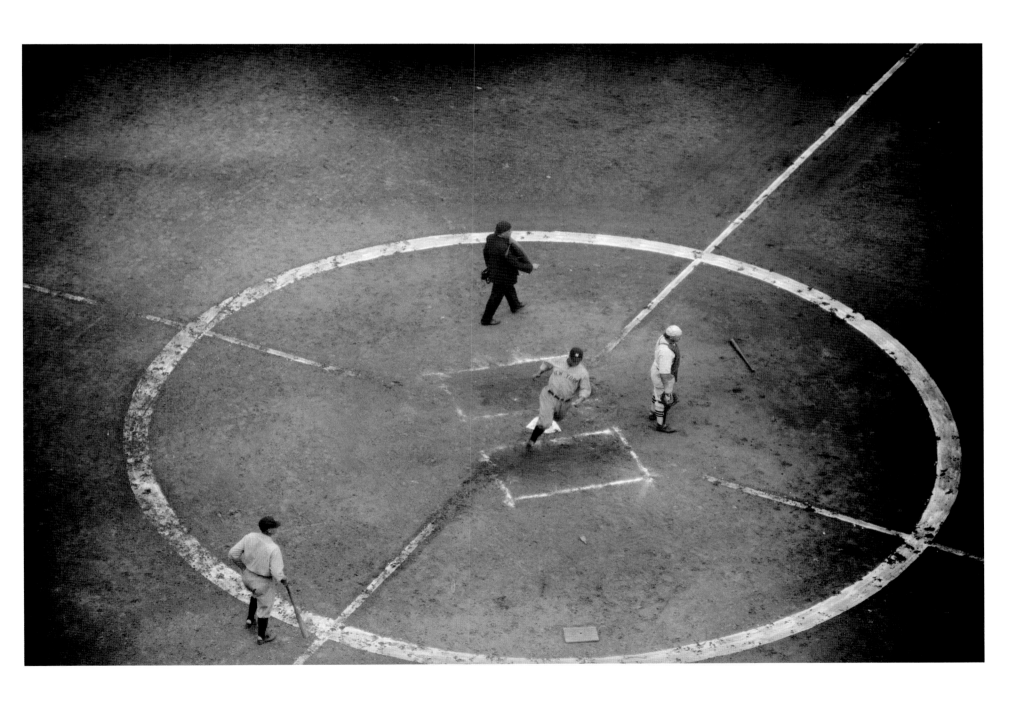

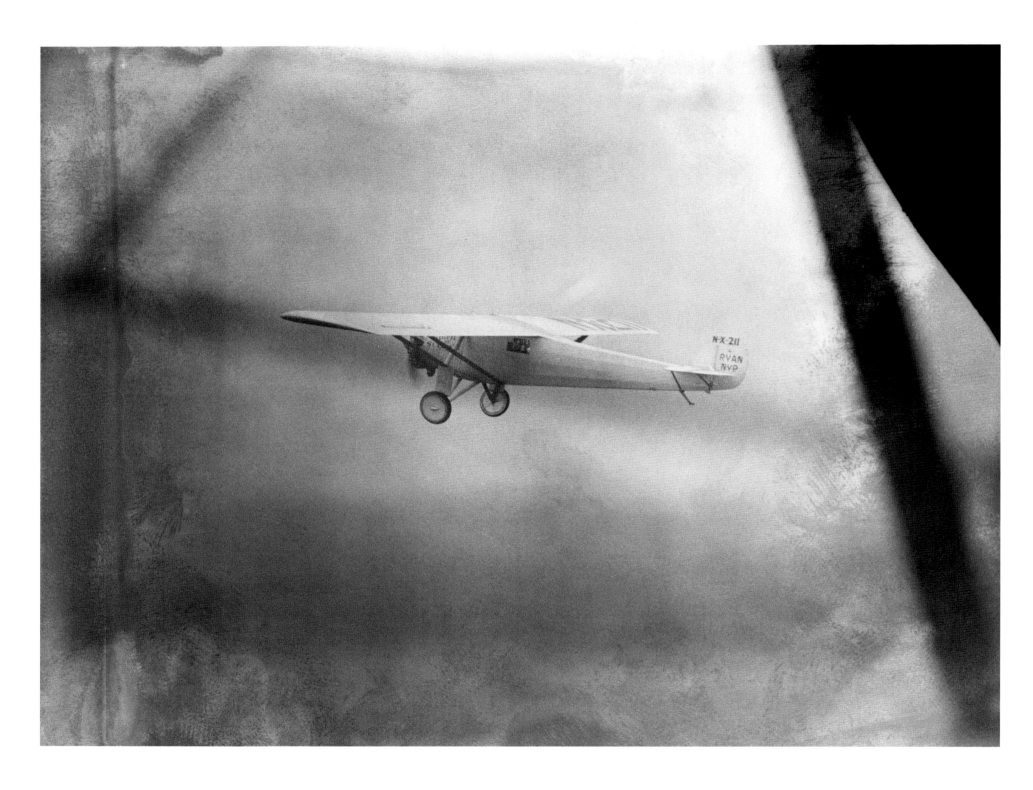

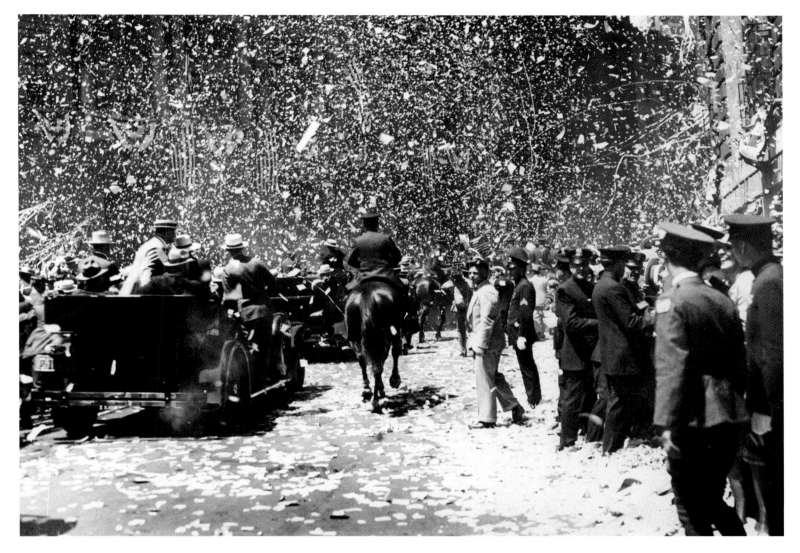

Lindy Arrives at New York

JUNE 14, 1927
PHOTOGRAPHER: UNKNOWN
NEW YORK, NEW YORK

Photo shows a view of Lindbergh in his car proceeding up Broadway amidst the cheering thousands throwing confetti.

MAY 20, 1927
PHOTOGRAPHER: UNKNOWN
LONG ISLAND, NEW YORK

Captain Charles A. Lindbergh, youthful daredevil aviator, hopped off from Roosevelt Field, Long Island, New York, in his Ryan monoplane, at 6:52 A.M., eastern standard time, on May 20th, in an attempt to reach Paris in a non-stop flight. This excellent photo, taken from the P & A plane, shows the "Spirit of St. Louis," Captain Lindbergh's plane, as it appeared in the air after more than an hour of flying.

The Governor's Lady and the Governor Himself

APRIL 16, 1927
PHOTOGRAPHER: UNKNOWN
ATLANTIC CITY, NEW JERSEY

Governor Alfred E. Smith and Mrs. Smith, as they saw themselves in the make-your-own-movie strip. The Governor and Mrs. Smith are spending the Easter holiday at Atlantic City where one of the new machines has been installed.

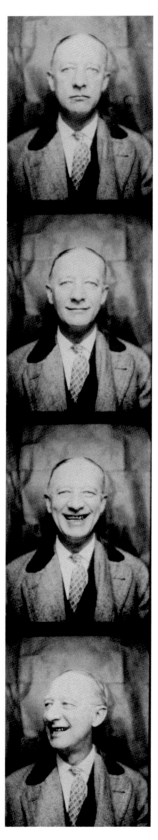

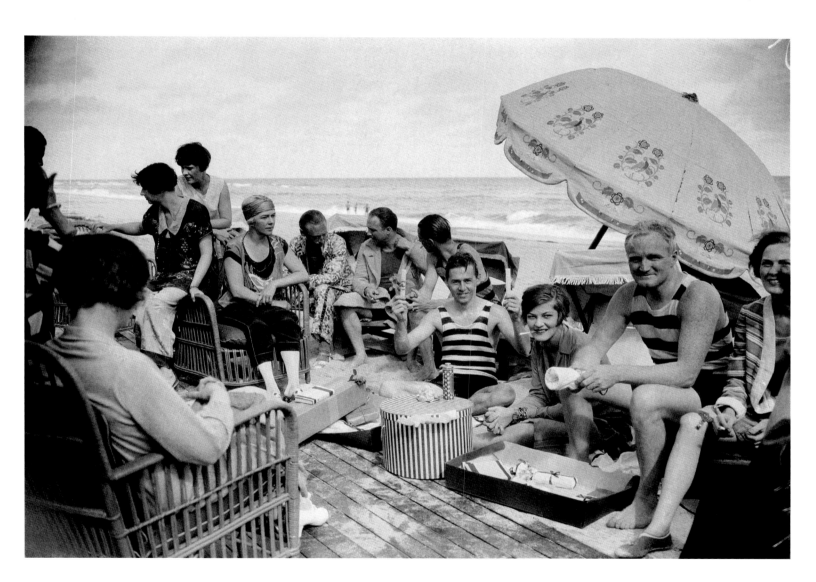

1927
PHOTOGRAPHER: UNKNOWN
PHILADELPHIA, PENNSYLVANIA

Left to right: Mrs. Harvey Shaffer,
Southhampton, New York, Mrs. Philip
Corbin, New York, Mr. Kenneth Van Riper,
New York, Mr. Blaine Webb, New York,
Mr. Albert H. Dewey Jr., Washington,
D.C., Mr. Maurice Fatio, Switzerland, Miss
Marjorie Oelrichs, Newport, New York,
Mr. Christopher Dunphy, New York,
Mrs. Jack Rutherford, Philadelphia,
Pennsylvania, on beach.

OCTOBER 24, 1929
PHOTOGRAPHER: UNKNOWN
NEW YORK, NEW YORK

Thousands mill around the New York Stock Exchange when the worst break in the history of the exchange occurred on October 24th. Wild scenes of disorder took place outside of the exchange as thousands of customers from the brokerage houses in the vicinity milled about in an effort to gain entrance. It was necessary to call out the police to dispel the crowds. J. P. Morgan, Charles Mitchell, and other prominent bankers met in a conference in an attempt to stop the crash.

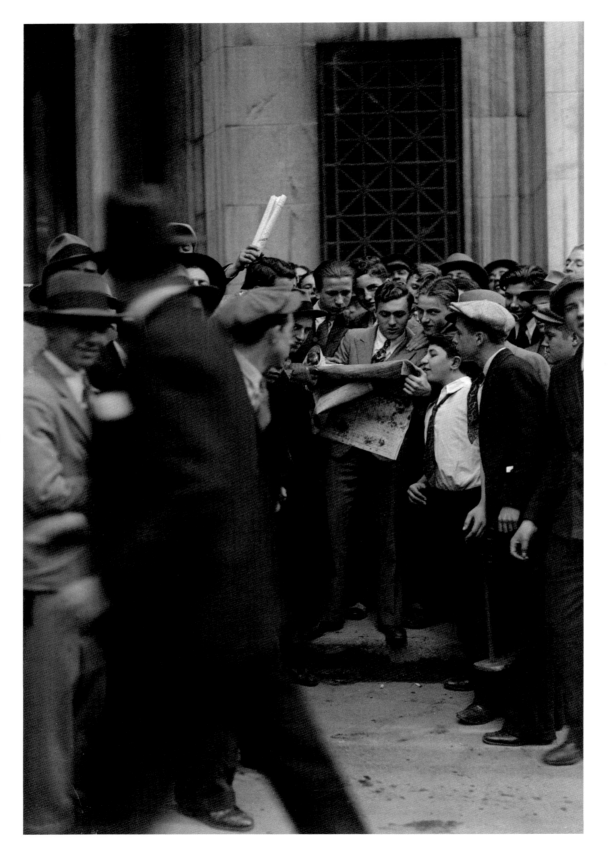

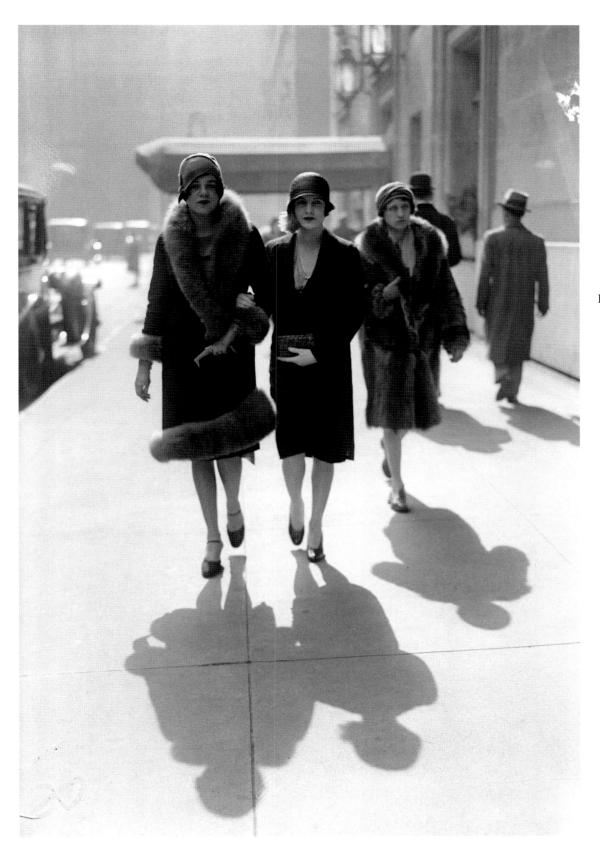

Society on Park Avenue,
Promenading Like Spring Sunshine

1929
PHOTOGRAPHER: UNKNOWN
NEW YORK, NEW YORK

Miss Sarah Chisholm (left)
and Mrs. Clifford Brokaw, Jr., as they
strolled down Park Avenue.

Funeral of "Little Augie"
Slain Gang Chief

OCTOBER 1927
PHOTOGRAPHER: UNKNOWN
NEW YORK, NEW YORK

Photo shows friends and relatives gathered at the grave of "Little Augie" (Jacob Orgen), slain gang chief in Mt. Judah Cemetery. Woman in black shown in center bending over the coffin is mother of the deceased.

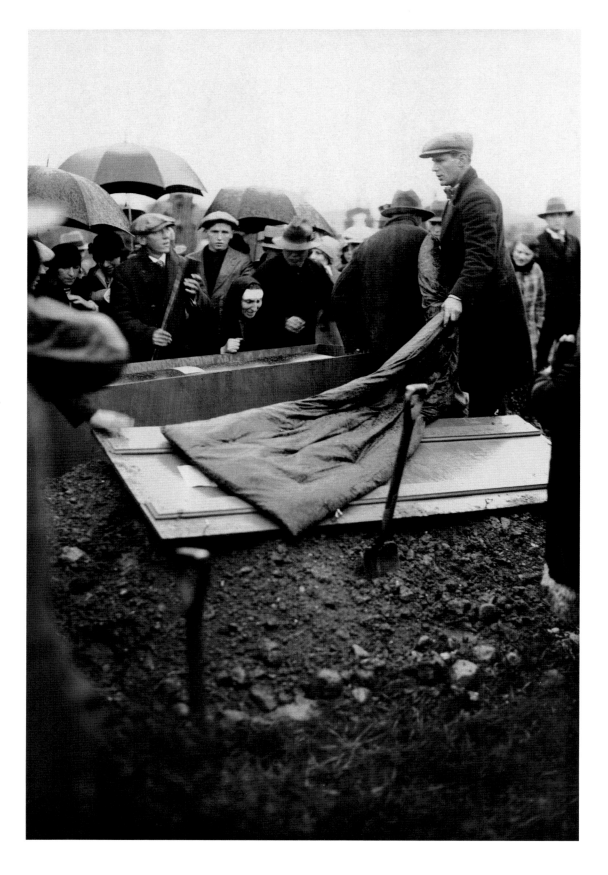

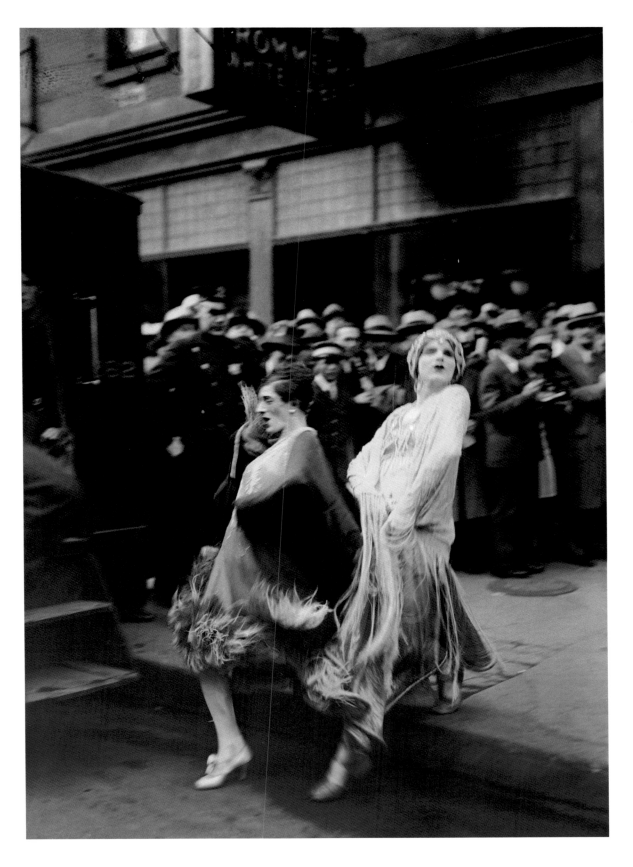

New Raid Stops Them!

C. 1930
PHOTOGRAPHER: UNKNOWN

Makeup, skirts and all, a couple of female impersonators flounce into patrol wagon at the Biltmore Theatre after yesterday's crowded matinee. Mae West's, *Pleasure Man*, was cut short by second police raid and the entire cast was taken for a ride to the police station. They will be arraigned for pleading in West Side Court this afternoon.

Mrs. Harry Houdini locked in a plate glass box from which she escapes to illustrate the secret 4th dimensional principle employed by her late husband.

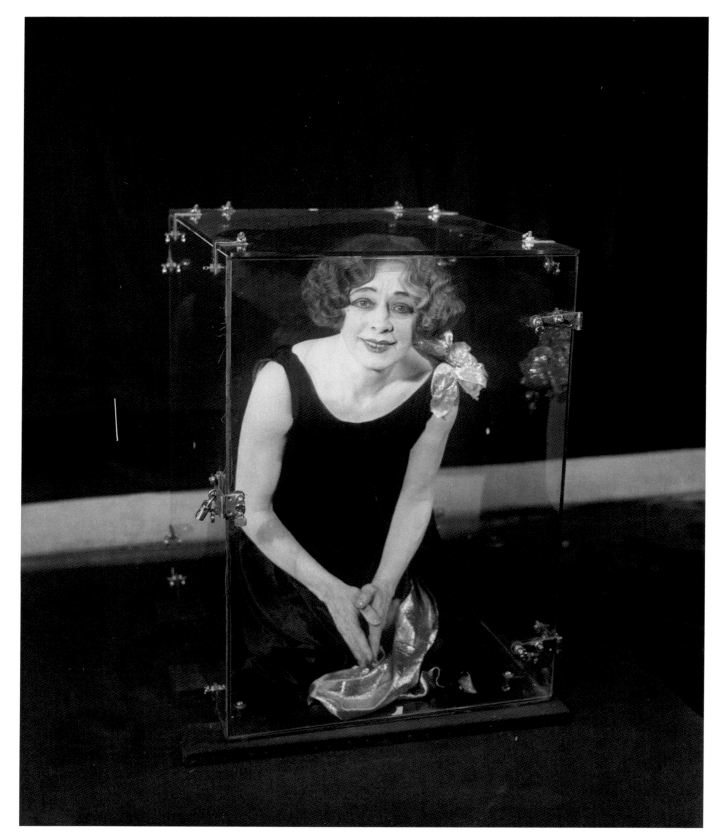

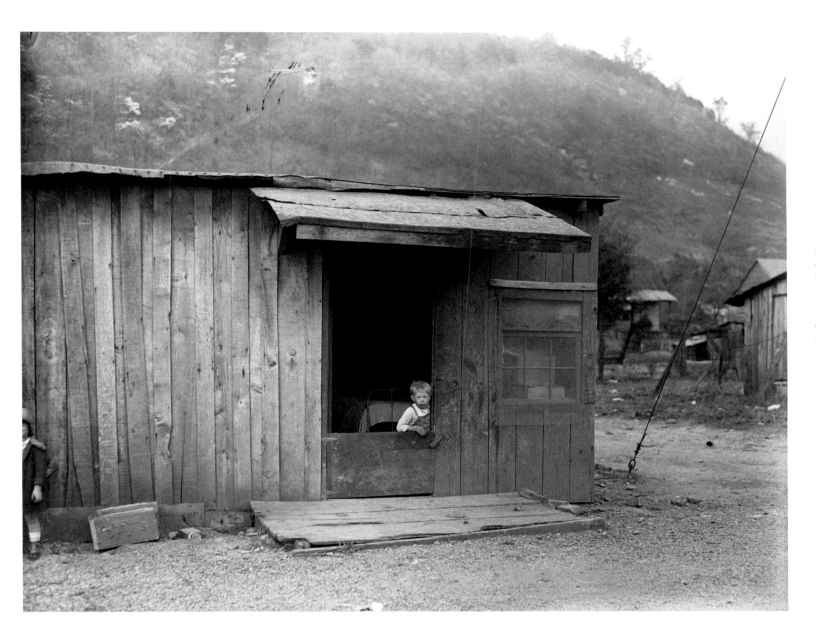

Tennessee Mill Workers Go
Out on Strike

APRIL 12, 1905
PHOTOGRAPHER: UNKNOWN
ELIZABETHTON, TENNESSEE

National Guardsmen were called
out to guard the mills of the American
Bemberg and Glanzstoff Corporation at
Elizabethton, Tennessee, when 5,000
employees went out on a riotous strike
for the second time within a month.
This photo shows the typical home of
the poorer class of factory worker.

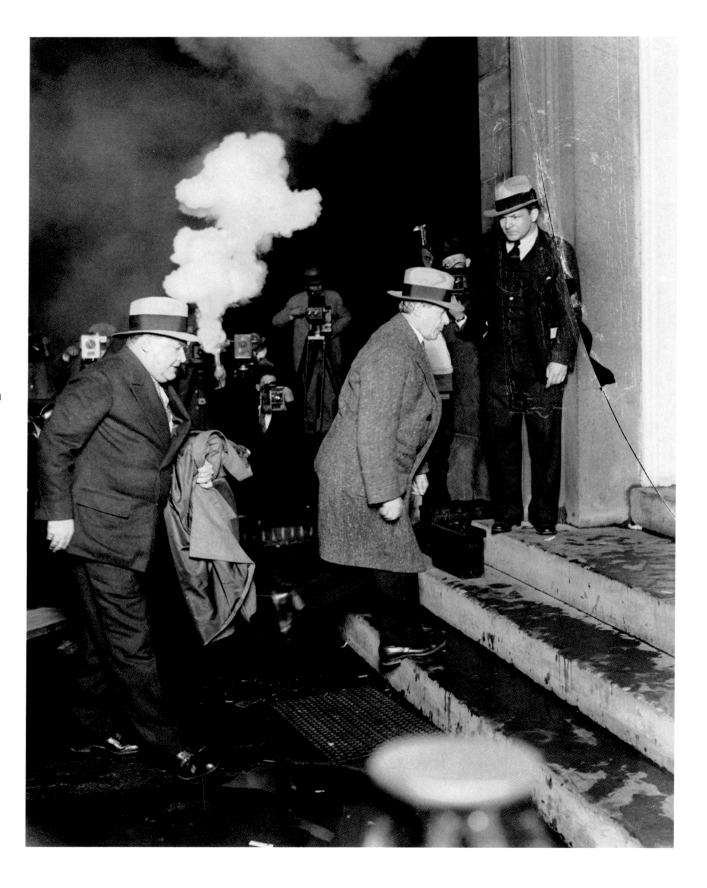

Sinclair Arrives at Jail for 90 Day Term

MAY 7, 1929
PHOTOGRAPHER: UNKNOWN
WASHINGTON, D.C.

Preceded by his brother, Earl, Harry Sinclair is shown arriving at District Prison last night where the millionaire oil magnate and sportsman will start 90 day term for contempt of the Senate.

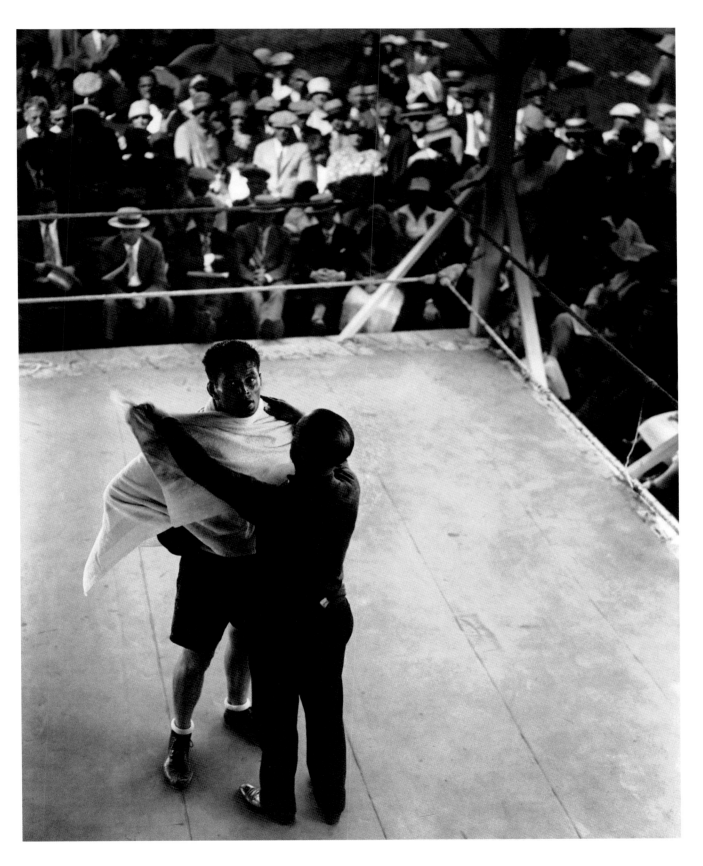

JULY 23, 1928
PHOTOGRAPHER: UNKNOWN
SPECULATOR, NEW YORK

Gene Tunney, in training at Speculator, New York, is rapidly winding up his campaign and has been working his sparring partners in fast sessions. Photo shows Lou Fink, trainer, wrapping Gene in a few extra towels to prevent possibility of catching cold, after ten rounds of sparring.

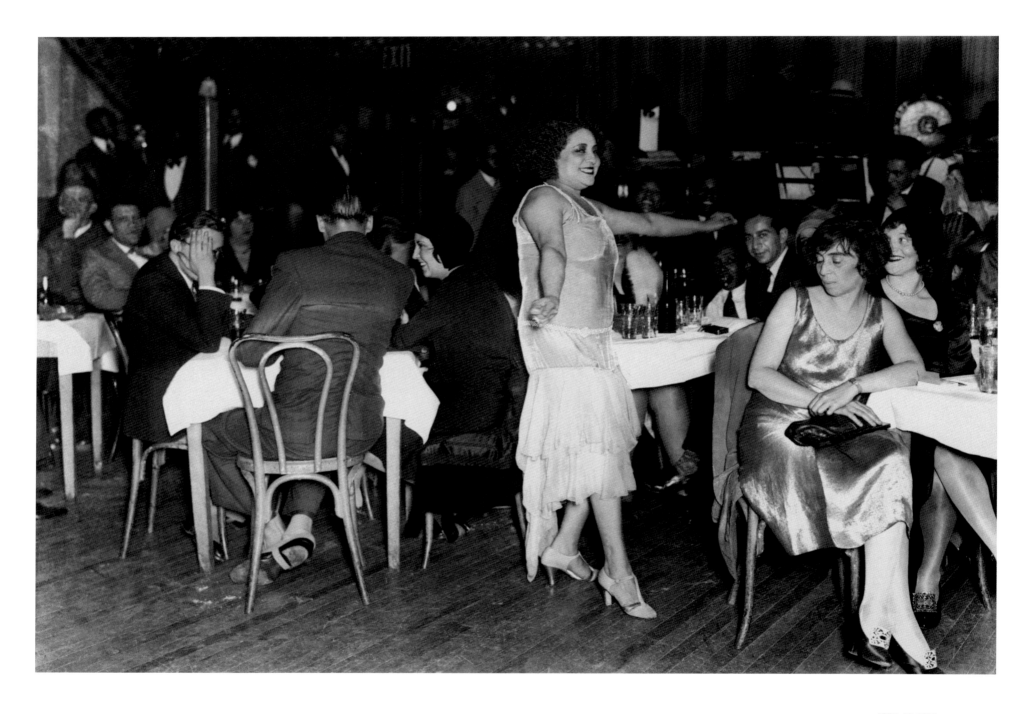

APRIL 12, 1905
PHOTOGRAPHER: UNKNOWN
NEW YORK, NEW YORK

Picture shows "The Entertainer," at Small's
Paradise Club in Harlem. A woman is
shown dancing while men and women
seated at tables watch.

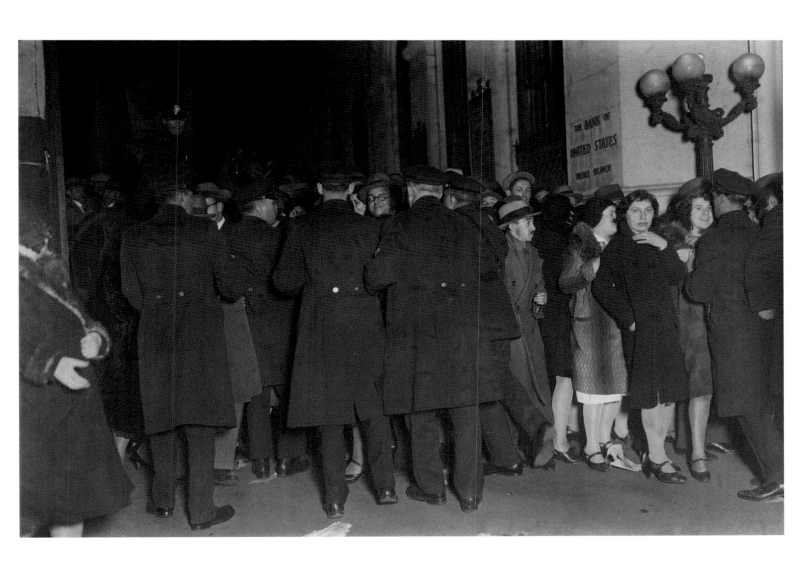

$3,000,000 Cash Stops Bank "Run" in New York

DECEMBER 10, 1930
PHOTOGRAPHER: UNKNOWN
THE BRONX, NEW YORK

Three million dollars in cash was rushed to the branch of The Bank of the United States at Freeman St. and Southern Blvd. to stem a run started by idle gossip of one of the neighborhood merchants. A score of clerks were rushed from the 58 other branches of the bank throughout the city to help pay out the money as officials reassured depositors there were plenty more millions to meet any demand that might be made. Scene outside the bank as crowd came to withdraw funds, and larger crowd gathered to watch.

The automobile in which two Deputy
Sheriffs of Harlan were slain on May 5th,
during a pitched battle with a crowd of
about 125 miners. The battle took place
on the outskirts of Evarts. Two of the
miners were slain.

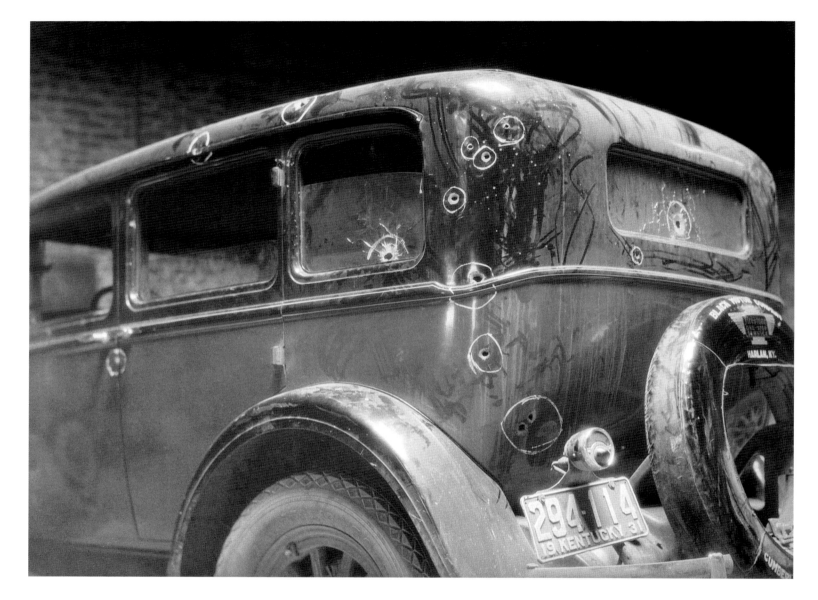

A Cooling Plunge En Masse

Oh, to be a youth again! Fond memories
of the "Old Swimmin' Hole" still linger in
the hearts of many old timers, but these
New York kids will vow this is just as
good. While the metropolis sweltered in
the hottest weather of the year, these lads
found the Hudson River at 49th Street, a
haven of refreshing coolness. Here are
the boys in a spectacular group dive that
would do credit to professionals. Note the
lad astride the shoulders of a fellow diver.

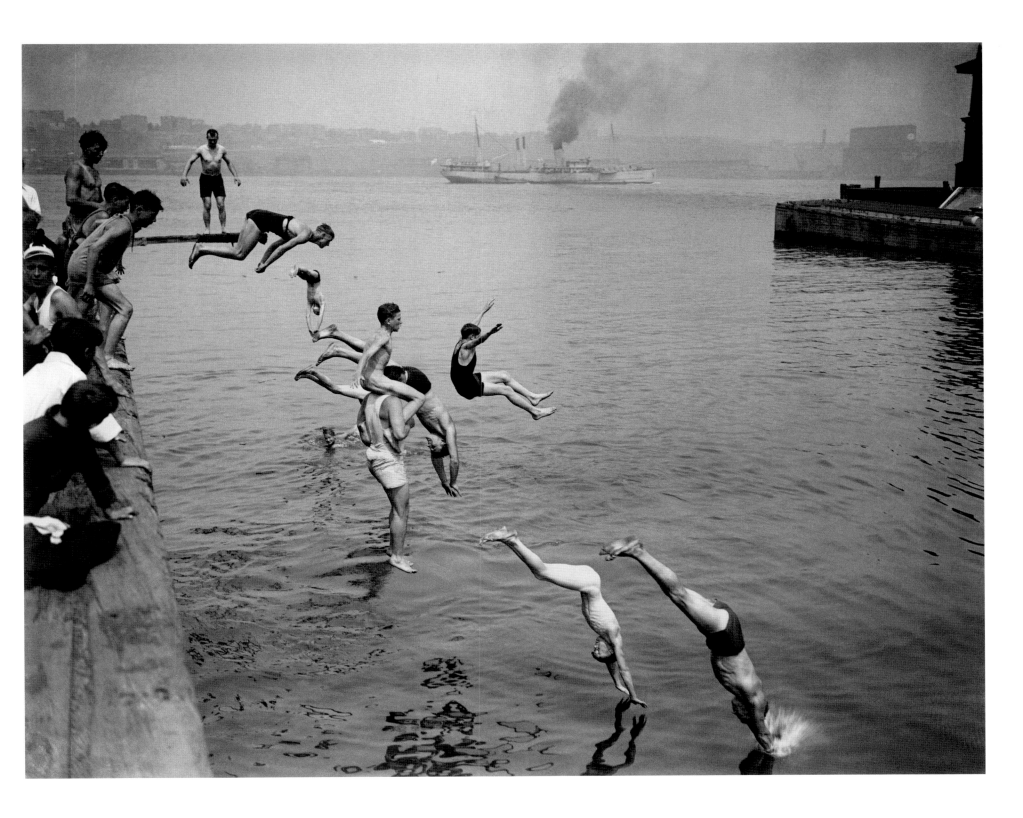

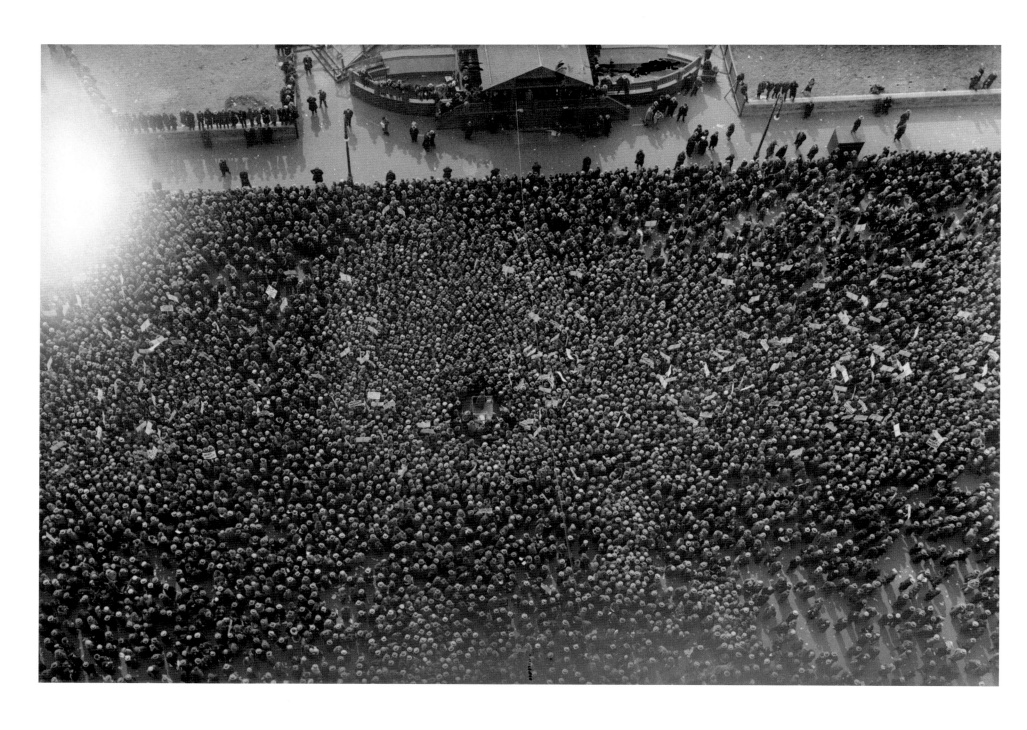

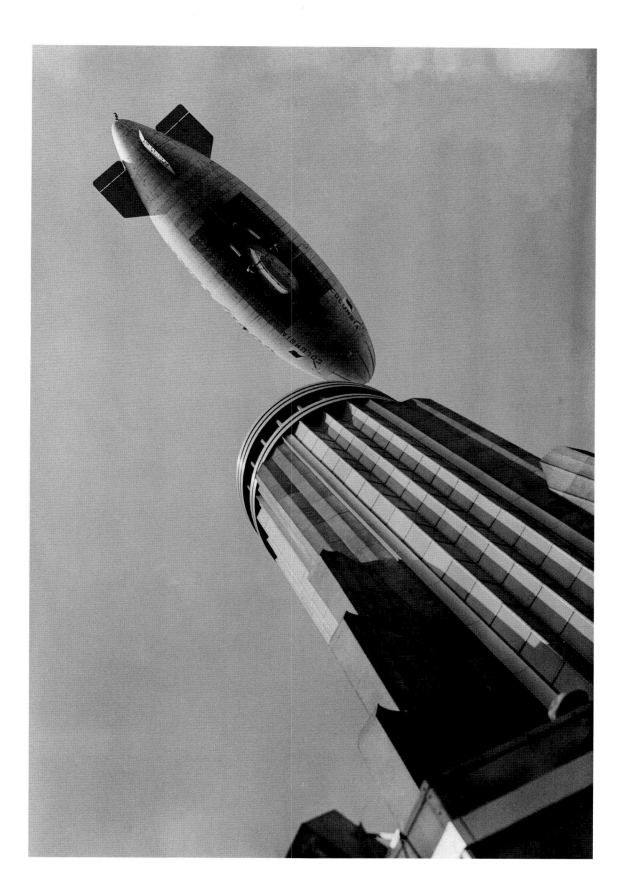

Goodyear Blimp passing over the
Empire State Building.

New York's Crimson Front!

One of the worst riots of its kind resulted
along the Communist front, Union
Square, New York City, when police re-en-
forced by firemen and detectives dis-
persed with much injury Communists
demonstrating against the unemployment
situation. Photo shows the greater part of
40,000 Reds who gathered in Union
Square, for the attempted march on City
Hall, which was frustrated by police.

AUGUST 6, 1932
PHOTOGRAPHER: UNKNOWN
LOS ANGELES, CALIFORNIA

While the two judges and referee look
closely, Herman Pihlajamaki of Finland
attempts to pin Einar Karlsson of Sweden
during their bantamweight bout in
the Olympic wrestling events at the
Los Angeles Olympiad.

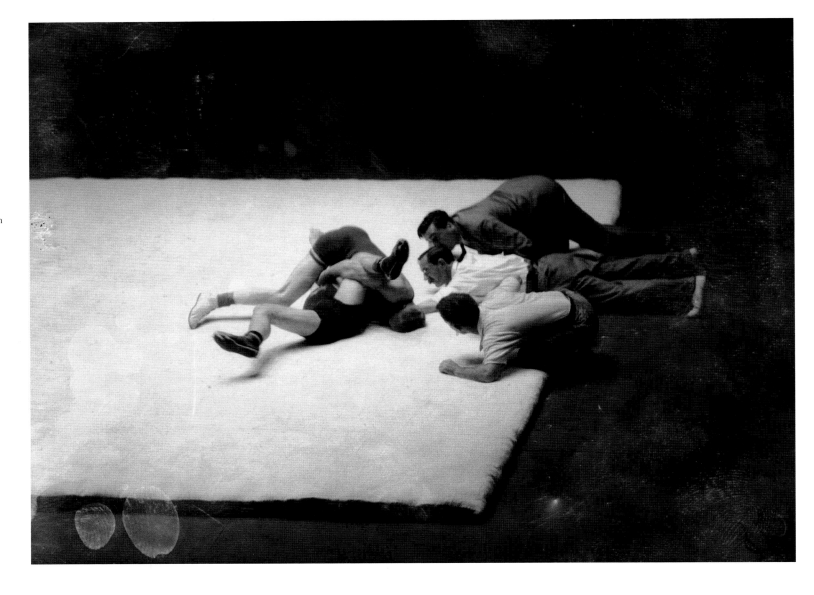

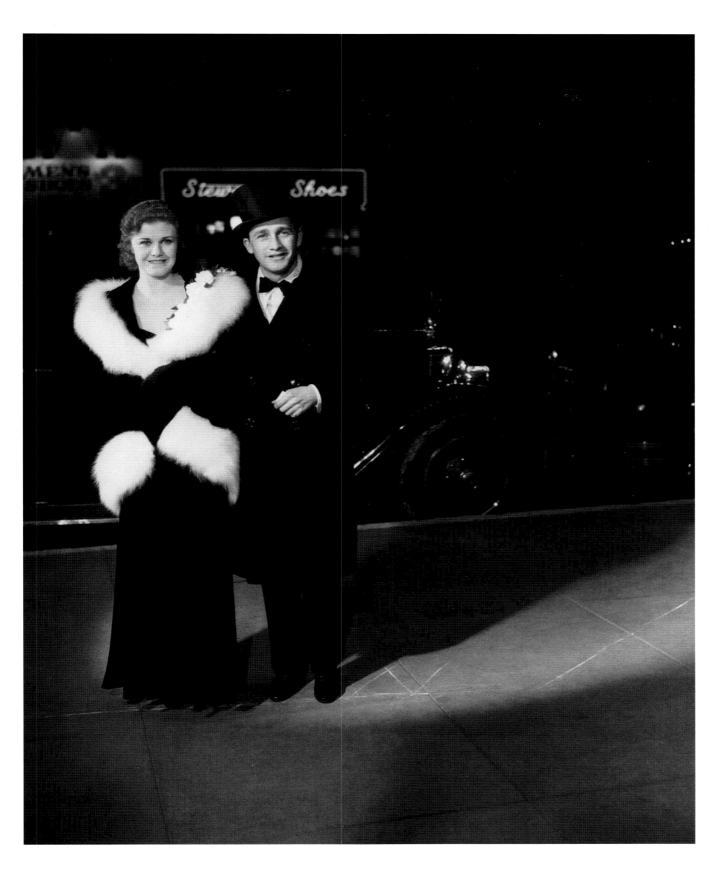

Stars arrive for opening performance of
Union Depot. Mervyn LeRoy and
Ginger Rogers.

JANUARY 26, 1932
PHOTOGRAPHER: UNKNOWN
NEW YORK, NEW YORK

It may be painful for the ant-like specta-
tors in the street below, but it's all in a
day's work for these smiling window
washers as they go about their precarious
work cleaning up the Empire State
Building, world's tallest structure, at dizzy
heights of hundreds of feet above the
street. The startling "shot" was made by
the photographer looking down upon the
window washers on the 34th street side
of the world-famed building. Note the
tiny insects that are motor cars and
pedestrians.

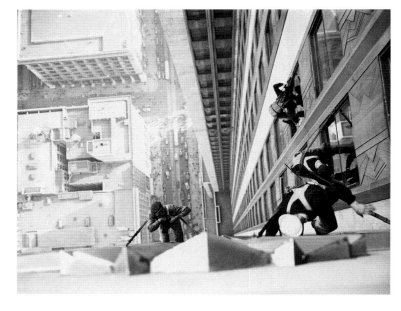

The Owl Light
Goes Night Clubbing to Get
the First Real Life Camera Record
of How New Yorkers Act in the
Wee Small Hours

OCTOBER 30, 1930
PHOTOGRAPHER: UNKNOWN
NEW YORK, NEW YORK

When Arthur Swanstrom, the noted pro-
ducer, planted a little kiss on the lips of
Eileen Healy, he did not know that the all
seeing owl light was lurking in the offing.
The time was 2 A.M. and the place, the
fashionable Club Richman. The picture
taken of this couple on the dance floor
is the first of its kind.

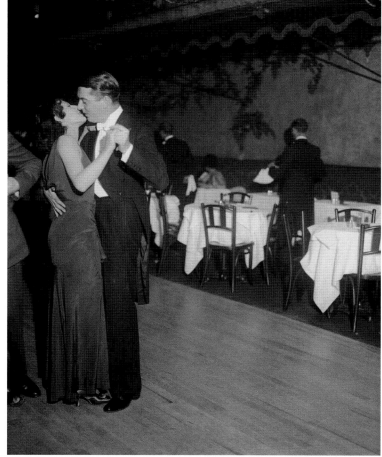

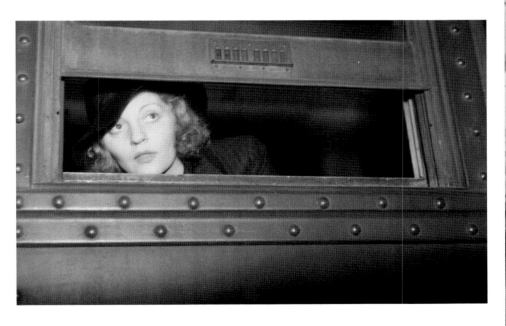

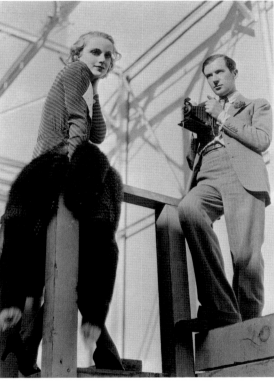

Tallulah Bankhead Bids
Hollywood Adieu

DECEMBER 3, 1932
PHOTOGRAPHER: UNKNOWN
HOLLYWOOD, CALIFORNIA

Tallulah Bankhead is shown looking out of pullman of *Santa Fe Chief* on the night of Nov. 30 as she left Hollywood, Calif. bound for New York. With no definite picture plans, Miss Bankhead is free to carry out her intent to do a play in New York or London. According to press reports she isn't under contract now to any film studios.

MARCH 9, 1931
PHOTOGRAPHER: UNKNOWN

Cecil Beaton is shown photographing Carole Lombard.

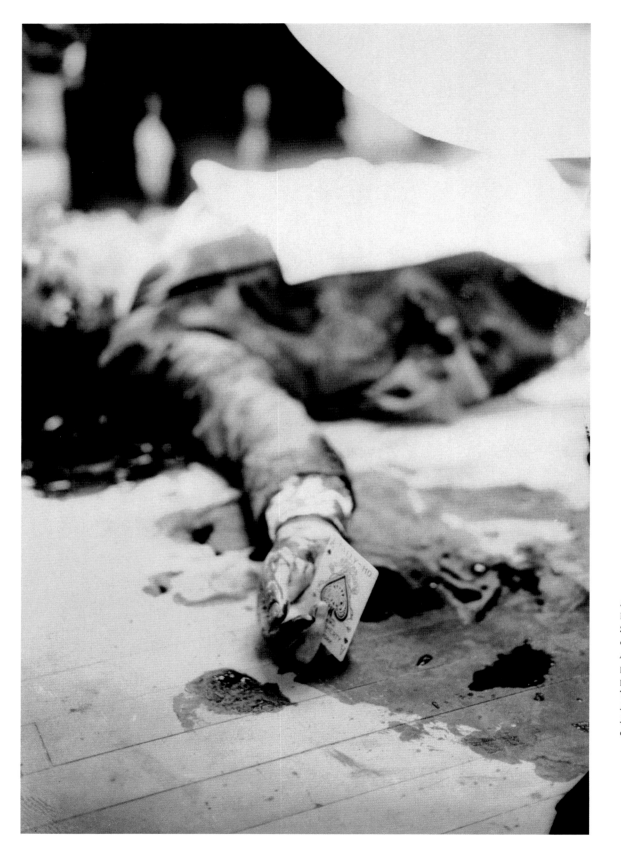

Body of Underworld
Boss Giuseppi Massari, Known as
"Joe the Boss"

APRIL 15, 1931
PHOTOGRAPHER: UNKNOWN
CONEY ISLAND, NEW YORK

Massari was shot by gunmen
while he played pinochle in a Coney Island
restaurant.

MARCH 26, 1931
PHOTOGRAPHER: UNKNOWN
SAN JUAN, PUERTO RICO

A tremendous reception was given to
President Hoover when he arrived in
San Juan, Puerto Rico. Thousands gath-
ered to voice their greeting. The U.S.S.
Arizona, which carried the presidential
party anchored at Ponce, from where the
party reached San Juan by automobile.
The President is seen driving through San
Juan with Governor Theodore Roosevelt
Jr. of Puerto Rico, in a fair representation
of a New York City ticker tape shower.

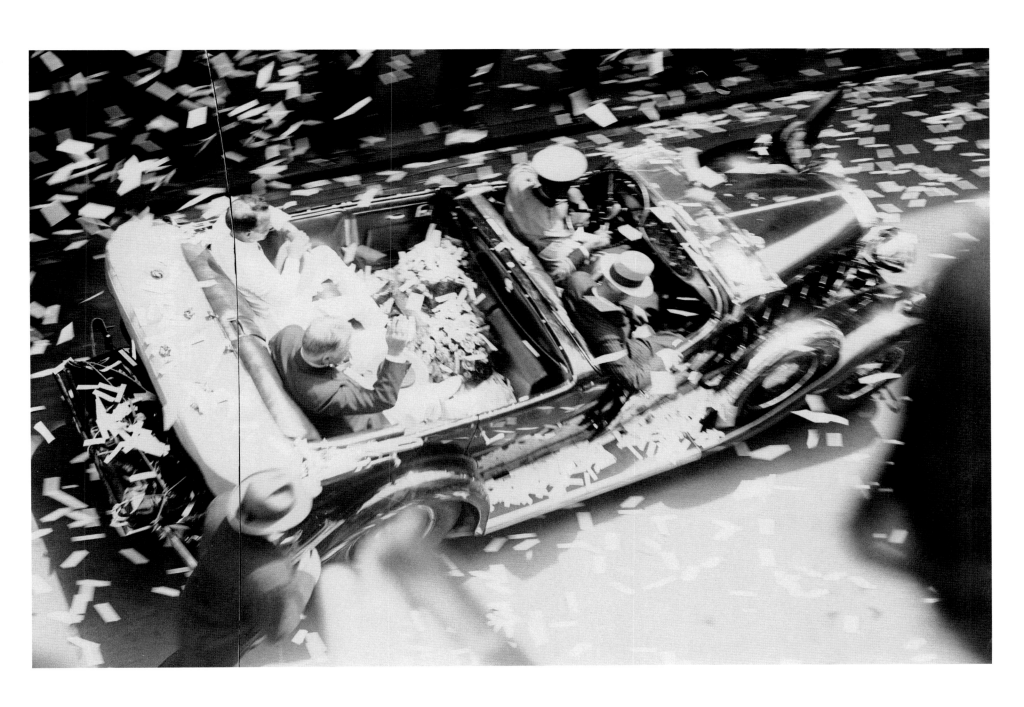

Police are shown trying to hold back veterans of the Bonus Army who went to the Capitol to protest the adjournment of the Bonus Bill that was passed.

Bonus Army Riots in Washington

Photo shows David Budd being locked up after Bonus riot. Another minor battle resulted in the arrest of John Pace, of Detroit, leader of the Radicals in the Bonus Army, and three others. The police got the marchers on the march again, but one veteran broke loose and climbed up a big tree with cat like agility. He was Walter Eiker of Detroit. Two detectives went after him. The marchers took advantage of this bit of burlesque and immediately broke their lines and started back toward the White House. At the White House every policeman at the gates was equipped with tear gas bombs. These will be used if the marchers get by the deadline.

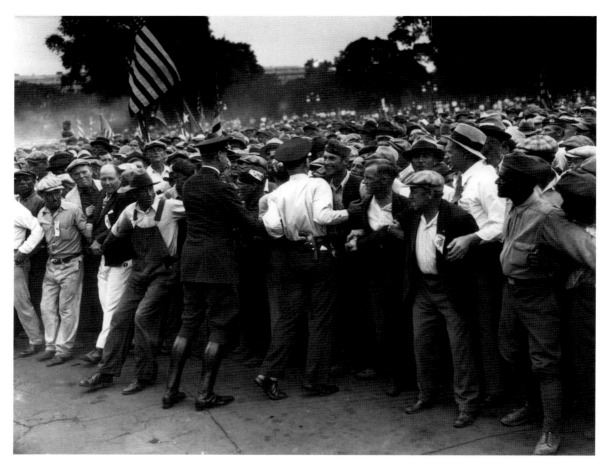

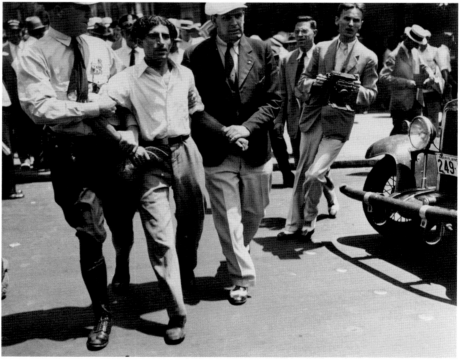

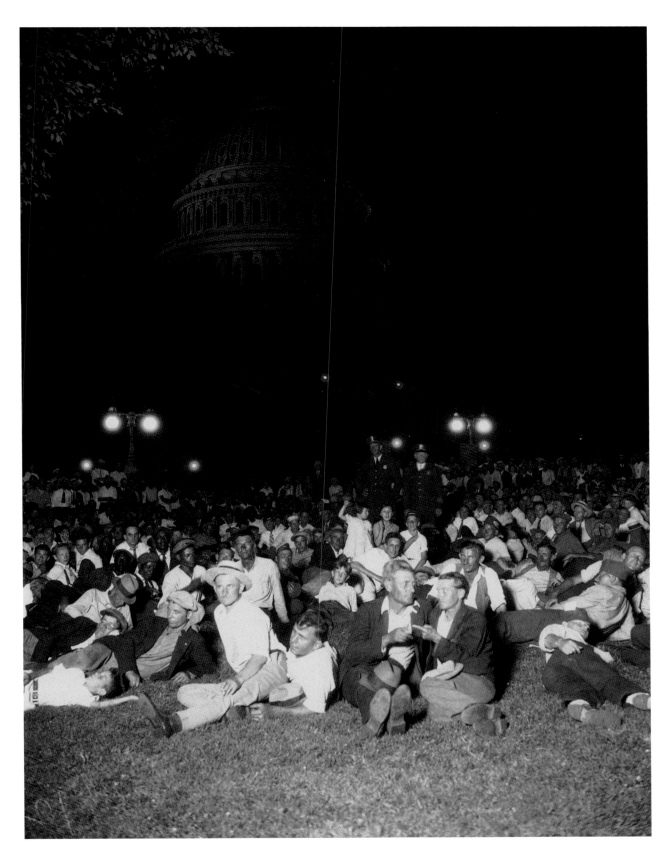

JULY 12, 1932
PHOTOGRAPHER: UNKNOWN
WASHINGTON, D.C.

Bonus marchers from the state of
California, settle down on the grounds of
the U.S. Capitol after parading around the
Capitol the night of July 12th, despite
police orders that there was to be no
camping on the grounds.

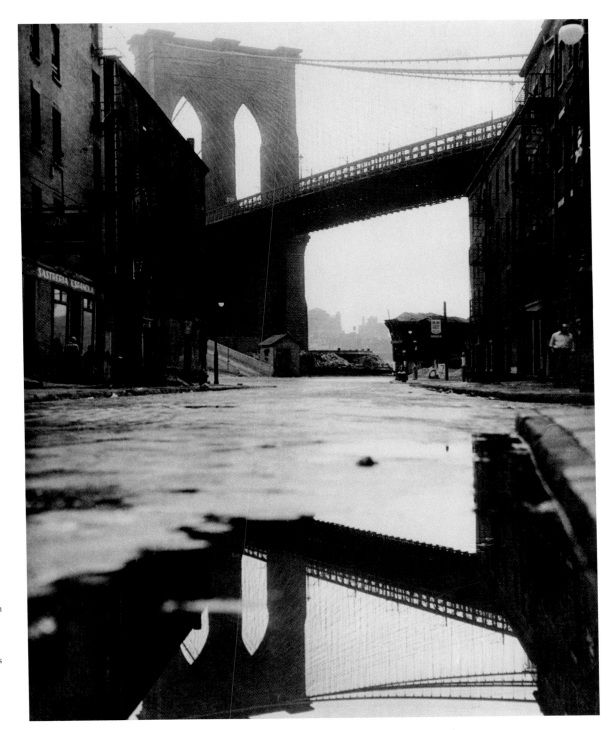

Waterfront Scene

APRIL 21, 1933
PHOTOGRAPHER: UNKNOWN
NEW YORK, NEW YORK

Rain brings a touch of beauty to a squalid section of New York City. The city's most famous span, Brooklyn Bridge, is reflected in detail on the wet pavement.

Cell Blocks Soon to House Most Desperate U.S. Criminals

OCTOBER 15, 1933
PHOTOGRAPHER: UNKNOWN
SAN FRANCISCO, CALIFORNIA

A view of the main cell block in the prison on Alcatraz Island in San Francisco Bay, which will soon be occupied by the most vicious and corrupt criminals in the United States. The Justice Department has determined upon Alcatraz as being inaccessible enough, both from within and without, to do as United States "Devil's Island." In all its long history as a military prison, not one inmate has ever escaped.

MARCH 2, 1934
PHOTOGRAPHER: UNKNOWN
CULVER CITY, CALIFORNIA

Left to right: Lyle Talbot, Alice Faye, Monte Blue, Jack LaRue, Lou Cody, George Raft and Frank Sebastian.

OCTOBER 2, 1933
PHOTOGRAPHER: UNKNOWN
MEMPHIS, TENNESSEE

Handcuffed and shackled, George "Machine Gun" Kelly (left) is flanked by heavily armed local police and department of justice officers, as he leaves Shelby County Jail, in Memphis, Tenn., for the Memphis airport, to board a plane for Oklahoma City, Okla., where he will be tried for the kidnapping of Charles F. Urschel. In prison at Oklahoma City, Kelly was chained to the bars of his cell.

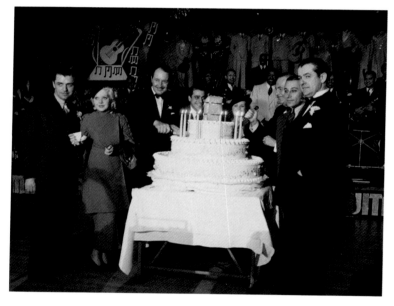

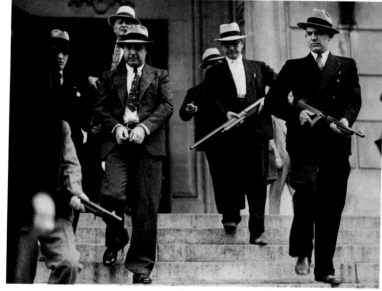

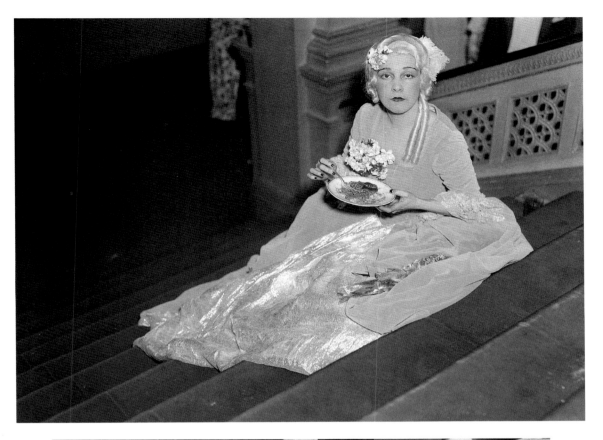

APRIL 27, 1934
PHOTOGRAPHER: UNKNOWN
NEW YORK, NEW YORK

Metropolitan Opera Ball. Mrs. A. McLanahan.

Stand Up and Drink!

MAY 21, 1934
PHOTOGRAPHER: UNKNOWN
NEW YORK, NEW YORK

Although official announcement had set no hour to mark the legality of drinking hard liquor at bars in New York State, a canvass of leading citizens promptly at 12:01, May 21st, used their newly-granted franchise. Shown here, the old familiar brass rail being held down by a few of the boys.

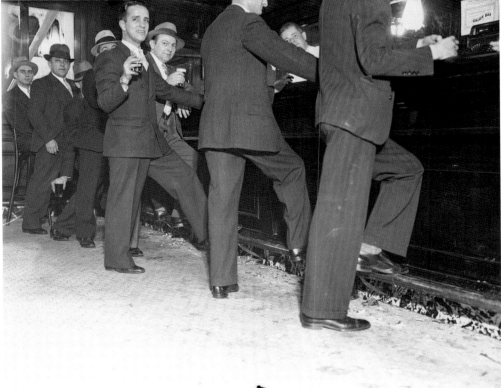

1932
PHOTOGRAPHER: UNKNOWN
LOS ANGELES, CALIFORNIA

Zabala of Argentina
during marathon here in the Olympic
Games in Los Angeles.

MARCH 22, 1933
PHOTOGRAPHER: UNKNOWN
HOLLYWOOD, CALIFORNIA

Many stars of the stage and screen turn
out to see Hollywood's premier showing
of Warner Brothers's *42nd Street*. Warner
Brothers Hollywood Theater was the
scene of the opening. Photo shows
Una Merkel.

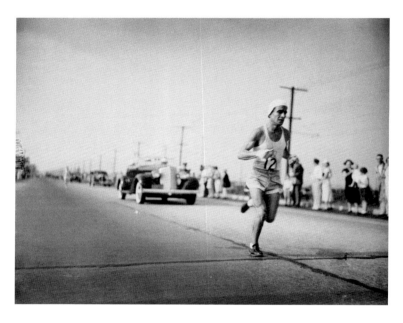

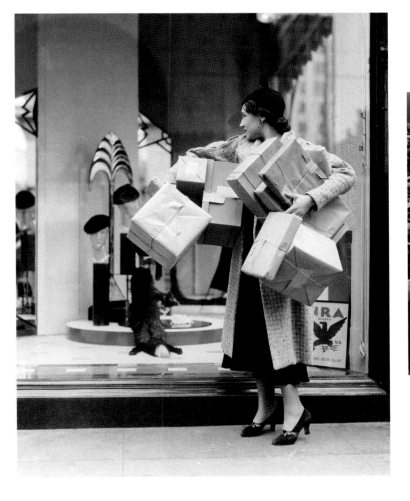

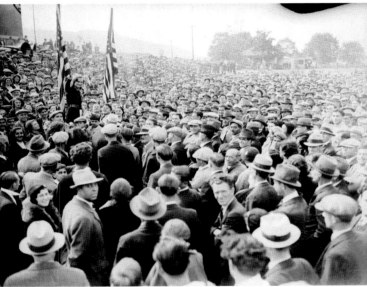

OCTOBER 13, 1933
PHOTOGRAPHER: UNKNOWN
LOS ANGELES, CALIFORNIA

This typical Los Angeles shopper is one of the residents of the West Coast Metropolis who have piled up a total of more than $12,000,000 worth of purchases in one day's opening sales of William Randolph Hearst's "Buy in September" Campaign supporting President Roosevelt's NRA drive. More than a million buyers crowded the stores of the city's several retail shopping districts during the day.

OCTOBER 21, 1933
PHOTOGRAPHER: UNKNOWN
PATTERSON, NEW JERSEY

Standing between two large American flags, Ann Burlak, comely and volcanic secretary of the Textile Workers' Union, is shown addressing the large crowd of Silk Mill strikers here October 21st. Some members of Ann's audience were "veterans" of the recent hand-to-hand battle the strikers had with Patterson police, in which three of the strikers were shot.

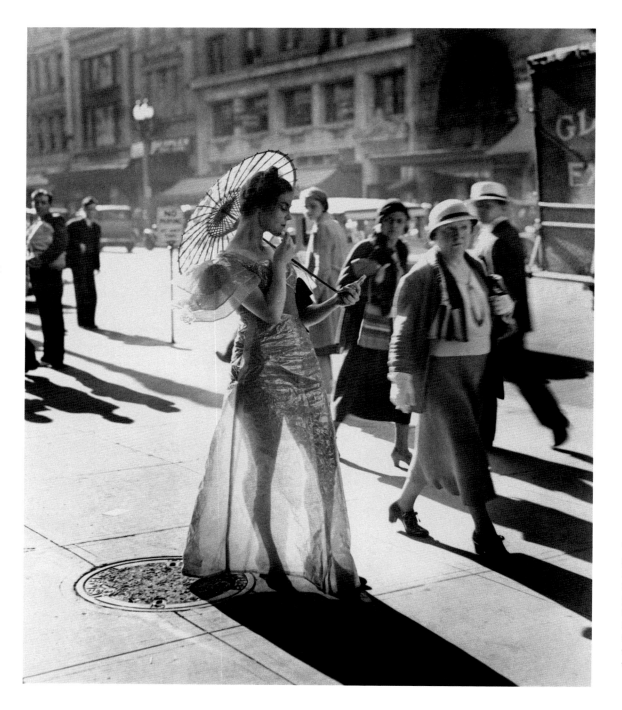

"Stop, Look, See Etc"

JUNE 5, 1933
PHOTOGRAPHER: UNKNOWN
WASHINGTON, D.C.

Miss Hariette Eriksen of 2009 Eye St., N.W.
Washington, D.C. stops traffic in down-
town Washington as she appears in
the latest creation, "A Girl in Cellophane."
At any rate it looks cool.

**Thousands of Unemployed
Get City Jobs**

APRIL 6, 1933
PHOTOGRAPHER: UNKNOWN
NEW YORK, NEW YORK

The huge crowd of unemployed that
gathered in front of the Home Relief
Bureau at 23rd St. and Second Avenue
waiting for a chance to register for city
jobs. Other thousands gathered in front of
the Army building to enlist in President
Roosevelt's dollar-a-day reforestation con-
tingent found that the quota for New York
was already filled. Men with dependents
were given preference in both cases.

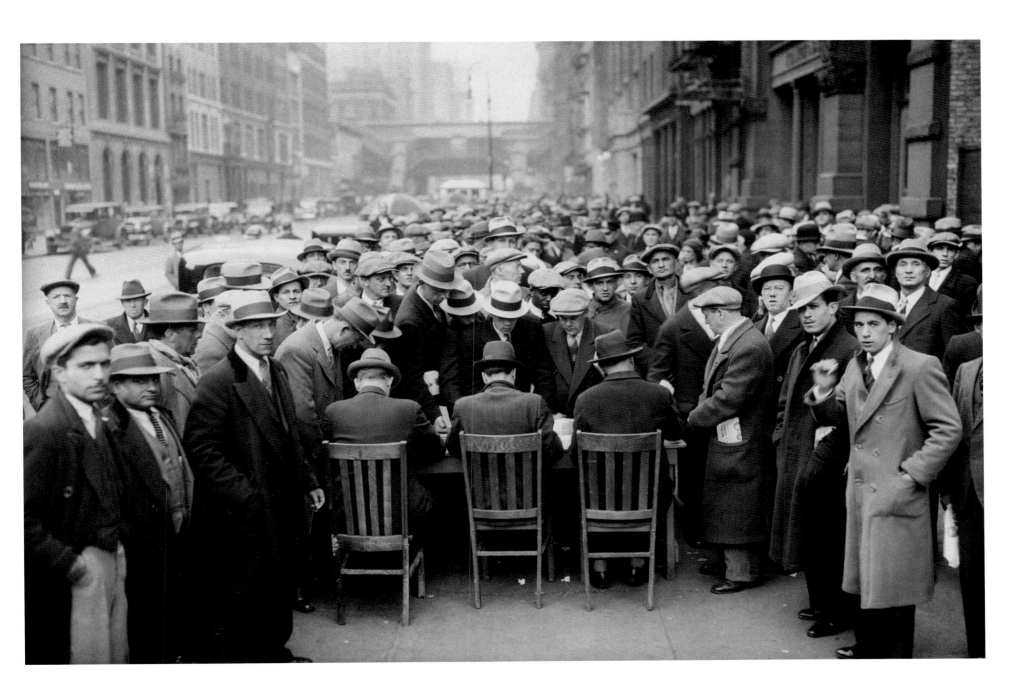

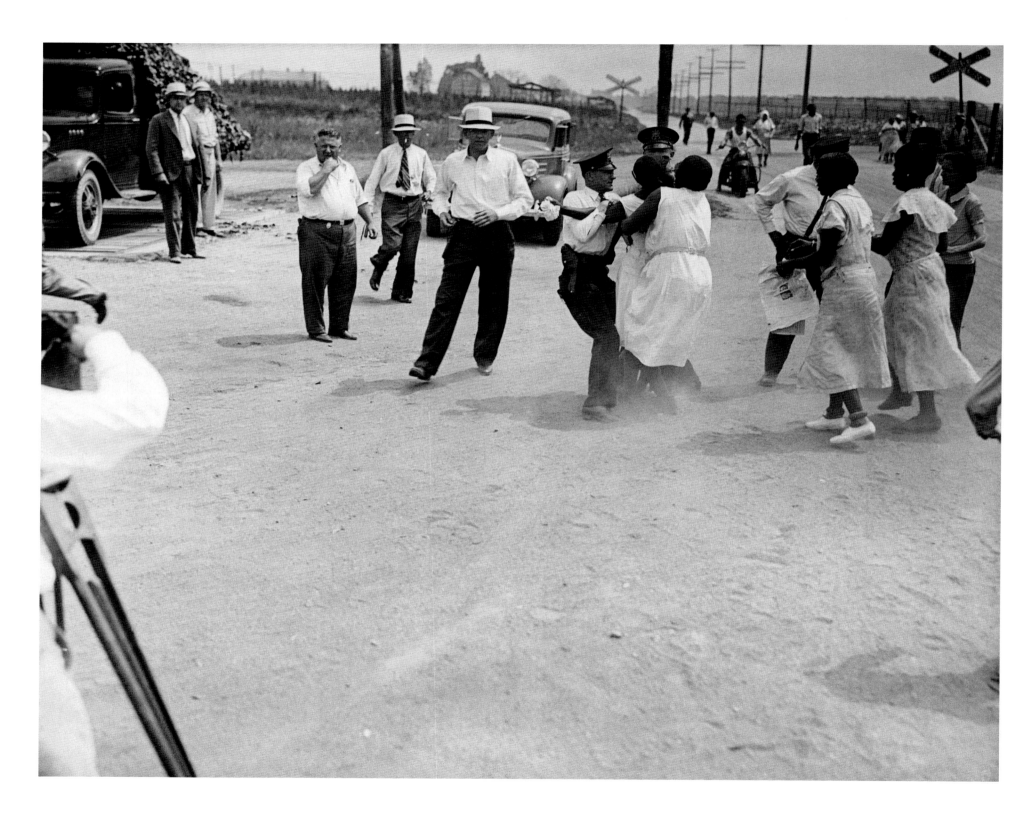

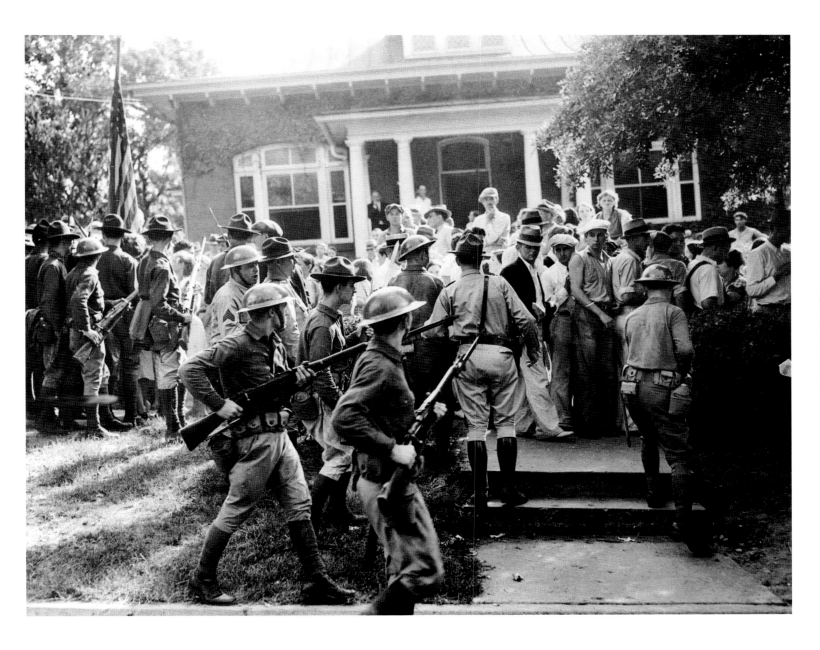

SEPTEMBER 7, 1934
PHOTOGRAPHER: UNKNOWN
GREENVILLE, SOUTH CAROLINA

Striking mill workers sullenly gave way before the bayonets of the National Guardsmen after the riot at the offices of the Woodside Mille. The workers became unruly as they received their last pay before going on strike and the troops were forced to use tear gas bombs before order was restored.

JULY 9, 1934
PHOTOGRAPHER: UNKNOWN
SEABROOK FARMS, NEW JERSEY

60 persons, both police and picketers, were injured in rioting at Seabrook Farms, near Bridgetown, N.J., following attempts by the strikers to unload trucks leaving the farm with produce. Photo shows women strikers trying to rescue a comrade who has been apprehended by police.

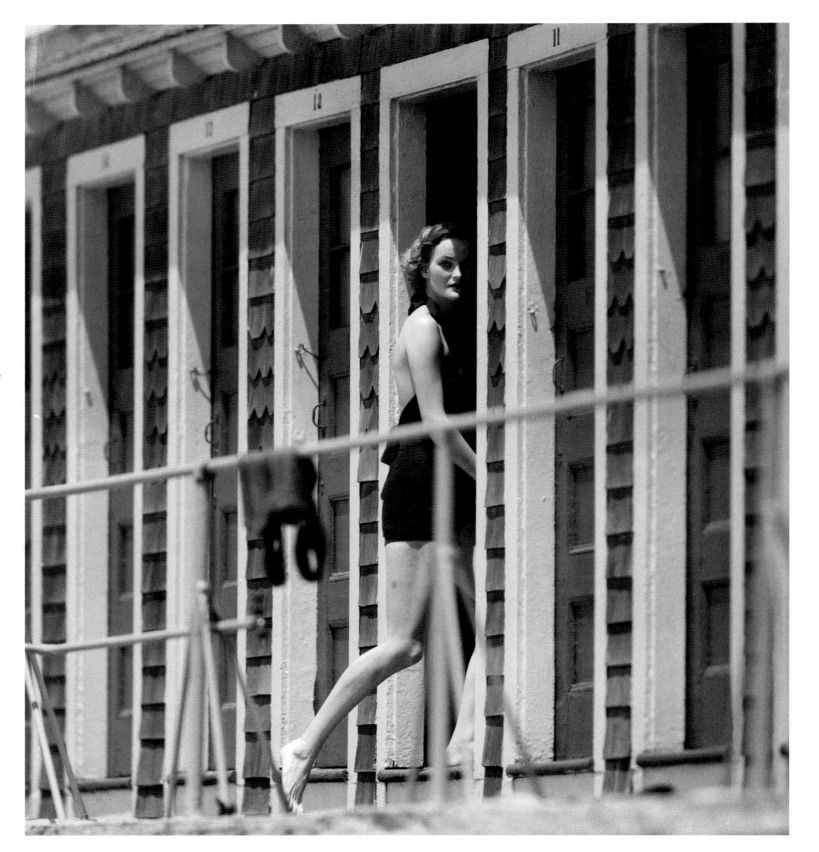

JULY 1, 1934
PHOTOGRAPHER: UNKNOWN
NEWPORT, RHODE ISLAND

The most exclusive strip of beach in the U.S. where the bluest of society's blue bloods are wont to disport themselves is Bailey's Beach. Doris Duke, heiress to the tobacco fortune and the richest girl in the world, is seen in a bathing suit for the first time by the camera, about to enter her bathhouse, after a day at Bailey's Beach.

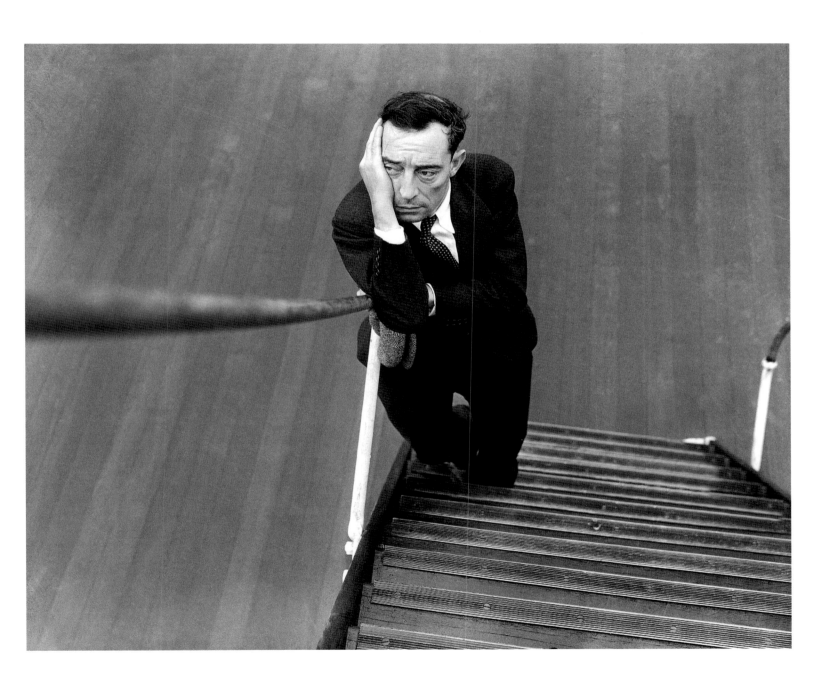

NOVEMBER 6, 1934
PHOTOGRAPHER: UNKNOWN
NEW YORK, NEW YORK

If Buster Keaton was glad to be back in the United States, he certainly kept it a secret. The cameraman asked the film comedian to smile and this is the result. He was aboard the *Ile de France* on his return from a 5 month tour of the continent.

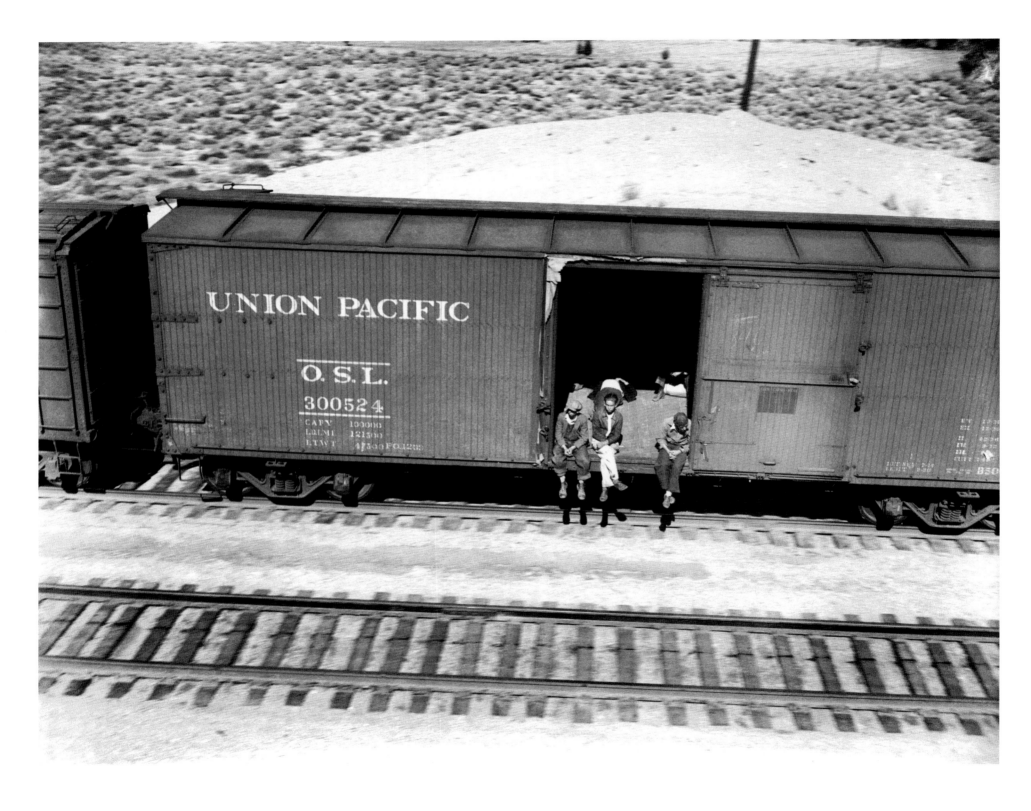

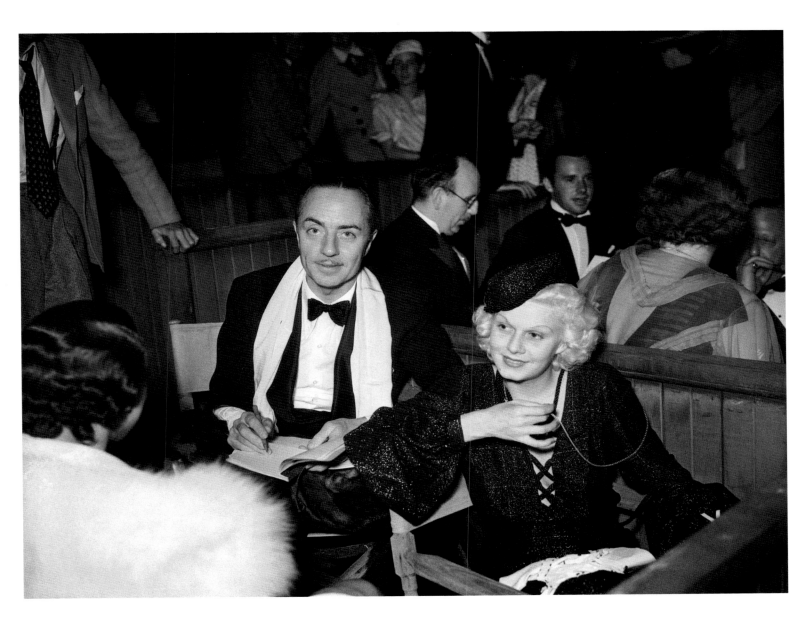

Film Notables Attend Reinhardt Production

SEPTEMBER 20, 1934
PHOTOGRAPHER: UNKNOWN
HOLLYWOOD, CALIFORNIA

William Powell and Jean Harlow pictured as they attended Max Reinhardt's production of Shakespeare's *A Midsummer Night's Dream* at the Hollywood Bowl.

Knights of the Rails

OCTOBER 23, 1934
PHOTOGRAPHER: UNKNOWN
USA

Empty box cars are utilized as transportation medium by itinerants entering Southern California from other states.

Sylvester Harris, colored farmer, wears a broad grin as he poses for his picture. The reason: he has just held a telephone conversation with Pres. Roosevelt and had the mortgage on his farm extended. Harris is pictured standing beside his mule in front of his farm house near Columbus, Miss. Sylvester describes himself as a typical Southern colored farmer.

Billboards "knocking" Upton Sinclair who is running for Governor. Street scene with cars and pedestrians.

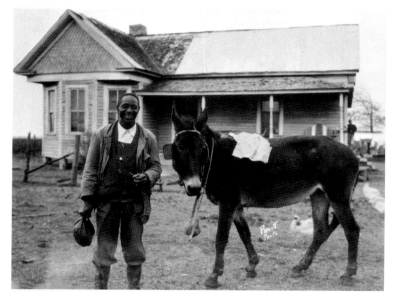

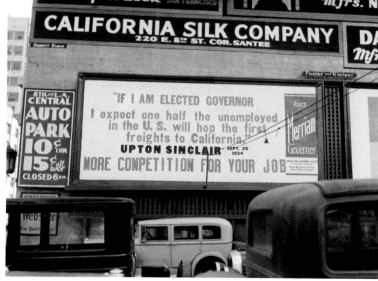

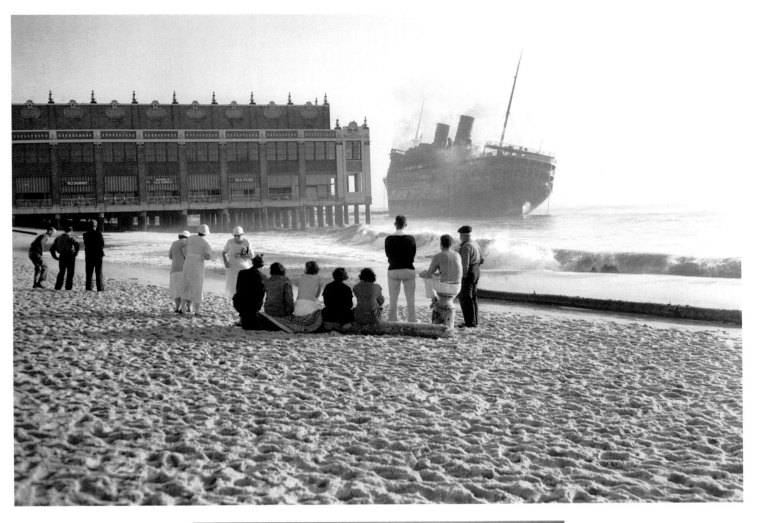

Floating Pyre for 170

SEPTEMBER 9, 1934
PHOTOGRAPHER: UNKNOWN
ASBURY PARK, NEW JERSEY

A stern view of the *Morro Castle* lying beached in front of Convention Hall, Asbury Park, N.J., still smoldering from the disastrous fire in which 170 lost their lives. According to reports, curious throngs were admitted to the beach, through Convention Hall, at a quarter a head, for a closeup view of the ill-fated vessel.

APRIL 25, 1935
PHOTOGRAPHER: UNKNOWN
SANTA MONICA BEACH, CALIFORNIA

Merle Oberon, British screen favorite, is pictured here with David Niven, ex-lieutenant in the Scottish Highland Infantry, and son of the late Lady Comyn-Platt, at Santa Monica Beach, California. The engagement of the couple is rumored.

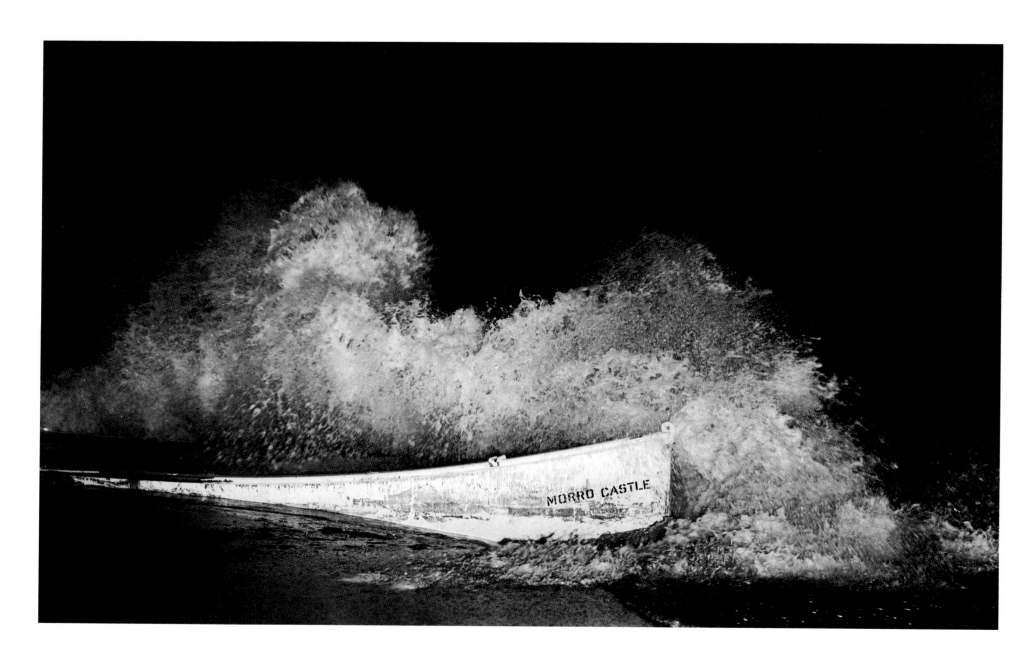

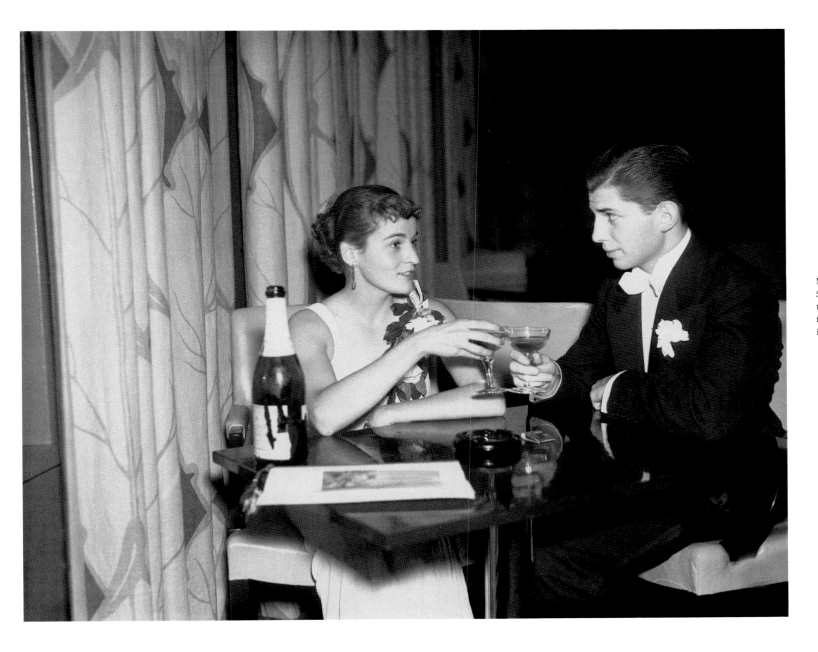

OCTOBER 4, 1934
PHOTOGRAPHER: UNKNOWN
NEW YORK, NEW YORK

Mr. and Mrs. Sanders Draper, Park Avenue Society Leaders, attend the opening of the Rainbow Room atop the 65th floor of the RCA building at Radio City. The opening was a benefit performance.

Sea and Sand "Work" on *Morro Castle* Lifeboat

SEPTEMBER 17, 1934
PHOTOGRAPHER: UNKNOWN
SPRING LAKE, NEW JERSEY

One of the abandoned lifeboats from the S.S. *Morro Castle*, shown embedded in the sand of the beach here. Wind and wave are combining to pound the craft to pieces. Soon it will be but a memory.

Mae West in the Witness Stand

JANUARY 18, 1934
PHOTOGRAPHER: UNKNOWN
LOS ANGELES, CALIFORNIA

Mae West appeared in court, in
Los Angeles, January 16th, as star
complaining witness against Edward
Friedman, charged with robbing her
of $12,000 worth of diamonds and
$3,400 in cash.

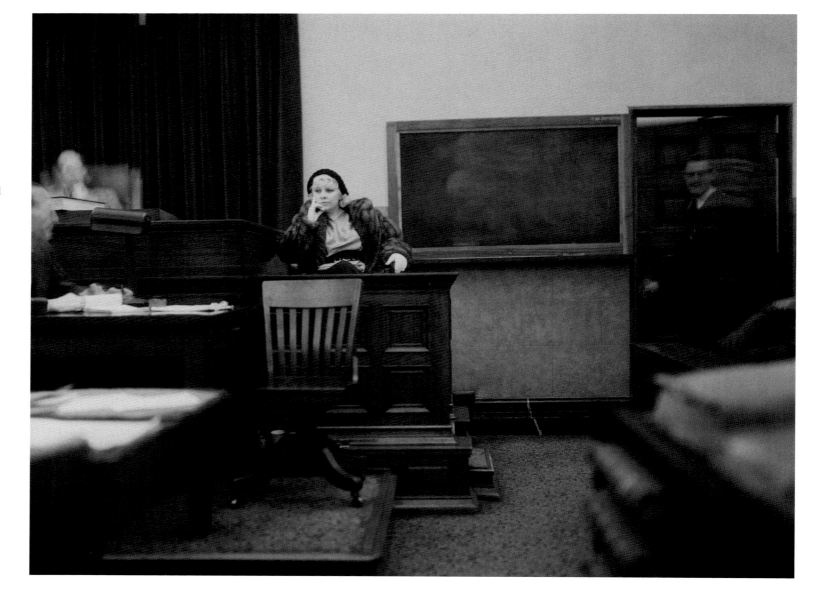

FEBRUARY 2, 1935
PHOTOGRAPHER: UNKNOWN
HARLEM, NEW YORK

Miss Aggie Francis and her escort,
Mr. Allen Mundy, arrive at Club 66 for the
exclusive Negro Ball.

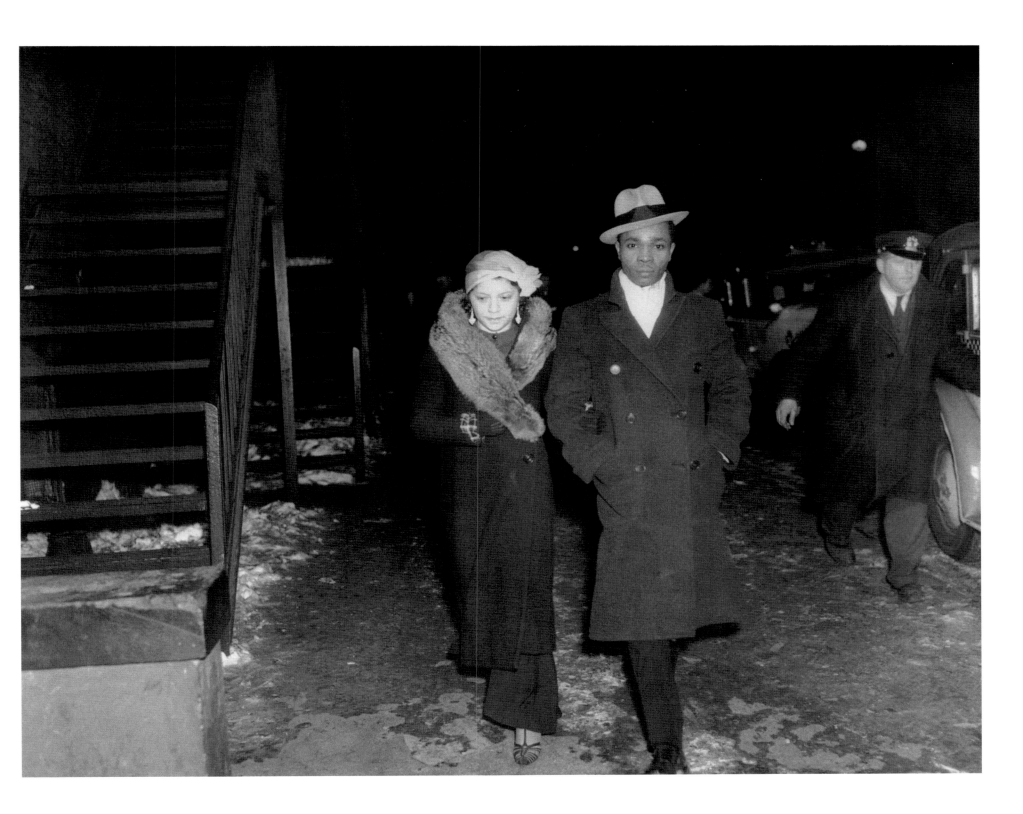

Irene Castle McLaughlin
at Palm Beach

MARCH 1935
PHOTOGRAPHER: UNKNOWN
PALM BEACH, FLORIDA

Irene Castle McLaughlin,
well known for her ballroom dancing,
is shown in Palm Beach.

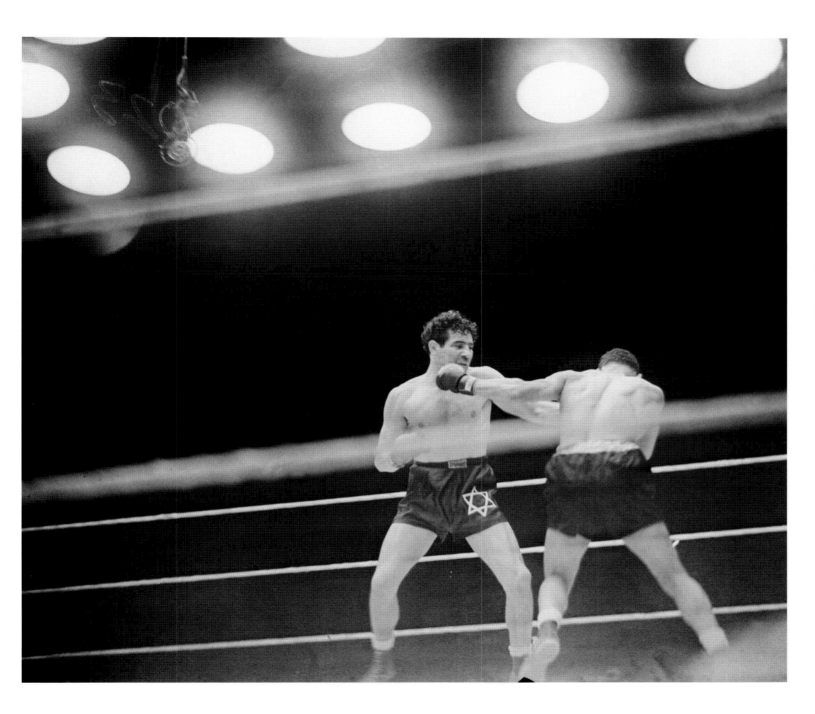

SEPTEMBER 24, 1935
PHOTOGRAPHER: UNKNOWN
NEW YORK, NEW YORK

Curiously, the biggest gate in which Joe Louis has shared was the $948,352 paid by fans who saw him dispose of Max Baer in a non-title bout. Here, Max absorbs one of the numerous left jolts that found his chin before Joe put over the finisher in the fourth round.

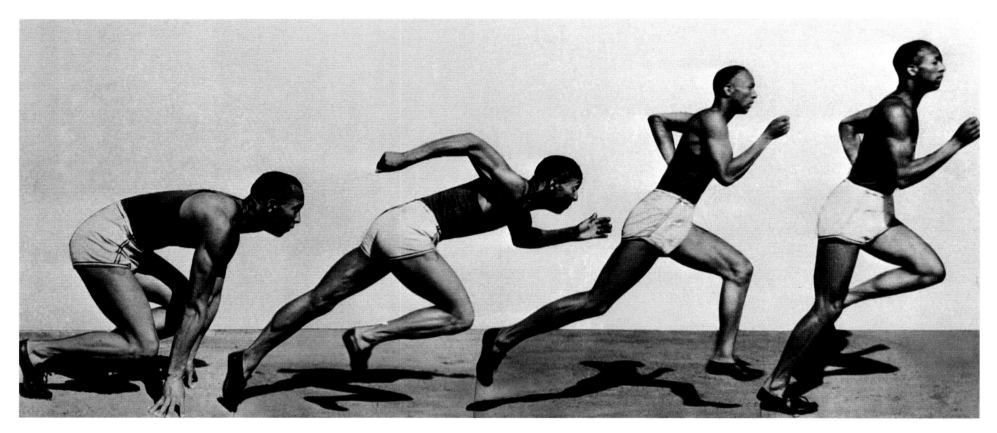

JUNE 18, 1935
PHOTOGRAPHER: UNKNOWN

Jesse Owens is shown in a composite
shot of the process of starting a dash or
sprint. He is shown from the "Get Set"
point (first image) to the almost-full stride
running point (last image).

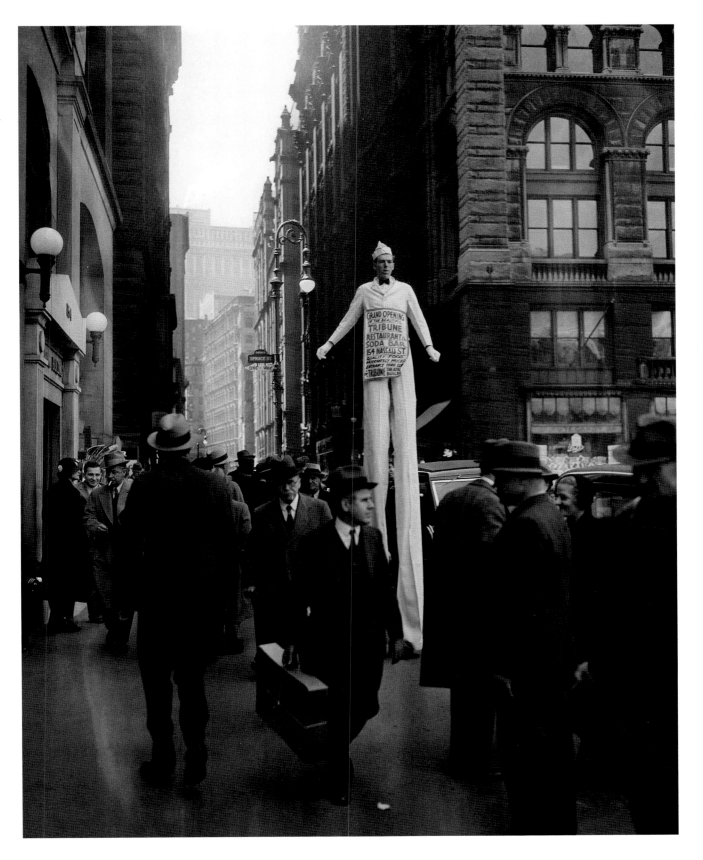

The Sidewalks of New York

MAY 23, 1935
PHOTOGRAPHER: UNKNOWN
NEW YORK, NEW YORK

A modern sandwich man. No matter how crowded the street this stilt-walker on Nassau Street in downtown Manhattan is sure to be seen. To be sure, the old-time sandwich men are still seen, but the newer and more modern methods of street advertising seem to be displacing them.

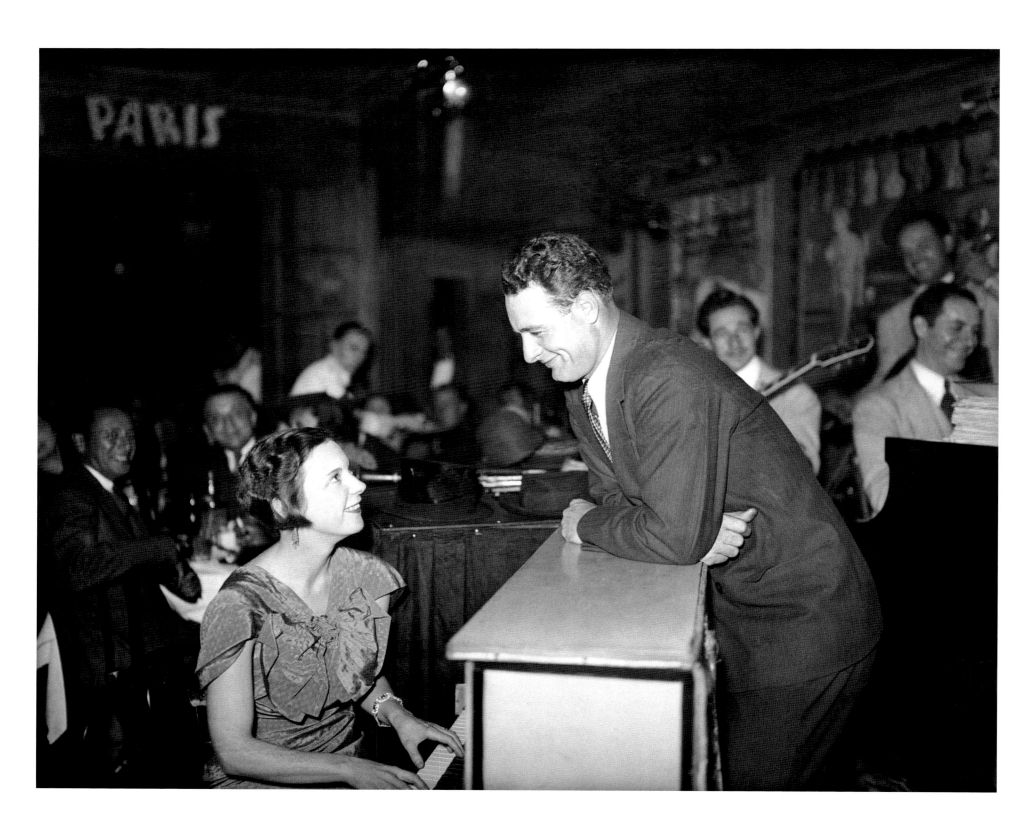

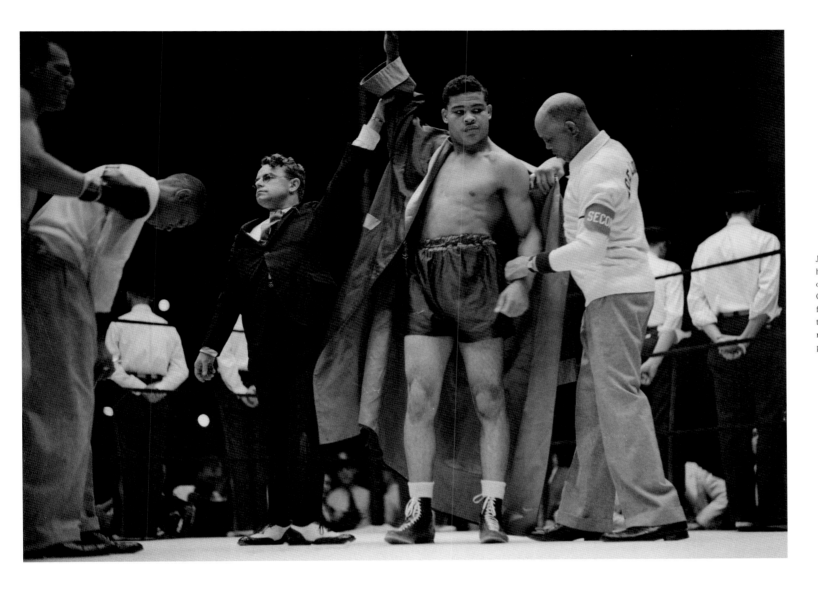

AUGUST 8, 1935
PHOTOGRAPHER: UNKNOWN
CHICAGO, ILLINOIS

Joe Louis, heavyweight challenger, after
he had been given a technical knockout
over King Levinsky in their fight in
Chicago. Hal Totten, announcer at the
fight, is holding Louis' hand up, while
trainer Jack Blackburn helps him with his
robe. Levinsky is at the extreme left, step-
ping groggily forward to shake hands.

SEPTEMBER 4, 1935
PHOTOGRAPHER: UNKNOWN
NEW YORK, NEW YORK

Mrs. Lou Gehrig sings her own composi-
tion, "I Can't Get To First Base Without
You," to her adoring husband, slugging
Yankee first baseman, during their visit to
Leon and Eddie's night club in New York
City. And if Mrs. Gehrig tossed them up to
Lou, it's doubtful that he could get to first
base either.

Harlem Celebrates Victory of Joe Louis, Its Idol

JUNE 2, 1935
PHOTOGRAPHER: UNKNOWN
NEW YORK, NEW YORK

Joe Louis, the Negro youth who came out of Alabama, via Detroit with the appellation "Brown Bomber" is the idol of his Race: so what more natural than a gala celebration of his sensational knockout victory over the great Livermore Lothario, Max Baer. That is just how Harlem celebrated the occasion—and we see here a bus-load of celebrants riding through Harlem and making the well known welkin resound to their enthusiasm.

JUNE 10, 1935
PHOTOGRAPHER: UNKNOWN
WASHINGTON, D.C.

J. Edgar Hoover (wearing hat), head of the Department of Justice, is pictured here attending the Frankie Klick-Tony Canzoneri fight. Hoover, pleased with the work of his "G Men" who broke the Weyerhauser kidnapping with two arrests, is pictured with Clyde A. Tolson (hat in lap), Assistant Director of the department.

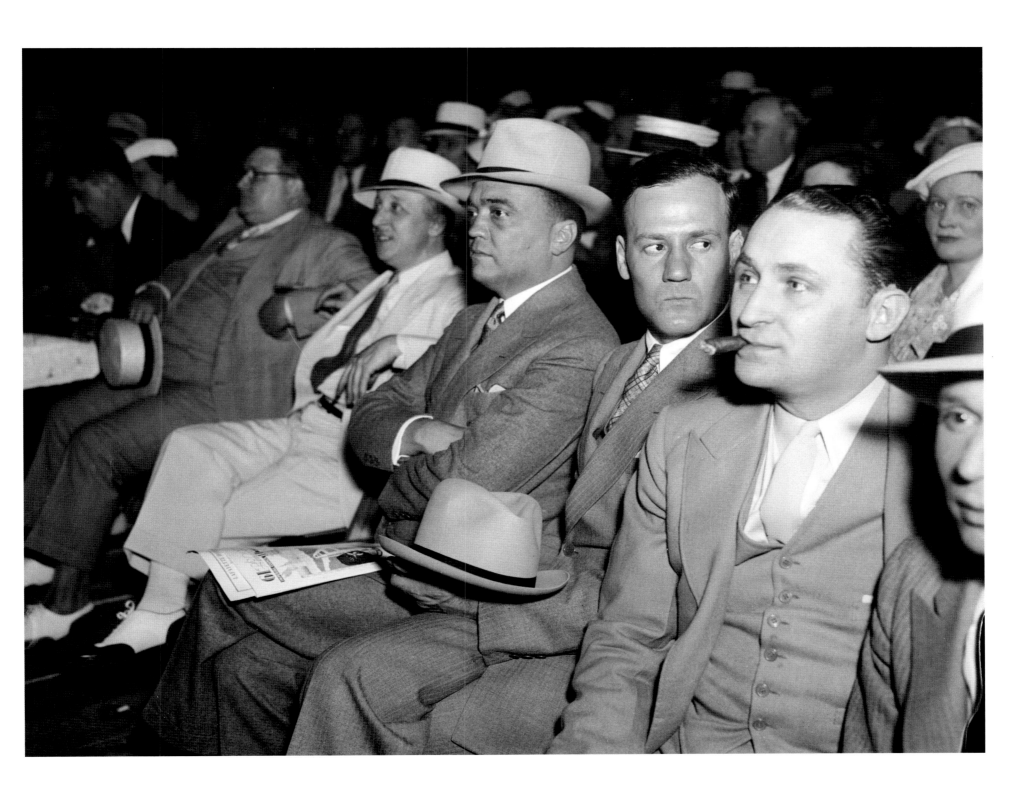

Thanksgiving at the Municipal Lodging House

NOVEMBER 26, 1936
PHOTOGRAPHER: UNKNOWN
NEW YORK, NEW YORK

Pictured are some of the hundreds of hungry, homeless men that were invited guests at the New York City Municipal Lodging House for the Thanksgiving Day dinner. Not only did they get a turkey dinner, but Bill Robinson and Jimmie Durante entertained them.

Charles "Lucky" Luciano, New York's reputed overlord of vice, is leaving the *Black Maria* handcuffed to a detective en route to Supreme Court from the Federal Detention Pen. Notice the handcuffs reflected in the shiny surface of the wagon. Luciano is charged with compulsory prostitution.

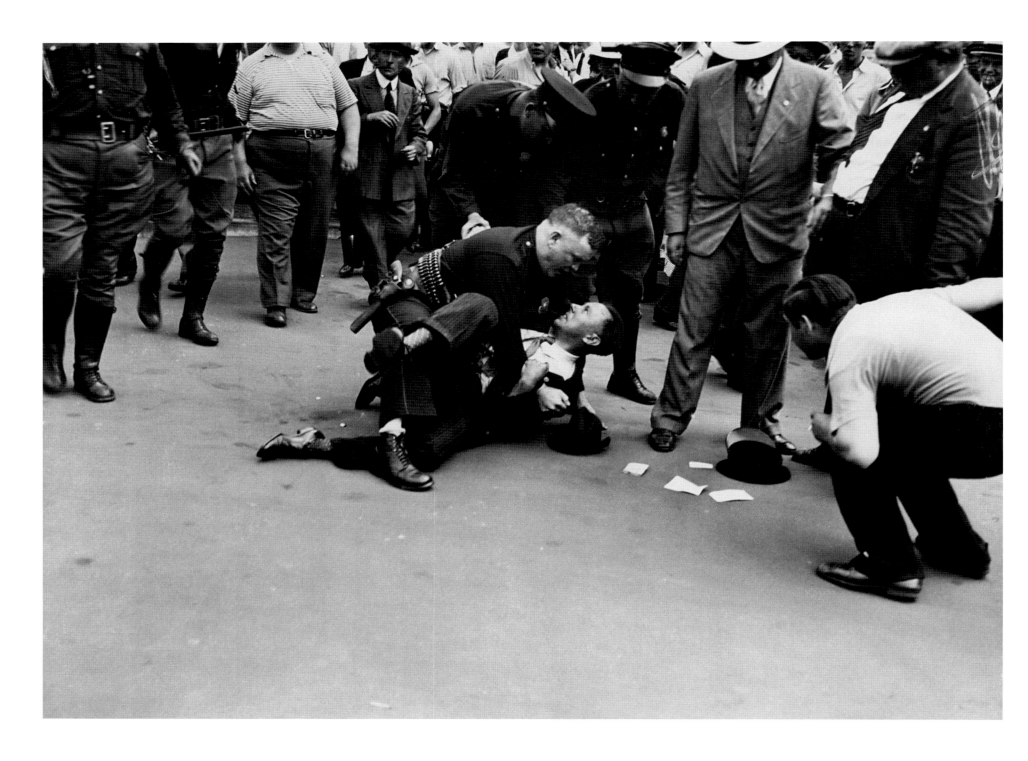

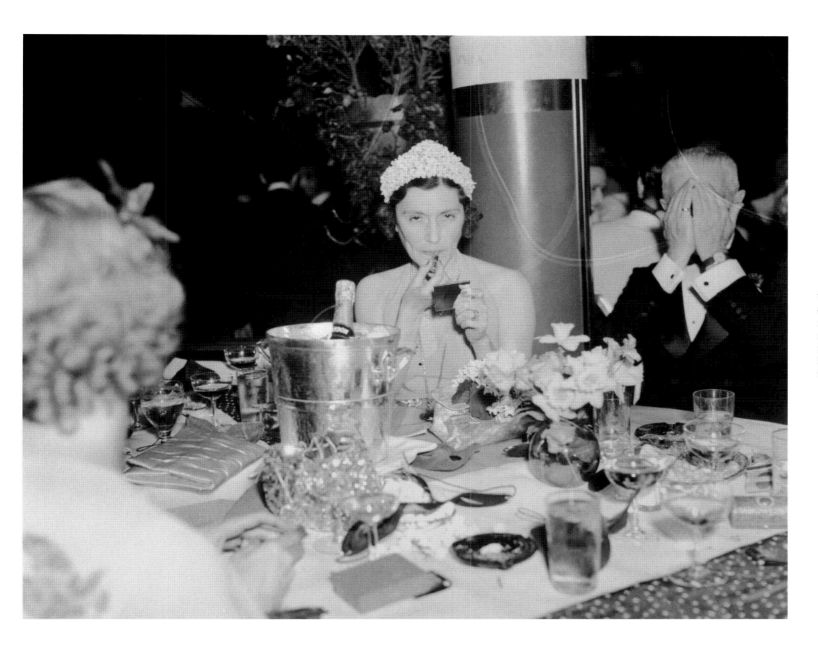

Portrait of Camera-Shy Lady

APRIL 17, 1937
PHOTOGRAPHER: UNKNOWN
NEW YORK, NEW YORK

Well-known for her avoidance of the camera, Mrs. J. Gordon Douglas wouldn't make an exceptional occasion of last night's Red, White and Blue Ball, given for Elsa Maxwell at the Waldorf Astoria. Mrs. Douglas is using her lipstick as a friend shields his face from the camera.

JULY 2, 1936
PHOTOGRAPHER: UNKNOWN
CAMDEN, NEW JERSEY

A Camden, N.J. policeman is shown wrestling with a striking RCA-Victor employee, outside the Camden plant. It is said the striker, who is one of hundreds daily picketing the plant, started the fight with the policeman. The April Grand Jury has been instructed to consider the strike.

Criminal Career Nipped in the Blood

MAY 21, 1937
PHOTOGRAPHER: UNKNOWN
NEW YORK, NEW YORK

Policemen at the scene of the murder of Johnny La Polla, Bronx policy operator, who stooped three gangland bullets while walking on East 102nd St., at 3 A.M. His enemies, police suggested, are legion. He had been arrested eleven times, and was being sought by police for a shooting.

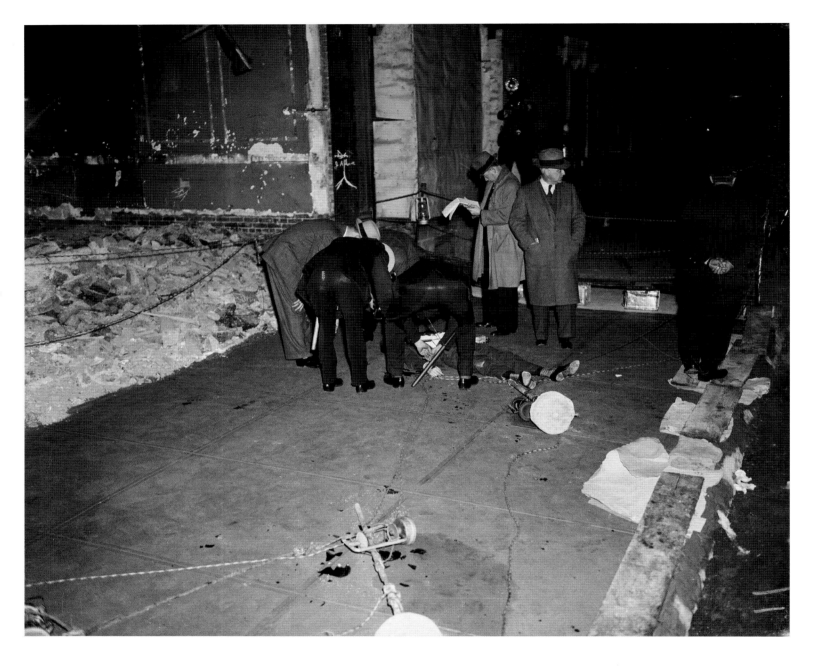

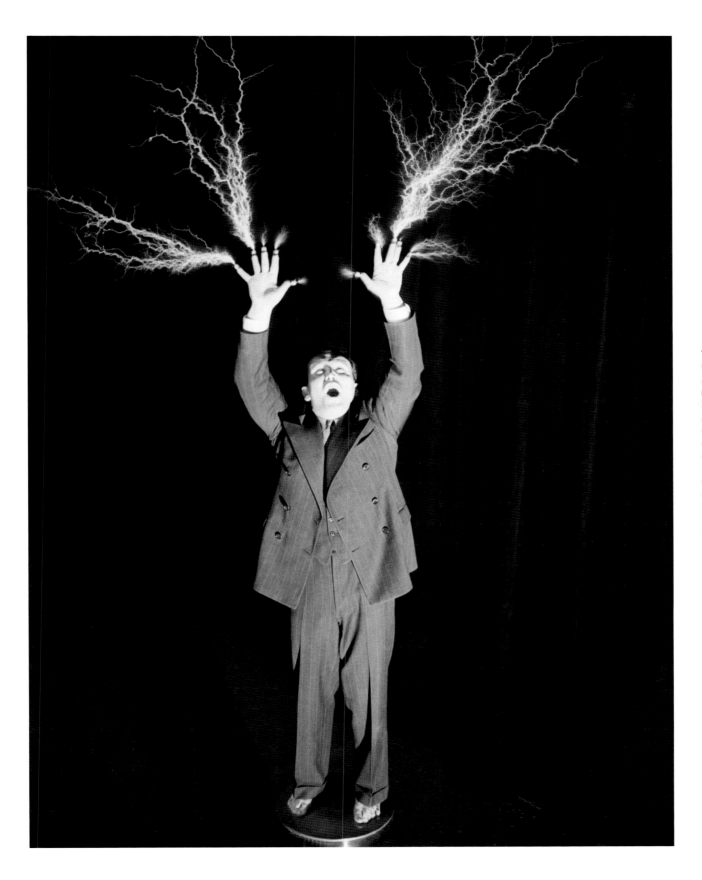

Sermons with a Shock

C. 1938
PHOTOGRAPHER: DAVID MCLANE
NEW YORK, NEW YORK

Touring evangelist sends million volts through body to demonstrate lectures. A stocky, dark-haired, youthful minister stands at a switchboard that has replaced his pulpit. He opens his service by using a pocket flashlight and a photo-electric cell to play "Onward Christian Soldiers" on a bugle. He deftly tosses together the contents of several test tubes to produce "Cold Light." He brings his sermon to a sensational climax by standing arms outstretched on a huge coil while a million volts of electricity pass through his body and crackle from his fingertips like lightning.

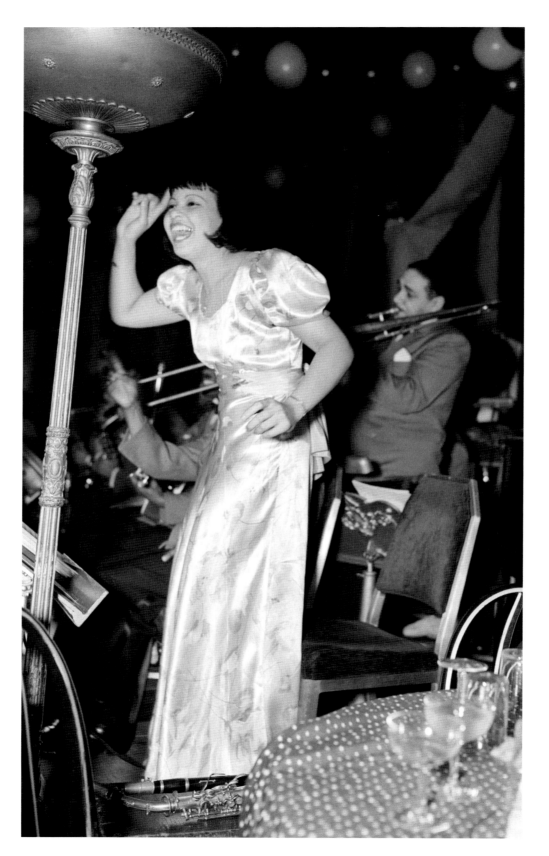

Edna May Harris, colored entertainer, pictured during her act at the Red, White and Blue Ball, given for Elsa Maxwell at the Waldorf Astoria last night, April 16th. A large crowd of socialites danced to the music of five orchestras in tribute to the famous giver of parties.

Where Were You on the Night of December Thirty-First?

As the clocks were tolling the hour of twelve on New Year's Eve Night, this scene was snapped in Times Square, New York. It seemed as if everybody in New York had flocked to the neighborhood, with horns, cowbells and all manner of noise makers to raise a raucous welcome to the New Year, and it seems incredible, looking at this mass of humanity, that there still were untold thousands within the city who were greeting the infant year with toasts and flowing bowls, in night clubs, restaurants, hotels and in private homes. Pa Knickerbocker put on his best bib and tucker to welcome the New Year; and from the moment that the clock pointed to the advent of the newest anno Domini, the old gentleman and his wife and their children whooped things up in a fashion that has not been known in almost a decade.

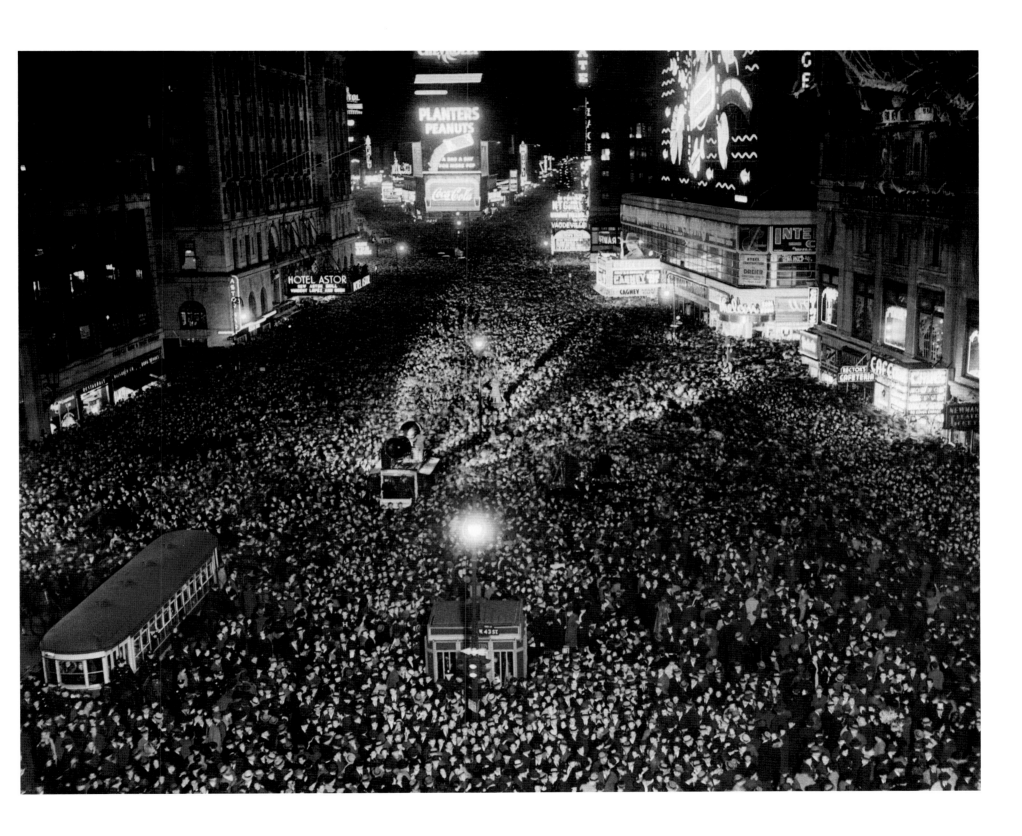

JUNE 22, 1938
PHOTOGRAPHER: UNKNOWN
NEW YORK, NEW YORK

Harlem crowds celebrate Joe Louis' victory
over Max Schmeling.

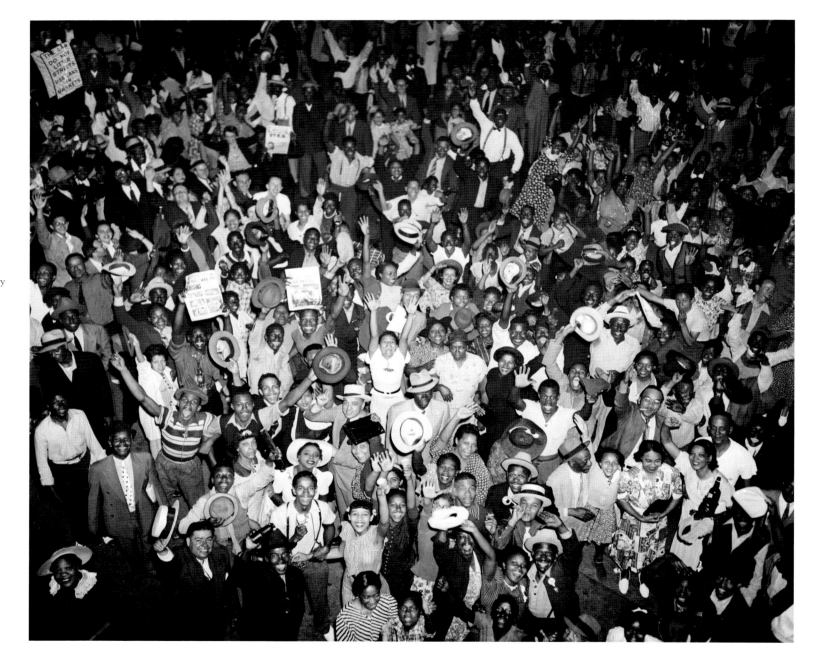

AUGUST 31, 1939
PHOTOGRAPHER: UNKNOWN
NEWPORT NEWS, VIRGINIA

Eleanor Roosevelt breaks a
bottle of champagne on the bow of the
S.S. *America* at its launch.

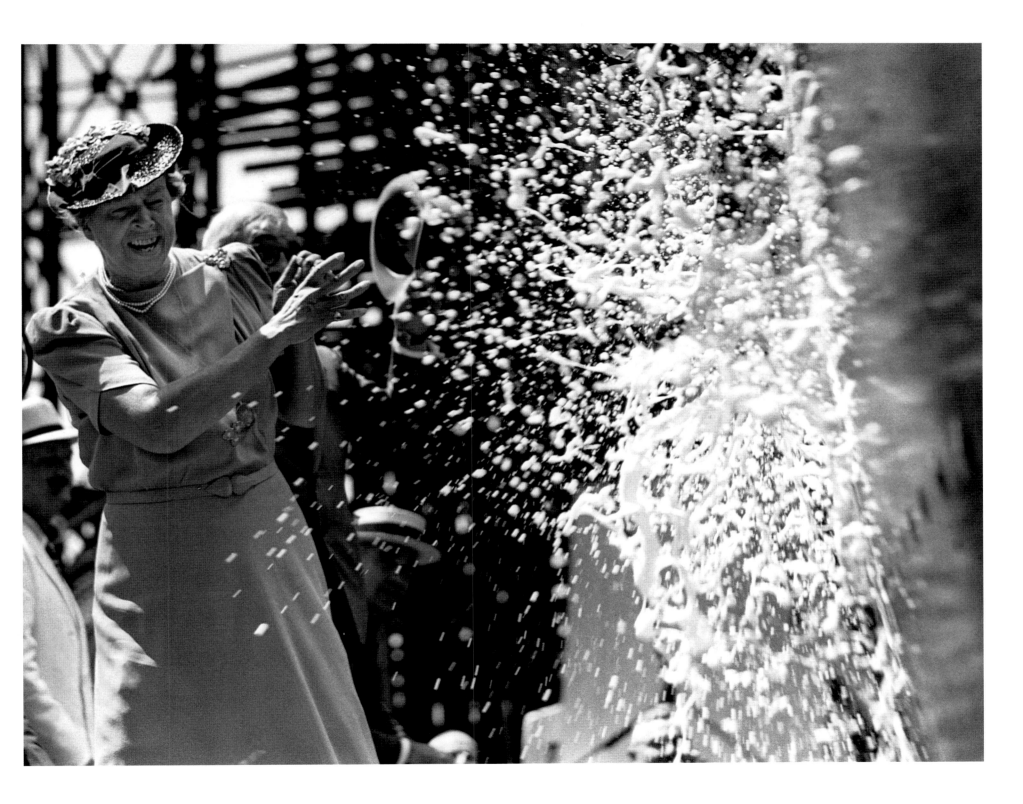

Our Bet is on the Law

FEBRUARY 21, 1939
PHOTOGRAPHER: UNKNOWN
NEW YORK, NEW YORK

A policeman and one of the demonstrators who picketed the meeting of the German-American bund at Madison Square Garden, N.Y., clash in the street outside the Garden. The policeman seems to have the upper hand. Because of bomb threats in an anonymous letter and announcements that leftist groups would picket the Nazi meeting in force, approximately 1,700 policemen had been ordered to surround the great sports arena, here. The bund meeting was called by its leader, Fritz Kuhn, who stated it was a "pro-American celebration of George Washington's Birthday."

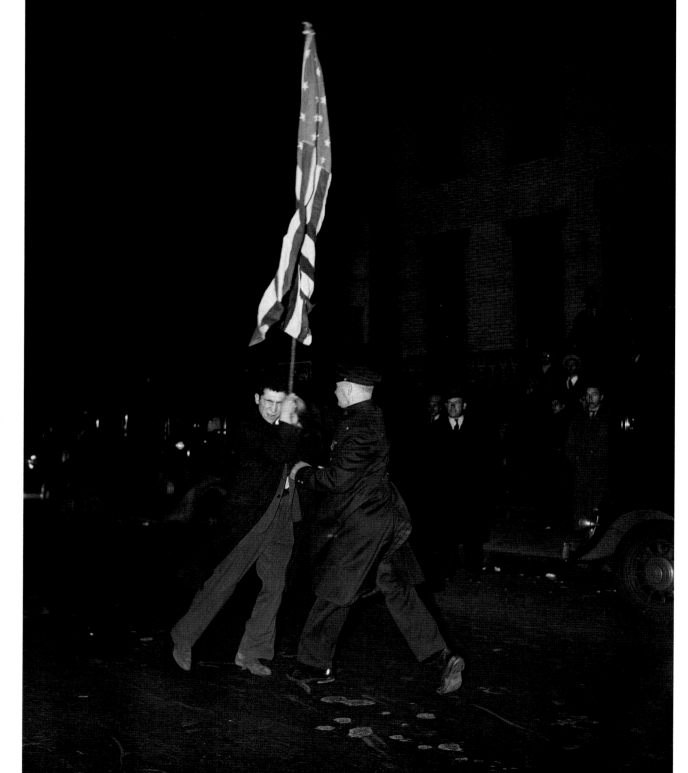

130

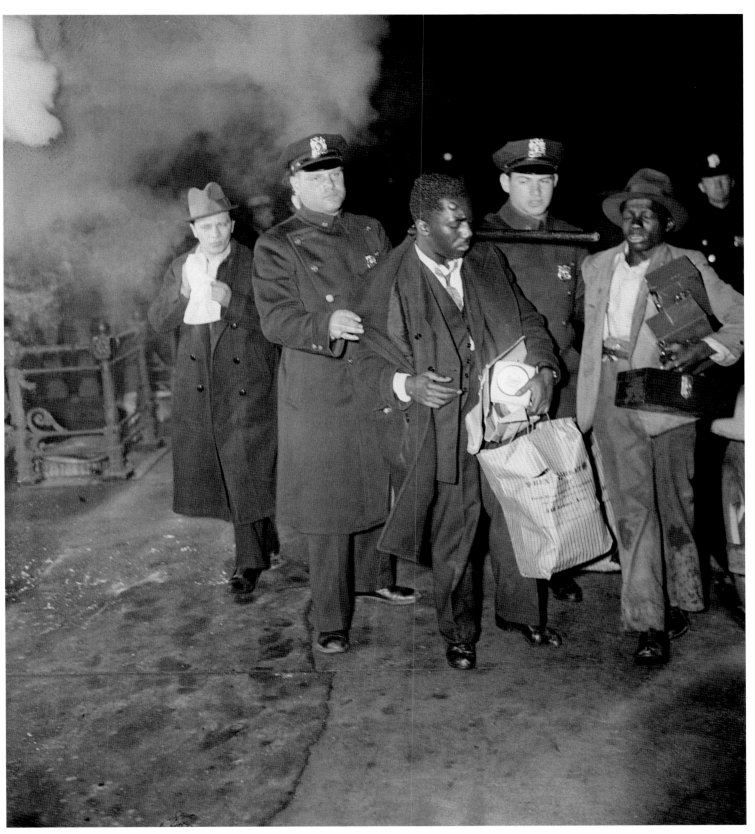

Police Escorting Suspect After Riot

MARCH 19, 1935
PHOTOGRAPHER: UNKNOWN
NEW YORK, NEW YORK

Rumors that a Negro boy—Lino Rivera—
had been beaten in a 5-10-25 cent store
on West 125th St. precipitated the worst
race riots that Harlem has seen in 25
years, and as heads were being cracked
with stones and clubs, and windows of
shops were being smashed by missiles,
looters took advantage of the fighting to
loot exposed window displays.

OCTOBER 1938
PHOTOGRAPHER: UNKNOWN
NEW YORK, NEW YORK

A tradition with Greta Garbo is that every time she visits New York, she dines at least once with Robert Rued, the former newspaperman, and friend of long standing, because he knew her before she rose to fame. But Greta is still as coy as ever where news photographers are concerned, so when the lens lads surprised her and Bob eating at the Manghery, the star hid her face with her hat—but she can be seen in the mirror behind Rued.

Three of Eight Held in Subway Thefts

1939
PHOTOGRAPHER: UNKNOWN
NEW YORK, NEW YORK

Held in connection with the alleged theft of $1,250,000 from the Independent Subway System were eight men, one of whom is pictured here at police headquarters.

JUNE 14, 1939
PHOTOGRAPHER: UNKNOWN
SAN FRANCISCO, CALIFORNIA

Children in parade at the Rodeo in
San Francisco, Calif.

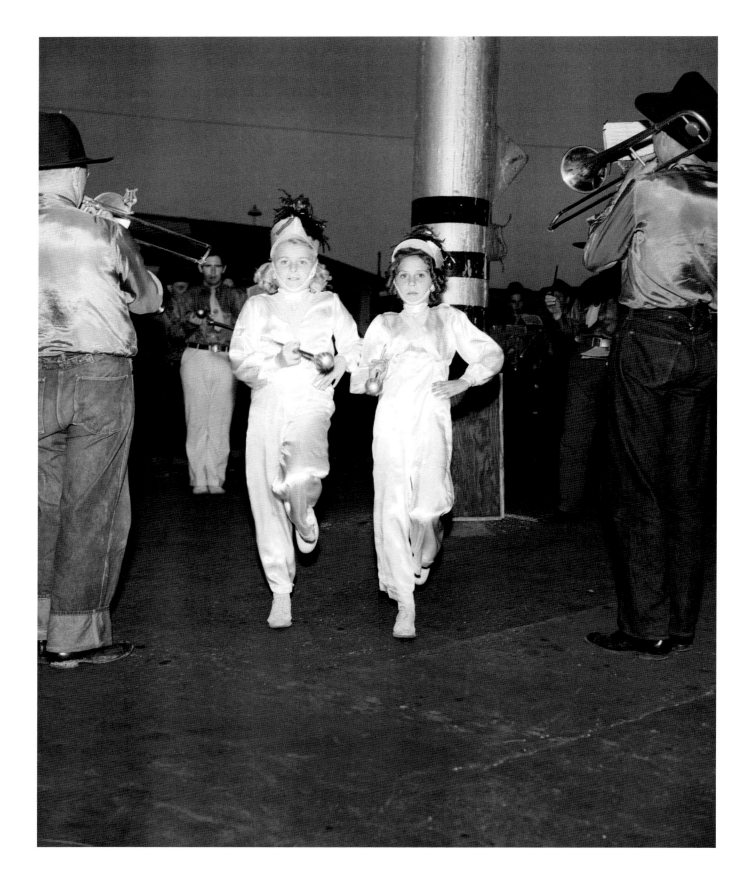

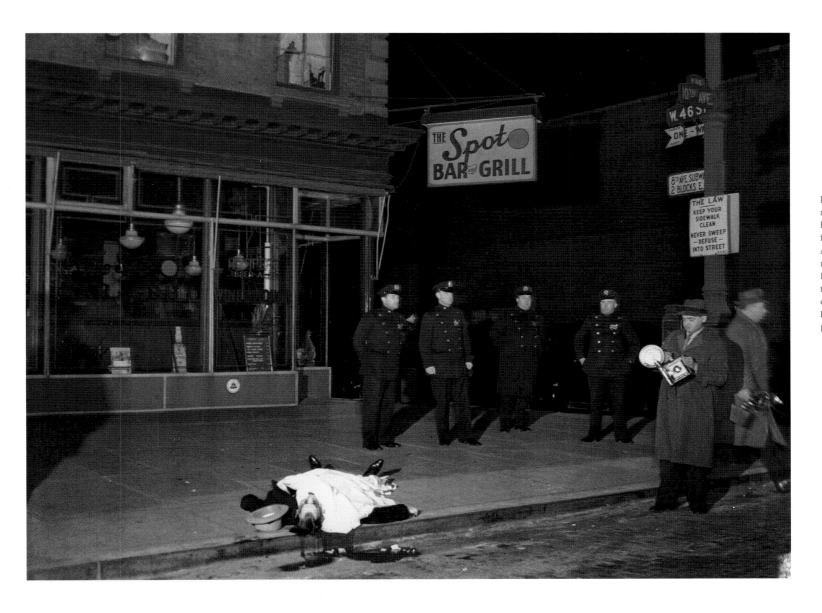

DECEMBER 9, 1939
PHOTOGRAPHER: UNKNOWN
NEW YORK, NEW YORK

David (the Beetle) Beadle, longshore-man, married and two children, former Hell's Kitchen Boy, was put on the spot in front of the Spot beer tavern at 651 10th Avenue, New York City, early Saturday morning at 1:30 A.M. by several men seen leaving the scene in a taxicab. The gun that was used was found thrown under a car a half-a-block away. Author's note: Photographer Weegee (Arthur Fellig) is pictured on right.

Two alleged trigger men of Murder, Inc.,
went on trial in Brooklyn, in a court
swarming with officers to prevent any at-
tempt to deliver or silence them. Here are
Harry (Happy) Malone (left), and Frank
(The Dasher) Abbadando, the two defen-
dants on trial for murder, in court as the
trial got underway.

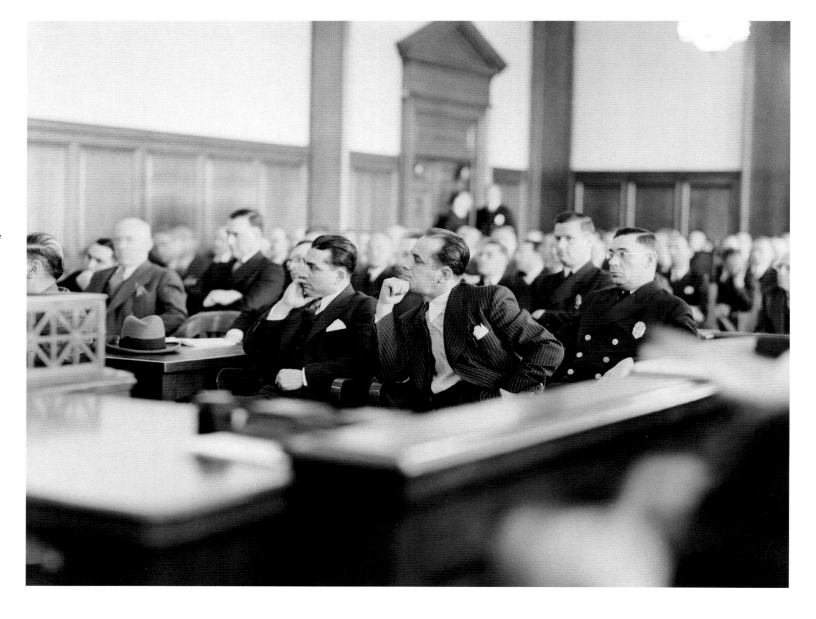

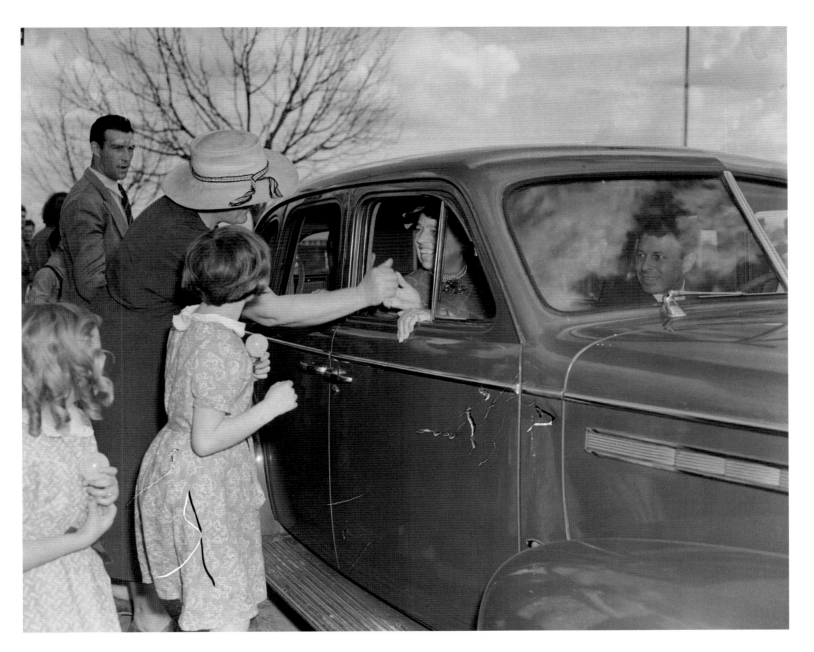

First Lady Visits Camp of Migratory Workers

APRIL 30, 1940
PHOTOGRAPHER: UNKNOWN
VISALIA, CALIFORNIA

Mrs. Franklin D. Roosevelt is followed by
the inhabitants as she inspects the well-
kept FSA Farmersville camp for migratory
workers after making a tour of the worst
of California's camps for dust bowl
refugees.

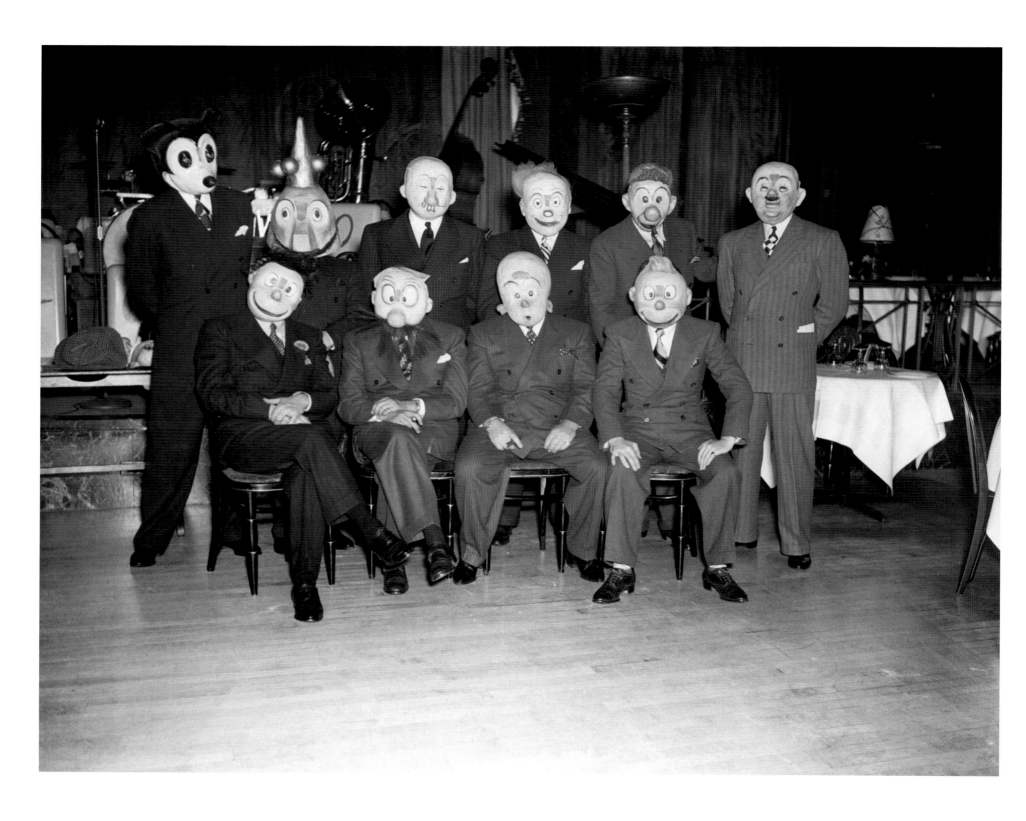

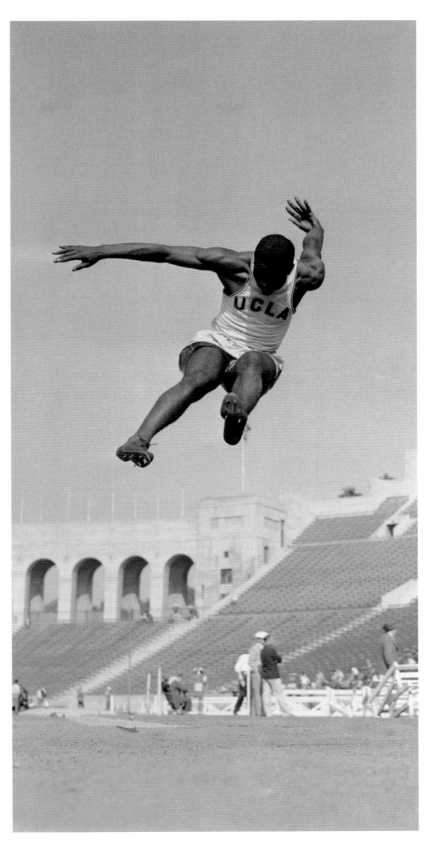

MAY 25, 1940
PHOTOGRAPHER: UNKNOWN
LOS ANGELES, CALIFORNIA

Midair action shot of UCLA student
Jackie Robinson winning an event at a track
meet at the Los Angeles Coliseum.

Now You See 'Em Now You Don't

APRIL 19, 1940
PHOTOGRAPHER: UNKNOWN
NEW YORK, NEW YORK

Here are some of the notables who will
appear at the April 25th Luncheon of the
Banshees when that group plays host to
many of the 1940 Republican and
Democratic presidential candidates and
several hundred newspaper publishers
and editors who will be in New York for
the American Newspaper Publishers
Convention. The ten pose (at top), as car-
toon characters, left to right standing are:
Lanny Ross, singer, as "Mickey Mouse";
Otto Soglow, cartoonist-creator of "The
Little King," as "The Little King"; Alex
Raymond, creator of "Flash Gordon," as
"Wimpy"; humorist Arthur "Bugs" Baer, as
"Jiggs"; Russ Westover, cartoonist-creator
of "Tillie the Toiler," as "Mac," Tillie's
boyfriend; and Ole Olsen, stage comic, as
"Judge Puffle." Seated, left to right: Jimmy
Hatlo, creator of "They'll Do It Every
Time," as "Fritz"; Jack Benny, famous radio
and screen comedian, as "The Captain";
radio comic Lou Costello, as "Henry"; and
Fred Waring, bandmaster, as "Hans."

JANUARY 18, 1940
PHOTOGRAPHER: UNKNOWN
PALM BEACH, FLORIDA

Countess Haugwitz Reventlow is seated
with a poodle in her lap as she watches a
tennis match.

Wilkie Welcomed in St. Louis

OCTOBER 18, 1940
PHOTOGRAPHER: UNKNOWN
ST. LOUIS, MISSOURI

Wendell L. Wilkie waving amid a shower of
confetti as he rode through St. Louis during
his second campaign tour of the middle west.

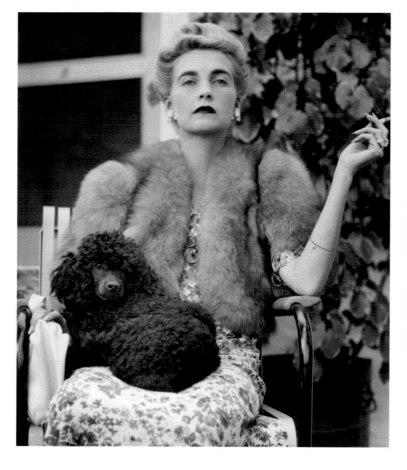

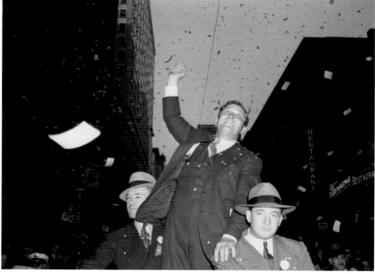

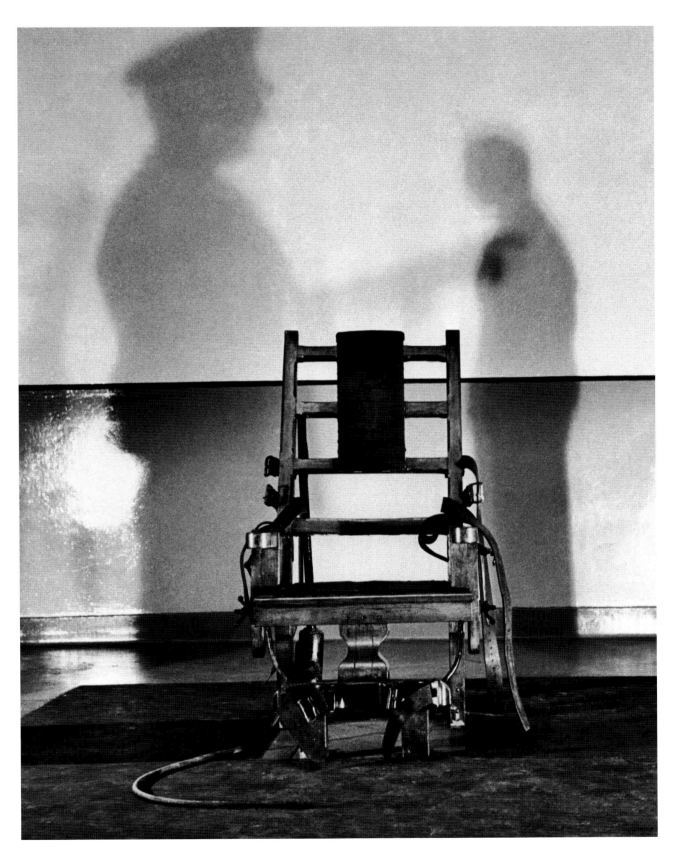

OCTOBER 18, 1940
PHOTOGRAPHER: UNKNOWN
OSSINING, NEW YORK

In this grim, business-like chair, hundreds of slayers, among them Judd Gray and Ruth Snyder, the only woman to be electrocuted in New York State, have paid the supreme penalty to society during Warden Lawes' incumbency. Lawes, noncommittal on the problem of capital punishment, has helped prepare condemned prisoners mentally and spiritually for their shuffle down "the last mile."

Titleless But Not Undecorated

JUNE 20, 1940
PHOTOGRAPHER: UNKNOWN
THE BRONX, NEW YORK

Arturo Godoy, the Chilean challenger, walks to his dressing room after futile fight to lift Joe Louis' heavyweight ring title. Arturo weathered almost seven rounds at the Yankee Stadium without much damage—using the same crouch and cling tactics which carried him through 15 rounds of his first fight with the Brown Bomber. But Joe caught him right as the seventh round was ending. Arturo dropped. From then on it was a question of time—and not much time either. Arturo was dropped twice in the next round and referee Billy Cavanaugh stopped the bout to award Joe Louis technical knockout victory in one minute 24 seconds of the eighth round. Arturo may not have a title—but he is not entirely undecorated—notice his battered face.

NOVEMBER 14, 1940
PHOTOGRAPHER: UNKNOWN
HOLLYWOOD, CALIFORNIA

Long shots showing Carthay Circle Theater and searchlights for the premiere of Charlie Chaplin's film, *The Great Dictator*.

FEBRUARY 1, 1940
PHOTOGRAPHER: UNKNOWN
POMPTON LAKES, NEW JERSEY

Joe Louis—Fight poses.

Making of a Rookie

OCTOBER 1940
PHOTOGRAPHER: UNKNOWN
FORT SLOCUM, NEW YORK

This group of raw recruits just left the ferry to land at Fort Slocum. The curtain will now be lowered while the men are examined and outfitted. Fort Slocum is the receiving and equipping station after which the rookies are sent to Army bases in the U.S. possessions.

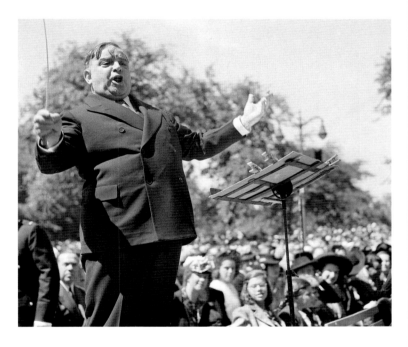

MAY 18, 1941
PHOTOGRAPHER: UNKNOWN
NEW YORK, NEW YORK

Mayor Fiorello La Guardia of New York City, takes the band leader's baton and leads the crowd, while he joins in, singing patriotic songs, on the mall at Central Park today. The Mayor spoke to the huge crowd which jammed the park in commemoration of "I am an American Day," which was proclaimed by President Roosevelt. The day was set aside to honor 2,340,000 American youths who reached their majority during the last year and 300,000 aliens who became citizens during the same period.

NOVEMBER 8, 1941
PHOTOGRAPHER: UNKNOWN
NEW YORK, NEW YORK

Rita Hayworth and Marlene Dietrich, Columbia Pictures glamour stars, depart for Hollywood after a New York visit, during which they shone at various affairs—the big town is a bit duller now.

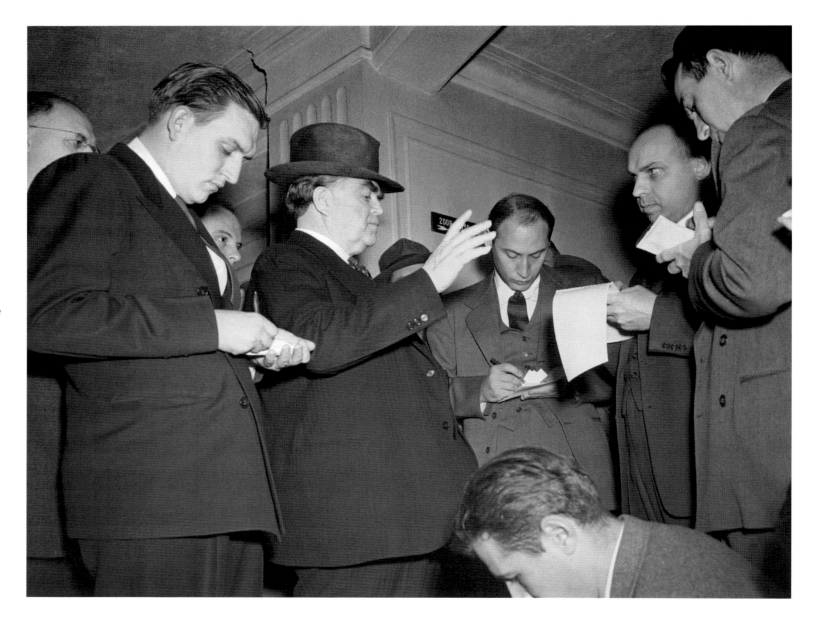

John L. Lewis, president of the CIO's United Mine Workers, is pictured as he spoke to reporters yesterday announcing that the eleventh hour conference which President Roosevelt had forced between steel executives and representatives of the UMW collapsed. Work stoppage in the captive mines, employing 53,000 men, is expected to bring added pressure for immediate and drastic antistrike legislation in Congress.

MAY 16, 1941
PHOTOGRAPHER: UNKNOWN
NEW YORK, NEW YORK

Commander J.S. Baylis, of the Coast
Guard, captain of the port of New York, is
questioned by newspapermen at the
Normandie's pier after ten armed U.S.
Coast Guardsmen were placed aboard
the huge French luxury liner, *Normandie*.
Other French ships in harbors throughout
the nation were similarly seized.

DECEMBER 7, 1941
PHOTOGRAPHER: UNKNOWN
NEW YORK, NEW YORK

Crowds in Times Square watch bulletin board for latest news of war moves by Japan in Pacific, after Nipponese planes had bombed U.S. bases. Soldiers in front row are particularly interested, for this news means their leaves are cancelled.

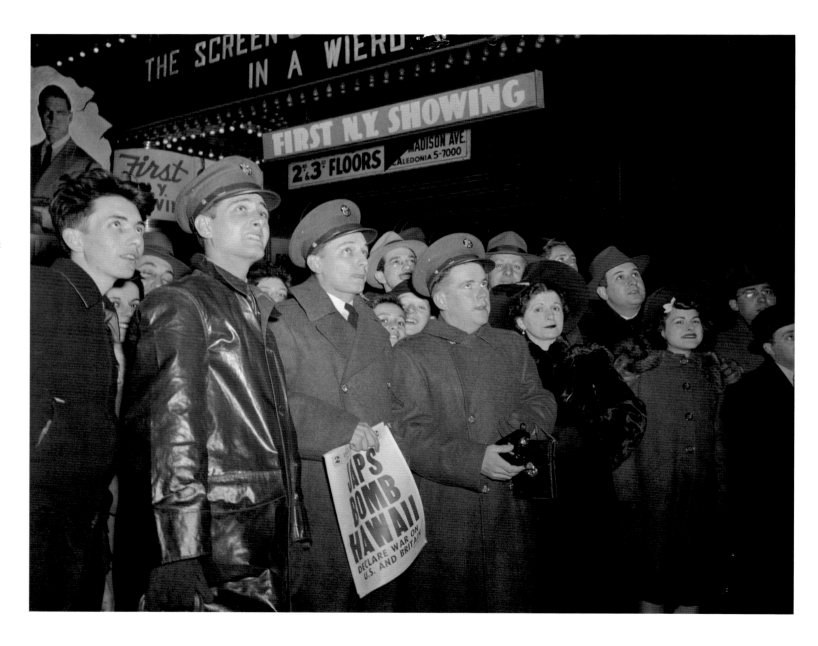

DECEMBER 1941
PHOTOGRAPHER: UNKNOWN
BROOKLYN, NEW YORK

Carlo Barone cringes pop eyed as he
hears Judge Liebowitz in Brooklyn
County court sentence him to die in the
electric chair for murdering Pietro
Morsellino. Liebowitz in passing sentence
stated that Barone was responsible for
18 murders.

DECEMBER 26, 1941
PHOTOGRAPHER: UNKNOWN

When the air raid alarm sounds, head for the room you have selected and equipped as a shelter. A cellar room usually makes an efficient shelter, particularly if the ceiling is supported by numerous columns.

Mobster Carried to the Grave

NOVEMBER 14, 1941
PHOTOGRAPHER: UNKNOWN
GLENDALE, QUEENS, NEW YORK

The simple pine box containing the body of Abe Reles, mobster who fell to his death from a sixth floor hotel window, is carried to a grave in Mount Carmel cemetery, Glendale, Queens.

Extending his hitting streak to 44 games with his swing against the Boston Red Sox, Joe DiMaggio ties Willie Keeler's major league record set in 1897.

Approximately three of the seven weeks training course of the U.S. Marine recruits at Parris Island are spent on the rifle range where the future leathernecks are trained in the use of weapons with which a Marine is normally armed. This is followed by a week of advanced instruction in combat work and practice with the bayonet. Here, recruits undergo calisthenics under arms.

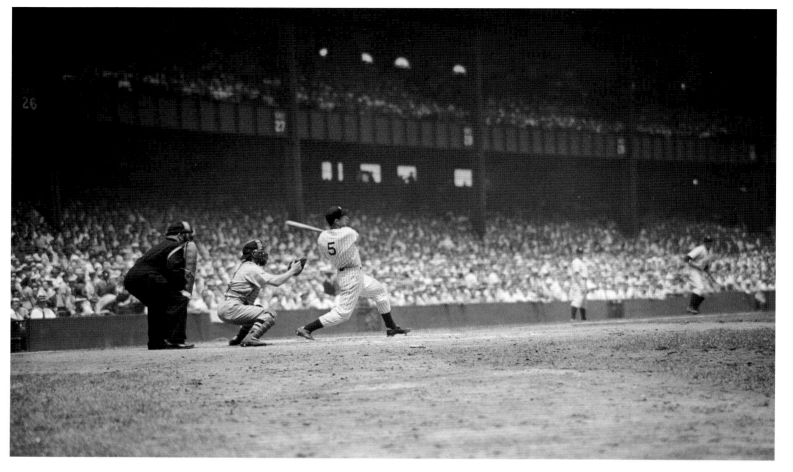

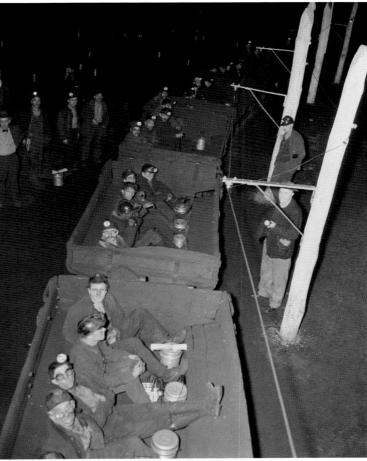

President Leaves Capitol After Asking War Declaration

DECEMBER 8, 1941
PHOTOGRAPHER: UNKNOWN
WASHINGTON, D.C.

President Franklin D. Roosevelt, his face grim, leaves the Capitol after asking the joint session of Congress for a declaration of war against the Japanese Empire. At left is Brigadier General Edwin Watson, White House aid. On the President's left is his son, Captain James Roosevelt, and Captain John Beardall, Naval aide to the President.

NOVEMBER 21, 1941
PHOTOGRAPHER: UNKNOWN
GARY, WEST VIRGINIA

Non-striking miners at No. 6 mine of United States Coal and Coke Colo., at Gary, descend into earth on Thanksgiving morning for work as usual despite spreading strike. This and other Gary workings were only mines in captive territory to operate, the miners having voted to go to work on this holiday to hold up their part in defense production.

Young Americans wait in line at the Navy Recruiting Office in Boston Monday, eager to enlist for service following Japan's attack on the United States. Before Japan's Sunday aggression, enlistments for the Navy had dropped to a point where draftees were being considered for service in that branch.

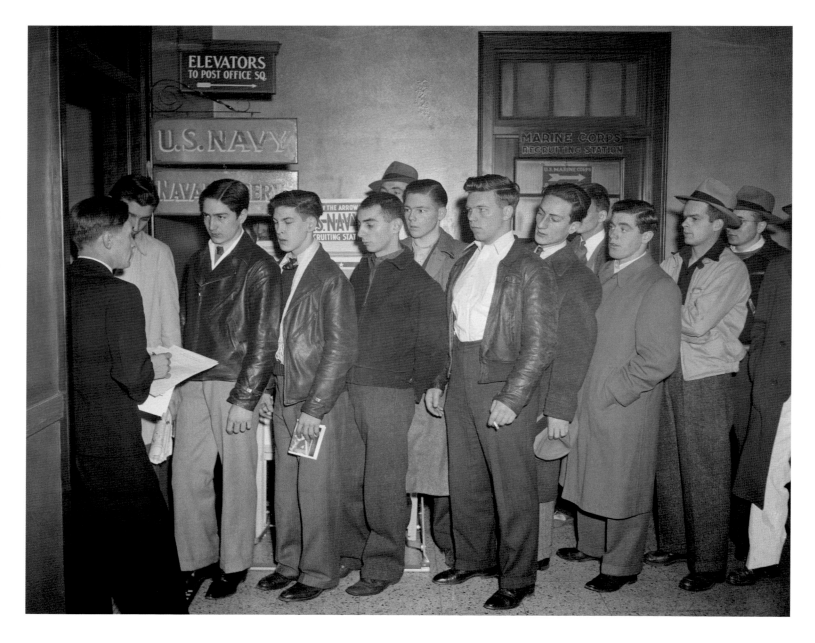

NOVEMBER 24, 1941
PHOTOGRAPHER: UNKNOWN
NEW YORK, NEW YORK

Robert J. Howard, left, of Buffalo, N.Y., and Charles R. Rose, Iaeger, West Virginia, survivors of the torpedoed United States destroyer *Reuben James*, enjoy cigars on the receiving ship *Seattle*, Pier 92, North River, after they and 35 other of the 45 survivors of the ill-fated destroyer were landed late November 24th.

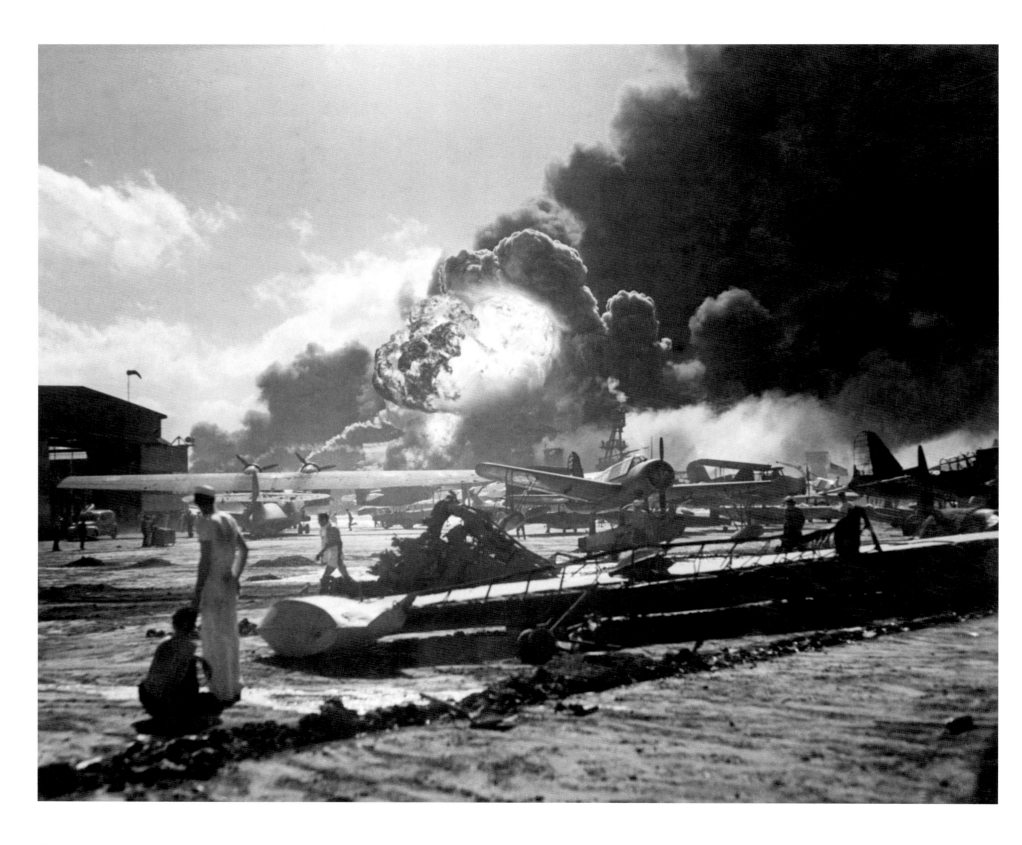

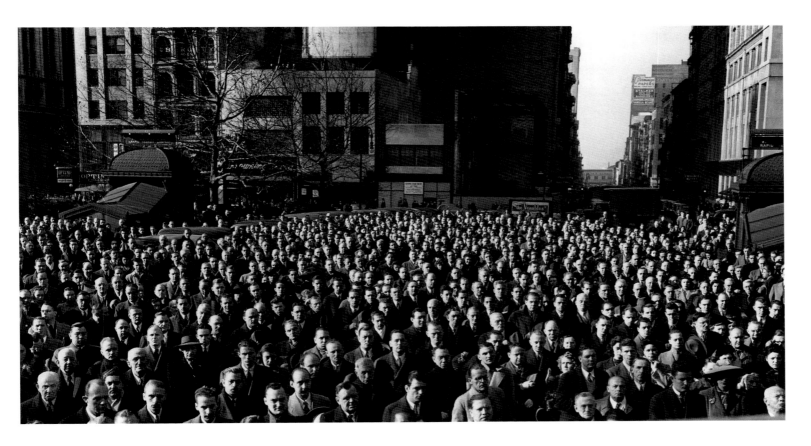

DECEMBER 8, 1941
PHOTOGRAPHER: UNKNOWN
CITY HALL PARK, NEW YORK

Crowd gathers to listen via radio
as President Franklin D. Roosevelt asks
Congress to declare war on Japan.

DECEMBER 7, 1941
PHOTOGRAPHER: UNKNOWN
FORD ISLAND, HAWAII

Against a background of smoke and
flame, the wreckage-strewn Pearl Harbor
Naval Air Station is shown after one of
the sneak attacks by Japanese bombers.
Note the wing of the blasted patrol
bomber in the foreground. The huge
ball of flame in the background came
from an explosion that happened just
as this photo was taken.

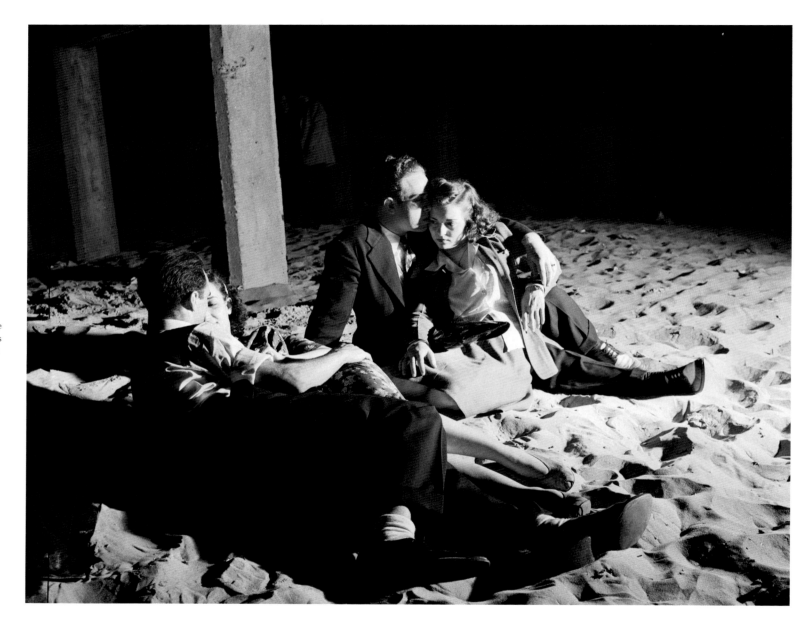

JUNE 5, 1942
PHOTOGRAPHER: UNKNOWN
CONEY ISLAND, NEW YORK

There are many who find the dimout no inconvenience at all, but a distinct improvement. Romance flourishes on the unlighted beach, and many engagements have already resulted from the combination of dimout and moonlight. Seaside equivalent of lover's lane is a strip of beach near the pier, which is known to the younger set as Necker's Neck.

FEBRUARY 9, 1942
PHOTOGRAPHER: UNKNOWN
NEW YORK, NEW YORK

Smoke and flame envelope the former French luxury liner *Normandie* as she lists at her pier at the foot of West 50th Street, after a disastrous five alarm fire.

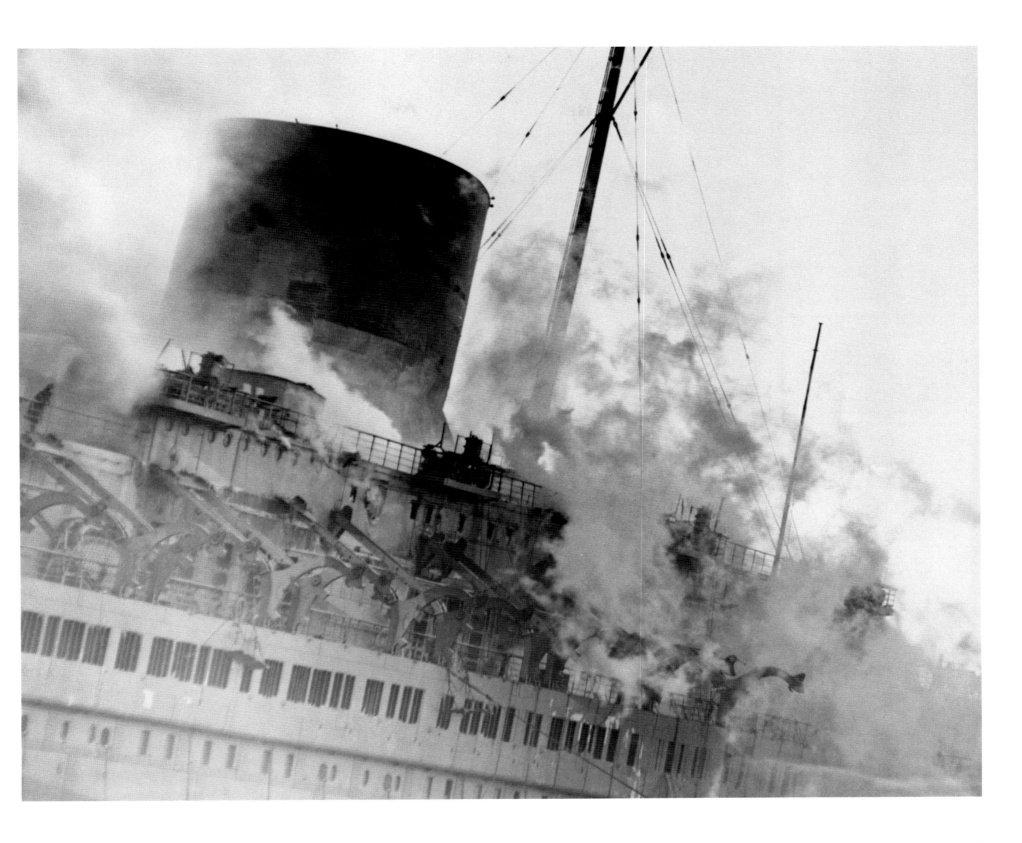

APRIL 24, 1943
PHOTOGRAPHER: UNKNOWN
LOS ANGELES, CALIFORNIA

Mrs. G.H. Macomber, sponsor, crashes a bottle of champagne in Der Fuehrer's face to launch a liberty ship at the California Shipbuilding Corp. yards, Los Angeles, on Hitler's birthday.

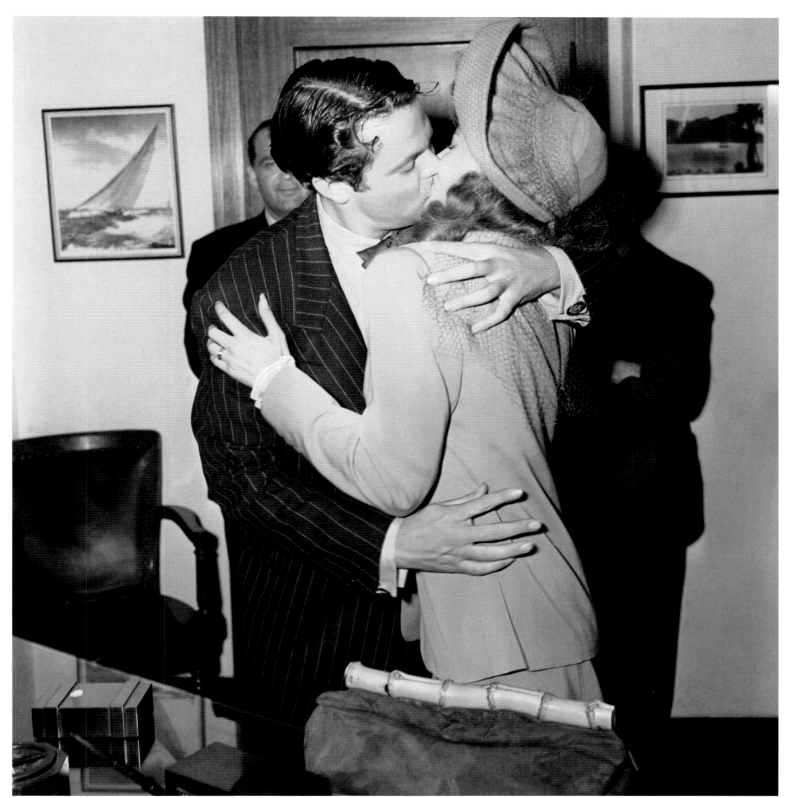

Rita Hayworth
Marries Orson Welles

SEPTEMBER 9, 1943
PHOTOGRAPHER: UNKNOWN
SANTA MONICA, CALIFORNIA

Orson Welles, actor, writer, director, producer,
and magician, embraces his bride, actress
Rita Hayworth, after a surprise wedding.

MARCH 21, 1943
PHOTOGRAPHER: UNKNOWN
NEW YORK, NEW YORK

Crowding through the tiny doorway of a Delancy Street grocery store, pushing their way to the counter, these New Yorkers fight to buy butter after learning that OPA [Office of Price Administration] has banned sales on the precious yellow stuff for the week beginning March 22, after which it will be rationed. The city's butter supply melted as hundreds rushed to neighborhood stores today to beat the midnight sales deadline.

JUNE 9, 1943
PHOTOGRAPHER: UNKNOWN
LOS ANGELES, CALIFORNIA

Cruising through the streets of Los Angeles in search of zoot suit clad youngsters who have been attacking servicemen throughout the city, soldiers triumphantly hold aloft pieces of the "glad plaid" they captured when they met and mauled their antagonists. As a result of the undeclared war between boy gangs and servicemen, the Navy, Marines, and Coast Guard have declared the entire city out of bounds.

AUGUST 3, 1943
PHOTOGRAPHER: UNKNOWN
NEW YORK, NEW YORK

Rounded up in Harlem for looting and rioting, this young Negro lad, one of 360 held, is shown as he arrived at police headquarters adorned in a top-hat and jacket, probably gotten the easy way. Six were killed and 200 were hurt in the Harlem riot that started early last night.

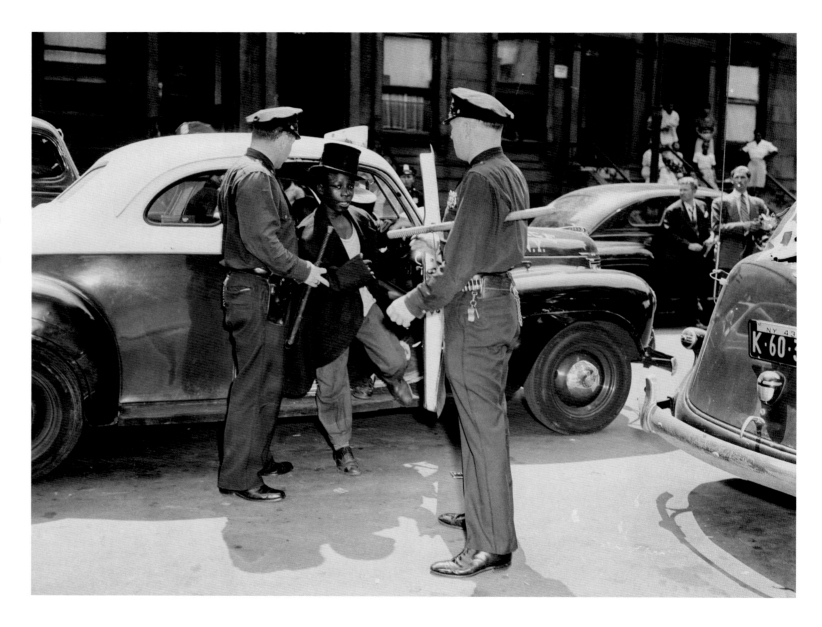

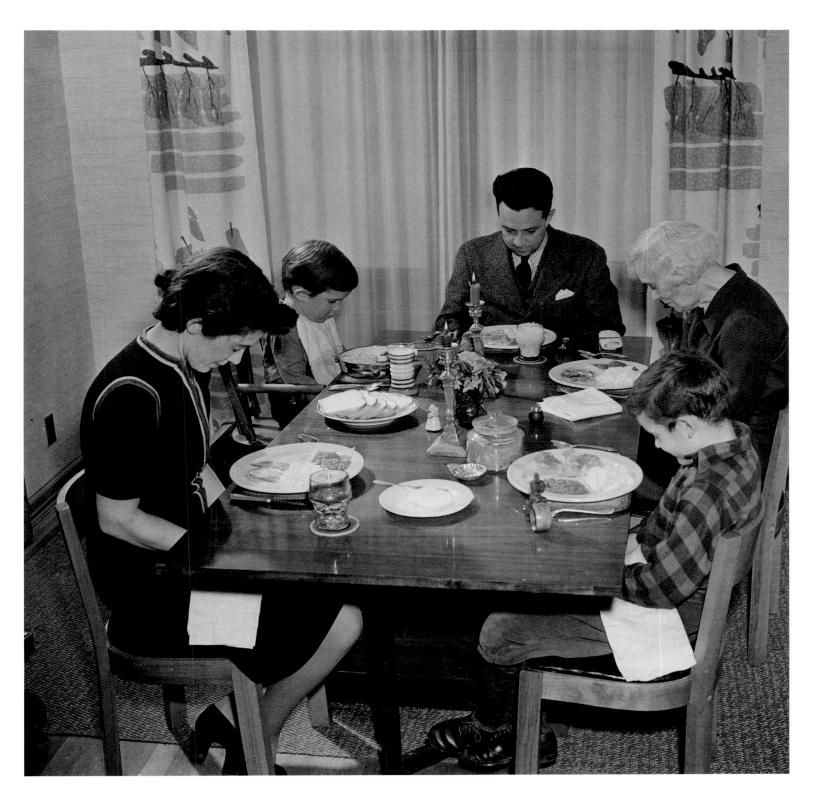

Dinner on the Home Front

JANUARY 8, 1943
PHOTOGRAPHER: UNKNOWN

Though there is less sugar now, and no second cups of coffee, this American family still has a plentiful repast in the comfort of their home. Typical of most Americans, they appreciate the need for wartime rationing and say, "grace," for what they are privileged to have.

Well, it was a gala day in Pasadena when crooner Frank Sinatra arrived in town on his way to Hollywood to make pictures, (so they tell us!). Here, on a stepladder (marked "RKO," strangely enough!), Sinatra (recently nicknamed "Swoonatra") looks puzzled as he contemplates a crowd of autograph-seeking fans. Hey, Bing, you'd better oil up those notes!

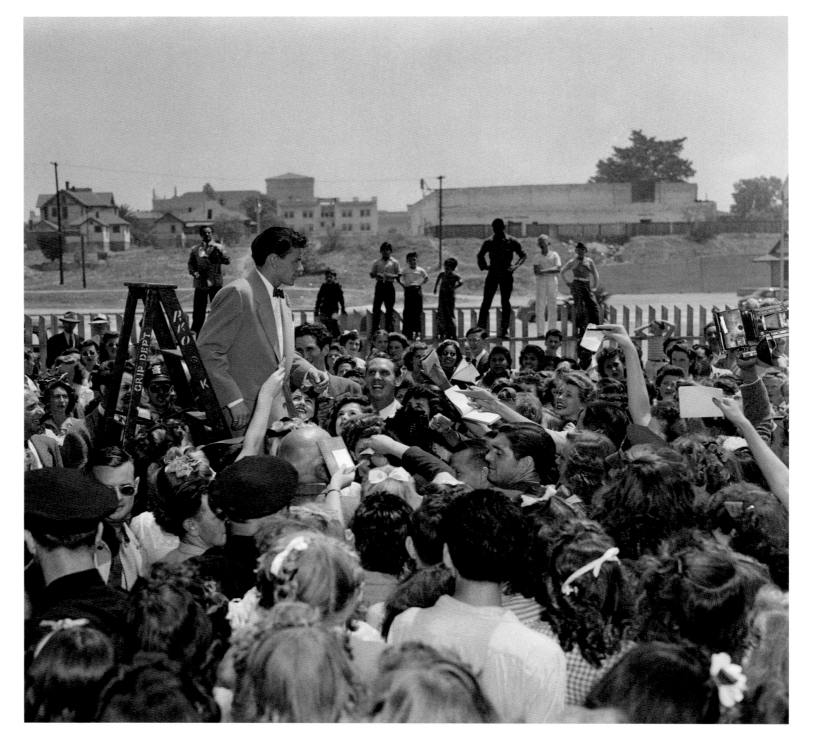

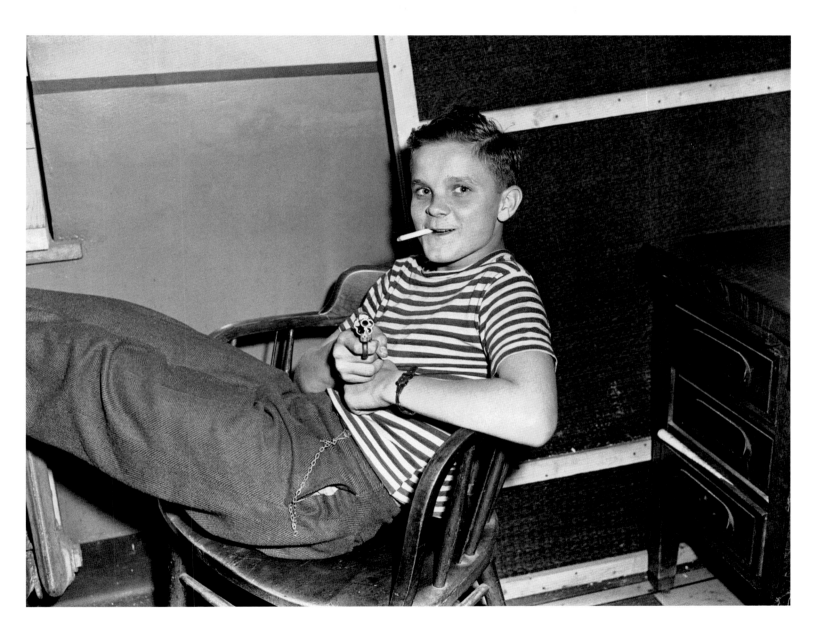

AUGUST 1, 1943
PHOTOGRAPHER: UNKNOWN
NEW YORK, NEW YORK

Assuming a typical "movie hard boiled" pose here, after he was apprehended following a hold up, is Robert (Baby Face) Naschik, 16, who admits to 30 robberies and burglaries. The youthful desperado caught from descriptions given to police by patrons of a bar and grill which he had victimized, says that he escaped from a New Jersey State Reformatory on July 5th.

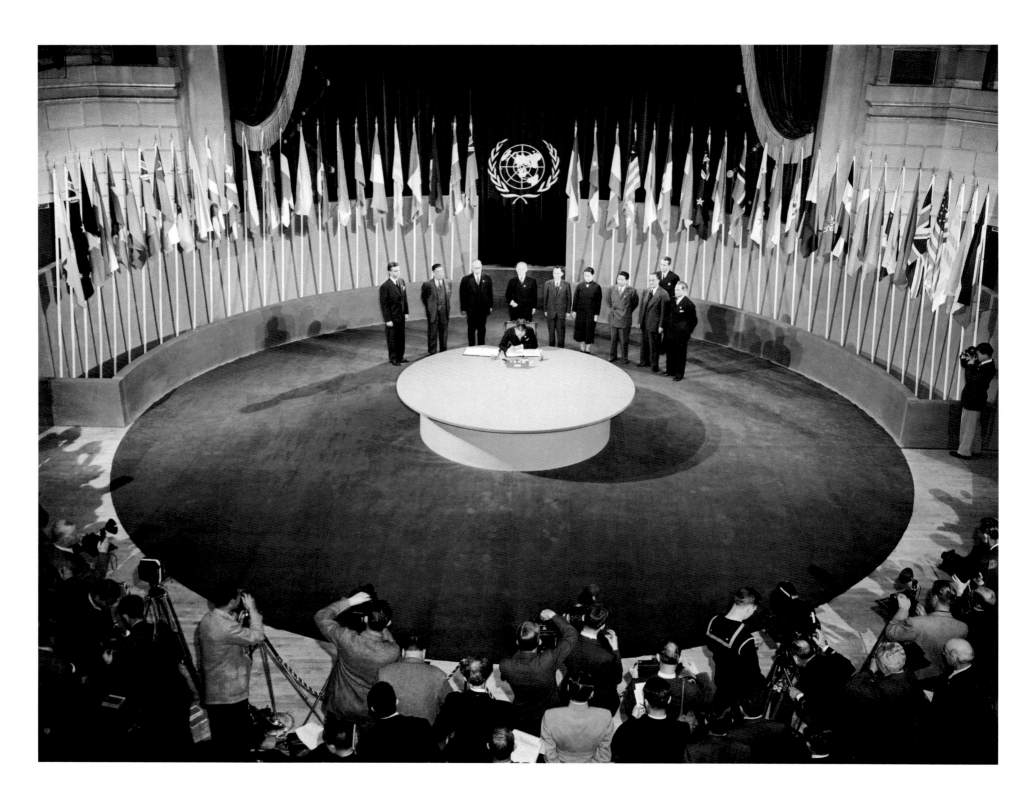

MAY 1943
PHOTOGRAPHER: WEEGEE (ARTHUR FELLIG)
NEW YORK, NEW YORK

Woman dances with "Shorty" at
Sammy's Bowery Nightclub, also known as
the Poor Man's "Stork Club."

JUNE 28, 1943
PHOTOGRAPHER: UNKNOWN
SAN FRANCISCO, CALIFORNIA

China, the first of the United Nations to
suffer from Fascist aggression, is the first
to sign the UNCIO Charter designed to
prevent wars in the future. V.K. Wellington
Koo, Chairman of the Chinese Delegation,
signs here for China, as his countrymen
look on.

Running over this obstacle is quite a trick, but these WAACs in training do it in good time. It is not all parades and desk work for these girls. There is plenty of muscle work to do before they get in shape for actual assignments.

Boxer Henry "Hank" Armstrong (left) avoids the right hook of Beau Jack in a non-title lightweight bout at Madison Square Garden.

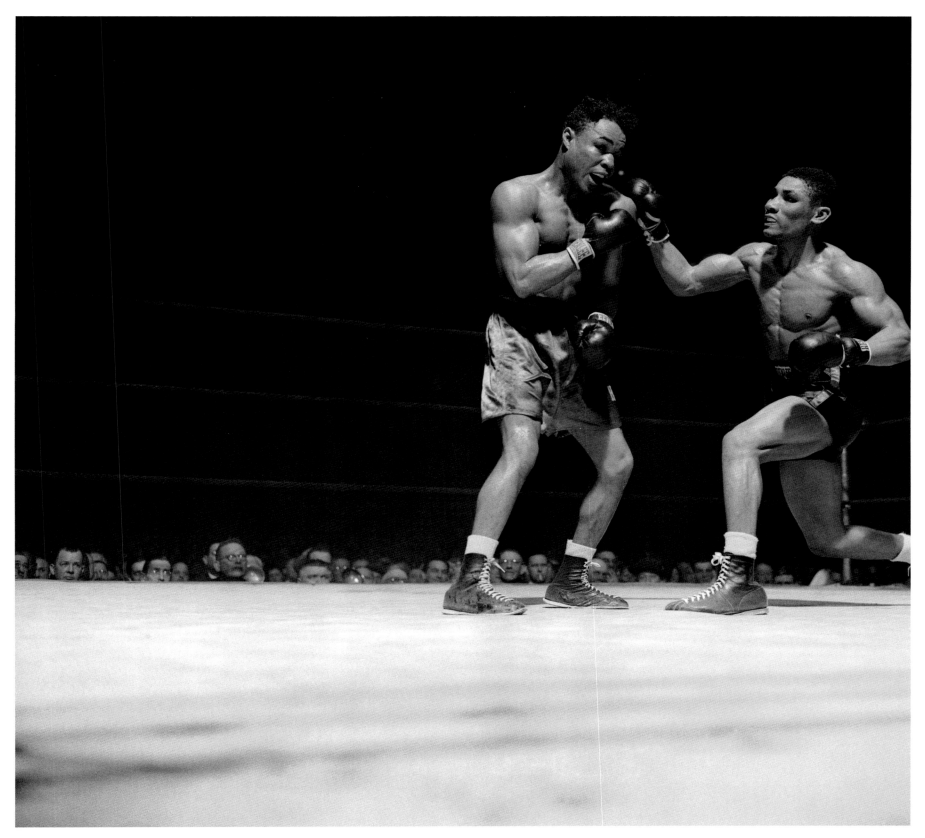

NOVEMBER 3, 1942
PHOTOGRAPHER: UNKNOWN
LOS ANGELES, CALIFORNIA

Film actor Errol Flynn nervously fingers
his tie as he enters the Los Angeles court
for preliminary hearing on charges of
Statutory rape. During the testimony yes-
terday of Betty Hansen, former drugstore
waitress, Flynn occasionally smiled and
at other times looked grim.

No Time for Comedy

MARCH 25, 1944
PHOTOGRAPHER: UNKNOWN
LOS ANGELES, CALIFORNIA

There are times when even the funniest
of funnymen don't see anything in life to
be funny about. Apparently Charles
Chaplin, famed film comedian, has struck
one of these bad spots in his current trail
on a Mann Act charge of Los Angeles.
These studies of the comedian show that
he is taking a profoundly serious view of
his dilemma.

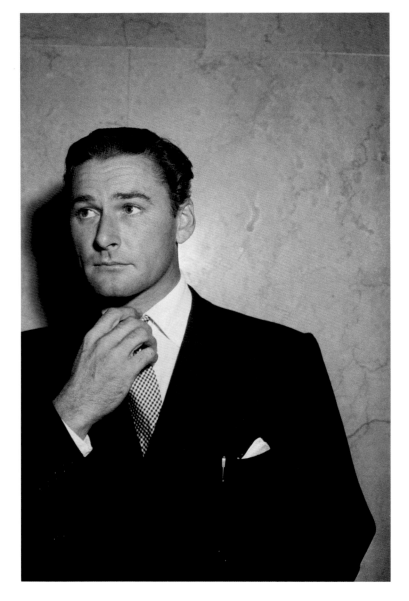

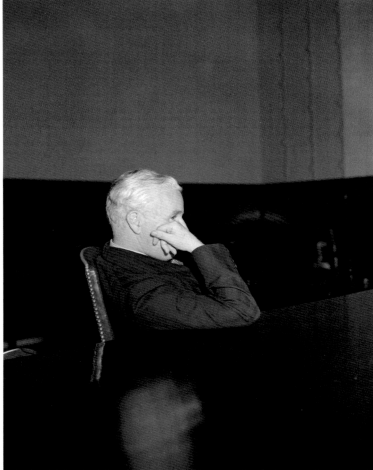

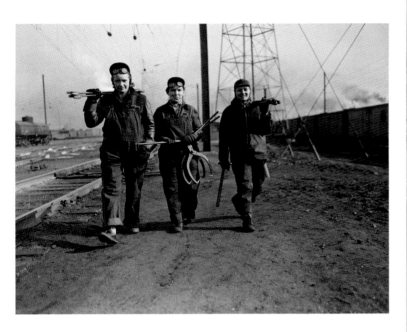

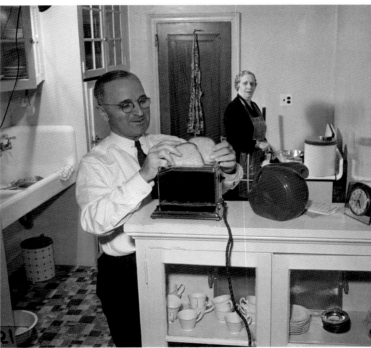

JANUARY 16, 1944
PHOTOGRAPHER: UNKNOWN

These women are doing a hard job and they dress for the part. There can be no flounces or lace trimmings in a section gang. Hauling heavy tools from place to place is in itself a good day's work for a gal, even if she didn't have to use them. The girls are Catherine Bell, Margaret Lucas, and Stella Bove.

JULY 19, 1944
PHOTOGRAPHER: UNKNOWN
WASHINGTON, D.C.

Latest reports from Chicago indicate that Harry S. Truman, from Missouri, is likely to be Democratic Candidate for Vice President. Here is Senator at his home officiating at the toaster as he helps Mrs. Truman get breakfast.

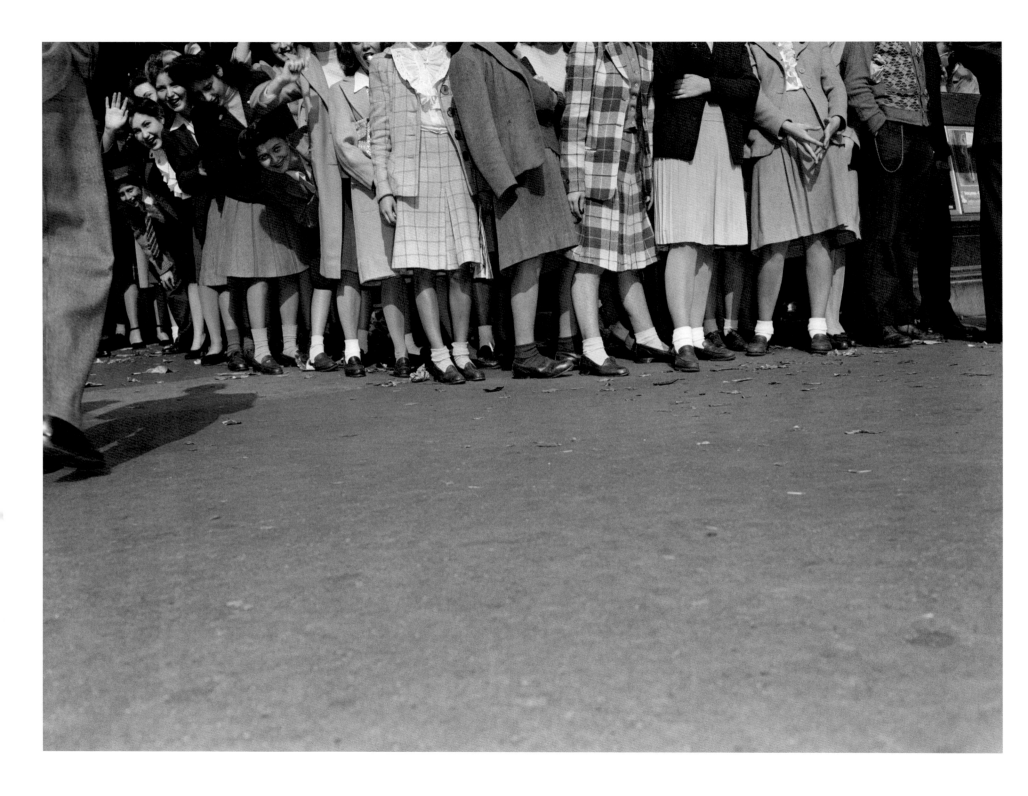

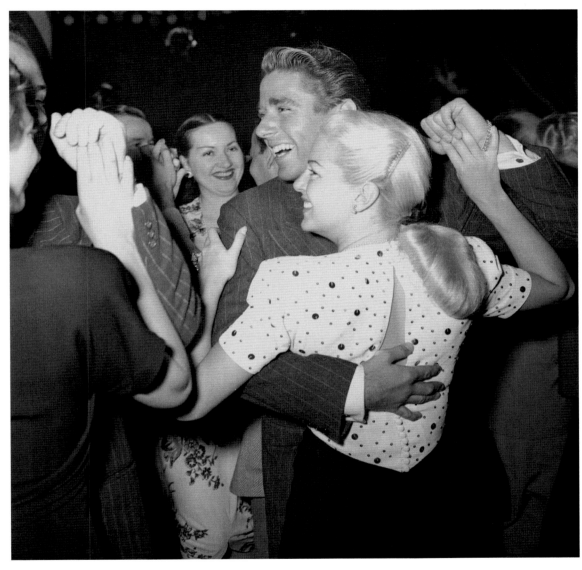

Wedding Bells Again?

MAY 27, 1944
PHOTOGRAPHER: UNKNOWN
HOLLYWOOD, CALIFORNIA

Hollywood's newest gluesome twosome, Lana Turner and Peter Lawford are caught in a moment of merriment at the Mocambo. Lana, recently divorced from Stephen Crane, is being frequently squired about the Hollywood night spots by Lawford.

Bobby Soxers

OCTOBER 12, 1944
PHOTOGRAPHER: UNKNOWN
NEW YORK, NEW YORK

Frank Sinatra fans outside the Paramount Theatre, N.Y.C.

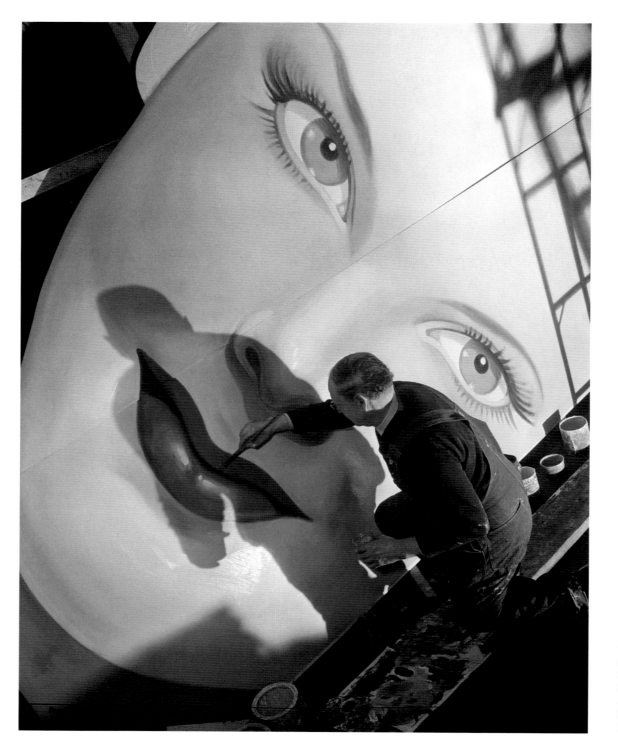

APRIL 7, 1944
PHOTOGRAPHER: UNKNOWN

The cupid's bow lips of the eye-ful tower are longer than an archery bow. The face measures 16 feet from chin to crown.

OCTOBER 23, 1945
PHOTOGRAPHER: UNKNOWN
NEW YORK

This photograph was snapped aboard the super-dreadnought U.S.S. *Missouri* as the huge battlewagon moved up the North River to her berth. The big ship, scene of Jap surrender signing was delayed six hours by fog, which enveloped New York Harbor during the day.

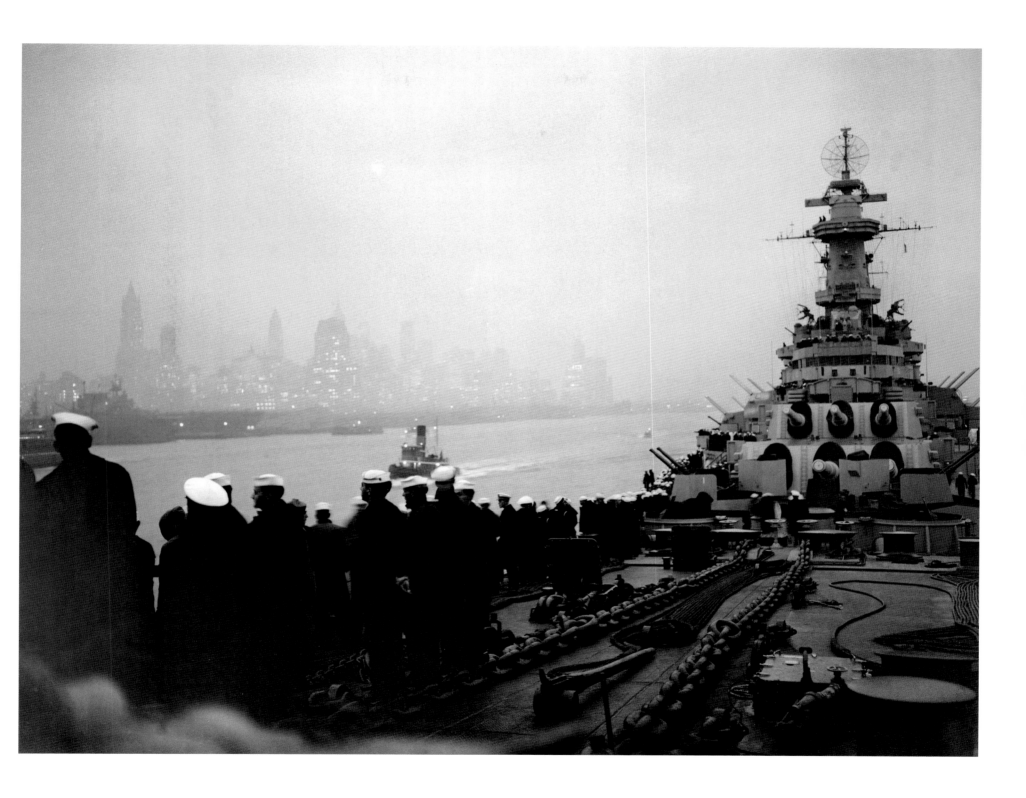

Their Loss is the Nation's

APRIL 15, 1945
PHOTOGRAPHER: UNKNOWN
HYDE PARK, NEW YORK

Dressed in black and wearing a heavy mourning veil, Mrs. Franklin D. Roosevelt bows her head before the grave of her husband, as the nation's chief executive is laid to rest in the garden of his Hyde Park estate today. With Mrs. Roosevelt is her daughter, Mrs. Anna Boettiger (left) and her son, Brig. Gen. Elliott Roosevelt (wearing cap). Her emotion well-controlled during the proceedings, accepted from an Army captain the flag which draped her husband's casket and, after a long look at it and the grave, handed it to Elliott.

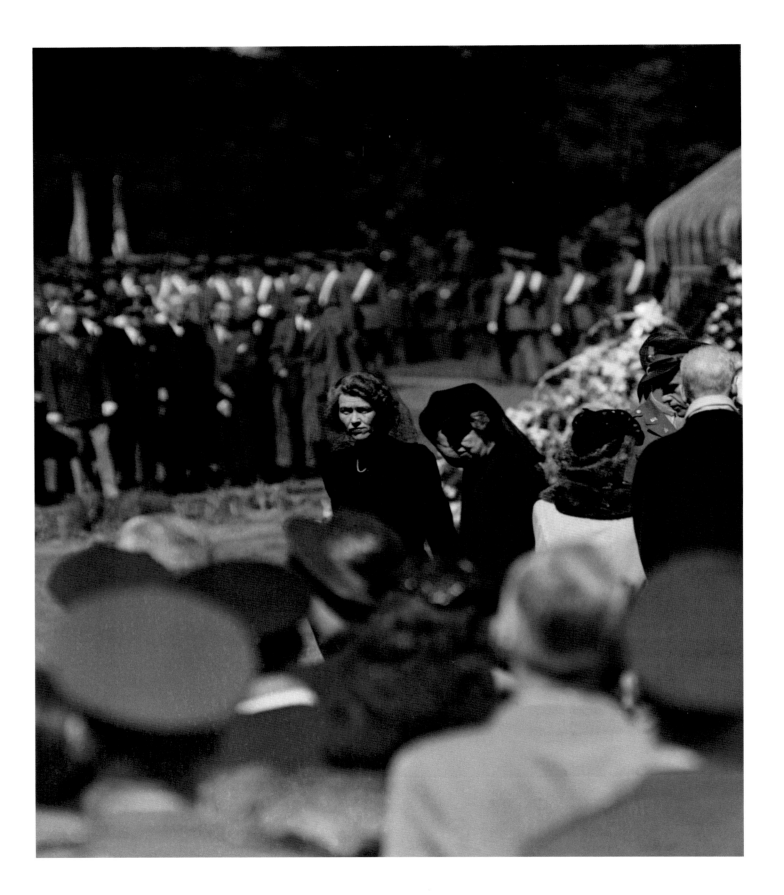

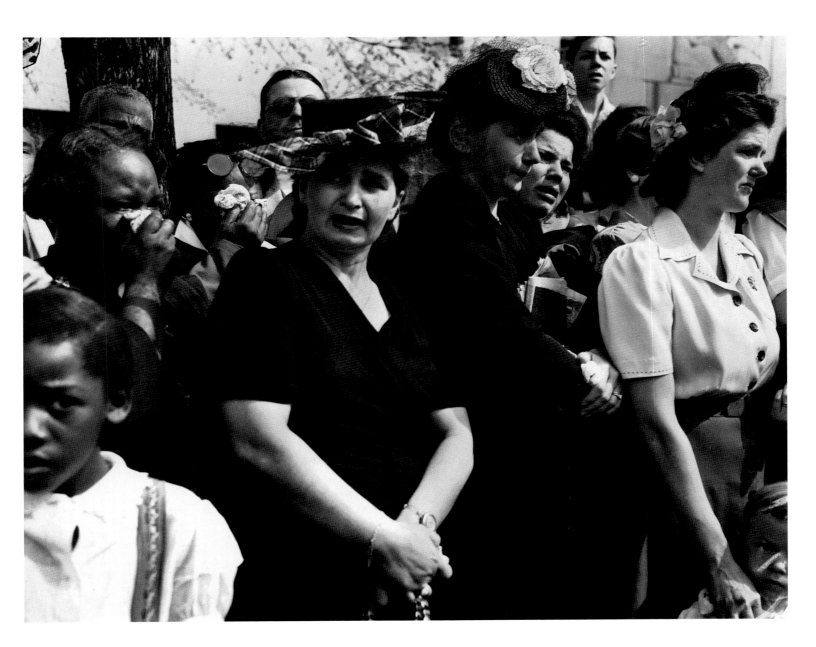

Grief Knows No Class, Color or Creed

APRIL 14, 1945
PHOTOGRAPHER: UNKNOWN
WASHINGTON, D.C.

Genuine grief that all Americans are feeling is expressed in the faces of these women, as they stand in the crowd watching President Roosevelt's funeral procession make its solemn way to the White House for 4 P.M. funeral services this afternoon.

Pajama Party

AUGUST 14, 1945
PHOTOGRAPHER: UNKNOWN
NEW YORK CITY, NEW YORK

For many New Yorkers, wakened from their sleep to hear the good news of the reported Japanese acceptance of allied surrender terms, the early hours of August 14th became a gala pajama party. With an apron thrown over her pajamas, the girl in foreground climbed atop the fender of a crowded car and rode, shouting jubilantly, through Times Square. Some of the other girls aboard the car still have their hair done up in pins.

"Hubba, Hubba—
The War's Over!"

AUGUST 14, 1945
PHOTOGRAPHER: UNKNOWN
NEW YORK CITY, NEW YORK

These youths have a car to help them in their celebrations of Japan's surrender to the Allies, and they park in the vicinity of New York's Times Square to spread some joy among the largest crowd in the square's history. They wave their flags, and their bottle, as they mount atop the car to get a good view of the festivities.

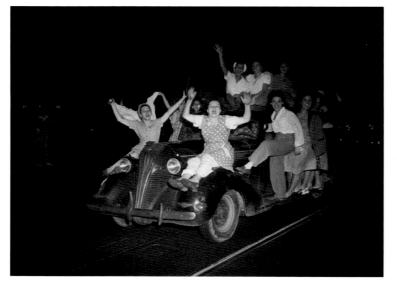

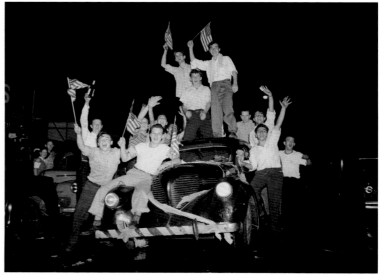

There Was Dancing in the Streets

MAY 7, 1945
PHOTOGRAPHER: UNKNOWN
NEW YORK, NEW YORK

Unconditional surrender of the *Ehrmacht*, although still unofficial, was their cue for a bunch of youngsters to carry over their celebrating far into the evening on Times Square. They brought along the musical instruments, sat on cars, and sent a solid number bouncing down the White Way. A sailor caught the mood, grabbed an elderly woman, and to the delight of bobby soxers who beat time with their hands, danced a modern, victory version of "The Sidewalks of New York."

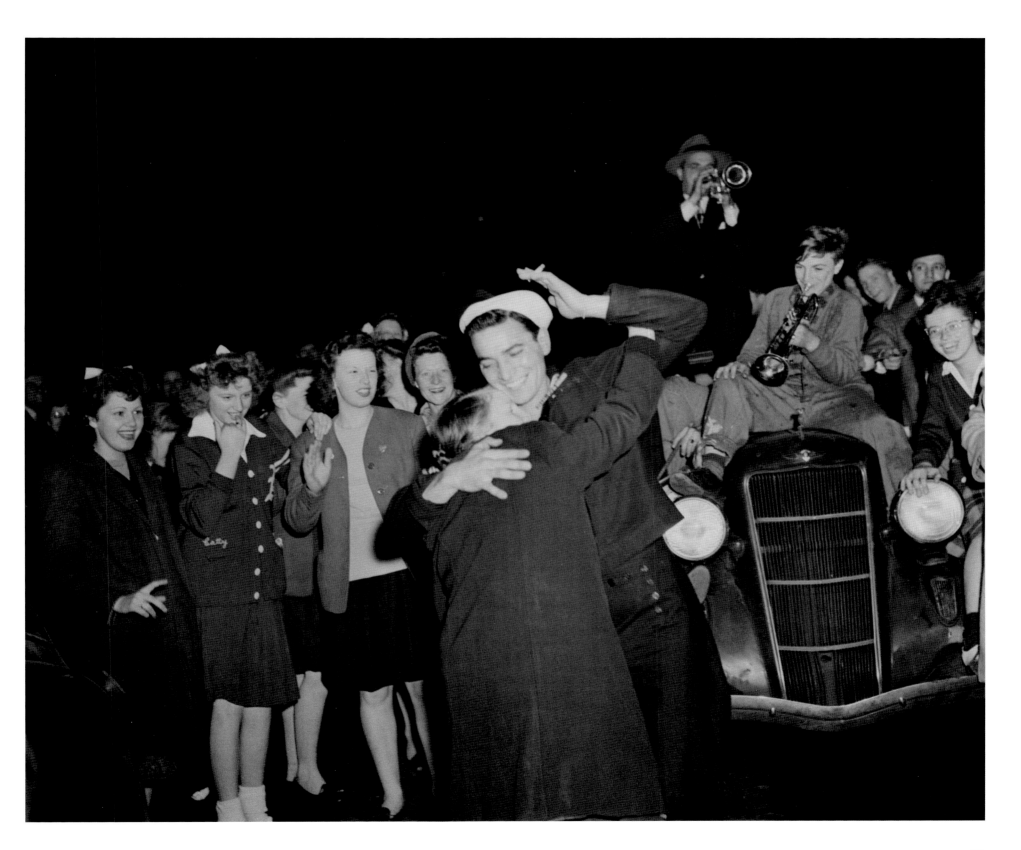

General Dwight Eisenhower with Mrs. Eisenhower, his wife, in car as he waves to crowd in Abilene, Kansas, during welcome home reception. Cadet nurses are shown in background.

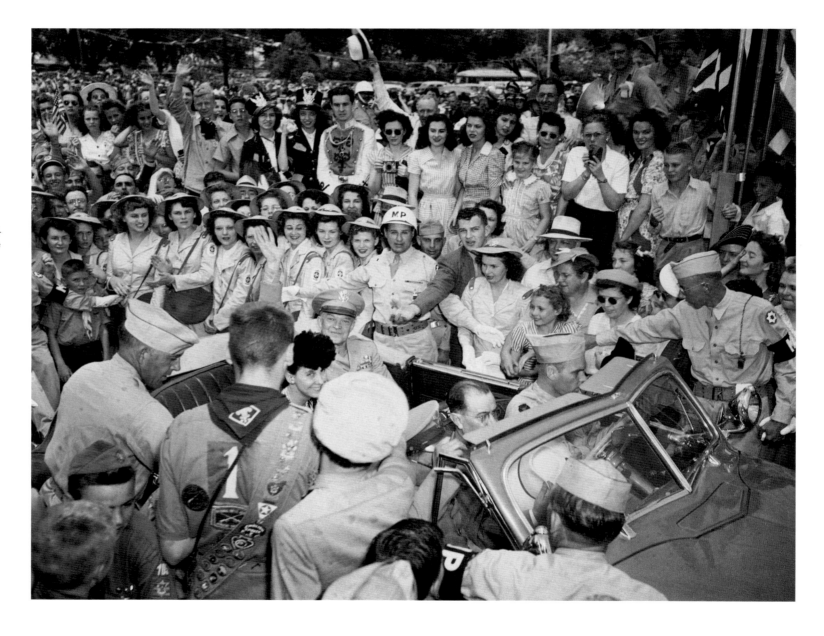

DECEMBER 1945
PHOTOGRAPHER: UNKNOWN
DECATUR, ALABAMA

Heywood Patterson, the thrice convicted member of the group of Negroes who are defendants in the south's most celebrated criminal case, the Scottsboro case is shown. Another member of the group has been singled out by fate, and now Clarence Norris will await the court actions and repeals which will have to be fought out before both Patterson and Norris, and perhaps the rest of the group pay the last penalty for the crime of which they have been convicted. All of the Negroes were convicted twice and sentenced each time to death; the first verdict having been set aside by a State Court. Norris was convicted by a jury and was sentenced by Judge Callahan.

NOVEMBER 15, 1945
PHOTOGRAPHER: UNKNOWN

Passengers aboard Pan American World
Airways' fleet of transatlantic land planes
enjoy a sound movie aboard one of the
clippers, as part of the International
Airlines Program of improving travel com-
forts for the post-war passenger. It was
shown for the first time on the New York
to London flight.

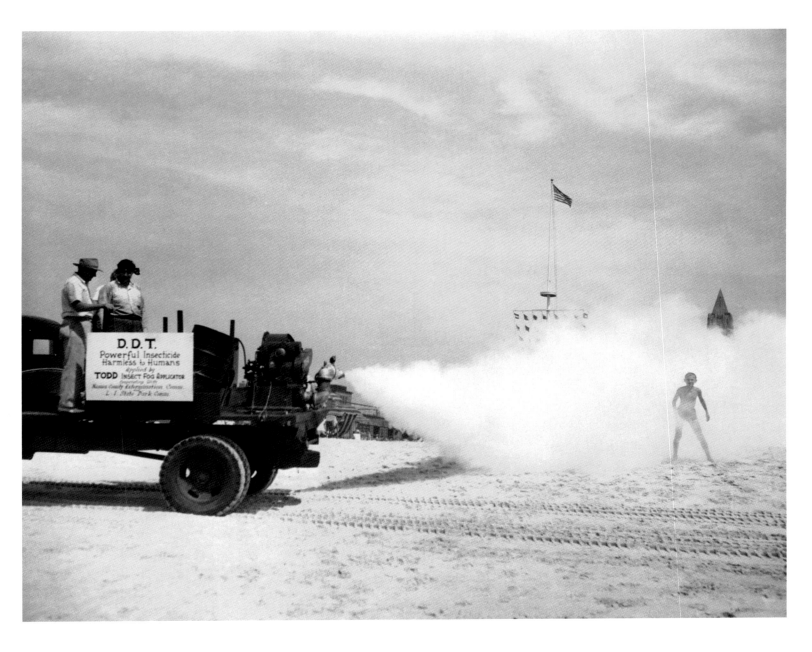

JULY 8, 1945
PHOTOGRAPHER: UNKNOWN
LONG ISLAND, NEW YORK

Jones Beach crowds saw the first public tests of the Todd Insecticidal Fog Applicator, an insect-killing machine developed by Todd Shipyards Corp. An entire four-mile area was blanketed with DDT oil fog as Sunday bathers ducked out of the way of the machine.

A view of the hole rammed into the 78th
and 79th stories of the Empire State
Building by a U.S. Army Bomber flying in
the fog. Part of the wreckage hangs from
the 78th story.

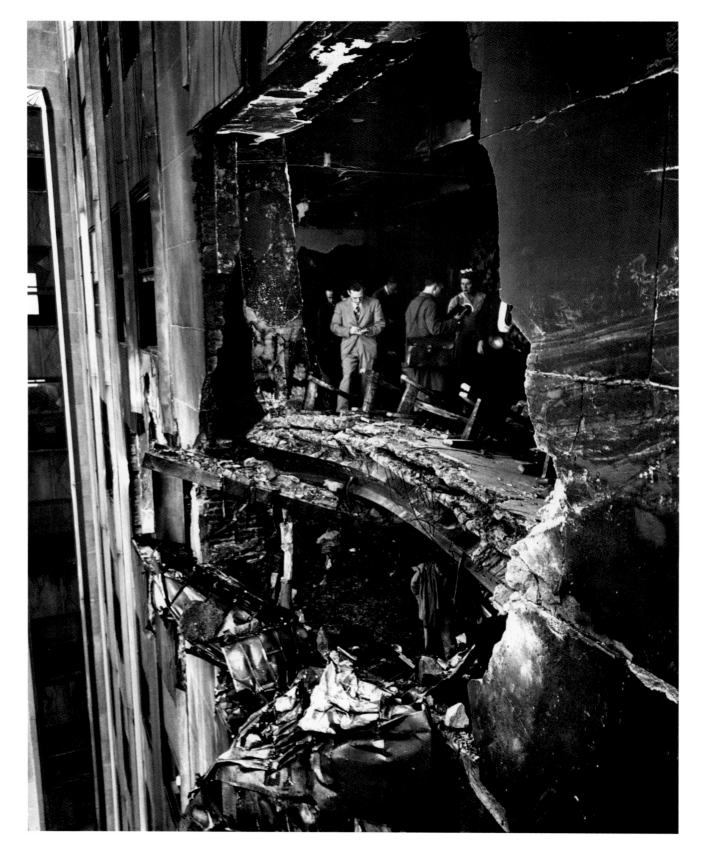

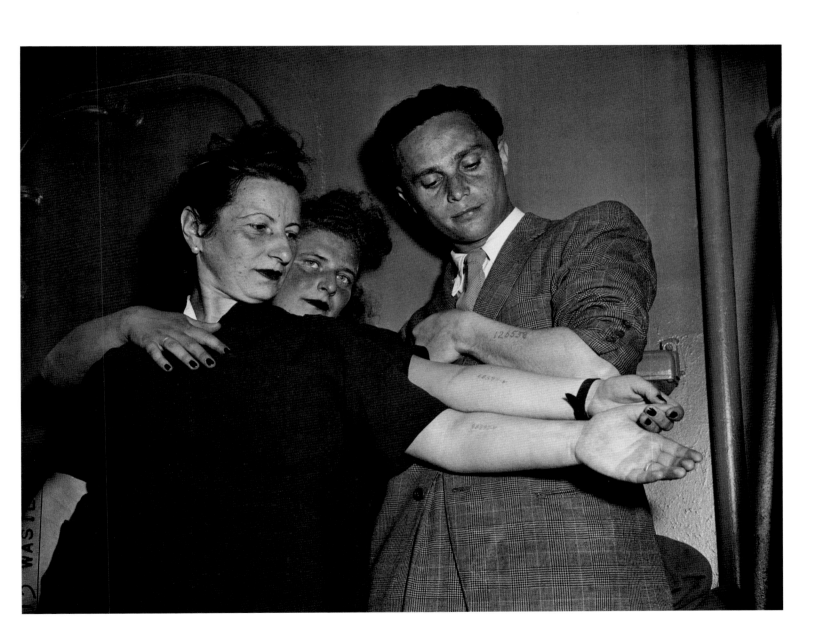

MAY 20, 1946
PHOTOGRAPHER: UNKNOWN
NEW YORK, NEW YORK

Three passengers exhibit the numbers with which they were branded in Nazi concentration camps upon their arrival in New York today along with 800 other liberated refugees aboard the SS *Marine Flasher* out of Bremenhaven. They are, left to right: Else Springut; Rita Springut, 21, her daughter; and Moses Fish. Miss Springut, who will live in New York with her mother, was an inmate in 5 concentration camps, including Auschwitz. They were liberated in Wiesbaden, Germany.

Dazed Morris Reif bends over after Beau Jack connects with a powerful right to the side of the head in the second round of their bout at the Madison Square Garden. Jack won by a knockout late in the fourth round of their scheduled 10-round bout. Reif is from Brooklyn, N.Y., and Jack is from Augusta, Georgia.

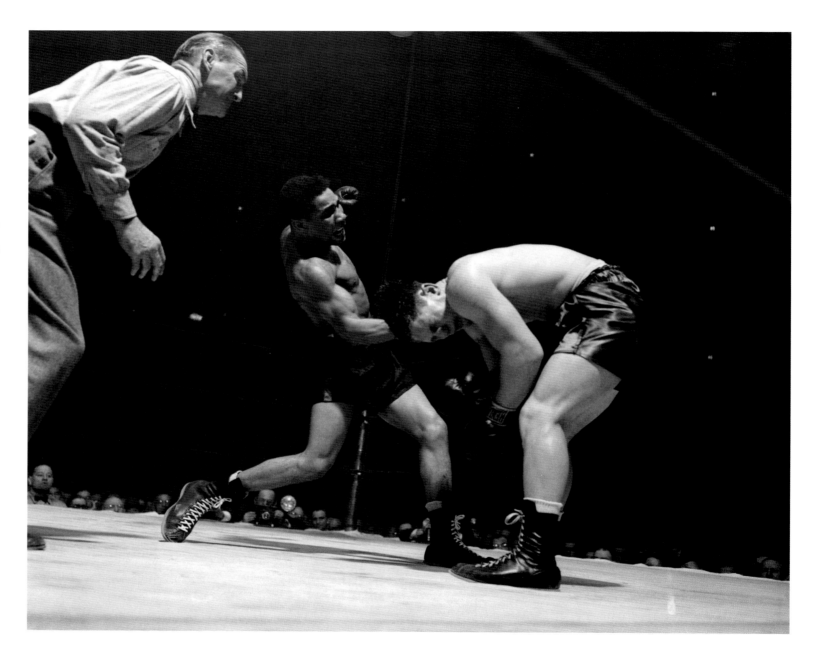

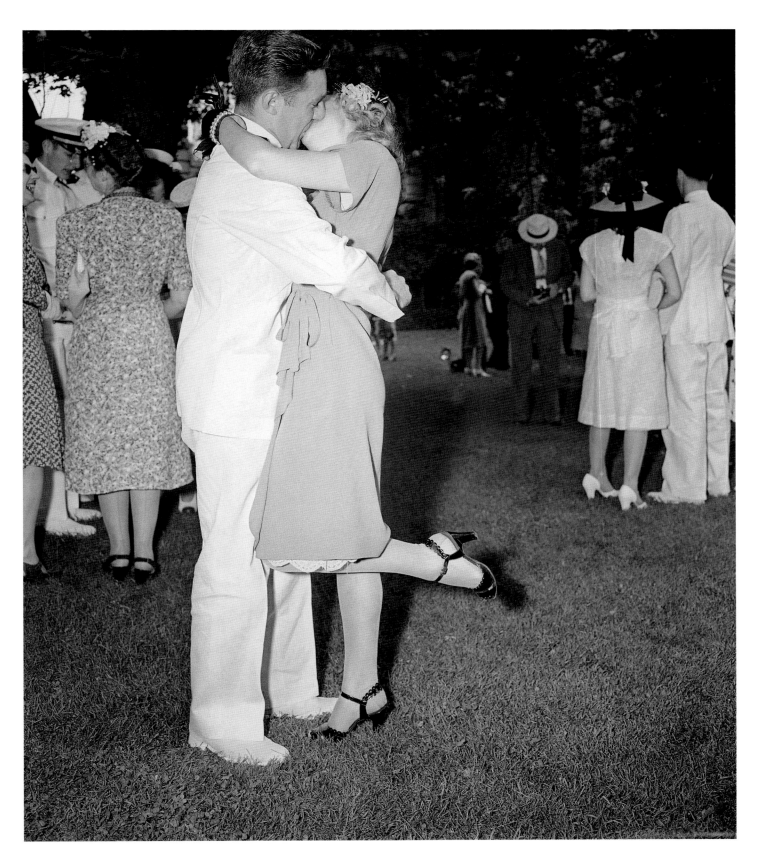

JUNE 5, 1946
PHOTOGRAPHER: UNKNOWN
ANNAPOLIS, MARYLAND

Gloria M. Weems of San Diego, California rewards Ensign Raymond N. Baker of Pittsburgh, Pennsylvania with a kiss, after commencement exercises for the U.S. Naval Academy Class of 1947.

JULY 28, 1947
PHOTOGRAPHER: UNKNOWN
WASHINGTON, D.C.

The closing session of Congress is always an interesting event, and this time the family of Representative Hale Boggs of Louisiana had ringside seats at the ceremony. The Representative is shown with the family, after the curtain had rung down. Left to right are Mrs. Boggs, Tommy, 6½ years old; Congressman Boggs; Barbara, 8 years old; and Corrine (aka Cokie), 3½ years old.

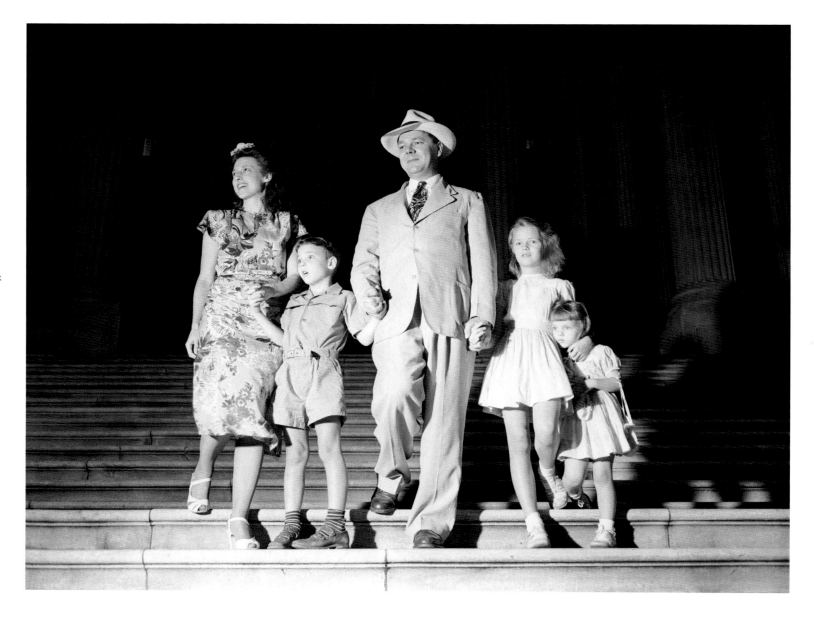

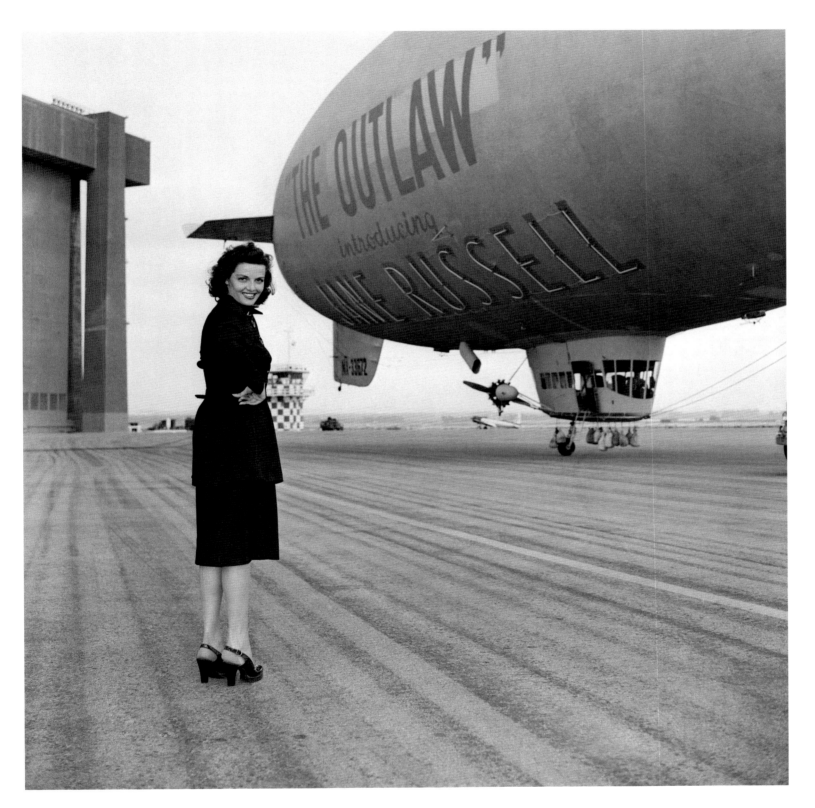

The Sky's the Limit

MAY 29, 1946
PHOTOGRAPHER: UNKNOWN
HOLLYWOOD, CALIFORNIA

Howard Hughes, industrialist, engineer and producer of motion pictures, bought a surplus Navy blimp, the first sold to a civilian, and splashed "Howard Hughes Daring Production The Outlaw" all over the sides in twenty-foot letters. At night, the signs are lit up with neon, making night skywriting an actuality. Jane Russell, star of the picture, takes a preview of the 167-foot blimp.

JULY 30, 1946
PHOTOGRAPHER: UNKNOWN
MONROE, GEORGIA

The funeral for two of the victims in the July 25th lynching in Walton County were held at the Mt. Perry Baptist Church Sunday. This photo shows the procession, led by the pastor, as the bodies of George Dorsey and his sister, Dorothy Dorsey Malcolm were taken from the church to the cemetery nearby.

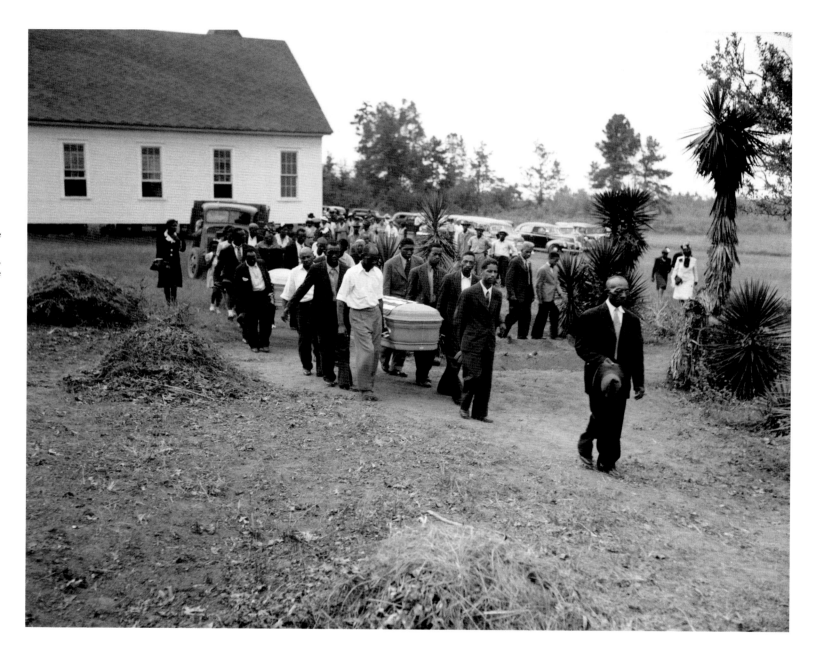

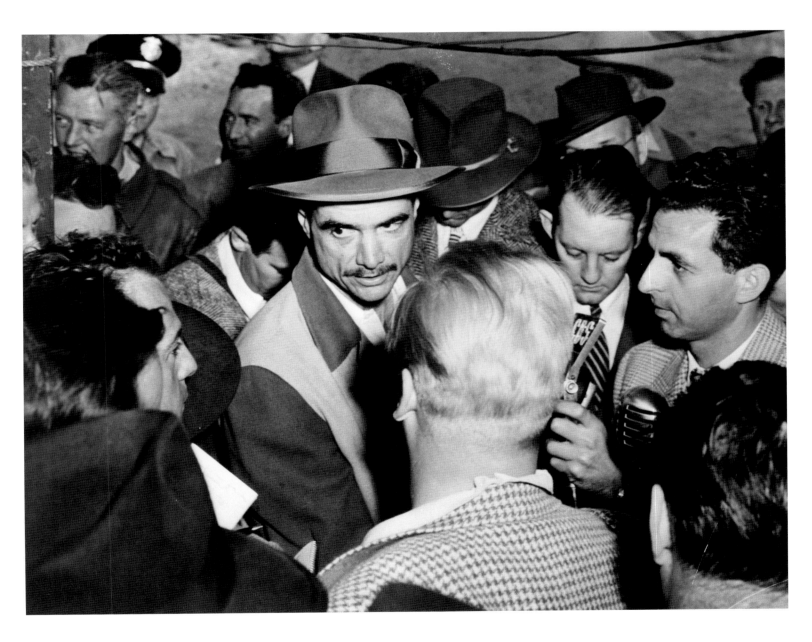

NOVEMBER 5, 1947
PHOTOGRAPHER: UNKNOWN
SAN PEDRO, CALIFORNIA

Millionaire planemaker Howard Hughes is surrounded by members of the press after successfully taking his 200-ton flying boat into the air in a surprise flight during initial taxi tests in Los Angeles Harbor.

Movie Star Has Fountain Appeal

APRIL 1, 1946
PHOTOGRAPHER: UNKNOWN
HOLLYWOOD, CALIFORNIA

Hollywood High school girls mob the counter at the owl drug store, Hollywood Blvd., upon learning that the soda dispenser is movie actor Dana Andrews, the latter took the job to enable him to put realism into a role he is playing in *The Best Years of Our Lives*.

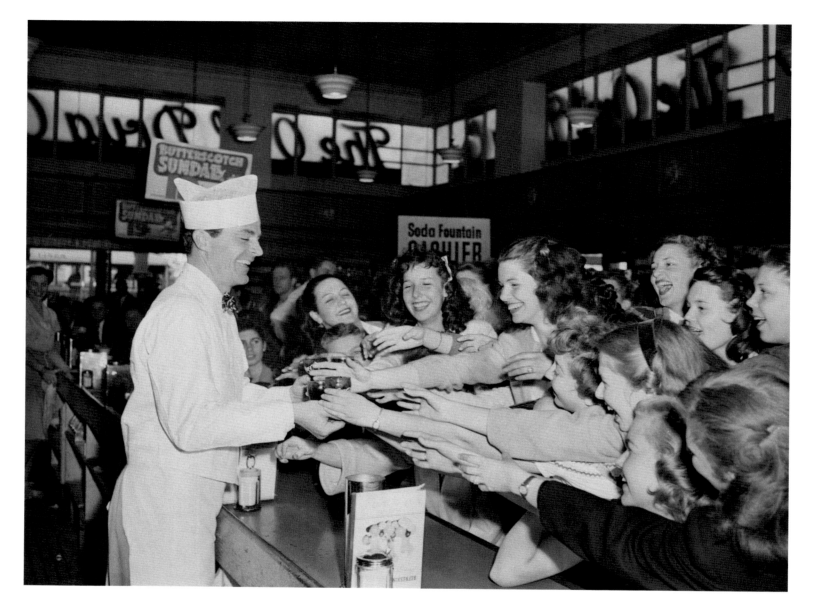

APRIL 18, 1947
PHOTOGRAPHER: UNKNOWN
BROOKLYN, NEW YORK

Jackie Robinson, the Brooklyn Dodgers' Negro first-base recruit, scores on his first Major League homer, made off southpaw Dave Rosolo of the New York Giants in the third inning at the Polo Grounds. Left fielder Tatum, next man up, congratulates the slugger as the Giant's catcher, Cooper, looks on. The Giants opened their home-season at the Polo Grounds with a bang by defeating the Dodgers.

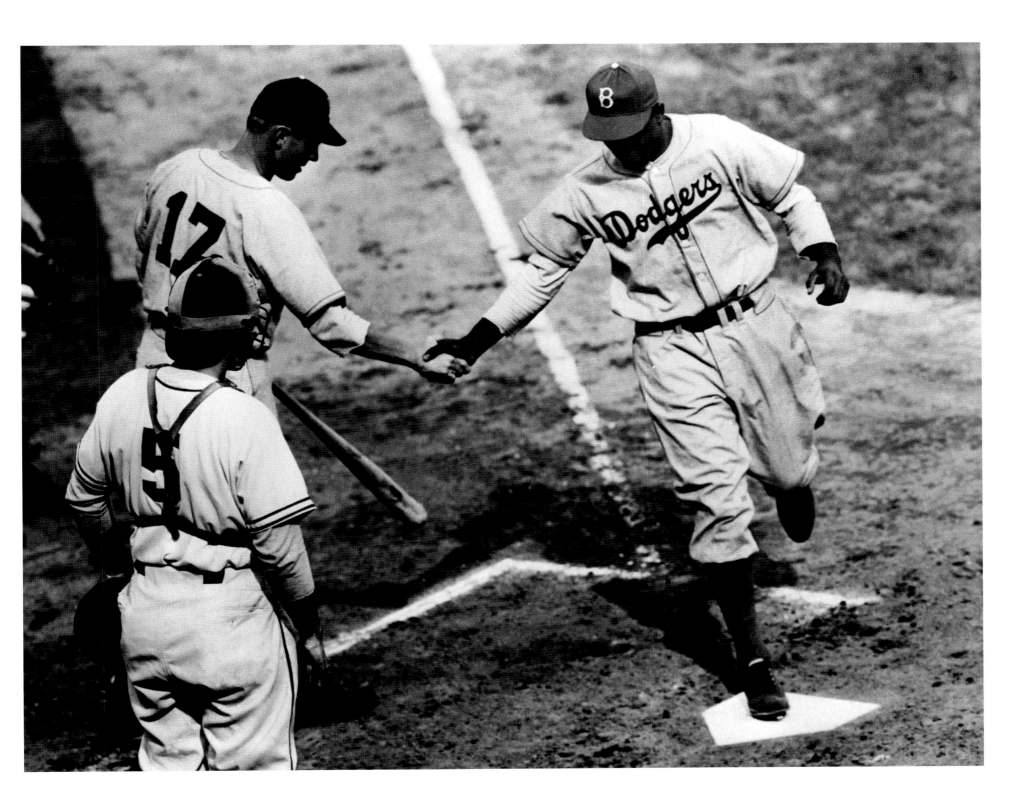

FEBRUARY 26, 1947
PHOTOGRAPHER: UNKNOWN
NEW YORK, NEW YORK

New York music—the red hot variety
—is the specialty at New York's Savoy
Ballroom; and that kind of music makes
for the red hot jitterbugging of Harlemites.
Dancers create miniature cyclones as they
jitter to hot jazz. Sometimes it quiets down
and gets smoother. Ricky Babbit and Lucy
Simms are smooth.

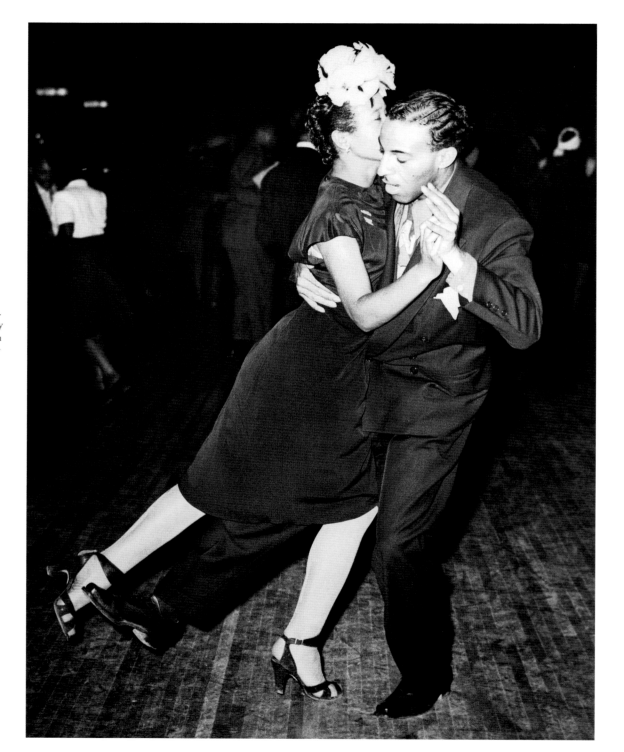

SEPTEMBER 1946
PHOTOGRAPHER: UNKNOWN
DETROIT, MICHIGAN

Yankee Joe DiMaggio is out at third in the
second inning of the game with Tigers at
Briggs Stadium in Detroit. Tiger third
baseman George Kell has the ball in his
glove. The Yankee's 5-4 victory clinches
the American League Pennant for the
Boston Red Sox, (who won in Cleveland
over the Indians), since the Tigers were
the only team with the slim but mathe-
matical chance of taking the flag.

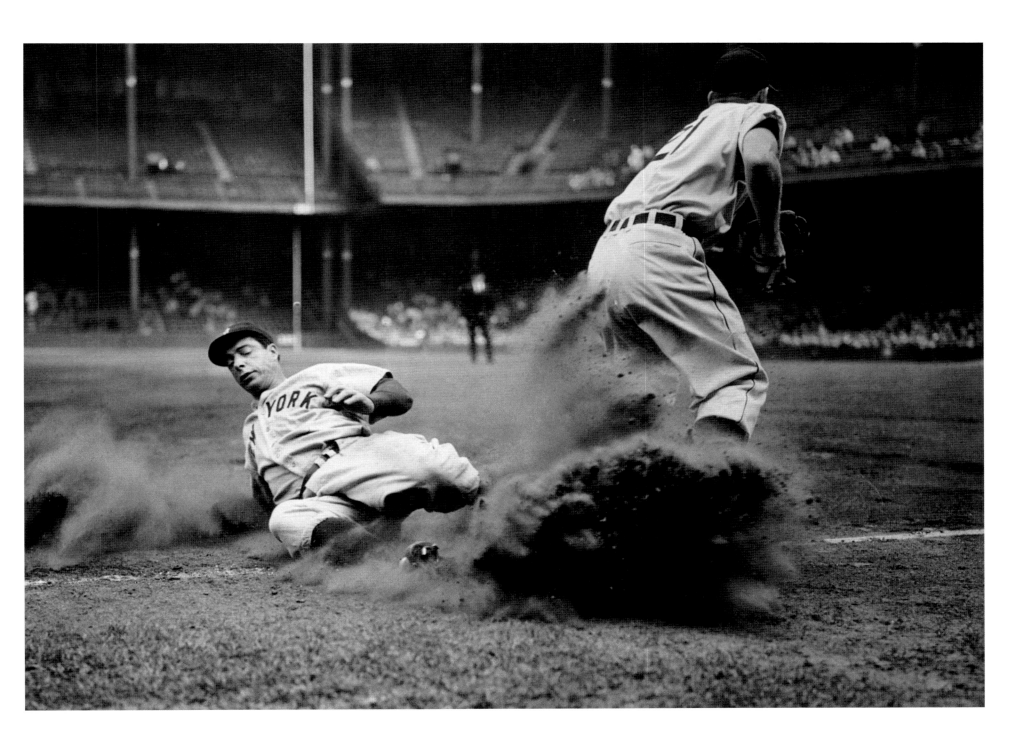

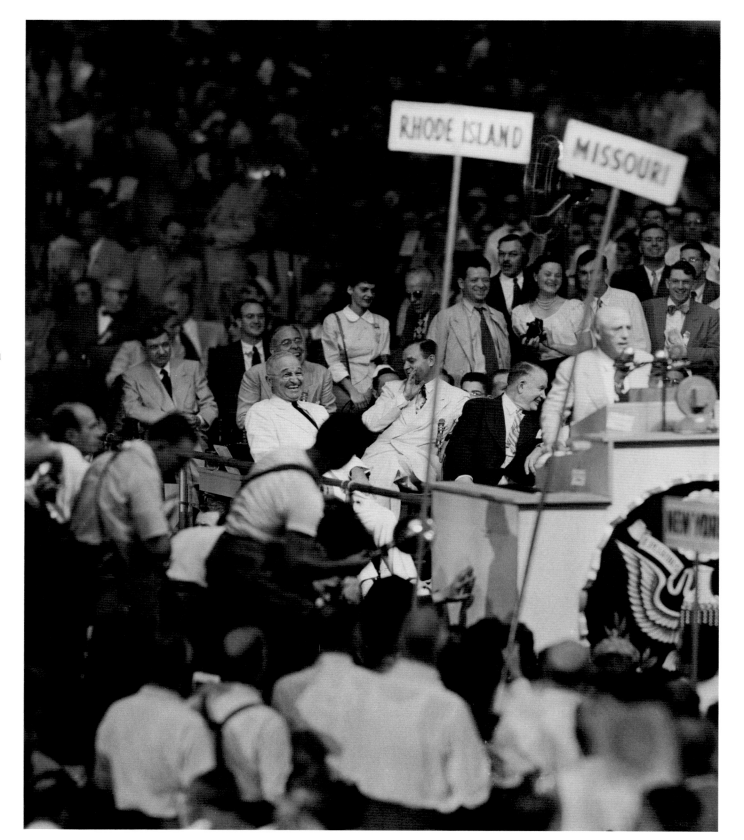

JULY 15, 1948
PHOTOGRAPHER: UNKNOWN
PHILADELPHIA, PENNSYLVANIA

Appearing to enjoy the show, President Truman laughs heartily as he sits at the rear of the speaker's platform with Democratic National Chairman J. Howard McGrath, awaiting his speech.

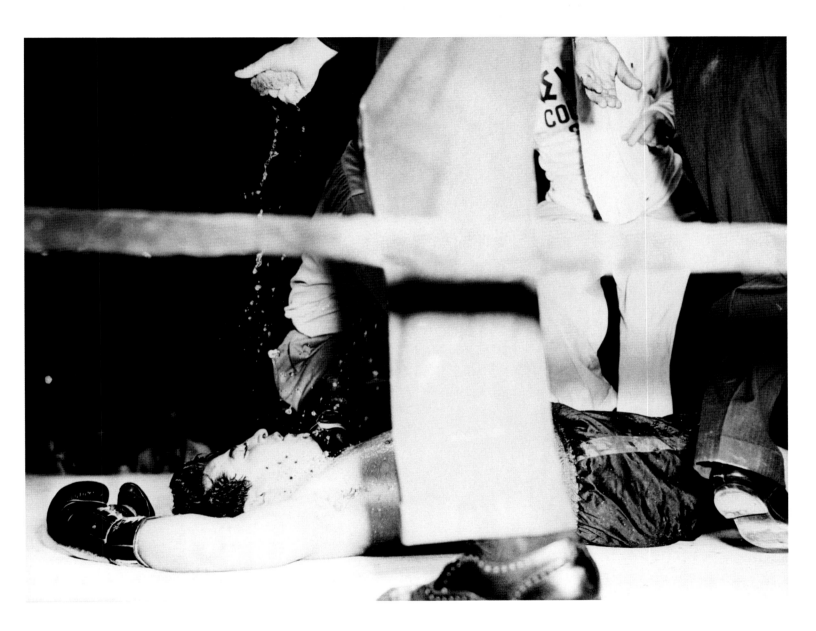

JUNE 11, 1948
PHOTOGRAPHER: UNKNOWN
NEWARK, NEW JERSEY

Rocky Graziano, middleweight champ from New York's East Side, lies unconscious as his trainer squeezed water into his face to revive him after he was knocked out by Tony Zale in Newark Stadium last night.

MARCH 30, 1949
PHOTOGRAPHER: UNKNOWN
MIAMI BEACH, FLORIDA

Encased in his iron lung, polio victim
Fred Snite, Jr., looks about him in a bus
specially built so that he can look out of
the windows when he travels. With him
are (left to right): Fred Snite, Sr.; the
younger Snite's children Marie, Kitty and
Pinky and their mother, Mrs. Fred Snite, Jr.

America's Miracle in Housing

APRIL 13, 1949
PHOTOGRAPHER: UNKNOWN
LEVITTOWN, NEW YORK

The largest, most complete, low-cost
development is Levittown, which has
sprung up from potato farmland on the
outskirts of suburban Long Island during
the past two years. By the end of this
year builders Levitt and Sons will have
completed 10,000 houses, all of which
are being sold for about $8,000. Carrying
charges, including taxes, water, insurance,
interest, and repayment of mortgages are
$58 a month, and the down payment is a
mere $90 in cash. Something money can-
not buy however, are the discharge papers
prospective buyers need to conclude the
sale. As long as there are ex-GI's who want
houses, and the chances are that demand
will exceed the supply, Levittown will not
sell to anyone else. Secret of the Levitts'
success in keeping costs down has
been their mass production methods.
Construction materials are bought and
delivered for many homes at once, and
working crews move from one structure
to the next in much the way a production
line moves in a large factory. Situated
a few miles north of New York's Jones
Beach, the development is not only a
group of houses, it is also an entire town,
with miles of concrete roads, several
shopping centers, schools, swimming
pools, churches of all faiths, bowling
alleys and beautiful parks. All these were
built by the Levitts to go with their dream
community.

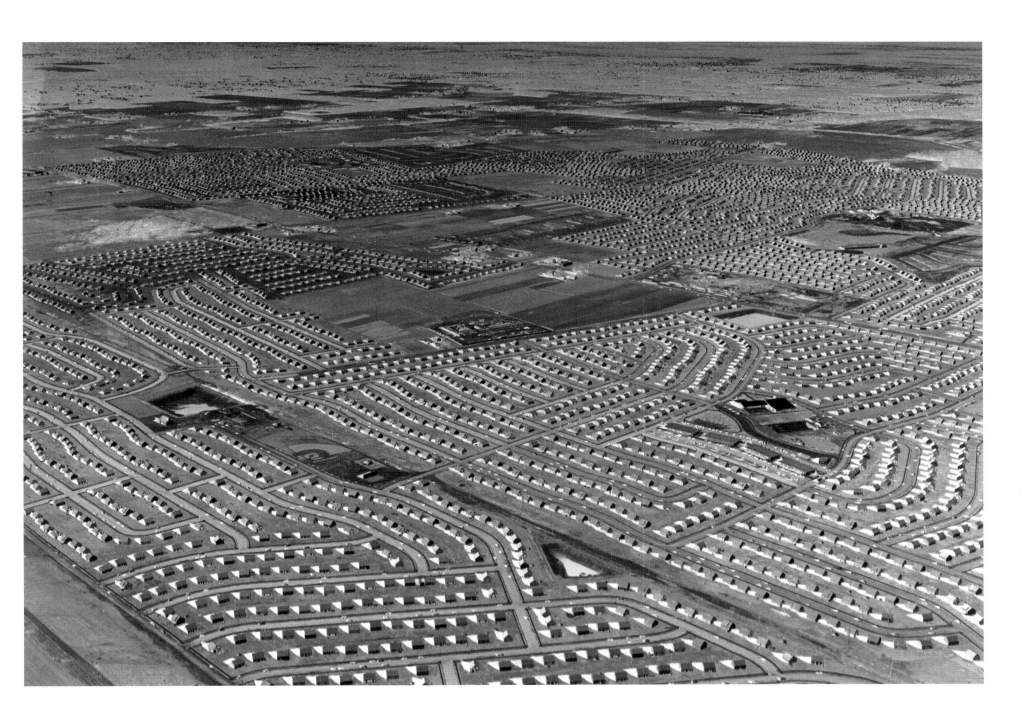

Spy Suspect Not Home

SEPTEMBER 29, 1949
PHOTOGRAPHER: UNKNOWN
NEW YORK, NEW YORK

Four milk bottles appear outside the
apartment of John Hitchcock Chapin
at 350 West 12th St. Chapin, who worked
on atomic research during the war, was
named by the House Un-American
Activities Committee for prosecution
on espionage charges. He and his wife
reportedly left the apartment Sept. 28
and have not yet returned.

Inspection by
the Commander-in-Chief

JUNE 10, 1948
PHOTOGRAPHER: UNKNOWN
BREMERTON, WASHINGTON

President Truman looks into the barrel
of a Garand rifle during an inspection
of Marine troops in Bremerton, Wash.,
before proceeding to Seattle, June 10,
on his cross-country tour. Speaking in a
Seattle stadium that was about half full,
the Chief Executive again charged that the
Republican-controlled Congress has pre-
vented passage of important legislation.

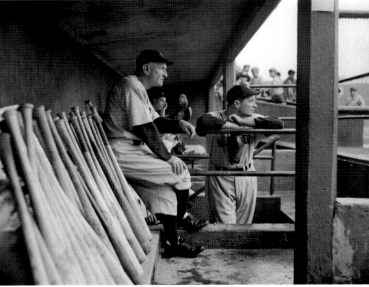

SEPTEMBER 15, 1950
PHOTOGRAPHER: UNKNOWN
PASADENA, CALIFORNIA

Evangelist Billy Graham, arms upraised, delivers his sermon to the crowd of more than 45,000 people that attended the mid-century Christian rally at the Pasadena Rose Bowl here.

SEPTEMBER 11, 1950
PHOTOGRAPHER: UNKNOWN
WASHINGTON, D.C.

Yankee manager Casey Stengel and pitcher Joe Page (right) watch the rainfall that dropped them another half-game in the torrid American League pennant fight. Their game with the Washington Senators was rained out, September 9, while the League-leading Detroit Tigers beat the Chicago White Sox, 7-0.

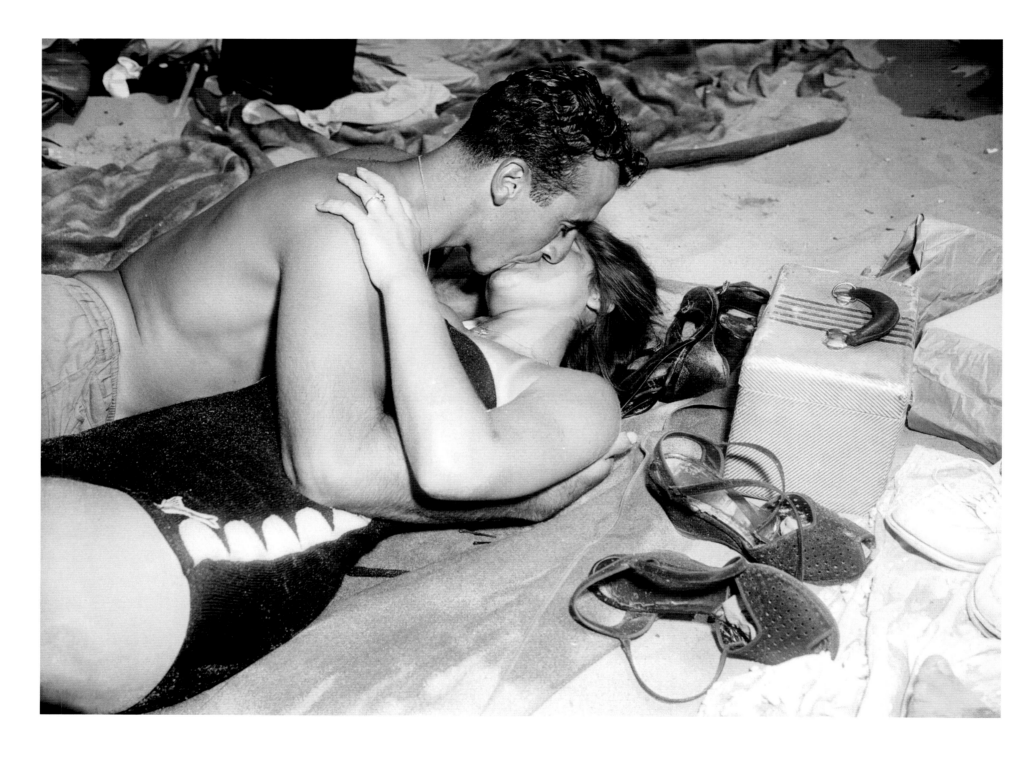

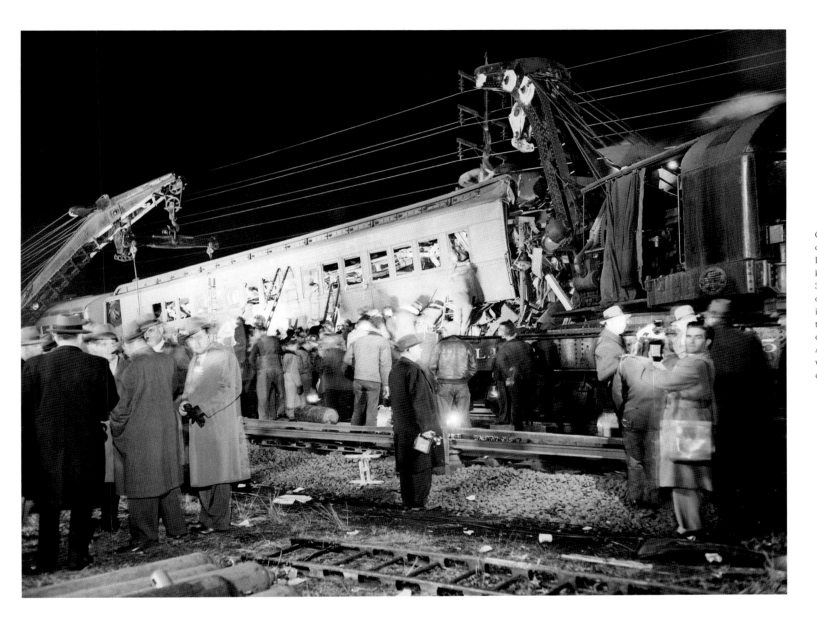

NOVEMBER 23, 1950
PHOTOGRAPHER: UNKNOWN
RICHMOND HILL, NEW YORK

Giant railroad cranes lift apart the completely telescoped cars of the Long Island Railroad trains which crashed killing 78 persons and injuring almost 300. The crane operation was carried out gently since victims were still trapped in the trains. The inner car can be seen through the window of the top one which draped over it like a shell. At right is Acme staff photographer Andrew Lopez, who worked through the night at the disaster scene.

JUNE 30, 1949
PHOTOGRAPHER: UNKNOWN
CONEY ISLAND, NEW YORK

Lovers kissing at Coney Island.

Crime Committee Calls Cohen

NOVEMBER 19, 1950
PHOTOGRAPHER: UNKNOWN
LOS ANGELES, CALIFORNIA

Mobster Mickey Cohen looks a bit bored as he waits to explain his plush income to the Senate Crime Committee, headed by Sen. Estes Kefauver, as they began their investigation of local crime patterns in Los Angeles. Cohen is fingered as top witness of the 22 persons subpoenaed for appearance.

SEPTEMBER 14, 1950
PHOTOGRAPHER: UNKNOWN
DETROIT, MICHIGAN

His face bruised and swollen from the blows of challenger Laurent Dauthuille, middleweight champ Jake La Motta relaxes to receive a rewarding buss from his wife after the fight. La Motta, on the defensive until the final round, was able to muster a smashing last-minute flurry and deliver the Frenchman his first kayo in 47 fights. Dauthuille's excellent showing may net him a return match with the Bronx Bull.

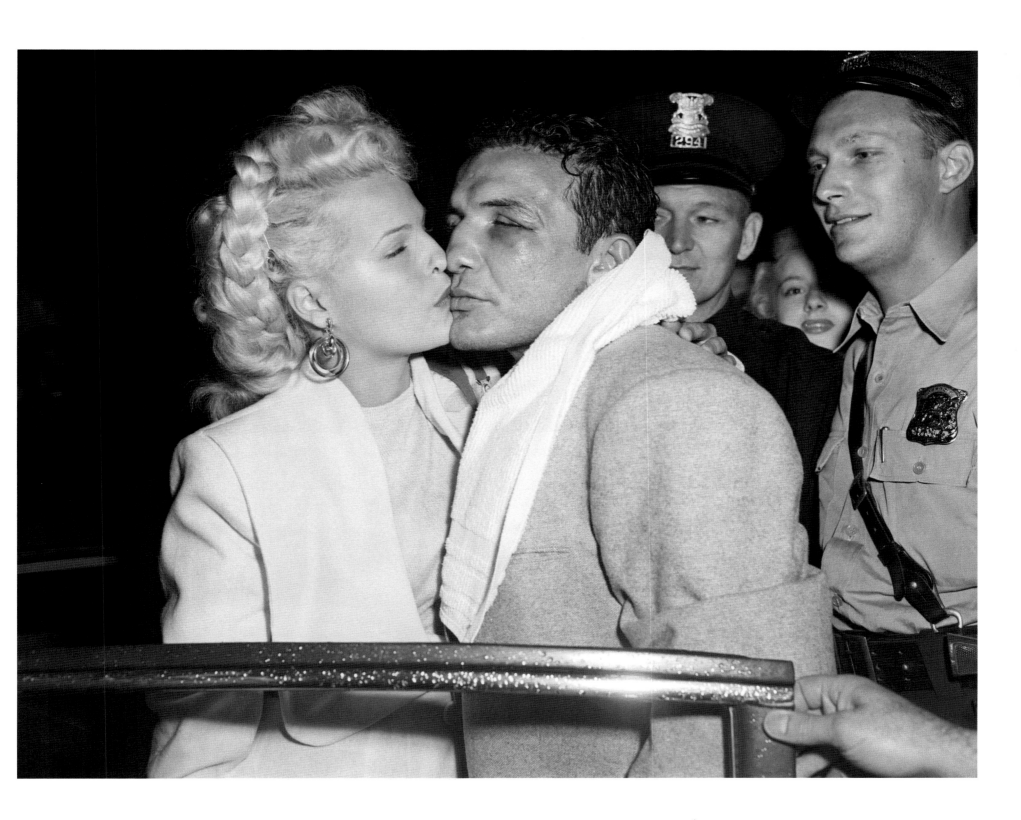

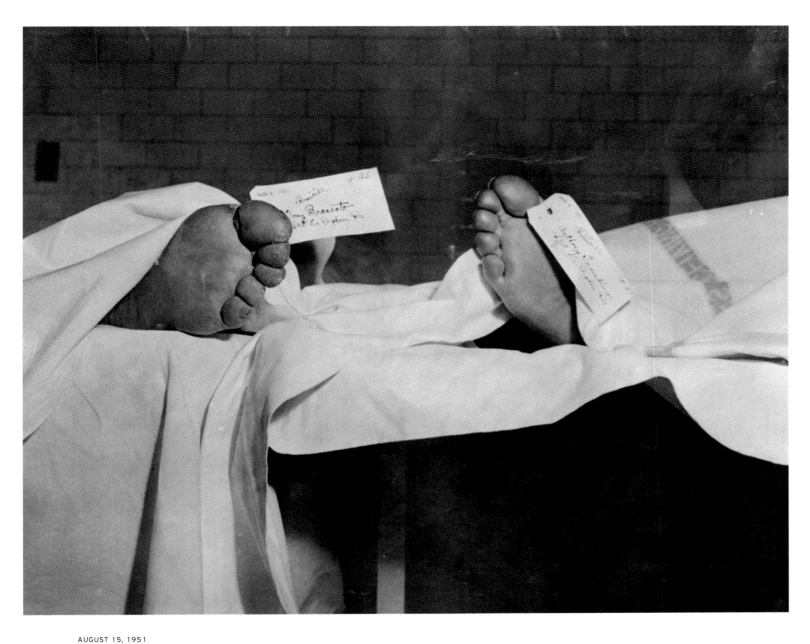

AUGUST 31, 1951
PHOTOGRAPHER: UNKNOWN
LOS ANGELES, CALIFORNIA

View of the toes of the bullet-riddled bodies of Tony Trombino and Tony Brancato, both underworld figures, are shown after they were found in a parked car near the famed Sunset Strip. Both had been shot through the head and neck, apparently by person or persons who occupied the backseat of the car. Both men were Kansas City gangsters. Brancato, recently listed by the F.B.I. as one of its "Ten Most Wanted Men," was released from jail in San Francisco last Friday on $10,000 bail as the suspect in the $35,000 holdup at the Flamingo Hotel in Las Vegas, Nevada. Both Trombino and Brancato were questioned in the slaying of Bugsy Siegel four years ago.

AUGUST 15, 1951
PHOTOGRAPHER: HANS REINHART
NEW YORK, NEW YORK

The maiden to whom Mother Nature has been less than generous can take heart. The new "perfect contour" inflatable brassiere is ideal for casual wear, formal gowns and even bathing suits. It has individual containers of lightweight vinylite plastic that can be inflated to provide a perfect contour without the discomfort of padding and the added weight. It is demonstrated here by model Dawn Arden.

Wearing a silver blue mink stole, Virginia Hill is pictured during her appearance before the Senate Crime Investigating Committee. Miss Hill, whose home was the scene of the fatal shooting of Bugsy Siegel in 1947, told the investigators that all her income came from her "friends" and gambling. She is now married to Hans Hauser, an Austrian ski instructor.

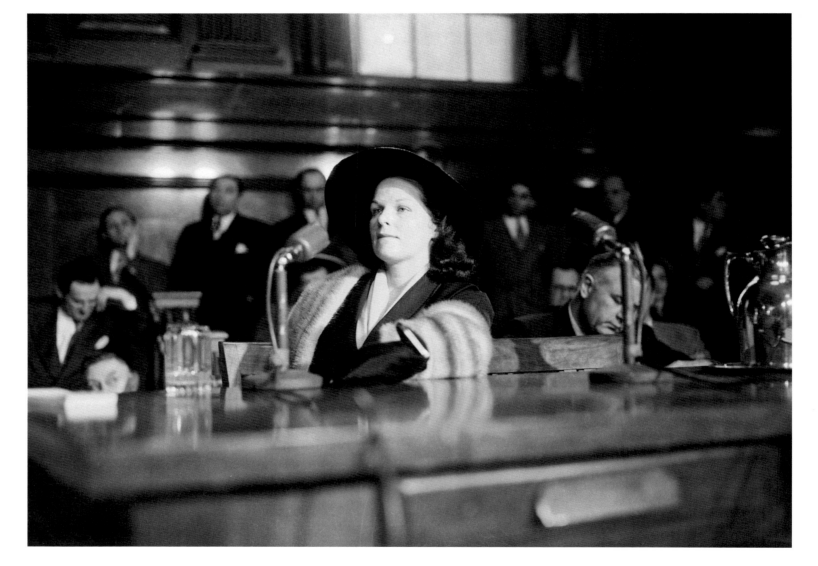

This was the scene in the corridor at Thomson School in Washington, D.C., during their air raid alarm drill. The children lined along the hall corridors, crouching on the floor, their heads against the wall. Their faces rest on their arms against the floor. The conduct of the drill showed good results, the principal of the school reported.

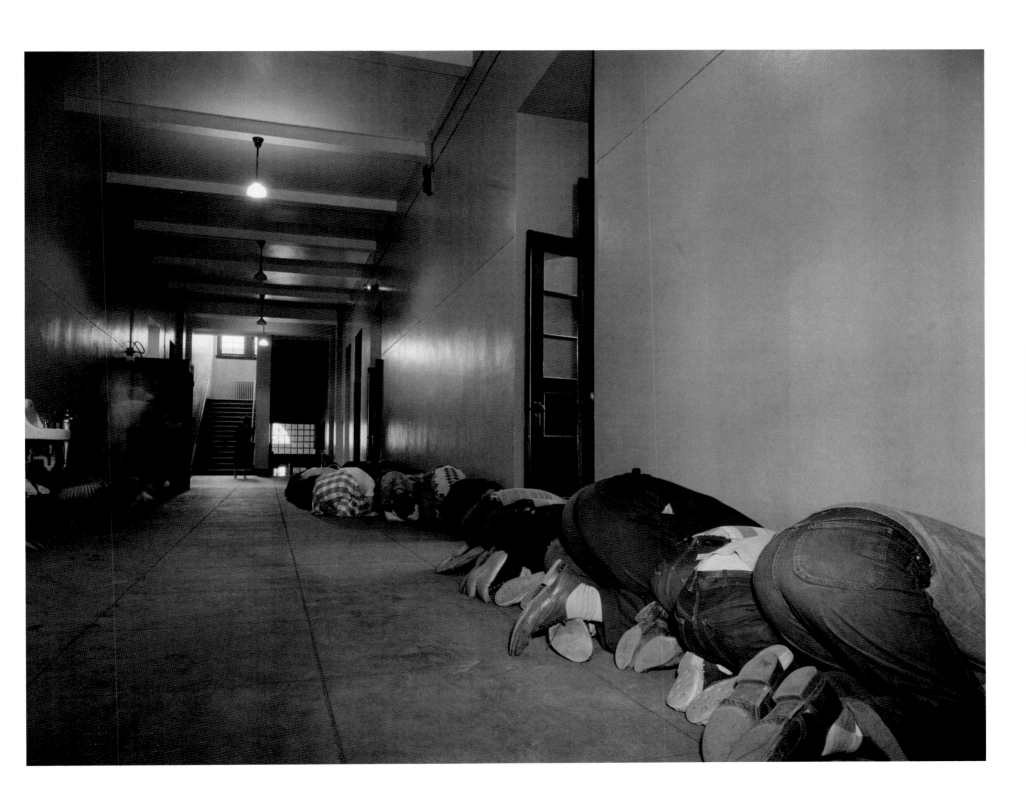

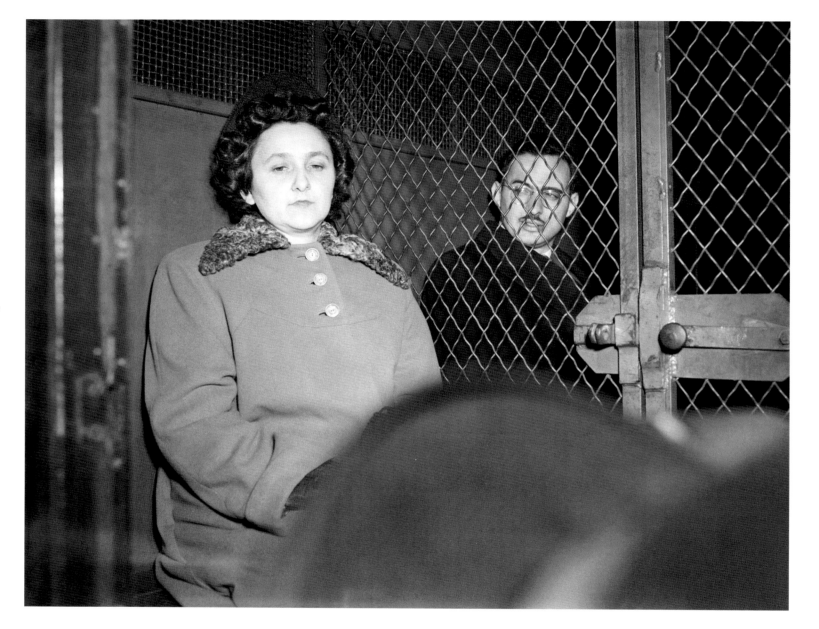

C. APRIL 1951
PHOTOGRAPHER: UNKNOWN
NEW YORK, NEW YORK

Shown here seated in a patrol van are
Ethel and Julius Rosenberg after their
conviction on charges of espionage. They
were later sentenced to death and, after
worldwide appeals for mercy, executed.

JUNE 13, 1951
PHOTOGRAPHER: UNKNOWN
THE BRONX, NEW YORK

A general view of the Whitestone Bridge
Drive-In Movie Theater. The theater, one of
two in the Greater New York area, sprawls
over 22 acres accommodating up to 1,200
cars. The screen is four times the size of
an ordinary screen, and there are two
projectors. Drive-in theaters are growing
increasingly popular. Today there are
3,000 such theaters in the U.S., 800 more
than there were just a year ago.

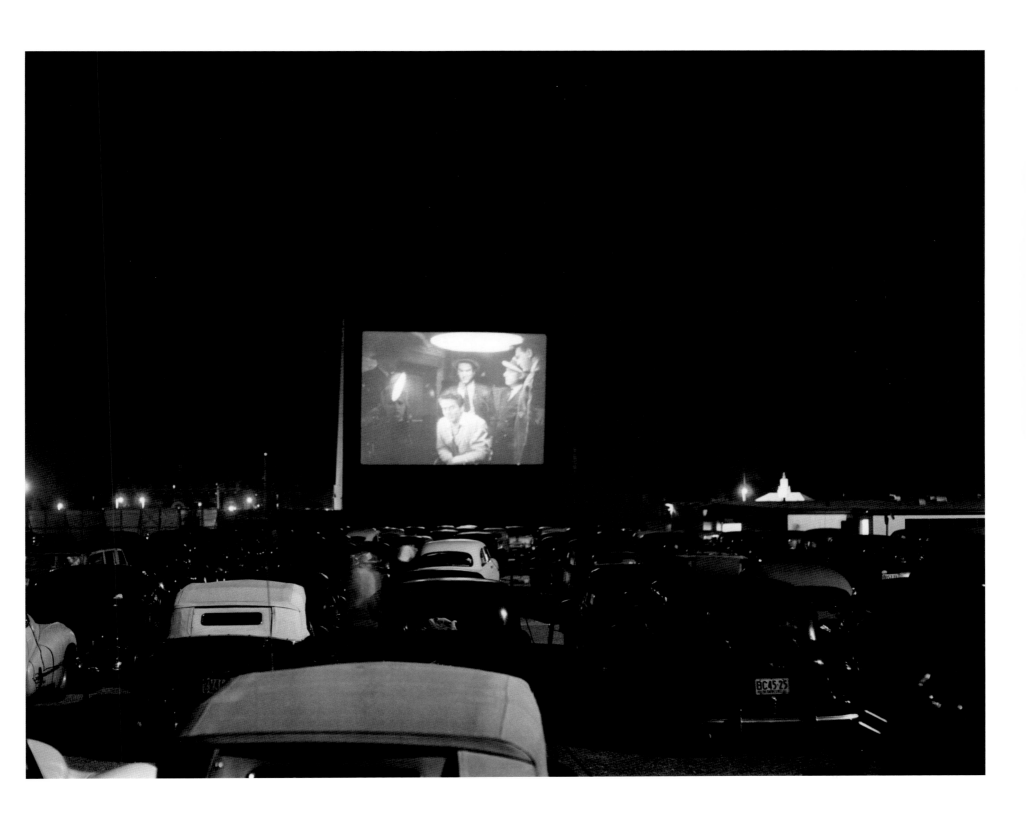

MARCH 30, 1951
PHOTOGRAPHER: UNKNOWN
LOS ALAMOS, NEW MEXICO

People the world over may be living in fear of the atomic bomb and shuddering at thoughts of it, but at Los Alamos, where thoughts are of little else and life is lived under its shadow, two children, their dog, and a soap box racer set a healthy tone amidst a scene of quiet calm. Surrounded by the very matrix of the fearful weapon, with its strange-shaped laboratories and plants, the residents and their community seem to have the peace, which comes from confidence. Jimmy Rogers, 12, one of the local children over the age of seven, carries an identification card and his little friend Gilbert Keegan, 5, don't hear talk of fear or panic, their elders know what is being accomplished.

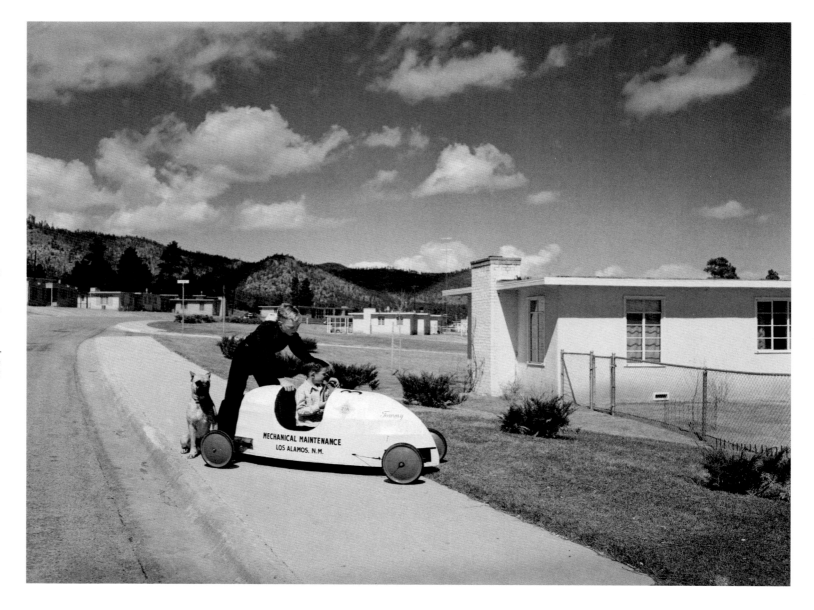

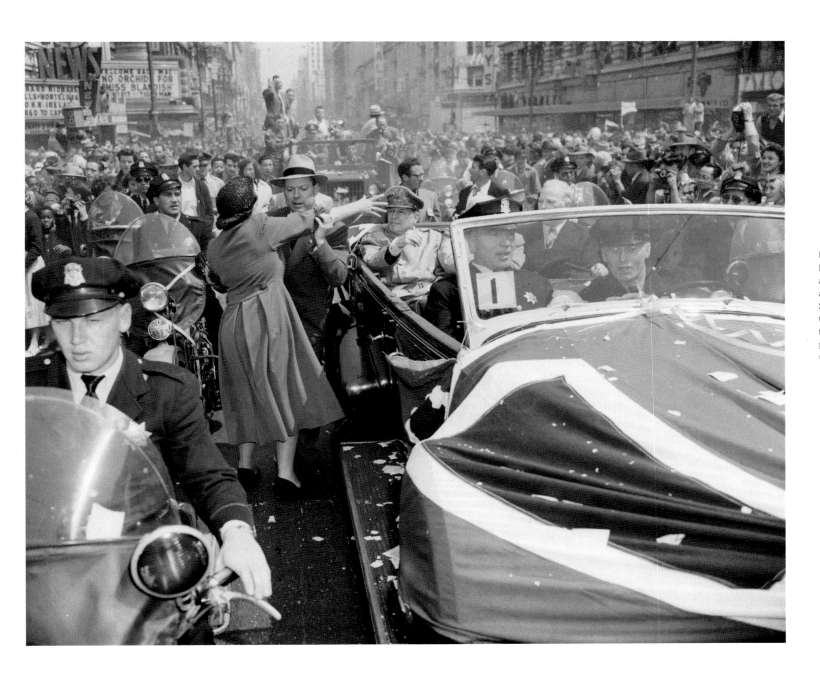

Reaching Enthusiasm

APRIL 19, 1951
PHOTOGRAPHER: UNKNOWN
SAN FRANCISCO, CALIFORNIA

During the hectic parade marking Gen. Douglas MacArthur's first day in the U.S., an over-enthusiastic woman is restrained as she reaches toward him. Secret Servicemen and police had a difficult time keeping crowds from breaking through police lines. Half a million persons in San Francisco hailed "Mac" upon his day in the city.

A lone traffic cop on usually bustling Fifth Avenue stands at his post during the atomic defense drill, which brought New York City to a standstill today for ten minutes to emphasize the dangers of atomic bombing. The street clock shows the time, 10:42, a minute before the all-clear. This view was made looking south on Fifth Avenue from 44th Street. Twelve thousand police, eleven thousand firemen and three hundred thousand Civil Defense volunteer workers handled the test air raid—the biggest in U.S. history.

For Crying Out Loud!

APRIL 25, 1952
PHOTOGRAPHER: UNKNOWN
COPACABANA CLUB, NEW YORK CITY

Clutching his head in what seems to be sheer agony, Ray sobs out the final verse of a song. Even the piano gets a workout when Johnnie sings. He pounds the keys mercilessly and even bangs the mahogany top.

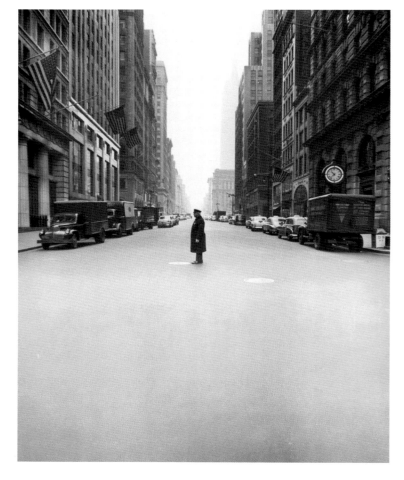

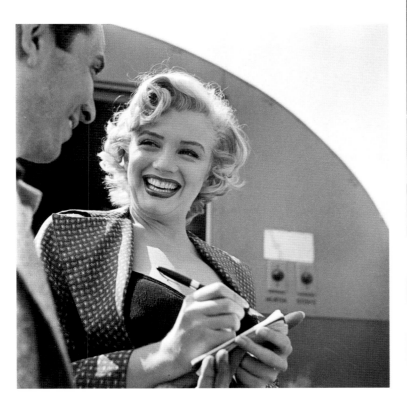

Which Do the Gentlemen Prefer???

JUNE 24, 1952
PHOTOGRAPHER: UNKNOWN

Carol Channing, the actress who made Lorelei Lee famous, is reported to be testing for the film role of her Broadway part in *Gentleman Prefer Blonds*. The Hollywood grapevine, however, reports that Carol will never get to play Lorelei for 20th Century Fox. The explanation given is that Carol would be entitled to demand top salary for the role and that studio executives long ago planned to hand the role to their budding and bosomy starlet, Marilyn Monroe who is under long-term contract, currently paying her $475 per week. Cost, plus the fact that Marilyn is a box-office sensation means, according to the experts, that Carol is doomed to disappoint.

Big-Time Evangelist

JULY 3, 1953
PHOTOGRAPHER: UNKNOWN

The evangelist's program reaches a dramatic moment when a "believer" leaves his crutches and walks out on the stage toward Miss Kuhlman.

Senator's Goodbye

AUGUST 23, 1954
PHOTOGRAPHER: UNKNOWN
WASHINGTON, D.C.

Senator Joseph R. McCarthy waves good-
bye to his lovely wife, Jean, who returns
the wave from the doorstep of their home
on Capitol Hill. Undemonstrative of their
love in public, the McCarthys kiss each
other goodbye at the door when the
Wisconsin lawmaker leaves for his office.

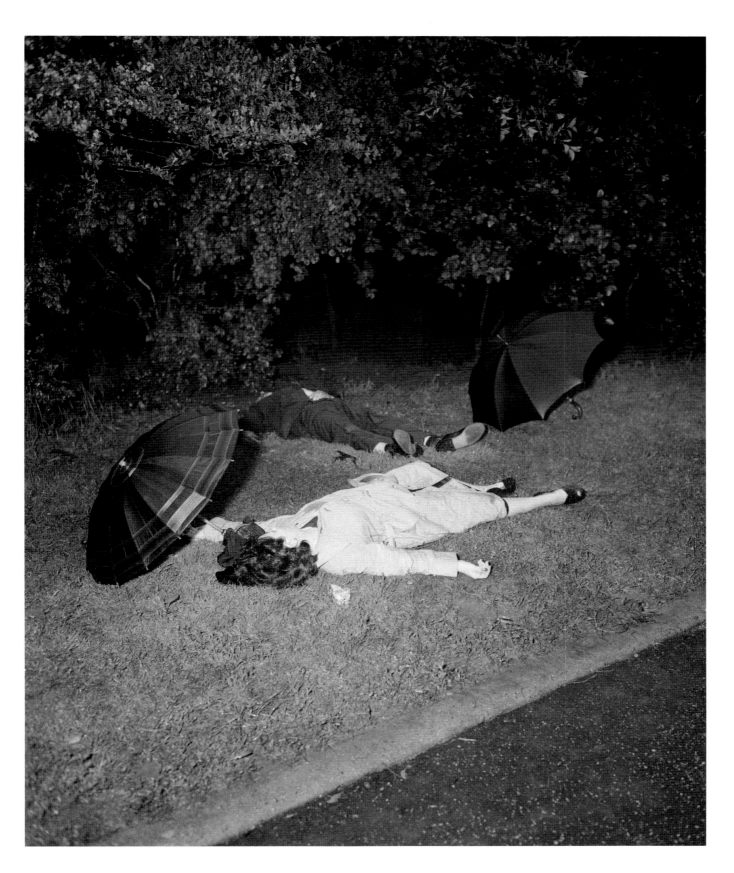

Police Suspect Murder in Central Park

JUNE 1, 1952
PHOTOGRAPHER: UNKNOWN
NEW YORK, NEW YORK

General views of death scene in Central Park at 106th Street East early this evening. Bodies are those of Juanita Rivera and Luis Rizarry. Police suspect the man murdered the woman and then committed suicide. Time of death set at 4 P.M. A forty-five caliber pistol was the death weapon and can be seen near the man's right foot.

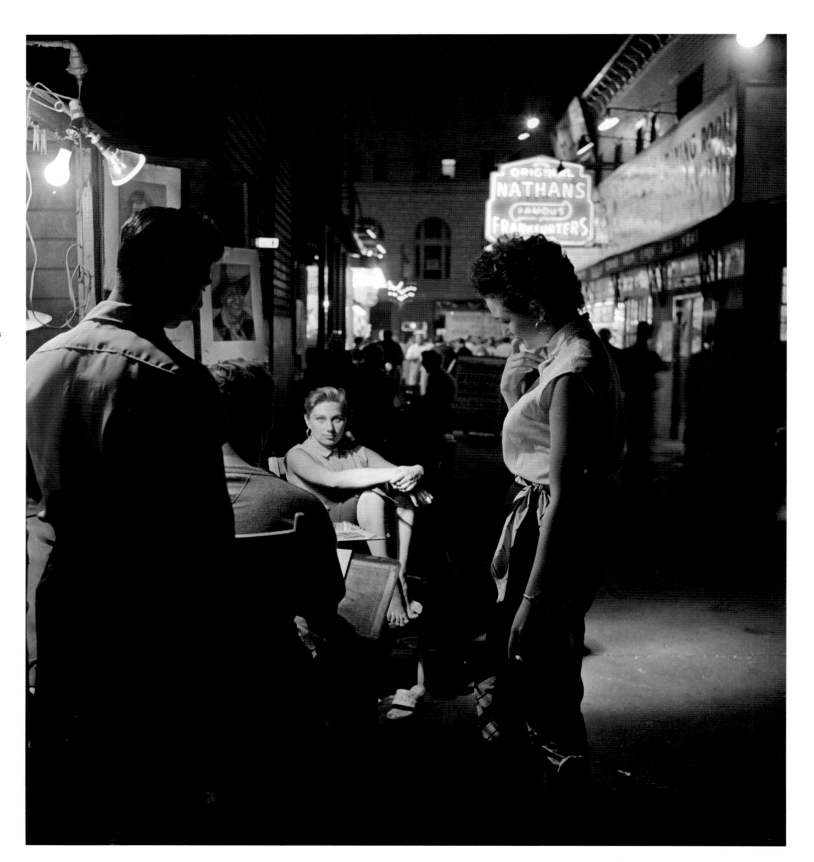

Artist at Coney Island carries on business as
two interested onlookers watch.

APRIL 1954
PHOTOGRAPHER: UNKNOWN
WASHINGTON, D.C.

Senator Joseph R. McCarthy (R.-Wisc.), (right), and Roy Cohn laugh at a remark by Counsel Ray Jenkins during an exchange in which Senator McCarthy apologized to Jenkins for an angry outburst yesterday in which he charged the tall rangy Tennessean had "bragged" about his prowess as a criminal lawyer.

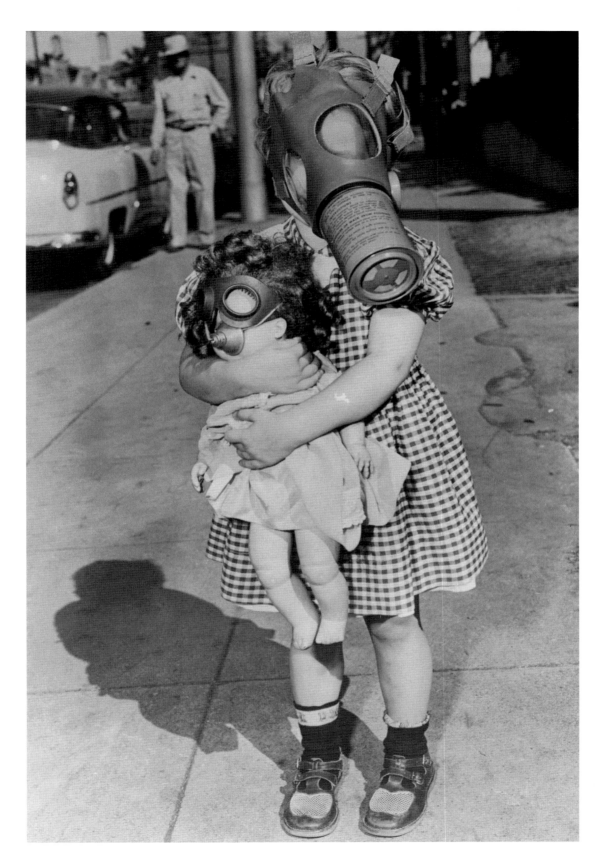

OCTOBER 21, 1954
PHOTOGRAPHER: UNKNOWN
PASADENA, CALIFORNIA

The doll too, was masked when Agatha Acker, 3, joined her mother and others parading in Pasadena to urge attendance at a smog protest meeting.

NOVEMBER 5, 1954
PHOTOGRAPHER: FRANK KUCHIRCHUK
CLEVELAND, OHIO

This model of the head of Marilyn Sheppard is held by the coroner's office for possible introduction at the trial of her husband, Dr. Samuel Sheppard, who is accused of her brutal slaying on July 4. The model shows where the wounds were inflicted with a weapon that has not been found.

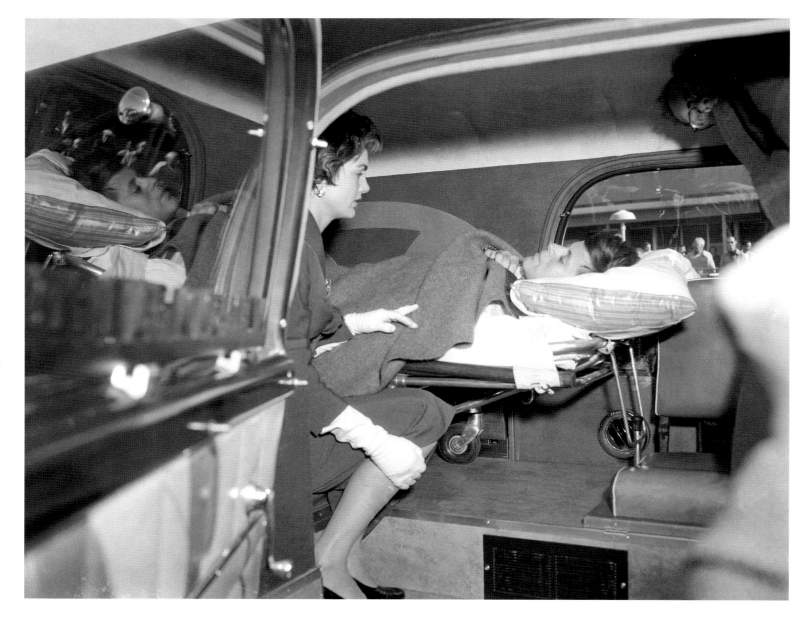

Recuperating

DECEMBER 21, 1954
PHOTOGRAPHER: UNKNOWN
WEST PALM BEACH, FLORIDA

Accompanied by his wife, Jacqueline, Sen. John Kennedy (D.-Mass.) is taken by ambulance to his father's residence at West Palm Beach, Florida. Released from a New York hospital following a spinal operation for a war injury, the 37-year-old legislator immediately was flown south to spend the Christmas Holidays. A hospital spokesman said Kennedy's convalescence would take several more months. He underwent the spinal operation to correct an injury that forces him to walk with the aid of crutches.

Down-Trodden

APRIL 16, 1954
PHOTOGRAPHER: UNKNOWN
CLEVELAND, OHIO

As mounted police arrive on the scene to prevent trouble arising from a 3,000-man picket line, an unidentified striker tries to shield himself from the horse's hoofs. The strike occurred at the Park Drop Forge Co., Cleveland, Ohio, where CIO-United Auto Workers Union members managed to prevent most non-strikers from entering the plant.

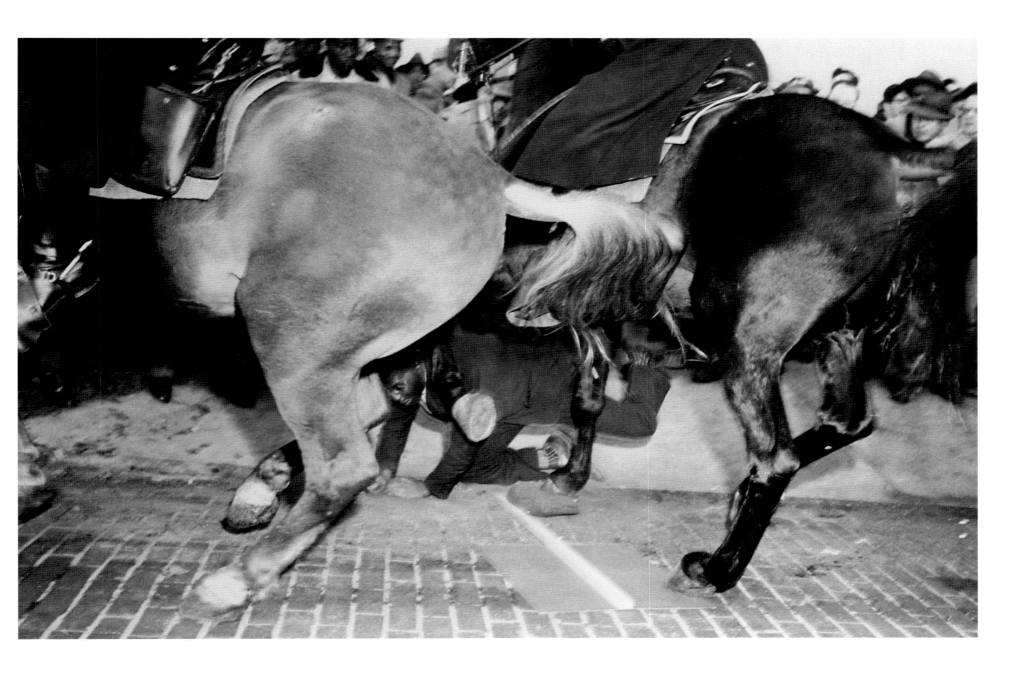

Amid the hectic household chores of ironing and feeding son Christopher, Mrs. Marie Breetveld finds time to watch the televised hearings of the McCarthy-Army controversy in Washington. Elsewhere throughout the United States millions of viewers, taking minutes from their lunch hour or work, crowded around T.V. sets to watch the proceedings.

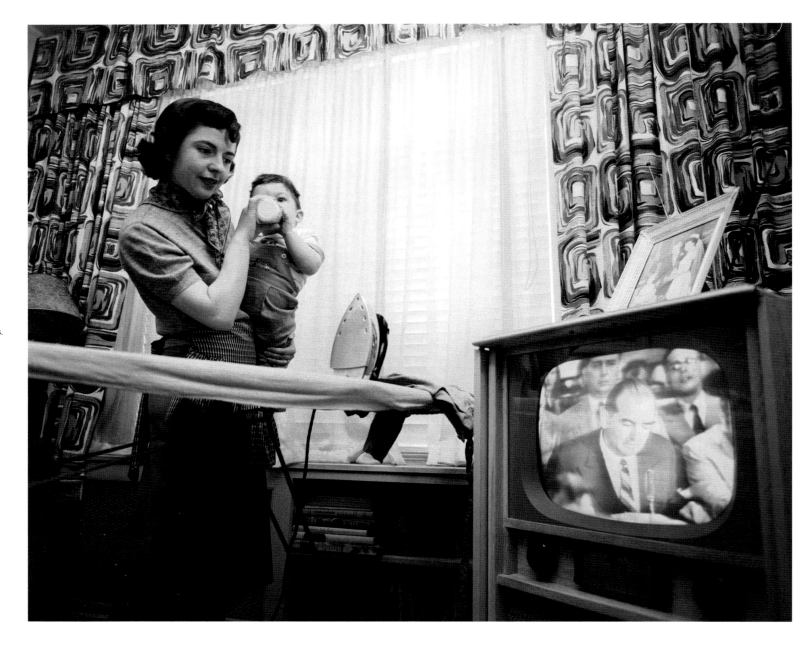

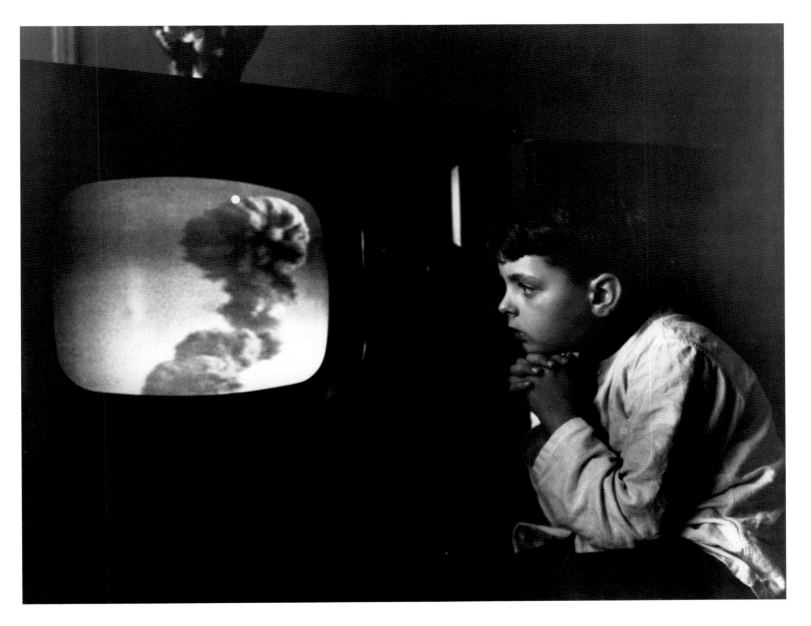

Awestruck at TV View of Blast

MAY 5, 1955
PHOTOGRAPHER: ARTHUR SASSE
THE BRONX, NEW YORK

Little Raymond Carlin, 7, of the Bronx is held spellbound before his television screen as he watched the awesome spectacle of an Atomic explosion twice as powerful as the one that crushed the Japanese city of Hiroshima, before Raymond was born. Raymond watched as the fireball soared skyward and the familiar mushroom cloud took on a bluish tone.

Looking for a Showcase Mannequin???

FEBRUARY 24, 1955
PHOTOGRAPHER: UNKNOWN
NEW YORK, NEW YORK

The "innards" of one of New York's famous landmarks will go under the gavel the week of March 7–16 when all furnishings and miscellaneous articles, including these showcase dummies, remaining in the John Wanamaker store on Eighth Street are sold at auction. Auctioneer O. Rundle Gilbert is shown looking over some of the 150 mannequins, which will be auctioned off.

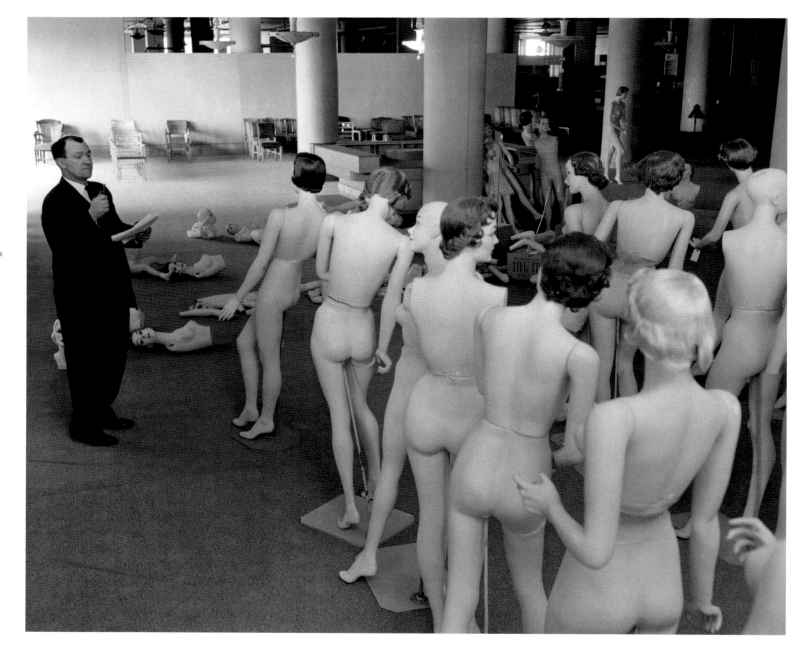

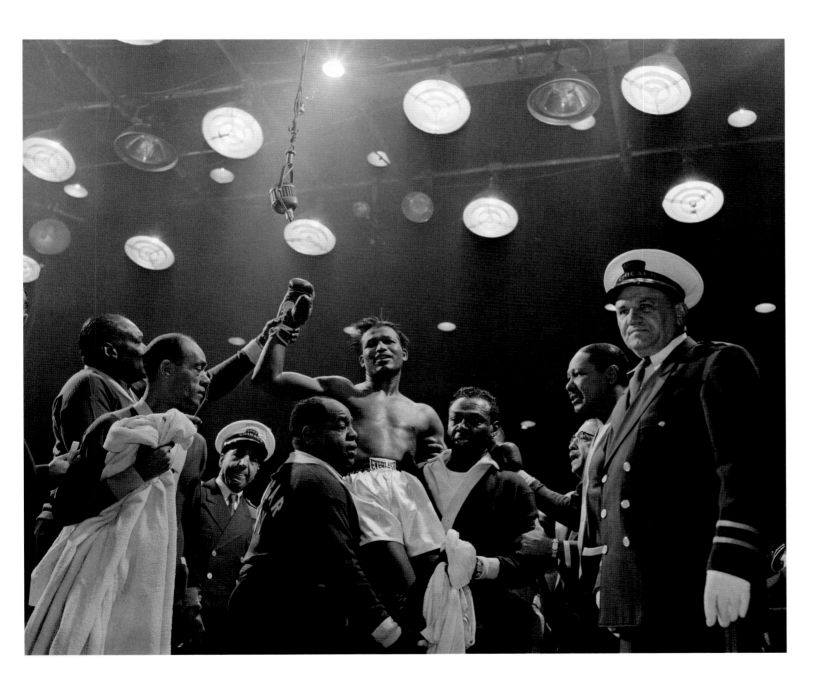

DECEMBER 9, 1955
PHOTOGRAPHER: UNKNOWN
CHICAGO, ILLINOIS

Sugar Ray Robinson smiles broadly as he is raised to shoulders of his handlers here, after scoring a 2nd round knockout over defending champ Carl "Bobo" Olson. The end came at 2:51 of the 2nd round. Carrying Robinson are Harry Wiley (left) and Honey Brewer.

JANUARY 19, 1955
PHOTOGRAPHER: MAURICE JOHNSON
WASHINGTON, D.C.

Vice President Richard M. Nixon, who worked his way through college as a gas station attendant, wipes off the car windshield for Barbara Larroca, of Arlington, Virginia, while serving as a gas station attendant for the March of Dimes in Washington. The station will donate the day's profits to the fund drive of the National Foundation for infantile paralysis.

APRIL 27, 1955
PHOTOGRAPHER: UNKNOWN
LOS ALAMOS, NEW MEXICO

"Inhabitants" of doom town bomb testing.

Training to Escape if Captured

SEPTEMBER 15, 1955
PHOTOGRAPHER: UNKNOWN
NEVADA

Brainwashing School,
shows torture treatments.

Look Mom! No Hands!

OCTOBER 18, 1955
PHOTOGRAPHER: ARTHUR SASSE
NEW YORK, NEW YORK

Don Jonathon goes flying through the air
and lands on Don Eagle during their bout
at Madison Square Garden tonight.
Tonight's event was the first of eight
scheduled for the Garden this season.

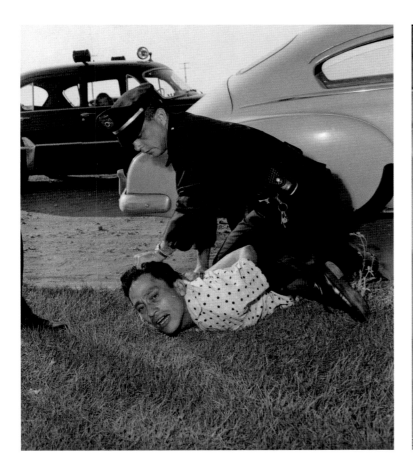

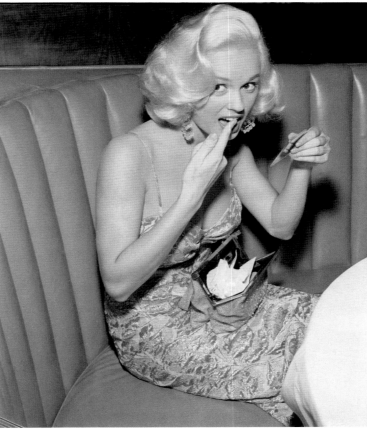

Subject Subdued

AUGUST 18, 1955
PHOTOGRAPHER: UNKNOWN
COMPTON, CALIFORNIA

Police Officer Robert Ludwig wrestles with kidnap suspect Everado Martinez, who, police said, was discovered in a parked car with seven-year-old Joyce Pike (shown sitting in police car). The child had been reported abducted earlier in the day.

AUGUST 17, 1955
PHOTOGRAPHER: UNKNOWN
LOS ANGELES, CALIFORNIA

Just like every other gal, actress Mamie Van Doren must check her makeup after dinner. Even in this off guard study of her, the blonde radiates the charm that has made her a pin up favorite.

NOVEMBER 28, 1955
PHOTOGRAPHER: UNKNOWN
WALPOLE, MASSACHUSETTS

Guards peer from their observation windows at the control center of the new prison. From this room can be controlled all alarms, communications and automatic doors. Commissioner Oswald stands at right background with some members of the press who accompanied him on tour.

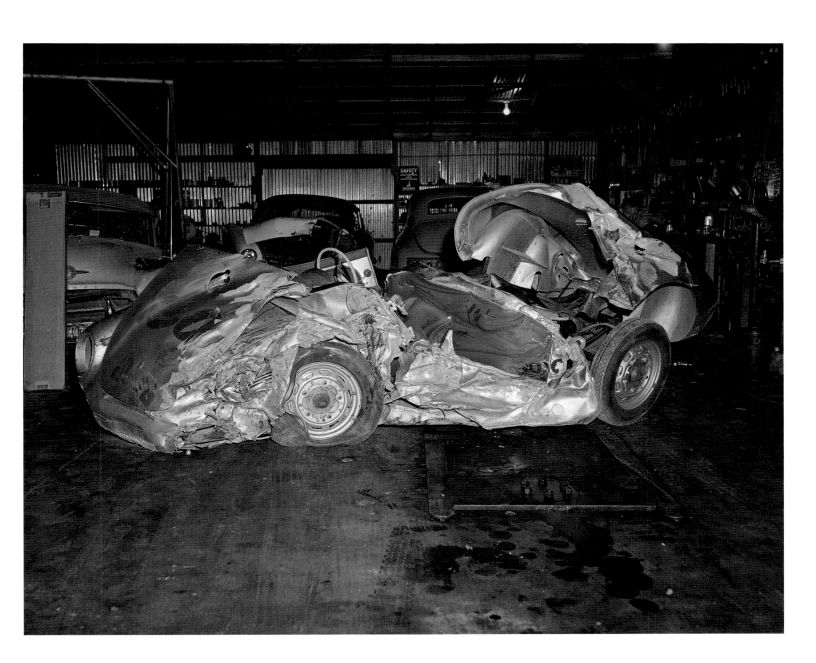

OCTOBER 1, 1955
PHOTOGRAPHER: UNKNOWN
PASO ROBLES, CALIFORNIA

Death overtook speed loving James Dean, 24-year-old film star and newest idol of the bobby soxers, at a highway intersection 28 miles east of Paso Robles last night. Pictured are the remains of a Porsche collided with college student's automobile at a junction.

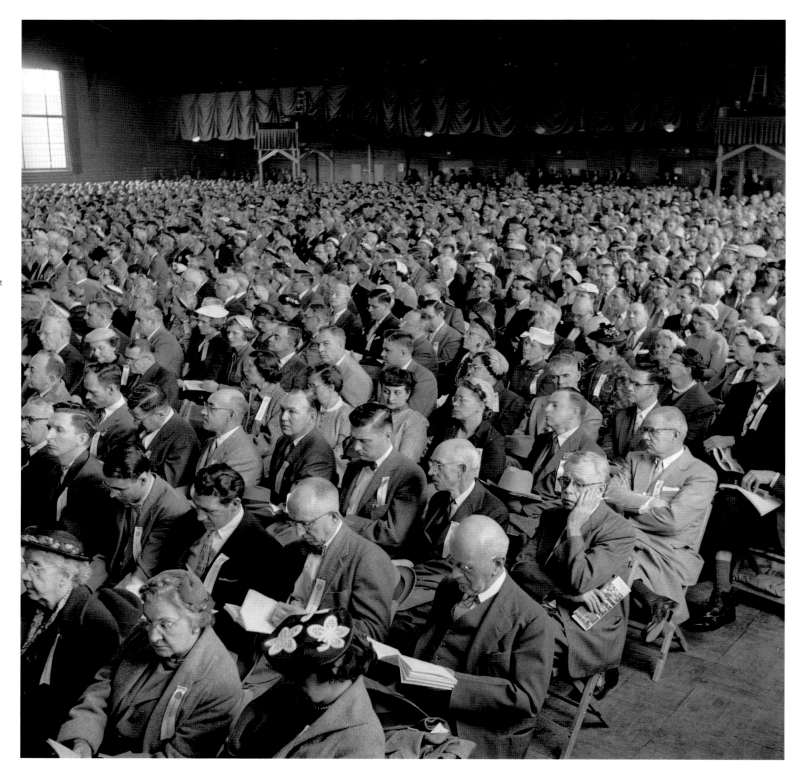

APRIL 17, 1956
PHOTOGRAPHER: UNKNOWN
SCHENECTADY, NEW YORK

General view of close to 4,000 share owners at
the 64th annual meeting of the General
Electric Company.

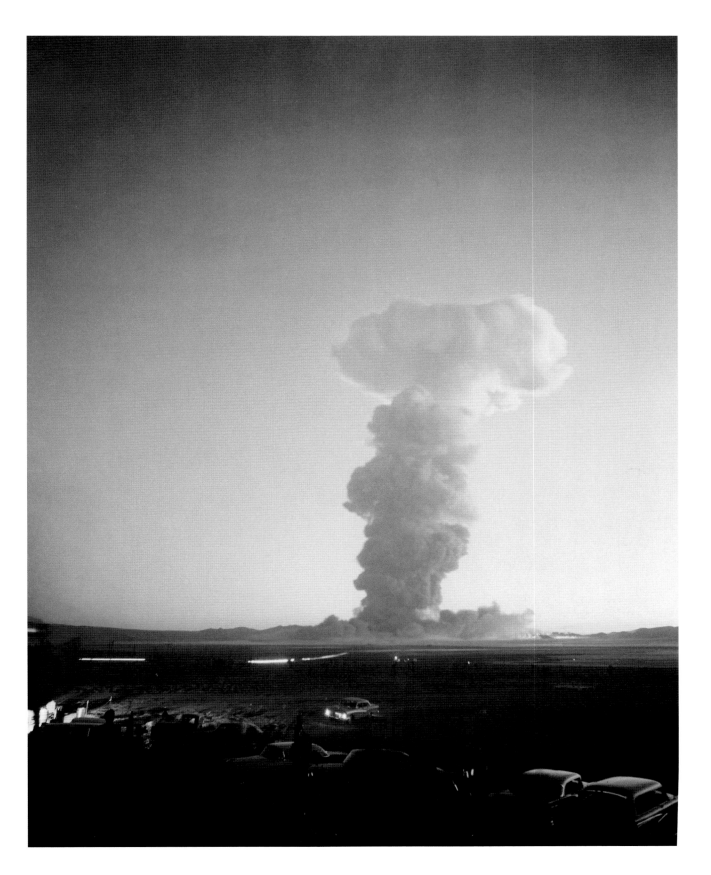

Atomic tests at Nevada, Yucca Flats.

Providence police pump bullets into the tires of an auto driven by holdup suspect Joseph Calitri as he attempts to escape a trap set up at his North Providence home. Calitri left the car and attempted to make an escape on foot across a small pond but was captured.

MARCH 9, 1955
PHOTOGRAPHER: UNKNOWN
NEW YORK, NEW YORK

Clad in a tightly-fitted gown, Marilyn Monroe glances over her shoulders on arriving at the Astor Theatre tonight for the benefit premiere of *East of Eden*. Marilyn served as an usherette. The proceeds went to the Actors' Studio.

JULY 1957
PHOTOGRAPHER: UNKNOWN
NEW YORK, NEW YORK

All shook up even before the show begins, excited teenagers are kept in line by police barricades outside the Paramount Theater. The youngsters were anxiously awaiting the opening of the box office so they could get inside to see Alan Freed's *Rock 'n Roll* stage show.

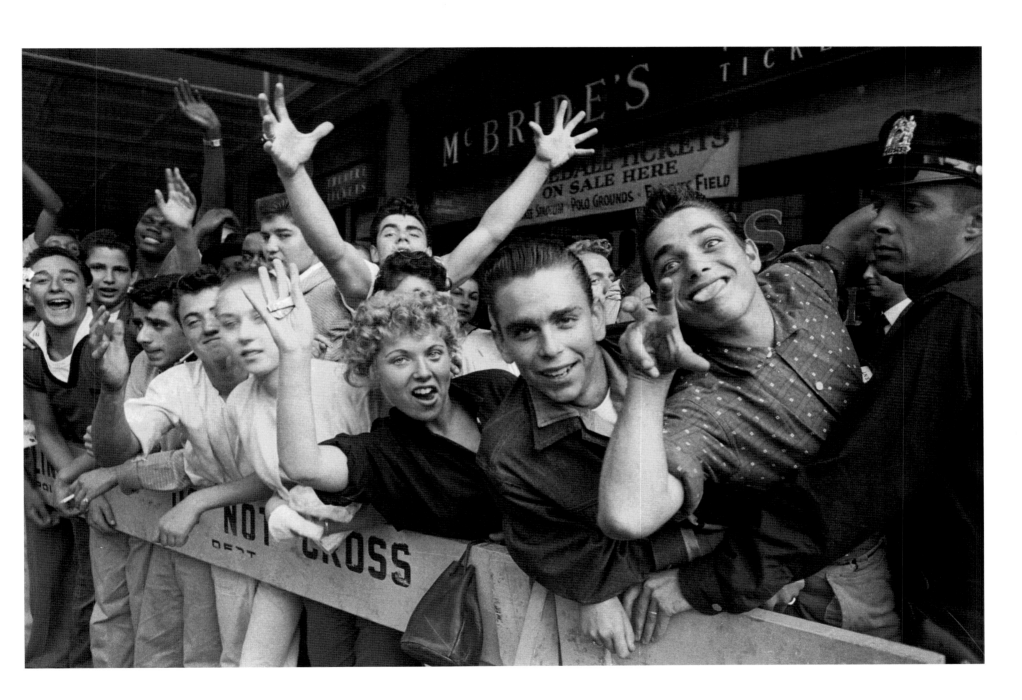

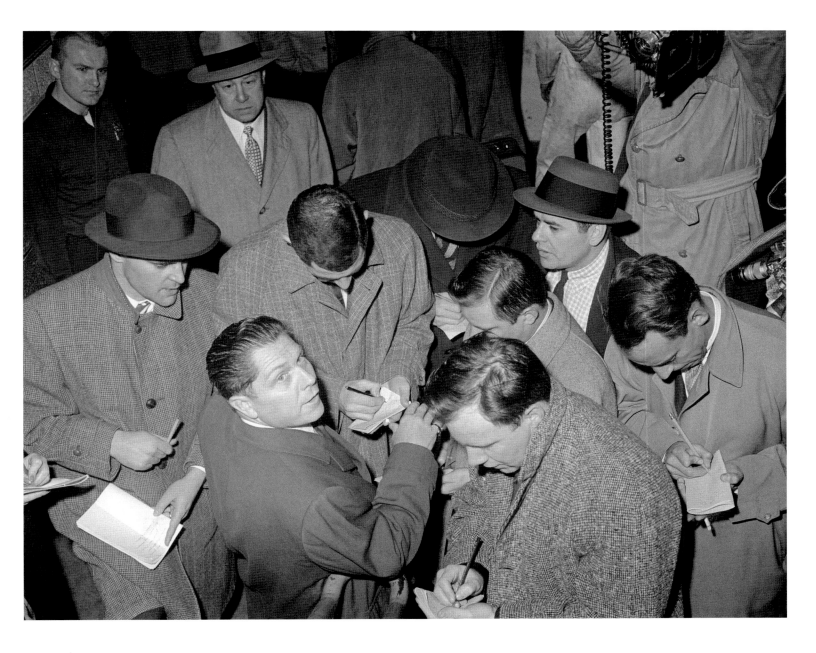

MARCH 15, 1957
PHOTOGRAPHER: UNKNOWN
DETROIT, MICHIGAN

Teamsters Union Vice President James
R. Hoffa (left, turning to face camera) is
surrounded by reporters on his arrival in
Detroit from Washington. Free on $2,500
bail, Hoffa is charged with trying to
obtain Senate Labor Rackets Committee
records through bribery. He said that,
to his knowledge, the Rackets Committee
has not issued any subpoenas for him
or for the union records in Detroit.

1956
PHOTOGRAPHER: UNKNOWN
BIRMINGHAM, ALABAMA

An interior view of a Montgomery
City transit bus is seen here. It's completely
empty as it stops in the middle of town
during the middle of the day. Signs
separating it into "White" and "Negro"
sections have been removed. Negroes in
Montgomery have continued to boycott
the city bus line.

DECEMBER 13, 1957
PHOTOGRAPHER: UNKNOWN
NEW YORK, NEW YORK

The scene in St. Patrick's Cathedral today as the infant daughter of Senator and Mrs. John F. Kennedy was christened Caroline Bouvier Kennedy by Archbishop Richard J. Cushing. Left to right are Robert Kennedy, brother of the Father, who acted as Godfather; Mrs. Michael Canfield, holding the baby, who acted as Godmother; Senator John Kennedy of Massachusetts, the Proud Father, and his wife, in background, can be seen Joseph P. Kennedy, father of the Senator and former U.S. Ambassador to England. Mrs. Canfield is sister of Mrs. John Kennedy.

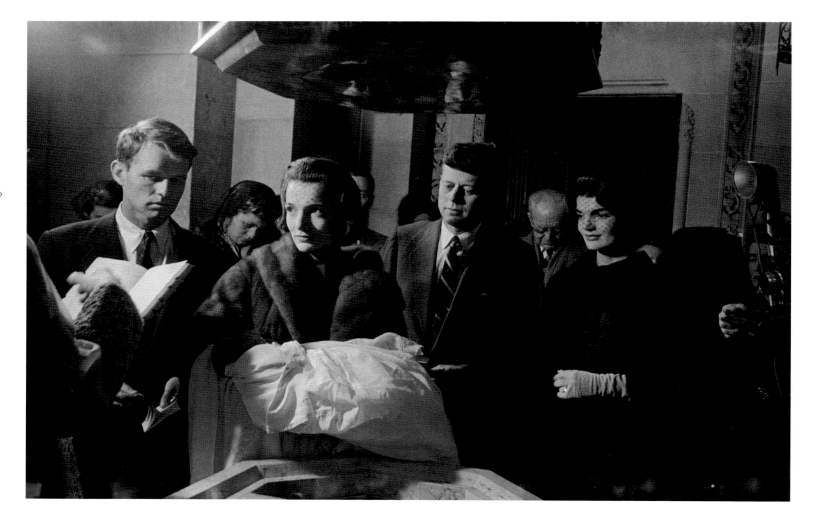

MAY 11, 1957
PHOTOGRAPHER: UNKNOWN
WASHINGTON D.C.

Robert Kennedy, Chief counsel of the Senate Rackets Committee, (center, with back to camera) holds an impromptu Press Conference after the committee's morning session yesterday. Not only impromptu, but quite informal as reporters huddled around Kennedy, with some stretched across the table in order to hear every word.

The Kayo...

FEBRUARY 22, 1957
PHOTOGRAPHER: UNKNOWN

Carmen Basilio-Johnny Saxton fight. Referee gives the signal that it's all over.

Infuriated hoodlum Johnny Dio glares
angrily at the camera after slugging
United Press photographer Stanley Tretick
(right), who ducks away after being hit.
Dio threw his punch at Tretick after the
mobster was ordered out of the Senate
hearing room by Rackets Committee
Chairman Sen. John L. McClennan (D-
Ark.) because of the hubbub which arose
when Dio strode in. Dio had been called
to testify on the alleged leadership of
labor racketeering in New York, Tretick
told reporters following the incident:
"He hit me on the left ear."

With hat over his heart, Governor Orval
Faubus of Arkansas, stands beside his
wife as they listened to the national an-
them being played prior to the start of the
Arkansas-Texas Christian University foot-
ball game. Army Secretary Brucker called
on Faubus to produce any evidence he
has that Army soldiers entered girls' dress-
ing rooms at Central High School in Little
Rock. The secretary said, "either Governor
Faubus has the evidence to support his
charges or he is guilty of a malicious
falsehood in slandering American troops
in the eyes of the people."

MARCH 9, 1957
PHOTOGRAPHER: UNKNOWN
LOS ANGELES, CALIFORNIA

Singer Frank Sinatra appears somewhat bemused as he arrives to face a Los Angeles County Grand Jury, which is investigating the famous "wrong door" raid conducted by Joe DiMaggio, during his divorce contest with Marilyn Monroe. Sinatra has claimed he remained outside in a car during the raid, a story contradicted by private detective Philip Irwin, who says Sinatra helped break down the door. The jury is looking into perjury charges.

OCTOBER 3, 1958
PHOTOGRAPHER: ART SARNO
NEW YORK CITY, NEW YORK

Roy Campanella
being carried into the stadium for the first
game of World Series.

APRIL 17, 1957
PHOTOGRAPHER: UNKNOWN

Sophia Loren is shown with actor Cary
Grant at a cocktail party given by pro-
ducer Stanley Kramer at a Hollywood stu-
dio tonight. The affair was given in honor
of the Italian actress, who starred in one
of Kramer's films.

Police Sgt. Russel R. Peterson examines the eight-inch carving knife that was reportedly used in the fatal stabbing of underworld figure Johnny Stompanato here, April 4th. Stompanato, 41, a recent steady escort of actress Lana Turner and former bodyguard for gambler Mickey Cohen was allegedly stabbed to death by Lana's 14-year-old daughter, Cheryl, during an argument in the actress' home. Police said Cheryl had admitted the stabbing. The girl was booked on a suspicion of murder charge.

MAY 10, 1958
PHOTOGRAPHER: GENE FORTE
WASHINGTON, D.C.

A group of persons from Philadelphia, Pa., and New Jersey picketed the White House today in protest of nuclear tests.

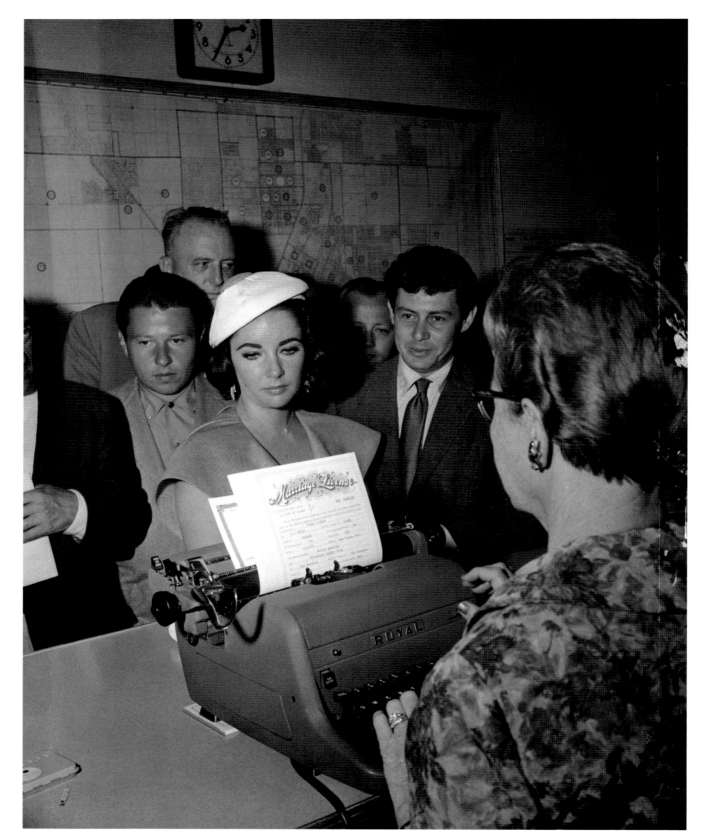

MAY 12, 1959
PHOTOGRAPHER: UNKNOWN
LAS VEGAS, NEVADA

Elizabeth Taylor and Eddie Fisher watch the county clerk type out their marriage license right after Fisher obtained a divorce from Debbie Reynolds. The couple will be married here at Temple Beth Shalom by the Rabbi who converted the actress to Judaism, Max Nussbaum.

252

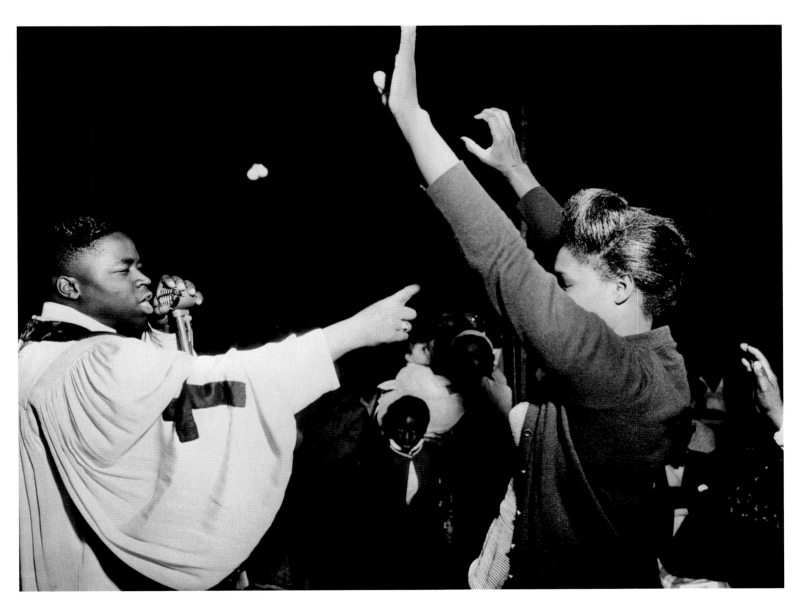

Harlem Evangelist Wins a Follower

AUGUST 30, 1957
PHOTOGRAPHER: NEW YORK JOURNAL
AMERICAN PHOTO FROM INTERNATIONAL
HARLEM, NEW YORK

The Rev. Milton Perry, 22-year-old Harlem evangelist (left), leads a follower with upraised arms to the reception of God at the evangelistic rally at 135 St. and Lennox Avenue. The Rev. Perry says that "A person's faith in God can accomplish anything" as he explained how some lame, blind and crippled persons have been "cured" in his revival tent. "I don't have the power to heal. I can only release their faith in God. That's what cures them."

APRIL 1, 1958
PHOTOGRAPHER: UNKNOWN
NEW YORK, NEW YORK

Mrs. William Woodward Jr. (left) arrives in New York from a vacation in Europe via the *QEII* and is greeted by her mother in law Mrs. William Woodward Sr. Three years ago Ann had shot dead her husband William Woodward Jr. (Elise's son) in what she said was confusion over a prowler in the house.

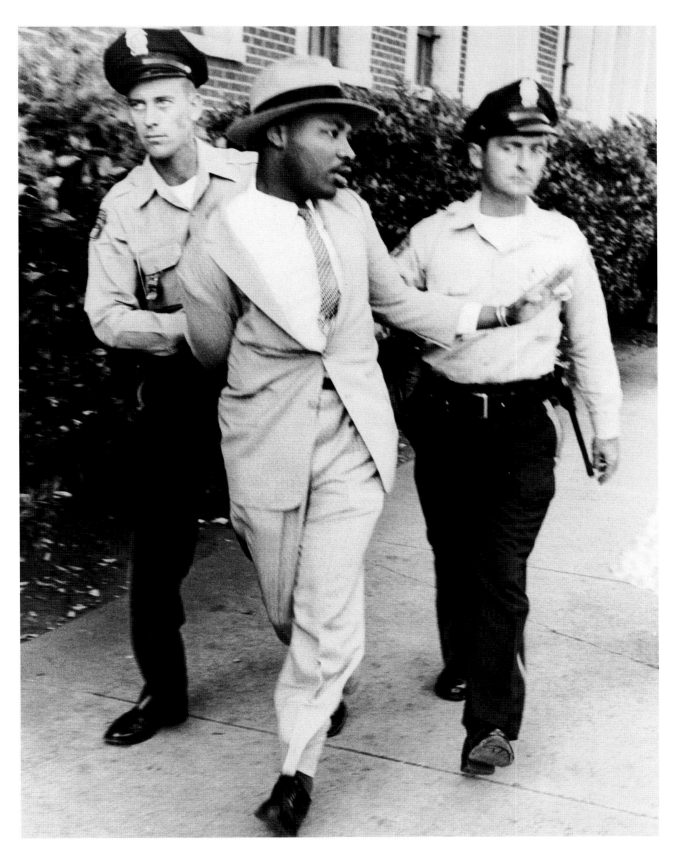

SEPTEMBER 4, 1958
PHOTOGRAPHER: UNKNOWN
MONTGOMERY, ALABAMA

Police officers O.M. Strickland and J.V. Johnson apply force in arresting the Reverend Martin Luther King for loitering near a courtroom where one of his integration lieutenants was on the stand. King, who gained national fame as a leader of the Negro bus boycott, charges he was beaten and choked by the arresting officers. Police deny the charges.

Female Admirers

APRIL 15, 1959
PHOTOGRAPHER: UNKNOWN
WASHINGTON, D.C.

Bugged by excited girls, Cuban Prime
Minister Fidel Castro greets admirers who
waited for him across the street from the
Cuban Embassy tonight where the Rebel
Leader went immediately after arriving
tonight. Castro is here on an 11 day
Campaign designed to win support for
his revolutionary regime.

JUNE 16, 1959
PHOTOGRAPHER: UNKNOWN
NEW YORK, NEW YORK

Nancy Ziluck smiles as classmates
wolf-whistle at her as she
arrives at Julia Richman High School.

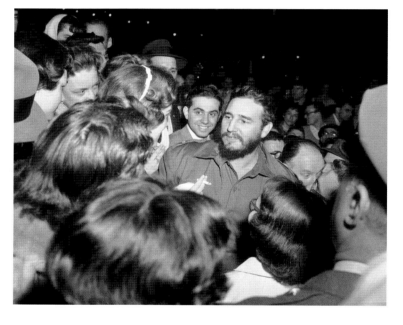

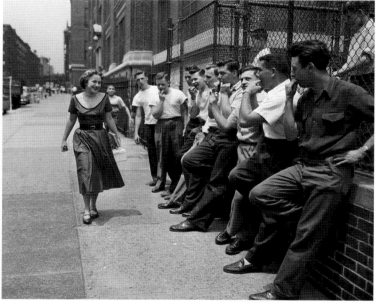

Alleged Leaders of Teen Killing

SEPTEMBER 2, 1959
PHOTOGRAPHER: UNKNOWN
NEW YORK, NEW YORK

Handcuffed, Sal Agron (smoking
cigarette) and Tony Hernandez, (right)
are shown at West 47th Street police
station here after their early-morning
capture. "Dracula" and "The Umbrella
Man," are alleged leaders of the Hell's
Kitchen playground attack here early
Aug. 30th that left two teenagers dead.
Man in left background of photo is an
unidentified detective. (Note crucifix
tattoo on right arm of Hernandez).

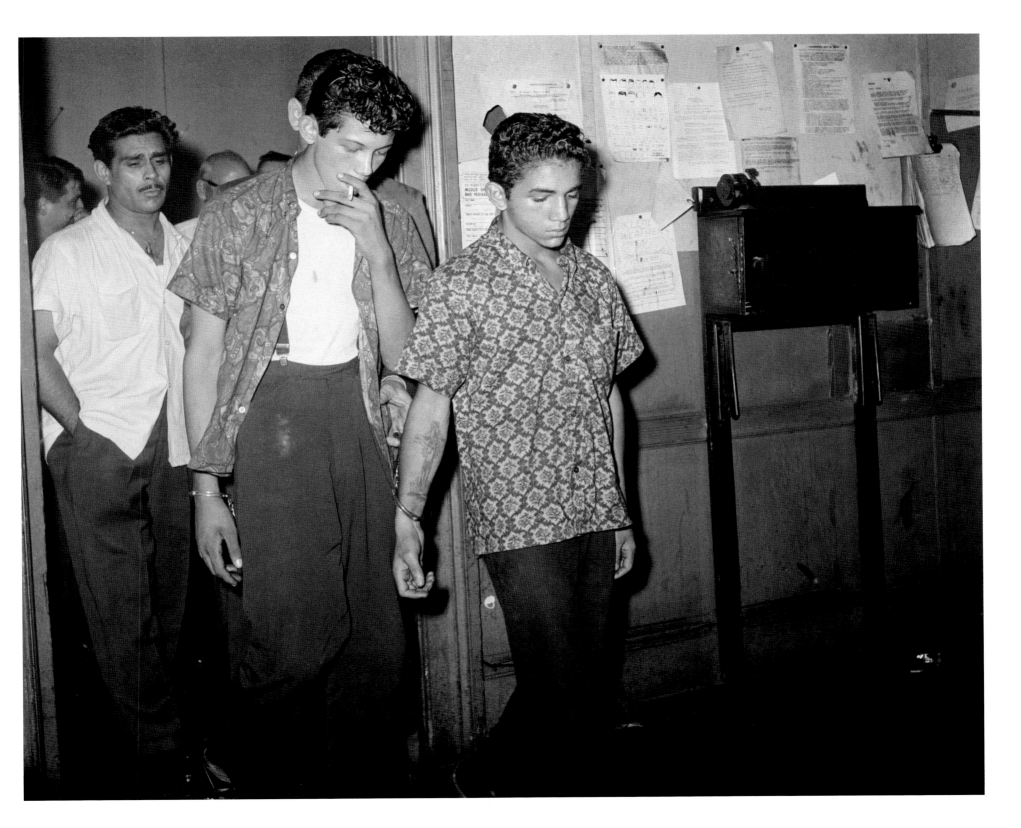

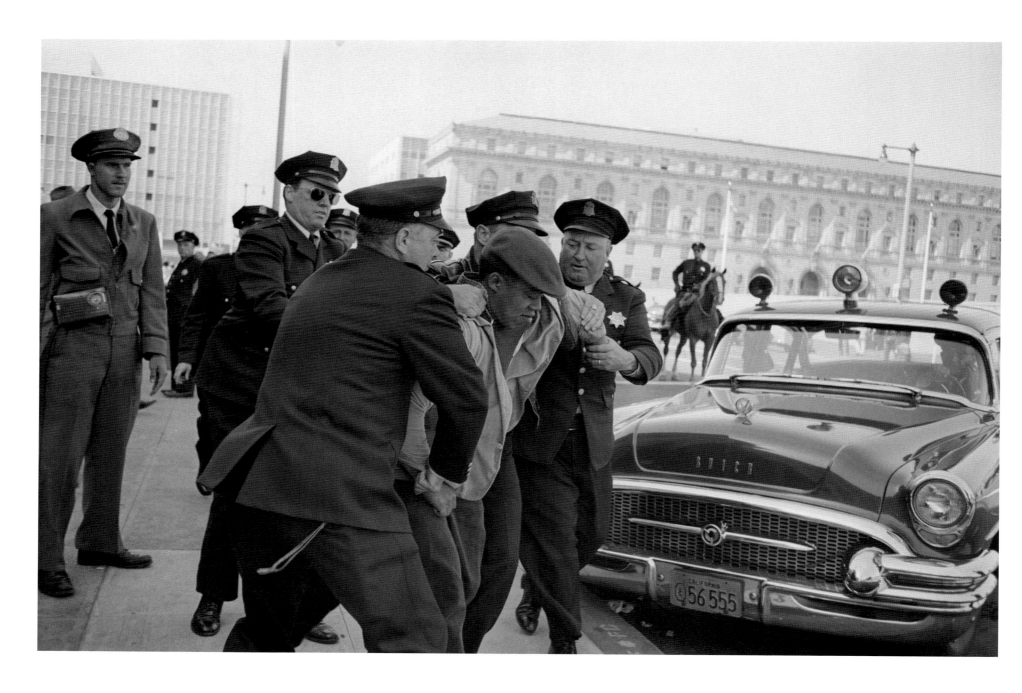

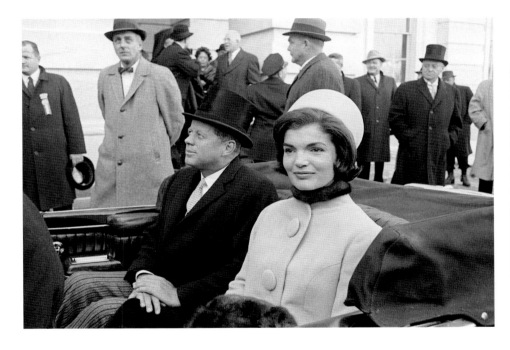

JANUARY 20, 1961
PHOTOGRAPHER: UNKNOWN
WASHINGTON, D.C.

The New President and First Lady. Washington, D.C.: President Kennedy and his wife leave the capitol building by car here, shortly after he took the oath of office as President of the United States. President Kennedy, 43, the youngest man ever elected to the Presidency called for a global alliance against "Tyranny, Poverty, Disease, and War." President Kennedy took the oath of office at 12:51 P.M. EST, to become the 35th Chief Executive of the land.

AUGUST 13, 1959
PHOTOGRAPHER: UNKNOWN
LITTLE ROCK, ARKANSAS

Under the watchful eye of a policeman, (left), three Negro girls walk from their car toward Hall High School. The girls returned to school for their second day of integrated classes almost ignored by 700 white students.

Police Escort

MAY 14, 1960
PHOTOGRAPHER: UNKNOWN
SAN FRANCISCO, CALIFORNIA

Unidentified demonstrator is escorted to patrol wagon after he became obnoxious and obstructed traffic outside City Hall where nearly 1000 students gathered to protest meeting of House Committee on Un-American Activities. The committee, holding hearings on Communist Activity in the Bay Area concluded meetings today.

Where the Boys Are is Where the Girls Do the Limbo

MARCH 30, 1961
PHOTOGRAPHER: UNKNOWN
FORT LAUDERDALE, FLORIDA

Hundreds of students gather around as a couple of coeds do the limbo to the beat of bongo drums on the beach at Ft. Lauderdale.

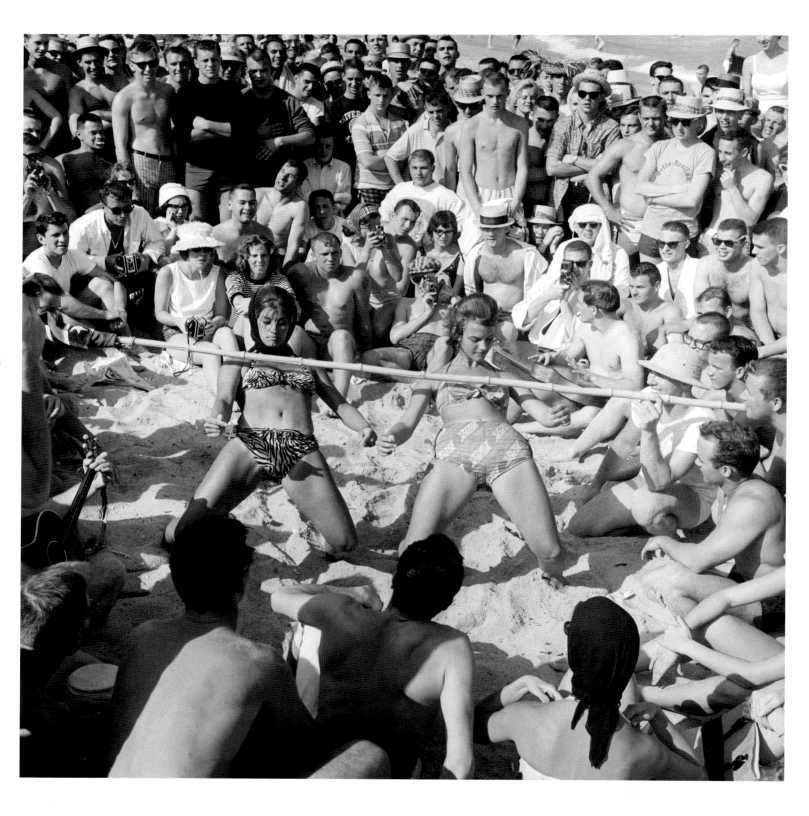

260

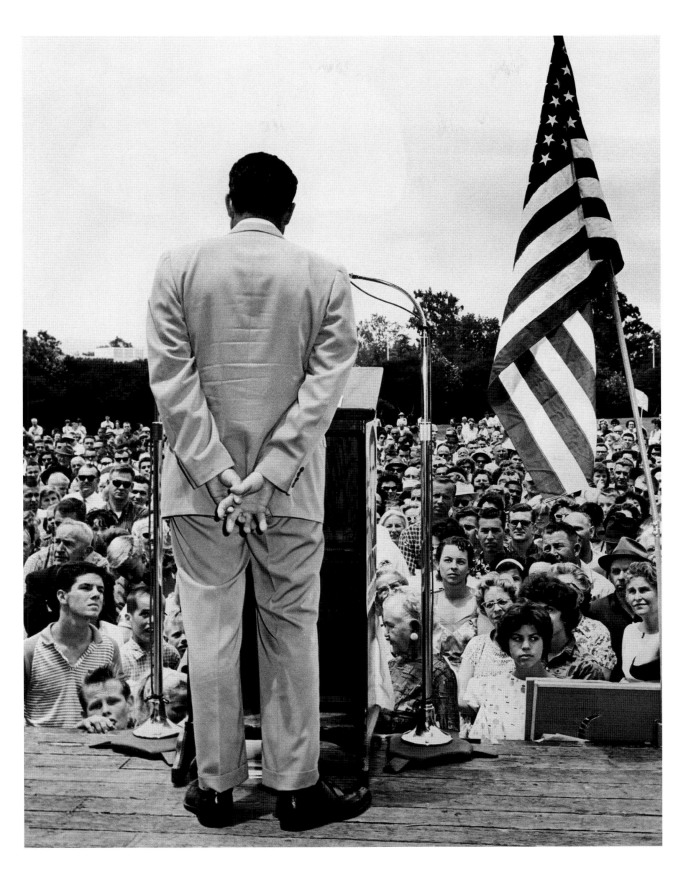

JUNE 2, 1962
PHOTOGRAPHER: UNKNOWN
PALO ALTO, CALIFORNIA

California Republican gubernatorial candidate Richard M. Nixon takes an odd stance, as he clasps his hands behind his back while addressing some 2,000 persons at a GOP rally. In his last northern California appearance before the primary election, Nixon said California needs a Governor who "will stand on his own two feet—not be propped by State-paid press agents and out of state politicians."

Chubby Checker "twists" away as he introduces the new dance craze to Hollywood celebrities at The Crescendo, a night club on the Sunset Strip. The Negro singing star, who is credited with popularizing the new back-breaking dance craze, gained a new group of converts to the fad when many of filmland's celebrities joined the frenzy on the dance floor.

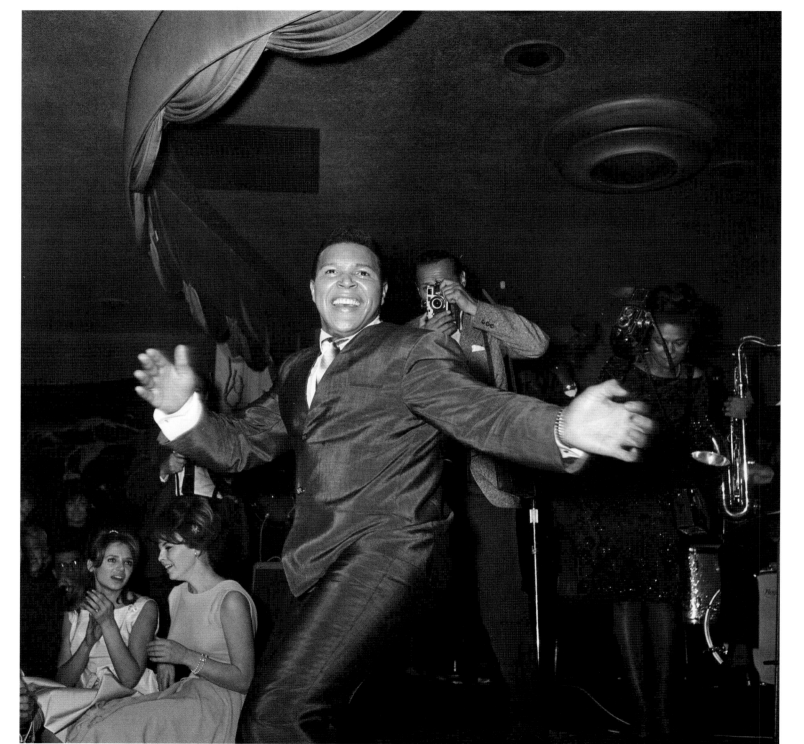

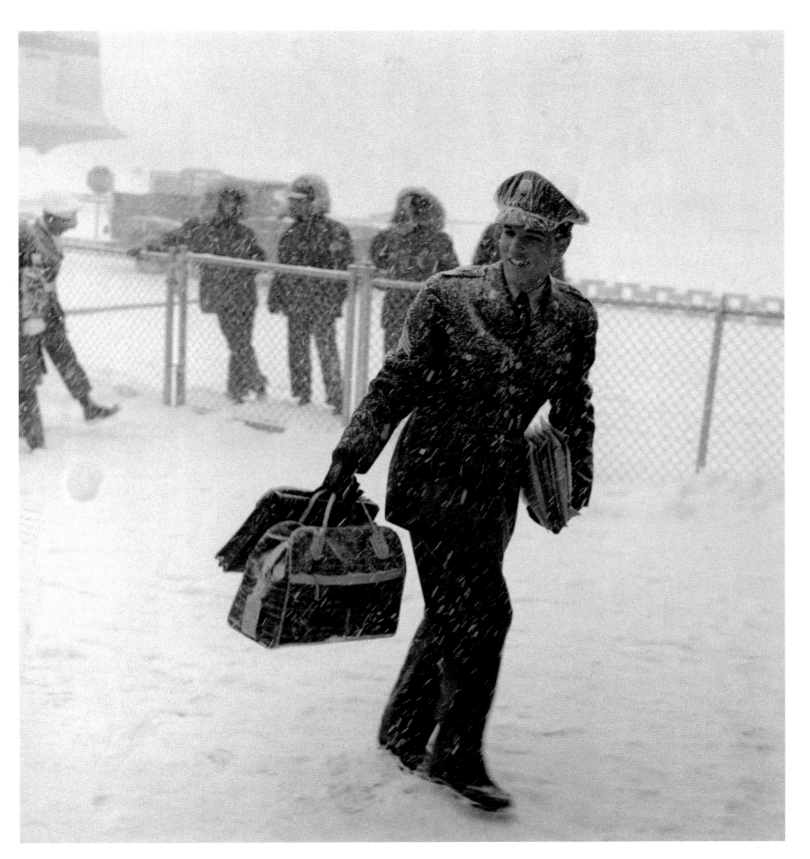

MARCH 3, 1960
PHOTOGRAPHER: UNKNOWN
NEW JERSEY

Sgt. Elvis Presley carries his bags through the snow upon arriving here by plane from Germany. He then went to nearby Fort Dix, where he is to stay for 48 hours while being separated from the army after two years.

What People Are Reading
These Days

OCTOBER 24, 1962
PHOTOGRAPHER: UNKNOWN
NEW YORK, NEW YORK

Newsstand does a brisk business,
as serious-faced commuters buy evening
papers for latest news of Cuban crisis.

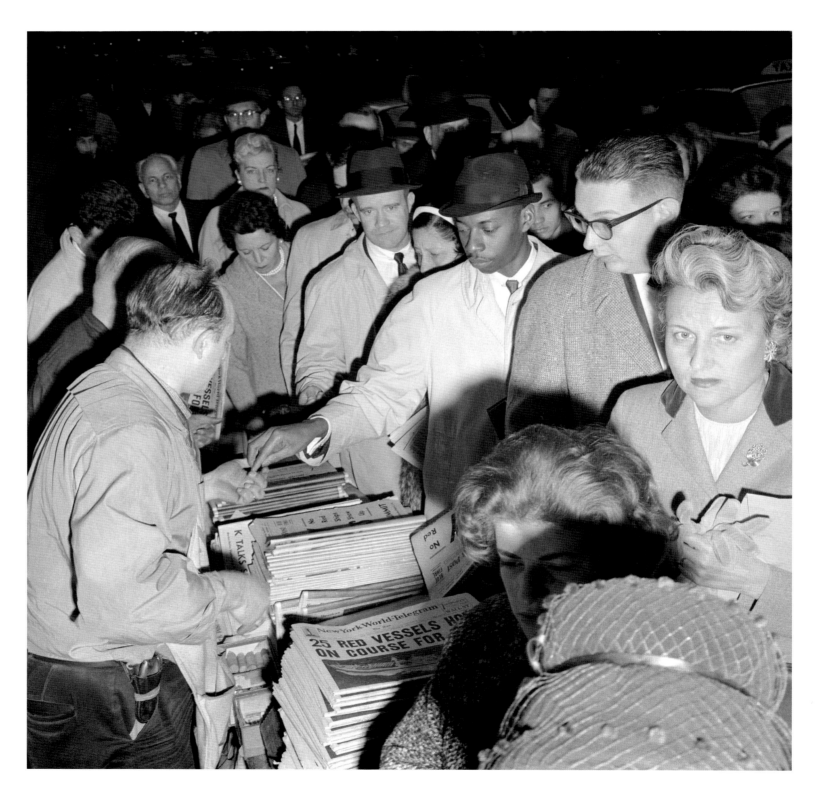

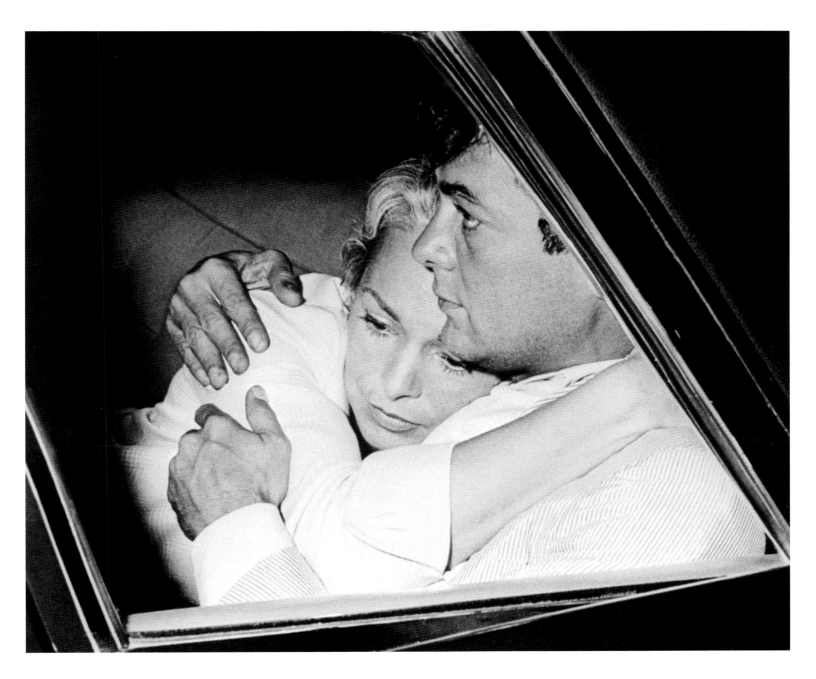

AUGUST 14, 1961
PHOTOGRAPHER: UNKNOWN
LOS ANGELES, CALIFORNIA

Actor Tony Curtis holds wife Janet Leigh in his arms in their auto at airport after her return here from Europe. Miss Leigh's father, insurance broker Fred R. Morrison, 52, was found dead in his office.

AUGUST 7, 1962
PHOTOGRAPHER: UNKNOWN
HOLLYWOOD, CALIFORNIA

The body of actress Marilyn Monroe
arrives at the mortuary August 5th.
The actress was found dead in her home
earlier in the day from an overdose of
barbiturates.

Forlorn Friend

AUGUST 6, 1962
PHOTOGRAPHER: UNKNOWN
HOLLYWOOD, CALIFORNIA

Marilyn Monroe's dog, Moff, seems to be
unhappy over the loss of his mistress, as
he is led from the Monroe house, August
5th. The actress was found dead in her
bed earlier in the day, from an overdose
of barbiturates. Photo shows a closeup of
the white dog being led away on a leash.

MARCH 25, 1965
PHOTOGRAPHER: UNKNOWN
SELMA, ALABAMA

This large billboard, pointing out Dr.
Martin Luther King at a communist train-
ing school, was one of a number erected
on U.S. 80, the highway over which 300
civil rights demonstrators marched. King,
who led the long march from Selma to
Montgomery, denied the allegations pur-
ported by the huge posters.

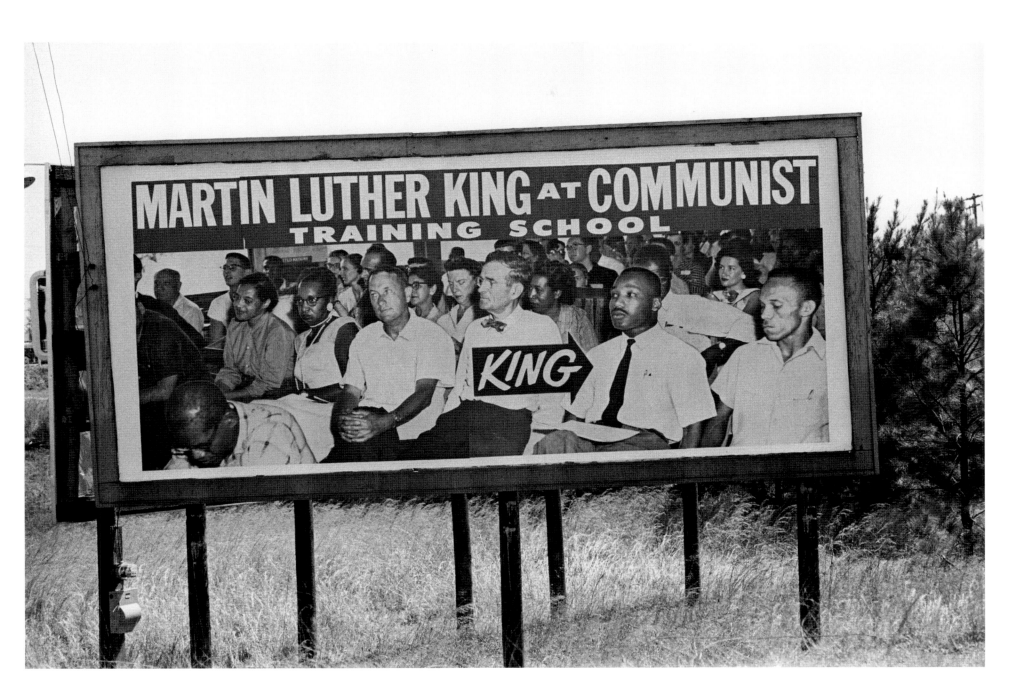

President Kennedy Performs a Citizen's Duty

NOVEMBER 6, 1962
PHOTOGRAPHER: UNKNOWN
BOSTON, MASSACHUSETTS

President John F. Kennedy leaves the voting booth at the Joy Street Police Station after casting his ballot. It took the Chief Executive less than one minute to cast his vote. Edward M. "Ted" Kennedy, 30, the President's youngest brother, won a smashing victory over his GOP opponent George Cabot Lodge, for the Massachusetts Senatorial seat.

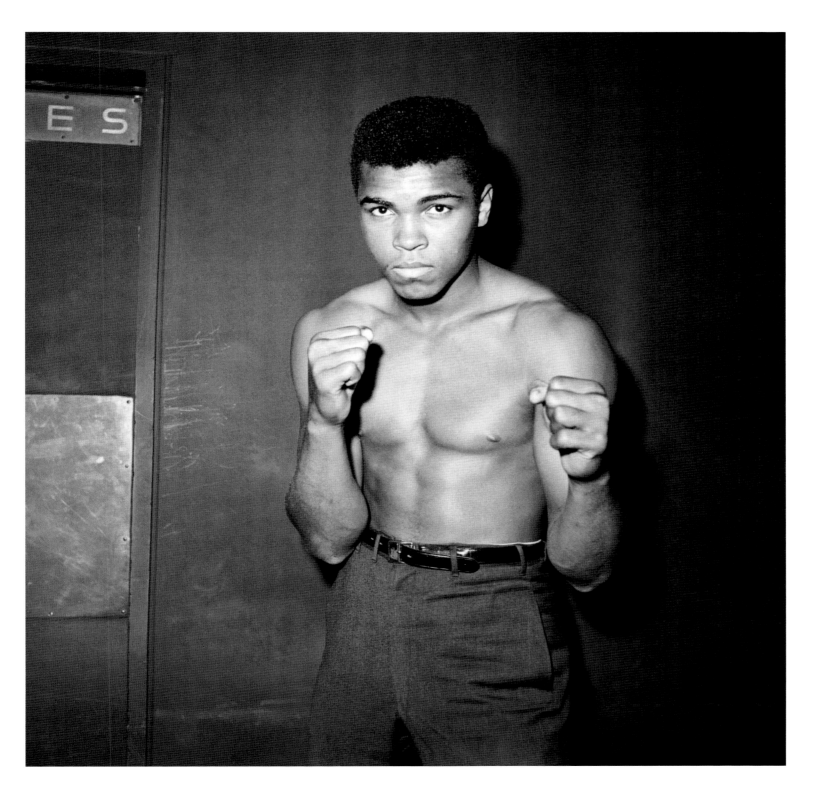

FEBRUARY 6, 1962
PHOTOGRAPHER: UNKNOWN

Cassius Clay, the Louisville slugger, and Sonny Banks, who is being hailed as another Joe Louis in his adopted city of Detroit, are two of the finest young heavyweight prospects in the current heavyweight picture. Clay, a handsome 20-year-old who has been fighting since October 29th, 1960, has won all of his ten fights, seven by knockout.

SEPTEMBER 8, 1962
PHOTOGRAPHER: UNKNOWN
ALBANY, GEORGIA

Ku Klux Klan wearing traditional hooded robes form a circle around a burning cross at a rally. Estimated 3,000 persons attended.

MAY 24, 1962
PHOTOGRAPHER: UNKNOWN
NEW YORK, NEW YORK

One minute after blast-off (which came at 8:45 A.M., EDT), the Atlas rocket carrying M. Scott Carpenter into space is shown on this TV screen in Grand Central Station here as it roars aloft from its Cape Canaveral launching pad. Thousands of people, most of them enroute to their jobs, stopped to watch the momentous flight which was expected to take Carpenter around the earth three times.

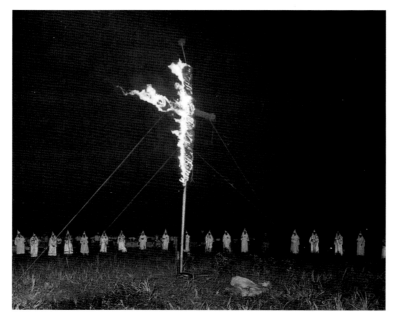

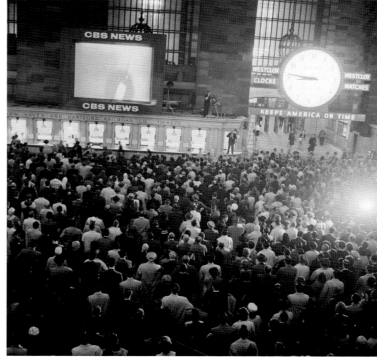

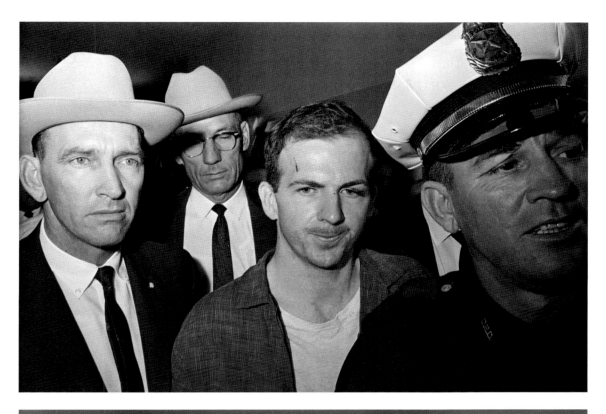

NOVEMBER 23, 1963
PHOTOGRAPHER: UNKNOWN
DALLAS, TEXAS

Twenty-four-year-old ex-marine Lee
Harvey Oswald is shown after his arrest
here on November 22. He received a cut
on his forehead and blackened left eye in
scuffle with officers who arrested him.
Oswald, an avowed Marxist, has been
charged with the murder of President
John F. Kennedy, who was killed by a
sniper's bullet as he rode in a motorcade
through Dallas.

NOVEMBER 23, 1963
PHOTOGRAPHER: UNKNOWN
DALLAS, TEXAS

A Dallas policeman holds the murder
weapon used to assassinate President
John F. Kennedy high over his head as he
carries it through crowd of newsmen at
police headquarters. Lee H. Oswald
has been charged with murder of the
president.

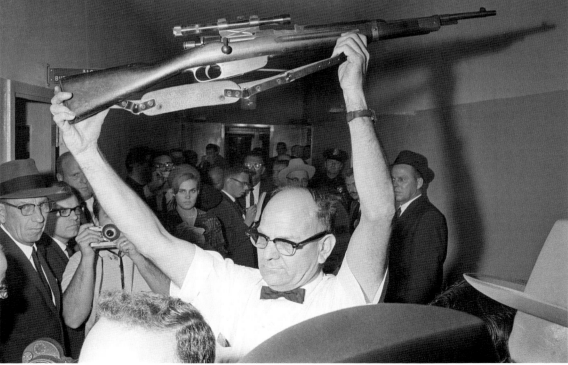

SEPTEMBER 1, 1963
PHOTOGRAPHER: UNKNOWN
PLAQUEMINE, LOUISIANA

A mounted Louisiana state trooper, armed with an electronic cattle prodder, charges into a crowd of Negro demonstrators when the Negroes attempted to march on the home of the local sheriff. The Congress of Racial Equality (CORE), said that 15 Negro children were injured when police dispersed the march.

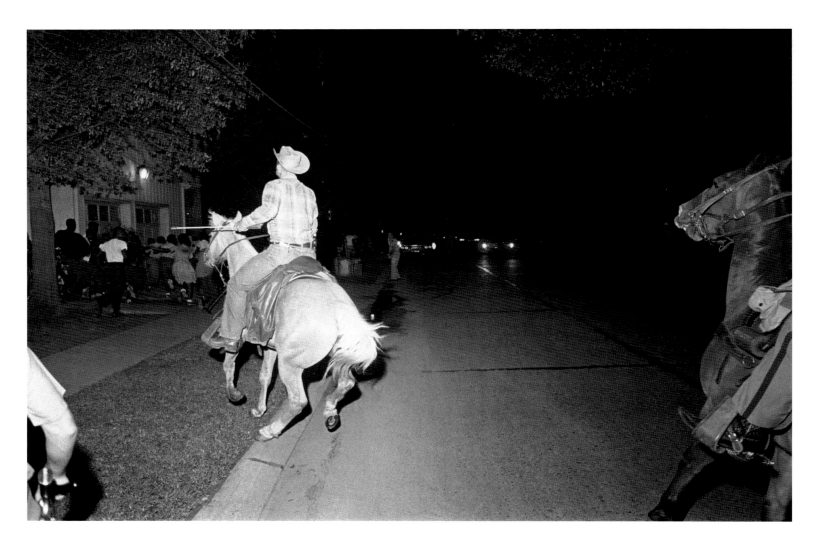

Eternal Flame Marking President
John F. Kennedy's Grave

NOVEMBER 26, 1963
PHOTOGRAPHER: UNKNOWN
ARLINGTON NATIONAL CEMETERY, VIRGINIA

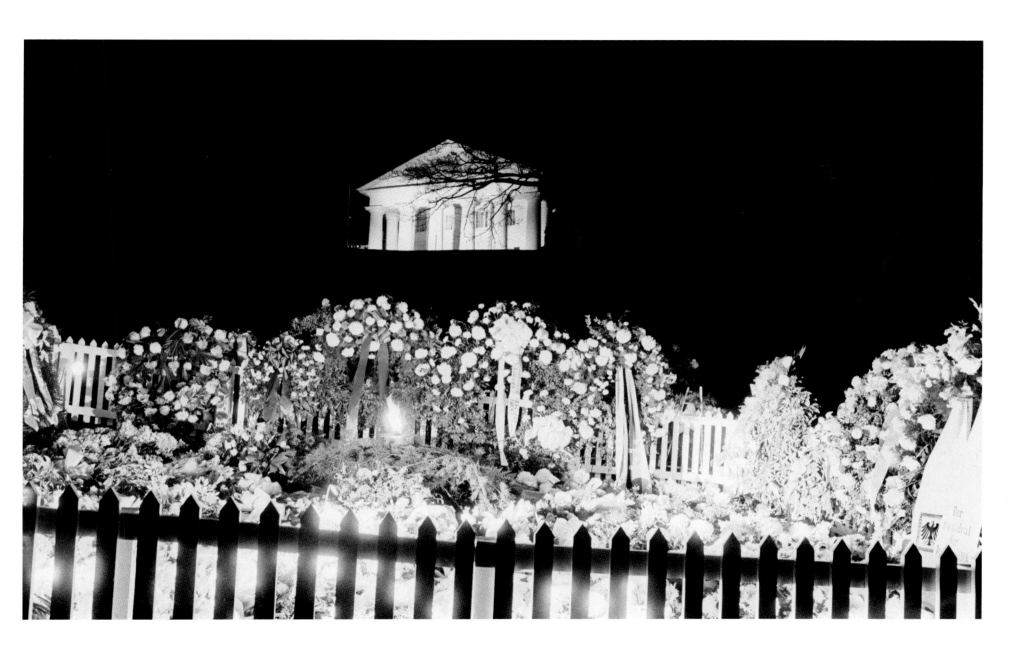

JANUARY 9, 1964
PHOTOGRAPHER: UNKNOWN
WASHINGTON, D.C.

Puffing away, Margie Hart, an UPI employee in New York, doesn't seem perturbed by the latest ominous news in store for the smoking set. A long-awaited report by Public Health Service advisory committee link smoking with cancer, other lung conditions, and even a rare form of blindness, Scripps-Howard Newspapers said. The report by Scripps-Howard science writer John Troan said the advisory committee "has concluded heavy cigarette smoking is a significant health hazard." The conclusions of the 10-man committee are to be made public on January 11th.

JUNE 11, 1963
PHOTOGRAPHER: UNKNOWN
TUSCALOOSA, ALABAMA

Vivian Malone is the object of considerable attention from those manning registration desks in Foster Auditorium at University of Alabama. Miss Malone and Jimmy Hood successfully registered to break the color barrier at the deep south school.

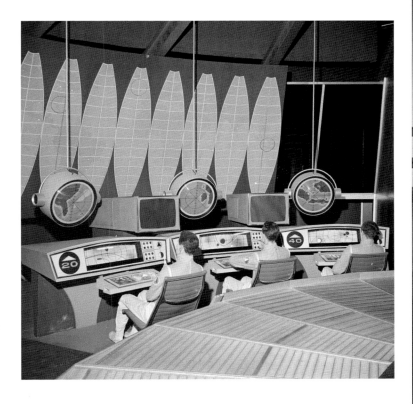

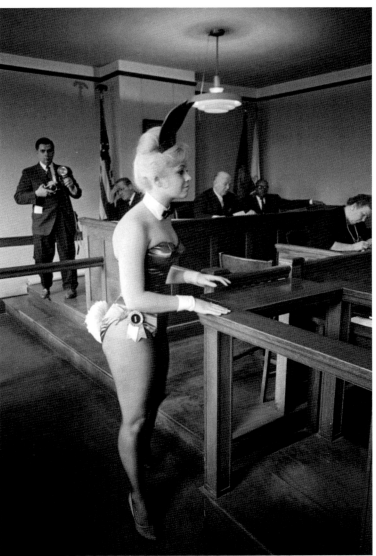

Actors in GM's "Futurama"

APRIL 8, 1964
PHOTOGRAPHER: UNKNOWN
QUEENS, NEW YORK

General Motor's 1964 World's Fair exhibit "Futurama" included a conjectural look at life in an undersea city.

FEBRUARY 13, 1963
PHOTOGRAPHER: UNKNOWN
BOSTON, MASSACHUSETTS

Geraldine Dorherty, 19, one of the "Bunnies" of the New York Playboy Club, appears before the Boston Licensing Board to demonstrate the type of costume that the waitresses would wear in a similar club in Boston. Playboy is applying for a liquor license. The board took the request under advisement.

Robert W. Goodman comforts his wife upon the arrival of their son's body at Newark Airport. A spokesman for the Goodman family said that the funeral service will be held at the meeting house of the Society for Ethical Culture in Manhattan, August 9th. The Goodman's son Andrew had been missing along with two other civil rights workers in Mississippi since last June. The F.B.I. discovered the bodies of the three late August 4th as the result of a tip by an informant.

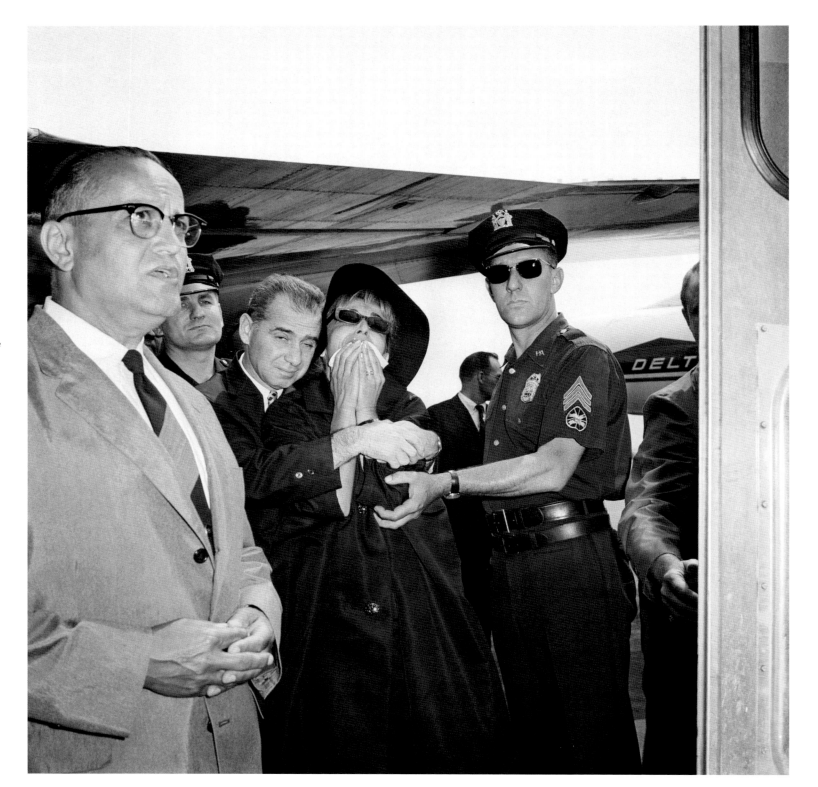

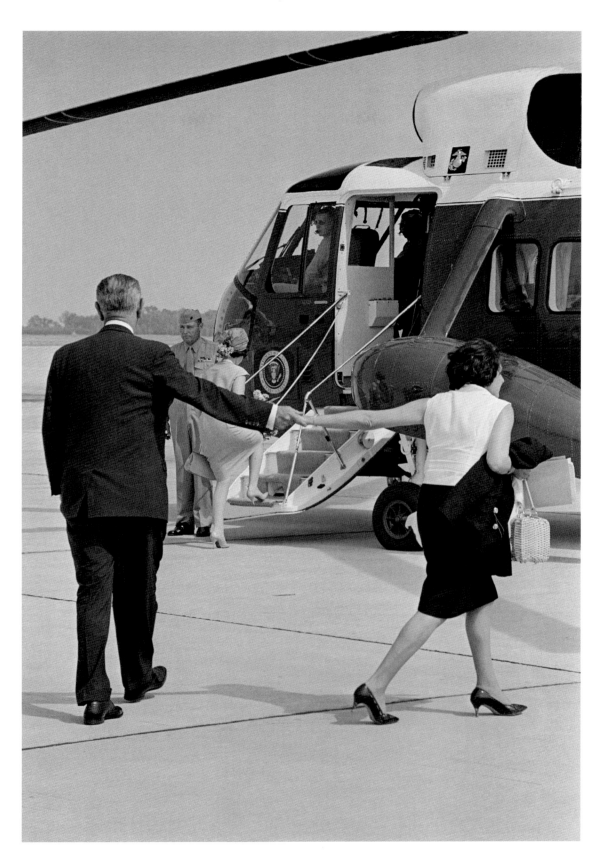

MAY 23, 1964
PHOTOGRAPHER: UNKNOWN
ANDREWS AIR FORCE BASE, MARYLAND

President and Mrs. Johnson returned
to nearby Andrews Air Force Base,
Maryland, after dedicating the George C.
Marshall Research Library at the Virginia
Military Institute in Lexington, Virginia.
Prior to boarding the helicopters for flight
to the White House, the Chief Executive
called over Helen Thomas, of United
Press International who accompanied
him on the trip, for a chat. The two part
with a handshake as Mrs. Johnson
boards helicopter.

Despite severe security precautions, some young fans of the Beatles did manage to find out where their chartered plane was unloading upon their arrival here for two performances. Left to right: Ringo Starr, John Lennon, George Harrison and Paul McCartney come down ramp from plane.

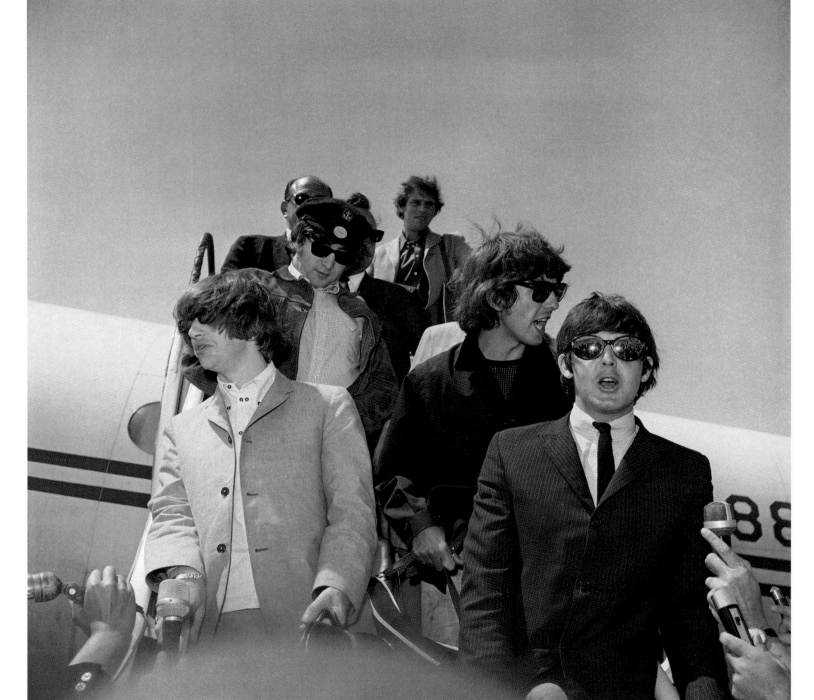

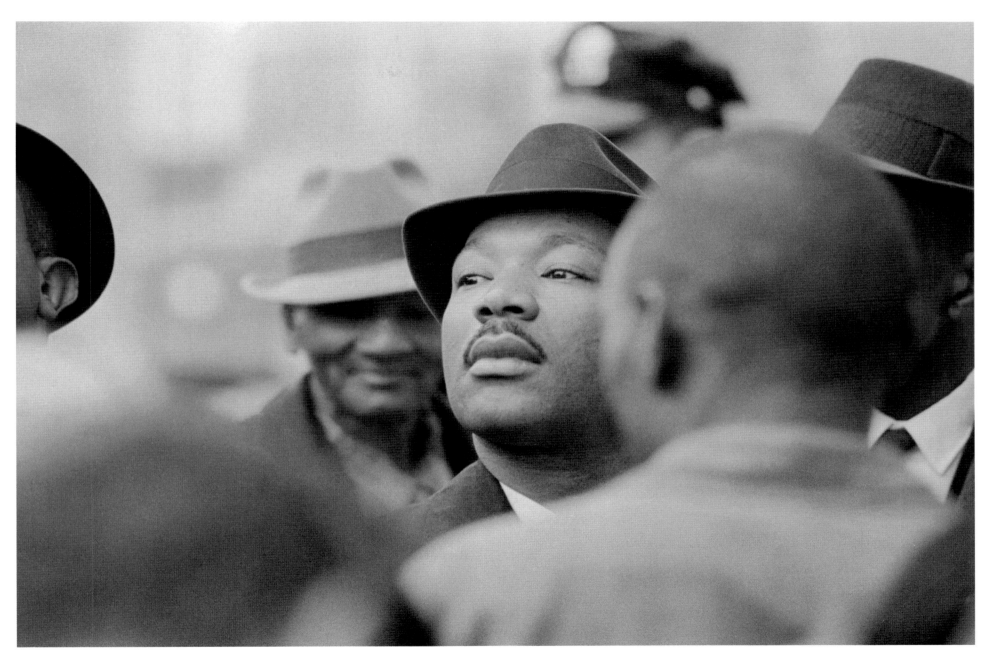

Voice of Protest

FEBRUARY 1, 1965
PHOTOGRAPHER: UNKNOWN
SELMA, ALABAMA

Dr. Martin Luther King, Jr., peers over
heads to determine the size of the group
here, as he and followers are arrested for
parading without a permit.

February 28,1926

A322650-SLUG,.(CONSTITUTION DISPLAY)
EVERY RELIC CALLS, "SAVE OUR SHIP"
New York....This display of priceless relics of the U.S.S
Constitution "Old Ironsides" lent by Lt. Col James Barnes
great-grandson of Commodore Bainbridge who commanded the
old Grigate in the height of her glory, is being shown in
the window of Aeolian Hall as a feature of the Drive of
recondition the old sea hero.

MR322652- WHO GAVE THE WRONG CUE?
The reconciliation of Mrs. Mabel Manton above, and her
husband William, the actor, has apparently gone awry
yesterday. Mrs. Manton's divorce suit naming Marjorie
Rambeau the actress, had been discontinued Friday, but
Manton dosent know where his wife is.

MR322651-TACKLING an alleged bandit single handed, Patrolman Matthew
Solomon, demoted from detective for permitting a prisoner
to escape proved his heroism during the holdup of a Broadwy
resturant He was seriously wounded

MR322653-SLUG,.(W.H. MAYER)
FATHER AIDS MAYER
Passaic N'J....Photo shows Judge William Mayer father of
Walter Mayer the youth who is dying from self inflicted
wounds in a Brooklyn hospital. Young Mayer admits having
shot and killed Shirley McIntyre Brookly girl who spurned
him as "inferior ". Judge Mayer is offering his all, to
help his son and only wishes he were able to take his sons'
place in the latter's present predicament

322654-BEAUTY IN LOVE SUIT
Photo shows Mrs. J. Paul Fernel, whose divorced husband,
A chicago beauty doctor is suing David G. Maxwell, retired
Chicago Millionaire flor alienation of affections. The suit
was filed in Los Angeles, for $500,000 and charges that
Mrs. Fernel upon promises of riches and a perfect love aff
air made in Heaven" lost her love for her husband

322655-SUES MILLIONAIRE FOR $500,000 FOR LOSS OF AFFECTIONS
Photo, showing him performing an operation is of Dr. Paul
Fernel Chicago beauty doctor who has brought suit in Los An
Angeles in the amount of $500,000 against David G.Maxwell
Multimillionaire. Fernel,-who-is-young-manufacturer of
Chicago for the alienation of affection of Mrs. Fernel who
is young and beautiful, Fernel charges that upon promises
of untold wealth, idleness and a "perfect love affair" made
in heaven Maxwell induced Mrs. Fernel to love him and cease
loving her husband

MR322656-SLUG,.(PAINTING)
FAMOUS PAINTING EXHIBITED AT MUSEUM OF ART
New York...Above isthe painting by Oiero Di Cosimo, renown
ed florentine artist which depicts men, Centaurs, Saytrs an
animals engaged in a general combat. This is only one of
the many valuable and wonderful paintings viewed in the gre
great art gallery every day.

MR322657-HARK, HERE'S THE FIRST CRACK OF SPRING
E'r the first robin has chirruped a chirrup or the earliest
bird cocked a single eye at the proberbial worm, this sign
of the vernal and the baseball season lightened the eyes an
hearts of Coney Island yesterday

Mr32265.... Fire at Long Beach. SCENES OF LONG BEACH L.I. BLAZE IN
WHICH HELPLESS COUPLE DIED. Couple burned to death in bunga
fire, Mr. & Mrs. Caroll Tompkins perished in the wind-swept
flames that destroyed their fame bungalow at Long Beach L.
Sunday. Therie horse in an adjacent stable, and a dog
died above is a general view showing wreckage of
g

BIBLIOGRAPHY

Barnhurst, Kevin G., and John C. Nerone. *The Form of News*. New York: Guilford Publications, Inc., 2001.

Collins, Francis A. *The Camera Man: His Adventures in Many Fields*. New York: The Century Co., 1916.

Cooke, David D. "News-Pictures." *Photo-Era* (June 1931).

Coopersmith, Jonathan. "From Lemons to Lemonade: The Development of AP Wirephoto." *American Journalism,* vol. 17, no. 4 (fall 2000).

Harnett, Richard M., and Billy G. Ferguson. *Unipress: Covering the 20th Century*. Colorado: Fulcrum Publishing, 2003.

Mich, Daniel D. "The Rise of Photojournalism in the United States." *Journalism Quarterly* (September 1947).

Mott, Frank Luther. *American Journalism, A History: 1690–1960*. New York: Macmillan, 1962.

Nasaw, David. *The Chief: The Life of William Randolph Hearst*. New York: Houghton Mifflin, 2000.

North, Anthony. "No, But I Saw the Pictures." *New Outlook* (June 1934): 17–21.

"Publishing, History of." *Encyclopædia Britannica*. Retrieved October 25, 2003, from Encyclopædia Britannica Premium Service. <http://www.britannica.com/eb/article?eu=117360>

Strider, Gray. The Inside Workings of a National News Photo Service." *Popular Photography* (July 1937).

Walters, Basil L. "Pictures vs. Type Display in Reporting the News." *Journalism Quarterly* (September 1947).

A logbook page from International News Photos showing image identification numbers and captions. A single book typically held approximately two months' worth of captions, all created as the images came into the INP office.

IMAGE REFERENCE NUMBERS

PAGE 2 BE027975 (U582302ACME)
PAGE 4 BE070180 (U800460ACME)
PAGE 6 BE031018 (U1055276)
PAGE 8 U387321INP
PAGE 10 BE082014
PAGE 11 BE004175; NA005646; BE027464; BE040132 (clockwise from top left)
PAGE 13 BE068922 (U1075267)
PAGE 14 BE024165 (left) BE035670 (right)
PAGE 15 BK001137
PAGE 16 BE032373
PAGE 18 U930992AACME
PAGE 19 U1079036
PAGE 21 U61019INP
PAGE 22 U45569INP
PAGE 23 U26905INP
PAGE 24 U25927INP
PAGE 25 U31461INP
PAGE 26 BE047382 (U30696INP)
PAGE 27 U27951INP
PAGE 28 U24944INP
PAGE 29 U21263INP
PAGE 30 U78959INP
PAGE 31 UB2414AINP
PAGE 32 U47192BINP
PAGE 33 U37258BINP
PAGE 34 U41303INP
PAGE 35 U31631INP
PAGE 36 BE080308 (UB2785GINP) (top) U78895INP (bottom)
PAGE 37 BE003406 (U43527INP) (top) U80845INP (bottom)
PAGE 38 U19180INP
PAGE 39 U118616INP
PAGE 40 U25002INP
PAGE 41 U298125INP
PAGE 42 U88716INP
PAGE 43 U107710INP
PAGE 44 U193075INP
PAGE 45 U491610INP
PAGE 46 U111764INP
PAGE 47 U151099
PAGE 48 U225259INP
PAGE 49 U197974INP
PAGE 50 U104147INP
PAGE 51 U249352INP
PAGE 52 U217606INP
PAGE 53 BE069383 (U102186P&A)
PAGE 54 U232322INP
PAGE 55 U265647INP

PAGE 56 U150485INP
PAGE 57 U179235INP
PAGE 58 U308027INP
PAGE 59 U258311INP
PAGE 60 U229494INP
PAGE 61 U349174INP
PAGE 62 U282736INP
PAGE 63 U276644INP
PAGE 64 U295633INP (top) U91827P-A (bottom)
PAGE 65 U356009INP
PAGE 66 U134741P-A
PAGE 67 U389969INP
PAGE 68 U381730INP
PAGE 69 U126906P-A
PAGE 70 U213533AP-A
PAGE 71 U104025ACME
PAGE 72 U406233INP
PAGE 73 U180511P-A
PAGE 74 U427397INP
PAGE 75 U106006ACME
PAGE 76 U483283INP
PAGE 77 U173563P-A
PAGE 78 U213802P-A
PAGE 79 U251679P-A
PAGE 80 BE066221 (U574874INP)
PAGE 81 U131904ACME
PAGE 82 U225193P-A
PAGE 83 U591893INP
PAGE 84 U196455ACME
PAGE 85 U603641INP
PAGE 86 U603840INP (top) BE033273 (U552171INP) (bottom)
PAGE 87 U207704ACME (left) U566647INP (right)
PAGE 88 BE023790 (U571526INP)
PAGE 89 U148838ACME
PAGE 90 BE050017 (U194144ACME) (top) U623610INP (bottom)
PAGE 91 U193805ACME
PAGE 92 U674006INP
PAGE 93 U221806ACME
PAGE 94 U688815INP (left) BE027073 (U238382ACME) (right)
PAGE 95 BE080764 (U697019INP) (top) U264871ACME (bottom)
PAGE 96 U197231ACME (left) U649505INP (right)
PAGE 97 BE023731 (U669931INP) (left) BE067862 (U674693INP) (right)

PAGE 98 BE033403 (U658206INP)
PAGE 99 U651122INP
PAGE 100 BE066875 (U270650ACME)
PAGE 101 BE066889 (U277362ACME)
PAGE 102 BE033129 (U704477INP)
PAGE 103 U716438INP
PAGE 104 BE027209 (U282437ACME)
PAGE 105 U711940INP
PAGE 106 BE049333 (U688994INP) (left) U283426AACME (right)
PAGE 107 U277416ACME (top) U303712ACME (bottom)
PAGE 108 U711611INP
PAGE 109 U713408INP
PAGE 110 U248916ACME
PAGE 111 U724537INP
PAGE 112 U727427INP
PAGE 113 BE027309 (U320023ACME)
PAGE 114 U309844CACME
PAGE 115 BE027229 (U306306ACME)
PAGE 116 BE050268 (U317849ACME)
PAGE 117 U315033ACME
PAGE 118 BE053654 (U748320INP)
PAGE 119 BE052352 (U737965INP)
PAGE 120 U371755ACME
PAGE 121 U774405INP
PAGE 122 U354842ACME
PAGE 123 BE080758 (U806507INP)
PAGE 124 U394885ACME
PAGE 125 BE027565 (U448646ACME)
PAGE 126 BE050102 (U806510INP)
PAGE 127 U795565INPA
PAGE 128 BE053662 (U848500INP)
PAGE 129 BE002829 (U519346)
PAGE 130 U868801INP
PAGE 131 U729318INP
PAGE 132 U858272INP
PAGE 133 U484595ACME
PAGE 134 BE027755 (U508495DACME)
PAGE 135 U533145ACME
PAGE 136 BE067903 (U555506ACME)
PAGE 137 U550420ACME
PAGE 138 U905670INP
PAGE 139 U558608AACME
PAGE 140 BE001071 (U897835INP) (left) U578468ACME (right)
PAGE 141 BE056499 (U578330ACME)
PAGE 142 U910552INP
PAGE 143 BE027975 (U582302ACME)
PAGE 144 U898897INP (top) U918346INP (bottom)

PAGE 145 BE076421 (U930871INP) (left) BE056733 (U940065INP) (right)
PAGE 146 U627510ACME
PAGE 147 BE034003 (U930764INP)
PAGE 148 U629966ACME
PAGE 149 U942235AINP
PAGE 150 U940389INP
PAGE 151 U632034ACME
PAGE 152 BE049786 (top) U627095AACME (bottom)
PAGE 153 BE002642 (U630110) (top) U628036ACME (bottom)
PAGE 154 BE042610 (U630122ACME)
PAGE 155 U628454ACME
PAGE 156 BE064676 (U669475ACME)
PAGE 157 BE004216 (U941686INP)
PAGE 158 BE059470 (U650474ACME)
PAGE 159 U637148ACME
PAGE 160 U683214ACME
PAGE 161 BE028502 (U697265ACME)
PAGE 162 U687852ACME
PAGE 163 U679695ACME
PAGE 164 U975364INP
PAGE 165 U672912ACME
PAGE 166 BE042586 (U694272ACME)
PAGE 167 U975286INP
PAGE 168 U764285ACME
PAGE 169 U685044-15ACME
PAGE 170 U970746INP
PAGE 171 BE028102
PAGE 172 BE028161 (U666632ACME) (left) U991137INP (right)
PAGE 173 U985981INP (left) BE028171 (U645146ACME) (right)
PAGE 174 BE035557 (U1004853INP)
PAGE 175 U724716ACME
PAGE 176 BE023729 (U719061ACME)
PAGE 177 U1027456INP
PAGE 178 U756871ACME
PAGE 179 BE002930 (U756824ACME)
PAGE 180 BE029014 (U768682ACME) (left) U768807ACME (right)
PAGE 181 U759113ACME
PAGE 182 U765406ACME
PAGE 183 U679372INP
PAGE 184 BE068656 (U778183ACME)
PAGE 185 BE042698 (U765191AACME)
PAGE 186 BE002219 (U1022122INP)
PAGE 187 U798797ACME
PAGE 188 U783013ACME
PAGE 189 BE070180 (U800460ACME)
PAGE 190 U1069119INP
PAGE 191 U799676ACME
PAGE 192 U1046515INP
PAGE 193 U852744ACME
PAGE 194 U1038507INP
PAGE 195 BE044156 (U1062867INP)
PAGE 196 BE077632 (U827058ACME)
PAGE 197 U810399ACME
PAGE 198 U875904ACME
PAGE 199 U1090586INP
PAGE 200 U899005ACME

PAGE 201 U901794ACME
PAGE 202 U882667ACME (left) U872710ACME (right)
PAGE 203 U950038ACME (left) U949238ACME (right)
PAGE 204 BE031903
PAGE 205 BE029709 (U955760ACME)
PAGE 206 U955494ACME
PAGE 207 BE056180 (U949536ACME)
PAGE 208 U1174711INP
PAGE 209 U1175936INP
PAGE 210 U964601ACME
PAGE 211 BE042826 (U967764ACME)
PAGE 212 BE048715 (U1165036INP)
PAGE 213 BE050362 (U972126)
PAGE 214 U965879ACME
PAGE 215 U967654ACME
PAGE 216 BE067636 (U1182906INP) (left) BE042805 (U996050ACME) (right)
PAGE 217 U1198367INP (left) U1031197 (right)
PAGE 218 U1065375
PAGE 219 U1000179A
PAGE 220 U1063654
PAGE 221 U1055985A
PAGE 222 U1268986INP
PAGE 223 U1267979INP
PAGE 224 BE030959 (U1076091)
PAGE 225 U1054765
PAGE 226 BE031018 (U1055276)
PAGE 227 U1141640
PAGE 228 U1276623INP
PAGE 229 U1096857
PAGE 230 U1274080INP
PAGE 231 U1281440INP
PAGE 232 U1292479INP (left) U1295233INP (right)
PAGE 233 U1089692 (left) U1089372 (right)
PAGE 234 U1095982
PAGE 235 BE048518 (U1294053INP)
PAGE 236 U1104625
PAGE 237 U1347403INP
PAGE 238 U1099283 (left) U1277674BINP (right)
PAGE 239 U1135316-6
PAGE 240 U1101212
PAGE 241 U1127165
PAGE 242 U1359730INP
PAGE 243 U1342818AINP
PAGE 244 BE055940 (U1337068INP)
PAGE 245 U1349899INP
PAGE 246 U1354721INP
PAGE 247 U1127488
PAGE 248 U1341163INP
PAGE 249 U1372564XINP
PAGE 250 BE031748 (U1154155)
PAGE 251 U1370796
PAGE 252 U1187132
PAGE 253 U1351510INP
PAGE 254 U1367994
PAGE 255 BE047083 (U1166086)

PAGE 256 U1184816 (left)
 BE031896 (DM995) (right)
PAGE 257 U1196901
PAGE 258 U1231059
PAGE 259 U1264226-10 (left)
 U1195175 (right)
PAGE 260 BE024618 (U1273285)
PAGE 261 U1334236
PAGE 262 BE060128 (U1306326B)
PAGE 263 U1219268
PAGE 264 U1352767
PAGE 265 BE024698 (U1292070)
PAGE 266 U1342523A (left)
 BE025289 (U1342530) (right)
PAGE 267 BE026076 (U1463695)
PAGE 268 U1354705A
PAGE 269 BE056136 (U1316728)
PAGE 270 BE049355 (U1346061) (left)
 BE045090 (right)
PAGE 271 U1402680-14 (top)
 BE025673 (U1402594) (bottom)
PAGE 272 BE025648 (U1392453)
PAGE 273 BE025791 (U1403095)
PAGE 274 U1408200 (top) BE025535
 (U1382878) (bottom)
PAGE 275 U1420039A (left)
 U1368041-15 (right)
PAGE 276 BE025945 (U1435544)
PAGE 277 U1426235-11
PAGE 278 U1485675A
PAGE 279 U1457835

All images are available at www.corbis.com

INDEX

Page numbers in *italics* refer to illustrations.

A Abbadando, Frank "The Dasher," *136*
Abilene, Kans., *182*
Acker, Agatha, *223*
Acme Newspictures, 8, 16, *17*, *205*
 inside workings of, 17–18
Acme Telephoto, 9, 17, 19
Actors' Studio, *238*
Agron, Sal, *256*
air raid drills, *151*, *210*, *216*
Alabama, University of, *274*
Albany, Ga., *270*
Alcatraz Island, *93*
America, S.S., *43*, *128*
American Bemberg Corporation, *75*
American Newspaper Publishers
 Convention, *139*
American Society of Newspaper Editors, 8
American Telephone & Telegraph Company
 (AT&T):
 coast-to-coast transmission by, 17
 Public Telegraph Service launched by, 17
 telephoto technology and, 8, 9
Andrews, Dana, *194*
Andrews Air Force Base, Md., *277*
AP News Photo Service, 8, 16
AP Wirephoto, 17, 19
Arbuckle, Roscoe "Fatty," *57*
Arbuckle, Rosene, *57*
Arden, Dawn, *209*
Arizona, U.S.S., *88*
Arlington National Cemetery, Va., *43*, *272*
Armstrong, Henry "Hank," *170*
Army, U.S., *144*
Asbury Park, N.J., *107*
Associated Press (AP), 9, 12
 founding of, 7, 12
 image transmission service established
 by, 17
 monopoly of news service by, 12–13, 17
Astor, Mrs. John Jacob, *24*
Astor Theatre, *238*
Atlantic City, N.J., *26*, *57*, *68*
Atlas rocket, *270*
Atomic tests, *227*, *237*, *251*
Augusta, Ga., *188*
Auschwitz, *187*
aviation, 7, *8*, 9, *11*, 16, *35*, *67*, *83*, *184*

B Babbit, Ricky, *196*
Baer, Arthur "Bugs," *139*
Baer, Max, *113*, *118*
Bailey's Beach, R.I., *102*
Baker, Raymond N., *189*
Bakewell, Frederick, 8, 17
Bankhead, Tallulah, *87*
Bank of the United States, *79*
Banks, Sonny, *269*
Barone, Carlo, *149*
Basilio, Carmen, *244*
Baylis, J. S., *147*
Beadle, David (the Beetle), *135*
Beardall, John, *153*
Beatles, *278*
Beaton, Cecil, *87*
Bell, Catherine, *173*
Bell Laboratories, 8, 9
Benny, Jack, *139*
Berlin, Irving, *54*
Best Years of Our Lives, The, *194*
Bettmann, Otto, 14
Bettmann Archive, 14
Biltmore Theatre, *73*
Bingay, Malcolm, 8–9
Birmingham, Ala., *241*
Blackburn, Jack, *117*
Black Maria, *121*
blimps, *83*, *191*
Blue, Monte, *94*
bobby soxers, *175*, *180*, *235*
Boettiger, Anna, *178*
Boggs, Barbara, *190*
Boggs, Corrine "Cokie," *190*
Boggs, Hale, *190*
Boggs, Mrs. Hale, *190*
Boggs, Tommy, *190*
bomb shelter, *151*
Bonus Army, *90*, *91*
Bonus Bill, *90*
Booth, Clare, *55*
Boston, Mass., *39*, *154*, *268*
Boston Braves, *28*, *39*, *47*
Boston Licensing Board, *275*
Boston Red Sox, *22*, *152*, *196*
Bove, Stella, *173*
box cars, *105*
boxing, *113*, *117*, *118*, *128*, *142*, *144*, *170*,
 177, *199*, *206*, *229*, *244*, *269*
Brady, Matthew, 15
Brainwashing School, *232*
Brancato, Tony, *209*
brassiere, inflatable, *208*
Breetveld, Christopher, *226*
Breetveld, Marie, *226*
Bremerton, Wash., *202*
Brewer, Honey, *229*
Bridgetown, N.J., *101*
Briggs Stadium, *196*
Brokaw, Mrs. Clifford, Jr., *71*
Bronx, N.Y., *79*, *142*, *212*, *227*
Brooklyn, N.Y., *22*, *35*, *47*, *59*, *136*, *149*, *188*,
 194
Brooklyn Bridge, *93*
Brooklyn Dodgers, *47*, *194*
Brooklyn Nationals, *22*
Brucker, Army Secretary, *246*
Budd, David, *90*
Burlak, Ann, *97*
bus boycott, *241*, *255*
"Buy in September" Campaign, *97*

C California Shipbuilding Corp., *160*
Calitri, Joseph, *238*
Callahan, Judge, *183*
Camden, N.J., *123*
Camera Man, The (Collins), 16
cameras:
 early technology in, 15–16
 flash bulbs and, 15
 handheld, 11
Campanella, Roy, *249*
Canfield, Mrs. Michael, *242*
Canzoneri, Tony, *118*
Cape Canaveral, Fla., *270*
Caperton, Admiral, *24*
Capitol, U.S., *91*
Capitol Hill, D.C., *218*
caption writers, 16, 19
Carlin, Raymond, *227*
Carmel, Calif., *61*
Carpenter, M. Scott, *270*
Carthay Circle Theater, *142*
Castro, Fidel, *256*
Cavanaugh, Billy, *142*
Central High School, Ark., *246*
Central Park, New York, N.Y., *24*, *145*, *219*
Channing, Carol, *217*
Chapin, John Hitchcock, *202*
Chaplin, Charlie, *142*, *172*
Checker, Chubby, *262*
Chicago, Ill., *117*, *229*
Chicago Cubs, *23*
Chicago Inter-Ocean, 16
Chicago-Times Herald, 17
Chicago Tribune, 8, 16
Chicago White Sox, *203*
China, U.N. delegation of, *169*
Chisholm, Sarah, *71*
CIO-United Auto Workers Union, *224*
City Hall, New York, N.Y., *83*
City Hall Park, New York, N.Y., *157*
civil rights, *51*, *131*, *241*, *255*, *259*, *266*, *270*,
 272, *274*, *279*
Civil War, U.S., 15
Clay, Cassius, *269*
Cleveland, Ohio, *223*, *224*
Club 66, *110*
Club Richman, *86*
Coast Guard, U.S., *147*, *163*
Cody, Lou, *94*
Cohen, Mickey, *206*, *250*

Cohn, Roy, *221*
Collins, Francis A., 16
Columbus, Miss., *106*
communism, *51*, *83*, *202*, *259*
concentration camps, *187*
Coney Island, N.Y., *30*, *88*, *158*, *205*, *220*
Congress, U.S., *190*
Congress of Racial Equality (CORE), *272*
Connecticut, U.S.S., *24*
Convention Hall, N.J., *107*
Coolidge, Calvin, 17
Cooper, Kent, 9, 17
Cooper, Walker, *194*
Copacabana Club, *216*
Corbin, Mrs. Philip, *69*
Corbis, 14
Costello, Lou, *139*
Courier and Enquirer, 7
Crane, Cheryl, *250*
Crane, Stephen, *175*
Crescendo, The, *262*
Cuban Embassy, D.C., *256*
Cuban missile crisis, *264*
Culver City, Calif., *94*
Curtis, Tony, *265*
Cushing, Richard J., *242*

D Dallas, Tex., *271*
"Dare-Devil" photography, *40*
Dauthuille, Laurent, *206*
Dayton, Tenn., *64*
DDT, *185*
Dean, James, *235*
Decatur, Ala., *183*
Detroit, Mich., *196*, *206*, *241*, *269*
Detroit Free Press, 8
Detroit Tigers, *196*, *203*
"Devil's Island," *93*
Dewey, Albert H., Jr., *69*
Dietrich, Marlene, *145*
DiMaggio, Joe, *152*, *196*, *247*
Dio, Johnny, *245*
District Prison, *76*
Dorsey, George, *192*
Douglas, Mrs. J. Gordon, *123*
draft lottery, *20*
Draper, Mrs. Sanders, *109*
Draper, Sanders, *109*
drive-in, *212*
Duke, Doris, *102*
Dunphy, Christopher, *69*
Durante, Jimmie, *120*

E Eagle, Don, *232*
East of Eden, *238*
Ebbets Field, *22*, *47*
editors, 11

of news services, 12, 16, 19
photographers vs., 16
Edwards, N. E., *40*
Eiker, Walter, *90*
Eisenhower, Dwight D., *182*
Eisenhower, Mamie, *182*
Elizabethton, Tenn., *75*
Ellis Island, N.Y., *32*, *51*
Empire State Building, *83*, *86*, *186*
engravings, 15
Eriksen, Hariette, *98*
evangelists, *125*, *217*, *253*
Evarts, Ky., *80*

F Fatio, Maurice, *69*
Faubus, Orval, *246*
"fax" machine, *19*
invention and development of, 17
see also telegraph services
Faye, Alice, *94*
Federal Bureau of Investigation (F.B.I.), *209*,
 276
Fellig, Arthur, *135*, *169*
Fields, W. C., *62*
Fifth Avenue, New York, N.Y., *216*
Fink, Lou, *77*
Fish, Moses, *187*
Fisher, Eddie, *252*
Flamingo Hotel, *209*
flash bulbs, 15
Flynn, Errol, *172*
football, *48*, *246*
Ford Island, Hawaii, *157*
Fort Dix, *263*
Fort Lauderdale, Fla., *260*
Fort Slocum, *144*
Fortune, 9
42nd Street, *96*
Francis, Aggie, *110*
Frank Leslie's Illustrated Newspaper, 15
Freed, Alan, *238*
Friedman, Edward, *110*
FSA Farmersville camp, *137*

G Garbo, Greta, *132*
Gary, W. Va., *153*
Gates, Bill, 14
Gehrig, Lou, *45*, *64*, *117*
Gehrig, Mrs. Lou, *117*
General Electric Company, *236*
General Motors, *275*
Gentlemen Prefer Blonds, *217*
George C. Marshall Research Library, *277*
Georgia, *170*
German-American bund, *130*
Gilbert, Larry, *39*
Gilbert, Rundle, *228*
"Girl in Cellophane, A," *98*

Glanzstoff Corporation, 75
"G-Men," 118
Godov, Arturo, 142
Goelet, Mrs. Robert, Jr., 36
Gonzales, Elian, 7
Goodman, Andrew, 276
Goodman, Robert W., 276
Goodyear Blimp, 83
Gorman, Margaret, 57
Graham, Billy, 203
Grand Central Station, 270
Grant, Cary, 249
Gray, Gilda, 62
Gray, Judd, 141
Graziano, Rocky, 199
Great Dictator, The, 142
Greenpoint Hospital, 59
Greenville, S.C., 101
Gstalder, Herb, 14

H Haiti, 24
 halftone process, 8, 15
 early quality of, 16
Hall High School, Ark., 259
Hansen, Betty, 172
Harbor News Association, 12
 see also Associated Press (AP)
Harlan, Ky., 80
Harlem, N.Y., 78, 110, 118, 128, 131,
 164, 196, 253
Harlow, Jean, 105
Harper's Weekly, 15, 15
Harris, Edna May, 126
Harris, Sylvester, 106
Harrison, George, 278
Hart, Margie, 274
Hatlo, Jimmy, 139
Haugwitz Reventlow, Countess, 140
Hauser, Hans, 210
Hayworth, Rita, 145, 161
Healy, Eileen, 86
Hearst, William Randolph, 7, 8, 14, 16
 Acme Telephoto introduced by, 9
 AP troubles of, 14
 "Buy in September" Campaign of, 97
 as creator of UPI, 12
 photo transmission systems established
 by, 17
 sensational approach of, 14
 in tabloid competition, 16–17
Hearst-Selig photographers, 40
Hell's Kitchen, 135, 256
Hendricks, Justice, 26
Hepburn, Ralph, 58
Hill, Virginia, 210
Hindenburg explosion, 7, 9, 11
Hiroshima, Japan, 227
Hoffa, James R., 241
Hollywood, Calif., 85, 87, 96, 105, 142, 191,
 194, 250, 262, 266

Hollywood Bowl, 105
homeless men, 120
Home Relief Bureau, 98
Hood, Jimmy, 274
Hoover, Herbert, 88
Hoover, J. Edgar, 118
Houdini, Mrs. Harry, 74
House Committee on Un-American Activities,
 202, 259
Howard, Robert J., 155
Hudson, Frederick, 15
Hudson River, 80
Hudson "Super 6," 35
Hughes, Howard, 191, 193
Hutton, Edward, 48
Hutton, Mrs. Edward, 48
Hyde Park, N.Y., 178

I "I Can't Get to First Base Without
 You," 117
 Ile de France, 103
Illustrated Daily News, see New York Daily
 News
illustrated papers:
 engravings in, 15
 Hudson on, 15
 photography's role in, 15
 rise of, 14–15
 see also newspapers
Independent Subway System, 132
infantile paralysis, 37, 230
inflatable brassiere, 208
Ingersoll, H. H., 27
"Inside Workings of a National News Photo
 Service, The," 17–18
integration, school, 259, 274
International Airlines Program, 184
International News Photos (INP), 8, 9, 12,
 16, 17
 Soundphoto introduced by, 9, 17
International News Service (INS), 7, 14, 16
Internet, news media and, 7
Irwin, Philip, 247

J Jack, Beau, 170, 188
 Jackson, Bob, 9
 Japan, 153, 157
Japanese immigrants, 39
Jenkins, Ray, 221
"Joe the Boss," 88
Johnson, J. V., 255
Johnson, Lady Bird, 277
Johnson, Lyndon B., 277
John Wanamaker store, 228
Jonathon, Don, 232
Jones Beach, N.Y., 185, 200
Julia Richmond High School, 256
Justice Department, U.S., 93, 118

K Kansas City, Mo., 52
 Karlsson, Einar, 84
 Keaton, Buster, 103
Keegan, Gilbert, 214
Keeler, Willie, 152
Kefauver, Estes, 206
Kell, George, 196
Kelly, George "Machine Gun," 94
Kennedy, Caroline Bouvier, 242
Kennedy, Edward M., 268
Kennedy, Jacqueline, 224, 242, 259
Kennedy, John F., 224, 242, 259, 268, 271, 272
Kennedy, Joseph P., 242
Kennedy, Robert, 242, 243
King, Martin Luther, Jr., 255, 266, 279
Klick, Frankie, 118
Koo, V. K. Wellington, 169
Korn, Arthur, 17
Kramer, Stanley, 249
Kuhn, Fritz, 130
Ku Klux Klan, 51, 270

L La Guardia, Fiorello, 145
 Laidlaw, Mrs. James Lees, 23
 Lakehurst, N.J., 9, 11
La Motta, Jake, 206
Lapland, 37
La Polla, Johnny, 124
Larroca, Barbara, 230
LaRue, Jack, 94
Las Vegas, Nev., 209, 252
Lawes, Lewis E., 141
Lawford, Peter, 175
League Island Navy Yard, 24
Leigh, Janet, 265
Lennon, John, 278
Leon and Eddie's night club, 117
LeRoy, Mervyn, 85
Levinsky, King, 117
Levittown, N.Y., 200
Lewis, John L., 146
Lexington, Va., 277
Liebowitz, Samuel, 149
Life, 9
limbo (dance), 260
Lindbergh, Charles A., 8, 67
Linotype machine, 7
"Little Augie," 72
Little Rock, Ark., 259
Lodge, George Cabot, 268
Lombard, Carole, 87
Long Branch, N.J., 51
Long Island, N.Y., 59, 67, 185, 200
Long Island Railroad, 205
Lopez, Andrew, 205
Loren, Sophia, 249
Los Alamos, N.Mex., 214, 230
Los Angeles, Calif., 57, 61, 62, 84, 96, 97,
 106, 110, 139, 160, 163, 172, 206, 209,
 233, 247, 265
Los Angeles Coliseum, 139

Los Angeles Harbor, 193
"Lost Battalion" Regiment, 43
Louis, Joe, 113, 117, 118, 128, 142, 144, 269
Lucas, Margaret, 173
Luciano, Charles "Lucky," 121
Ludwig, Robert, 233
Luncheon of the Banshees, 139

M MacArthur, Douglas, 215
 McCarthy, Jean, 218
 McCarthy, Joseph R., 218, 221, 226
McCarthy-Army controversy, 226
McCartney, Paul, 278
McClennan, John L., 245
McCormick, Robert, 8
McGrath, J. Howard, 198
McLanahan, Mrs. A., 95
McLane, David, 125
McLaughlin, Irene Castle, 112
Macomber, Mrs. G. H., 160
Macon, Ga., 28
McPherson, Aimee Semple, 61
Madison Square Garden, 130, 170, 232
Malcolm, Dorothy Dorsey, 192
Malone, Dudley Field, 64
Malone, Harry "Happy," 136
Malone, Vivian, 274
Mann Act, 172
mannequins, 228
Maranville, Rabbit, 28
March of Dimes, 230
Marine Flasher, S.S., 187
Marines, U.S., 24, 152, 163, 202
Martinez, Everado, 233
Massari, Giuseppi "Joe the Boss," 88
Maxwell, Elsa, 123, 126
Memphis, Tenn., 94
Merkel, Una, 96
Metropolitan Opera Ball, 95
Miami Beach, Fla., 200
Midsummer Night's Dream, A, 105
migratory workers, 137
mill workers, 75, 101
mine workers, 146, 153
"Miss America," 57
Missouri, U.S.S., 176
"Miss X," 61
Mitchell, Charles, 70
Mocambo, 175
Monroe, Ga., 192
Monroe, Marilyn, 7, 217, 238, 247, 266
Montgomery, Ala., 255, 266
Montgomery City bus, 241
Morgan, J. P., 70
Morrison, Fred R., 265
Morro Castle, S.S., 107, 108, 109
Morsellino, Piedro, 149
Mount Carmel Cemetery, 151
Mt. Judah Cemetery, 72
Mt. Perry Baptist Church, 192
Mulford, Ralph, 35

Mummers Parade, 53
Mundy, Allen, 110
Murder, Inc., 136

N Naschik, Robert "Baby Face," 167
 National Foundation for
 infantile paralysis, 230
National Guard, U.S., 75, 101
Naval Academy, U.S., 48, 189
Navy, U.S., 43, 154, 163
 blimp of, 191
 Recruiting Office, 154
Nazi concentration camps, 187
Negro Ball, 110
Nevada, 232, 237
Newark, N.J., 199, 276
Newark Airport, 276
Newark Stadium, 199
New Jersey, 263
New Jersey State Reformatory, 167
New Outlook, 8, 17
Newport, R.I., 36, 102
Newport News, Va., 128
newsboy, 33
Newspaper Enterprise Association, 14, 16, 17
newspapers:
 Associated Press founded by, 7
 circulation increase of, 12, 15
 competition of, 8, 9
 conservative vs. sensational, 14
 cost of telegraph services and, 7
 editors vs. publishers in control of, 11
 illustrated, early years of, 14–15
 other media as threat to, 9, 16
 photography vs. text in, 14
 rapid growth of, 7–8
 urban vs. small town, 8
 Wirephoto's effect on, 8, 9
 see also illustrated papers; tabloids;
 specific newspapers
news photography, see photography, news
news services:
 AP's early monopoly on, 12–13
 editors of, 12, 16, 19
 growth of, 12
 photographs distributed by, 16, 17
New York, N.Y., 23, 24, 28, 33, 36, 37, 40, 44,
 51, 55, 60, 62, 67, 70, 71, 72, 78, 80, 83,
 86, 93, 95, 98, 103, 109, 113, 115, 117,
 118, 120, 121, 123, 124, 125, 126, 128,
 130, 131, 132, 135, 136, 139, 145, 147,
 148, 155, 158, 163, 164, 167, 169, 170,
 175, 176, 180, 186, 187, 188, 196, 202,
 209, 210, 212, 216, 219, 226, 228, 232,
 238, 242, 249, 254, 256, 264, 270
New York City Municipal Lodging House, 120
New York Daily Graphic, 15
New York Daily Mirror, 17
New York Daily News, 16, 19
 founding of, 8
 as tabloid paper, 16–17

New York Express, 7
New York Giants, *23, 194*
New York Harbor, *176*
New York Herald, 7, 17
New York Journal of Commerce, 7
New York Morning Journal, 14
New York Playboy Club, 275
New York Stock Exchange, *70*
New York Sun, 7
New York Times, 8, 15
 see also Wide World Photos
New York Tribune, 7, 15
New York World, 14
New York Yankees, *64, 117, 196, 203*
Niven, David, *107*
Nixon, Richard M., *230, 261*
Normandie, 147, 158
Norris, Clarence, *183*
North, Anthony, 8
North Providence, R.I., *238*
NRA, *97*
Nussbaum, Max, *252*

Oberon, Merle, *107*
Oelrichs, Marjorie, *69*
Office of Price Administration
 (OPA), *163*
Oklahoma City, Okla., *94*
 bombing of, 7
Olsen, Ole, *139*
Olson, Carl "Bobo," *229*
Olympic Games, *84, 96*
100 yard dash, 27
Orgen, Jacob "Little Augie," *72*
Ossining, N.Y., *141*
Oswald, Commissioner, *234*
Oswald, Lee Harvey, 7, 9, *271*
Owens, Jesse, *114*

Pace, John, *90*
Pacific and Atlantic (P&A),
 9, 12, 16, *16,* 67
Page, Joe, *203*
Pageant of Beauty, *57*
pajama party, *180*
Palm Beach, Fla., *48, 54, 112, 140*
Palo Alto, Calif., *261*
Panama-Pacific Exposition, *35*
Pan American World Airways, *184*
parades, *67, 134, 182, 215*
Paramount Theater, *175, 238*
Park Avenue, New York, N.Y., *55, 71*
Park Drop Forge Co., *224*
Parris Island, N.C., *152*
Pasadena, Calif., *166, 203, 223*
Pasadena Rose Bowl, *203*
Paso Robles, Calif., *235*
Patameda, Francis, *53*

Paterson, N.J., *97*
Patterson, Heywood, *183*
Patterson, Joseph Medill, 8
Pearl Harbor Naval Station, *157*
Peary, Robert E., *43*
Perry, Milton, *253*
Peterson, Russel R., *250*
Philadelphia, Pa., *24, 53, 69, 198, 251*
Philippine-American War, 17
Photo Era, 16
photographers, *16, 40, 135, 205, 245*
 anonymity of, 16
 camera advancements and, 11, 16
 job description of, 16, 19
 objective role of, 15, 16
 vs. editors, 16
photography, news:
 arrival of, 8
 camera advancements and, 11
 early technology of, 15–16
 evolution of, 9–10
 halftone process and, 8, 15, 16
 high costs of, 8, 16
 in illustrated papers, 15
 news services and, 16, 17
 in 1930s, 19
 objective role of, 15
 recent technology's effect on, 7
 speed of transmission of, 17, 19
 subjective interpretation in, 11, 16
 syndicated systems established in, 8, 16
 telegraph services and, 8, 9, 16, 17, 19
 text vs., 14, 15
 Wirephoto's effect on, 8, 9
Pihlajamaki, Herman, *84*
Pike, Joyce, *233*
Plaquemine, La., *272*
Pleasure Man, 73
polo, *59*
Polo Grounds, *22, 194*
Pompton Lakes, N.J., *144*
Popular Photography, 17
Powell, William, *105*
Presley, Elvis, *263*
printing presses, 7, 8
Prohibition, repeal of, 95
Public Health Service advisory committee,
 274
Public Telegraph Service, 17
Publisher's Press, 14
 see also United Press Associations
Pulitzer, Joseph, 8, 14

Queen Elizabeth II, *254*
Queens, N.Y., *151, 275*

race riots, *131*
Radio City Music Hall, *109*

Raft, George, *94*
Rainbow Room, *109*
rations, wartime, *163, 165*
Raymond, Alex, *139*
RCA building, *109*
Reagan, Ronald, 7
Record-o-phone, 19
Red, White and Blue Ball, *123, 126*
Red Cross, 28
"reds," *51, 83*
Reif, Morris, *188*
Reinhardt, Max, *105*
Reinhart, Hans, *209*
Reles, Abe, *151*
Reuben James, 155
Reynolds, Debbie, *252*
Richmond Hill, N.Y., *205*
riots, *131, 164*
Rivera, Juanita, *219*
Rivera, Lino, *131*
Rizarry, Luis, *219*
Robinson, Bill, *120*
Robinson, Jackie, *139, 194*
Robinson, Sugar Ray, *229*
Rock 'n Roll, 238
Rogers, Ginger, *85*
Rogers, Jimmy, *214*
Roosevelt, Eleanor, *128, 137, 178*
Roosevelt, Elliott, *178*
Roosevelt, Franklin D., *97, 98, 106, 145,*
 146, 153, 157, 178, 179
Roosevelt, James, *153*
Roosevelt, Theodore, Jr., *88*
Roosevelt Field, *67*
Rose, Charles R., *155*
Rosenberg, Ethel, *212*
Rosenberg, Julius, *212*
Rosolo, Dave, *194*
Ross, Lanny, *139*
Ruby, Jack, 7, 9
Rued, Robert, *132*
Russell, Jane, *191*
Ruth, Babe, *44*
Rutherford, Mrs. Jack, *69*

St. Louis, Mo., *140*
St. Louis Cardinals, *64*
St. Patrick's Cathedral, *242*
St. Vincent's hospital, *44*
Salvation Army, *28*
Sammy's Bowery Nightclub, *169*
San Francisco, Calif., *16, 35, 39, 93, 134,*
 169, 209, 215, 259, 278
San Francisco Examiner, 14
San Juan, P. R., *88*
San Pedro, Calif., *193*
Santa Fe Chief, 87
Santa Monica, Calif., *161*
Santa Monica Beach, Calif., *107*
Savoy Ballroom, *196*

Saxton, Johnny, *244*
Schenectady, N.Y., *236*
Schmeling, Max, *128*
school integration, *259, 274*
Scopes, John T., *64*
Scottsboro case, *183*
Scripps, E. W., 7, 8, *14,* 16
 as creator of UPI, 12
 criticisms of AP news services by, 14
 news services established by, 14
 photo transmission systems established
 by, 17
Scripps-Howard Newspapers, *274*
Seabrook Farms, N.J., *101*
Seattle, 155
Seattle, Wash., *202*
Sebastian, Frank, *94*
Secret Service, U.S., *215*
Selma, Ala., *266, 279*
Senate, U.S.:
 Crime Committee of, *206, 210*
 Labor Rackets Committee of, *241, 243,*
 245
Shaffer, Mrs. Harvey, *69*
Shelby County Jail, *94*
shelter, bomb, *151*
Sheppard, Marilyn, *223*
Sheppard, Samuel, *223*
Shinyu Maru, 39
Siegel, Bugsy, *209, 210*
Simms, Lucy, *196*
Sinatra, Frank, *166, 175, 247*
Sinclair, Earl, *76*
Sinclair, Harry, *76*
Sinclair, Upton, *106*
69th Street Armory, *36*
Small's Paradise Club, *78*
Smith, Alfred E., *68*
Smith, Art, *35*
Smith, H. L., *27*
Smith, Mrs. Alfred E., *68*
smog protest, *223*
Snite, Fred, Jr., *200*
Snite, Fred, Sr., *200*
Snite, Kitty, *200*
Snite, Marie, *200*
Snite, Mrs. Fred, Jr., *200*
Snite, Pinky, *200*
Snyder, Ruth, 16, *141*
Society for Ethical Culture, *276*
Soglow, Otto, *139*
Soundphoto, 9, 17
Southern Illustrated News, 15
Speculator, N.Y., *77*
Speed Graphic, 11, 16
"Spirit of St. Louis," *67*
Spot beer tavern, *135*
Springut, Else, *187*
Springut, Rita, *187*
Starr, Ringo, *278*
Stengel, Casey, *203*

Stickland, O. M., *255*
stilt-walker, *115*
stock exchange, *31,* 70
Stompanato, Johnny, *250*
strikes, worker, *75, 97, 101, 123, 146, 153, 224*
subway thefts, *132*
suffrage, women's, *23*
Swanstrom, Arthur, *86*
syndicated systems:
 establishment of, 7
 for photographs, 8
 see also news services

tabloids, 8, 19
 rise of, 16–17
 Talbot, Lyle, *94*
Tatum, Tommy, *194*
Taylor, Elizabeth, *252*
Teamsters Union, *241*
Teaschner, E. A., *27*
technology:
 camera advancement in, 11
 in early photography, 15–16
 newspapers affected by, 7–8
 photographic advancements in, 8, 15–16
 in telegraph services, 7, 17
 see also telegraph services
telegraph services:
 and AT&T's coast-to-coast transmission, 17
 beginning of, 7, 12, 17
 first photograph transmissions attempted
 by, 17
 high costs of, 8, 17
 inside workings of, 17–18
 reactions to advancements in, 8–9
 "shared experiences" made possible by, 9
 speed of photographs transmitted by, 17,
 19
 syndicated systems established by, 7, 8
 and transmission of photographs, 8, 9, 16,
 17, 19
telephoto, 8, 17
television, 9
Temple Beth Shalom, *252*
"Ten Most Wanted Men," *209*
Tennessee mill workers, *75*
text, photographs vs., 14, 15
Textile Workers' Union, *97*
Thaw, Harry K., *26*
Thomas, Helen, *277*
Thomson School, *210*
307th Regiment, *43*
308th Regiment, *43*
Tiananmen Square, 7
Times Square, New York, N.Y., *47, 126,*
 148, 180
Todd Insecticidal Fog Applicator, *185*
Todd Shipyards Corp., *185*
Tolson, Clyde A., *118*
Totten, Hal, *117*

touring evangelist, *125*
transfusion operation, *59*
Treadway, H. I., *27*
Tretick, Stanley, *245*
Troan, John, *274*
Trombino, Tony, *209*
Truman, Bess, *173*
Truman, Harry S., *173, 198, 202*
tuberculosis, children with, *60*
Tunney, Gene, *77*
Turner, Lana, *175, 250*
Tuscaloosa, Ala., *274*
twist, the, *262*

U UNCIO Charter, *169*
unemployed workers, *98*
Union Depot, 85
Union Square, New York, N.Y., *83*
United Auto Workers Union, *224*
United Features, 8
United Mine Workers, *146*
United Nations, *169*
United Newspictures, 8
United Press, 7, 14, 16, *19, 245*
United Press Associations, 14
United Press International (UPI), 12, 14,
 17, 277
 slogan of, 16
United States Coal and Coke Colo., *153*
Urschel, Charles F., *94*

V Van Doren, Mamie, *233*
Vanity Fair, 9
Van Riper, Kenneth, *69*
Virginia Military Institute, *277*
Visalia, Calif., *137*
Vogue, 9

W Waldorf Astoria hotel, *123, 126*
Wales, Edward, Prince of (*later*
 Edward VIII; Duke of Windsor)
Walpole, Mass., *234*
Walters, Basil W., 15
Wanamaker Department Store, *228*
Waring, Fred, *139*
Warner Brothers Hollywood Theater, *96*
Washington, D.C., *43, 57, 76, 90, 91, 98, 118,*
 146, 153, 173, 179, 190, 210, 218, 221,
 230, 243, 251, 256, 259, 274
Washington Senators, *203*
Watson, Edwin, *153*
Webb, Blaine, *69*
Weems, Gloria M., *189*
Welles, Orson, *161*
West, Mae, *73, 110*
Westbury, N.Y., *59*

Western Union, 12
Western Union building, *40*
Westover, Russ, *139*
West Palm Beach, Fla., *224*
West Side Court, *73*
White House, *90, 251, 275*
Whitestone Bridge Drive-In Movie Theater, *212*
Wide World Photos, 8, 16, 17
 Wired Photos introduced by, 9
Wiesbaden, Germany, *187*
Wiley, Harry, *229*
Wilkie, Wendell L., *140*
window washers, *86*
Wired Photos, 9
Wirephoto, 7
 arrival of, 8, 9, 17
 high costs of, 17
 newspapers revolutionized by, 8, 9
 use of photographs affected by, 9
Wiseman, Lorraine, *61*
Women's Auxiliary Army Corps (WAACs), *170*
women's suffrage, *23*
Woodward, Ann, *254*
Woodward, Elise, *254*
workers:
 on strike, *75, 97, 101, 123, 146, 153, 224*
 women, *173*
World Series, *22, 47, 64, 249*
World's Fair (1851), 17
World's Fair (1964), *275*
World Trade Center, 7
World War II, *148, 153, 154, 155, 157, 158,*
 163, 165, 176, 180, 187
Wright Brothers, 16
"wrong door" raid, *247*

Y Yankee Stadium, *142*

Z Zabala, Juan Carlos, *96*
Zale, Tony, *199*
Ziegfeld Follies girls, *62*
Ziluck, Nancy, *256*

This book is dedicated to all the unknown photographers whose work now lives on in the Corbis/UPI photo library and to Sally Gil, Carrie Hannigan, Lilabet, Alexandra, and Maxwell.

Special thanks to Robinya Roberts and Dina Keil and all of the Corbis staff who offered their support, and to Timothy Seldes, friend and agent extraordinaire.

Note: Captions accompanying photographs on pages 21 through 279 appear verbatim as found in the United Press International files. Where extant we have included the slug (title), photographer name, date, location, and caption per se. Grammar and punctuation have been altered in certain cases for clarity.

Editor: Deborah Aaronson
Designer: Tsang Seymour Design, New York
Production Manager: Maria Pia Gramaglia

Library of Congress Cataloging-in-Publication Data

Hannigan, William.
Picture machine: the rise of American newspictures / William Hannigan and Ken Johnston.
p. cm.
Includes bibliographical references and index.
ISBN 0-8109-4642-4
1. Photojournalism—United States–History– 20th century. 2. Phototelegraphy–sUnited States–History–20th century. 3. News agencies–United States–History–20th century.
4. United Press International–Photograph collections. I. Johnston, Ken. II. Title.

TR820.H2825 2004
070.4'9'0973—dc22

2004005961

Printed and bound in Singapore

10 9 8 7 6 5 4 3 2 1

Harry N. Abrams, Inc.
100 Fifth Avenue
New York, N.Y. 10011
www.abramsbooks.com

Abrams is a subsidiary of

LA MARTINIÈRE

Page 2: Hollywood movie premiere, 1940
(see page 143).

DULCE PALADAR

DE LILY VANILLI

Desde que empezó a vender sus pasteles en un mercado de East London, Lily Jones (alias Lily Vanilli) se ha convertido en una de las reposteras artesanas más apreciada de Reino Unido. Con una lista de clientes colmada de estrellas, la repostería de Lily se ha hecho famosa gracias a unas combinaciones de sabor únicas, unos diseños espectaculares y un gusto exquisito. En el año 2011 abrió su primera pastelería en Columbia Road (East London). Dirige un club privado de pasteles y cócteles y es una de las fundadoras de los Premios YBF. También es autora del libro *¡Un zombi se comió mi cupcake!*

DULCE PALADAR

DE LILY VANILLI

RECETAS Y CONSEJOS DE UNA PASTELERA ARTESANA MODERNA

LILY JONES

FOTOGRAFÍA DE ROMAS FOORD

editorial juventud

Barcelona

Título original: SWEET TOOTH
© Lily Jones, 2012
© de las fotografías, Romas Foord, 2012
© de la fotografía adicional (página 2), Steve Ryan, 2012
Publicado por acuerdo con Canongate Books Ltd, Edimburgo
© de la traducción española:
EDITORIAL JUVENTUD, S. A., 2014
Provença, 101 - 08029 Barcelona
info@editorialjuventud.es
www.editorialjuventud.es

Traducción de Susana Tornero Brugués
Fotografía: Romas Foord
Estilo: Lily Jones
Ilustración (páginas 36-37): Katherine Pont

Primera edición, 2015
DL B23930-2014
ISBN 978-84-261-4135-4
Núm. de edición de E. J.: 12.903

Impreso en China en papel libre de ácido por
C&C Offset Printing Co., Ltd
Printed in China